**www.archimuse.com/
mw2000/**

Museums
and the
Web 2000

Archives & Museum Informatics

Consulting, Publishing and Training
for Cultural Heritage Professionals

Informatics: The interdisciplinary study of information content, representation, technology and applications and the methods and strategies by which information is used in organizations, networks, cultures and societies.

Archives & Museum Informatics organizes conferences, workshops and seminars, publishes journals and monographs, and consults for archives and museums worldwide. For the past 10 years, our educational goal has been to provide specialists in archives and museum information systems with timely and challenging opportunities for professional exchange and training. Our consulting services emphasize inter-institutional collaboration, strategic planning and standards-based solutions.

To be kept informed of coming events, conferences and new publications contact us at:

Archives & Museum Informatics
2008 Murray Avenue, Suite D
Pittsburgh, Pennsylvania
15217 USA
phone: +1 412 422 8530
fax: +1 412 422 8594
email: info@archimuse.com
http://www.archimuse.com

Ask to be put on our mailing list.

Distribution of the Proceedings to MW2000 Conference registrants was sponsored by **bigchalk.com**.

www.archimuse.com/
mw2000/

Museums and the Web 2000

Selected Papers from an International Conference

edited by
David Bearman and
Jennifer Trant

Museums and the Web 2000
Selected papers from an international conference

edited by David Bearman and Jennifer Trant
Pittsburgh, PA: Archives & Museum Informatics
ISBN: 1-885626-20-7

Printed in the United States of America

Contents

Introduction

Museum Applications

Techniques & Methods

Organization & Management

Evaluation

About the Authors

Introduction

The Year In Review: Reaching Audiences and Assessing Results

David Bearman and Jennifer Trant, Archives & Museum Informatics

An Introduction to MW2000

This fourth volume in the series of Museums and the Web Conference Proceedings bodes well for the transformation of museum practice and the acceptance of the web as a main vehicle in the communications strategy of all cultural and heritage institutions. New applications of the web to museum have expanded our definition and understanding of that work, and changed how we relate its nature and significance to museum visitors. The methods and techniques we have at hand to bring museum content to the web are growing in sophistication. Finally we are almost at the point where we don't have to build the tool in order to build the site. With this growing sophistication, comes an increased awareness on the organizational and management issues involved in deploying and maintaining a successful museum web site. Our creativity is challenged as we redefine organizational paradigms and tap new funding sources to ensure that our web content remains vibrant and relevant to our uses. And how much more we know about those users now! We're changing the target of our skill in evaluation and assessment from the exhibition gallery and educational program to our online offerings, and the results show us, how far we've come, and how far we've got to go to meet expanding user expectations.

This print volume of the Museums and the Web 2000 conference proceedings is organized to reflect these topical divisions: Museum Applications, Techniques and Methods, Organization and Management and Evaluation. The accompanying CD-ROM follows the structure of the meeting, and includes full abstracts of all presentations as well as the texts of all the papers here (with color illustrations and live links) and many other papers that couldn't be included in the print. Together the print and CD volume provide a unique snapshot of another year in the great progress of museums on the web.

Museums and Web Applications

In the past year, museums continued to explore the ways they have found to make their collections available in conjunction with the World Wide Web: as part of an on-site exhibition, as interactive multimedia, as new programming and experiences, and in conjunction with museum educational programs. The four papers in this first section of the Museums and the Web 2000 Conference Proceedings examine specific cases of museum applications of these approaches, each of which shows signs of maturing both by fitting into other museum activity better and meeting the audience in increasingly well defined genre's of web interaction.

Scott Sayre's report of the hugely successful on-site installation at the Minneapolis Institute of Art, which employed interactive elements to document the restoration of a single work of art and to engage the museum visitors with the members

of the museum staff involved in the restoration. The resulting exhibit was engaging to the on-site visitors and gave them a sense of deep understanding of the nature of museum work and involvement with the people behind an important local institution. Its web manifestation succeeds almost as well at creating a sense of place and belonging. We can hardly fail to be impressed with this demonstration of how a technology that has often been depicted as alienating and superficial both cements interpersonal relations and a sense of local pride, and can engage individuals for long hours in great depth.

A huge national museum devoted to what many would regard as a somewhat arcane subject has difficulty making itself relevant to those who are not primarily interested in its focus. Sarah Ashton and Sophia Robertson demonstrate how two very deep applications can make the content of a rich museum resource relevant to users with many different experiences and interests. In the process, they document the challenges facing museum staff as they seek to continue to extend meaningful access to their collections. The nature and extent of the on-going activity required to expand content, provide new views and means of access to it, develop better tools for end users and manage the continued expansion of a website, begin to define just how much of a program commitment is made when a museum takes its collections online.

The Minneapolis Institute of Arts and the National Maritime Museum in Greenwich have found ways to enhance the power and reach of traditional museum programming by introducing interactive media and online access. But new kinds of museum programming are not the only web-inspired activities that create fundamentally new requirements and demand new practices from museums. The University of Illinois researchers (Bennett, Sandore, Grunden & Miller) have explored some of the implications of bringing primary resources from museums into use in elementary school teaching. Few museum professionals would identify the importance of metadata concerning curricular requirements and learning objectives as a sine qua non of usable museum content (few would even know for sure what metadata was, or could correctly identify its role in enabling use). This concrete study of how museum educational programming could change as the audience for the museum experience is reached over the web rather than by telephone from across town documents just how much even familiar looking museum applications will be transformed at they meet the demands of remote online audiences.

Jennifer Trant's report on the Art Museum Image Consortium, as an instance of a digital library of primary resources in the humanities, examines such transformative requirements systematically. What kinds of entities can make digital library resources in the future and how will they build and sustain the sense of community required to construct vast collections over many years? How can they select content when virtually everything in the world needs to be digitized? What documentation is necessary and what knowledge representations adequate for a useful resource? How can the technologies be chosen to interoperate and last without being prohibitive to participants? And what intellectual property protection and administration is required? Finally, how can a sustainable economic model be implemented, which can support these programs over decades? By looking in depth at the choices and decisions made by the Art Museum Image Consortium (AMICO), Trant exposes how the answers to each of these fundamental questions are specific to the digital library resource, and in what ways they are generic to the world of digital library resources.

Techniques and Methods

Constructing the museum experience in the Web age, involves mastering numerous new tools, techniques, methods, approaches and perspectives which are themselves evolving rapidly. The Museums and the Web conference is one of numerous venues where these 'tricks of the trade' are exchanged. The papers in this sections report on a few of the many exchanges of tacit knowledge within an evolving new media profession.

This set of papers takes up two interrelated sets of questions: First, can the web make possible new and satisfying ways of studying the world's distributed artistic heritage? What methods can enable us to examine works of art in depth? Can we afford to create and distribute the image resolution required? Will techniques such as digital watermarking support the legal and economic security required?

And secondly, what methods will enable us to construct meaning from complex virtual social spaces and representations of virtual objects? How can we tell a non-linear story? How can we move through time and space both without getting lost and frustrated? Can we learn lessons of value in the real world from virtual objects?

Jim Spadaccini, describes how new techniques can lead to altogether new programming opportunities. Without broadband telecommunications, the types of museum sponsored events Spadaccini and colleagues at the Exploratorium have engendered would not have occurred. Webcasting and delivering streaming media at the users request, both extend the kind of programming which museums can initiate and make the museum and active participant in real-time documentation of natural, political and artistic events.

One of the exciting challenges of pioneering solutions in a digital realm, is that it involves overcoming an interrelated set of technical, economic, social, legal and philosophical hurdles. Michael Douma and Michael Henchman, explore a series of multimedia techniques for examining works of art. The metaphors which give their tools names are intended to make the function of each software tool immediately understandable – the spyglass, the zoom, floating descriptions, image rollovers, pop-up images, virtual reality scenes. In each case the authors explore how the physical world realization of this tool compares with the realization in a virtual presentation and the advantages of the latter. It is clear that such methods have considerable promise and, with widespread web-based access to rich images, could significantly democratize the ability to study art.

Maria Daniels addresses whether such widespread rich imagery is deliverable. The underlying philosophical and economic issues intertwine – such rich images were transformative, could they be integrated? Protecting ownership was critical, as was adding value through standardization of the knowledge representations. Longevity of data is tied in some ways to standards, and in others to automated processes which were essential also to make rich data capture economically affordable. In this paper the apparently simple task of rendering some coins in high resolution is laid bare as the deservedly considered and experimental project that it still is – something which will help inform future digital library projects.

Torsten Bissel and his colleagues at the German National Research Center for Information Technology have looked in detail at the claims made by vendors of digital watermarking technologies. Digital watermarking companies make claims that on the surface make it seem very attractive to label digital intellectual property in this way in order to be able to trace or prove misuse later. Sorting out the specific types of benefits being promised by different technologies and then evaluating their efficacy, is not something that can easily be done by individual consumers. Therefore studies such as this by large national technology laboratories play a critical role in promoting an understanding of their utility. While it is unfortunate that the current state of these technologies do not support the claims being made for them, and that those seeking technological means of protecting intellectual property may have to rely on encryption and access control, or social controls and legal contracts, it is important to have the facts.

If we have the ability to deliver lots of multimedia digital objects (and to a large extent, of course, we already do), how will users of these virtual representations be enabled to do things that they cannot easily do in the "real' world?

David Greenfield explores the potential of non-linear narratives. Grounding his exploration in "Grandfather's Virtual Kitchen', a space where stories are told from the perspectives of all those present, he suggests the power that can be released by a visitor being able to 'see the world', 'hear the story', from multiple perspectives. One of the crucial issues here is how to provide the necessary contextual clues so that the audience does not become lost and can participate actively in changing points of view.

A similar challenge is confronted by Francesca Alonzo, Franca Garzotto and Sara Valenti as the develop means to enable virtual visitors to move in time and in space through 3D representations of the city of Milan. Standing on a known street, how can a visitor change centuries. What needs to be done to remain oriented when the street on which we stood today 'becomes' a field or forest two hundred years ago? Developing the techniques and genre clues that will be required to communicate accurately what has occurred when we are engaged in 3D temporal navigation of virtual spaces is the kind of challenge that our literate society encountered in inventing the genre of movies, radio plays and printed text – new media require new orienting mechanisms.

When such orienting mechanisms are in place, we can use "virtual objects in real education" as Glen Hoptman and his colleagues at Lightbeam Studios, in conjunction with the web educators at bigchalk.com, propose. Grounding an approach to education in the superficially hostile experiential philosophy of American educator John Dewey, they begin to explore what will be required to give virtual experiences the authority of "Thisness' which Dewey claimed was the foundation of progressive education.

Organizational Issues

If the first half of this book shows us what can be done by museums on the web and examines some promising approaches, the second half is firmly set in the practical questions regarding how to do it and whether it works. The papers in this section are case studies in the organization and funding of the museum web effort. The players are governments, private enterprise, museums and academia. All sorts of combinations are

being explored from collaborations between commercial and not-for-profit organizations to make money with cultural heritage to national and international efforts undertaken with public funding for the public good. Variants involve sponsorship by industry and academia, volunteer led projects and outsourcing. While no single recommended practice emerges from these case studies, the testify together to the need for museums to be open to a huge variety of inter-institutional relationships in seeking to realize their own mission and objectives. It should go without saying that this requires continued vigilance since institutions with which museums "partner" in these endeavors do not have quite the same interests as the museum.

Kevin Sumption examines the concept of 'meta-center' usually called gateways or portals for museums. He focuses particularly on those funded by national governments, such as AMOL (Australia), CHIN (Canada) or the 24 Hour Museum (UK) to promote a sense of national identity, inter-working between institutions in the cultural sector, and other public policy objectives. In a tentative examination of their real and potential benefits, Sumption identifies some future directions they might take. He doesn't ask whether such publicly funded meta-centers are likely to succeed in the age of e-commerce or whether museums have a particular interest in the success of one or another sort of gateway. Over the next few years, as different models for encouraging museum participation in different kinds of portals mature, these questions, and relative assessments of the success of different portals in bringing traffic to the museum, will come to the fore.

One kind of museum meta-center which is going to be an increasingly important feature of the museums and the web landscape is the museum shopping center. Chris Tellis and Rebecca Reynolds Moore explore the rationale and business plans behind one such collaborative and report on some of its early successes. They raise general issues about the kinds of business partnerships which museums should consider and how to decide about the organization of incidental business activities in museums (whether the café or the store). And they begin to examine the potential of retail e-commerce as an organizing principle for content delivery which stands in contrast to the commerce free government sponsored meta-centers discussed by Sumption, or academic gateways or such business to business commerce as tourism industry driven museum web applications.

It is important to recognize that government, and private industry, also have other agendas which museum web applications can help achieve. In Nora Hockin's report on 'Canada's Digital Collections', we are given an inside view of how youth employment functions of a national government can be creatively managed to generate online content from museums. Often such apparently unrelated governmental programs can provide substantially greater financial support than direct cultural funding; in this case the ancillary benefits of creating a skilled workforce with experience in cultural documentation could also be substantial.

Guiliano Gaia takes a similar perspective in exploring the other agenda's of potential private funding for museum endeavors. In several case studies and some abstract analysis of web sponsorship opportunities, Gaia demonstrates that the museum can be a desirable association for private enterprise and visa versa. The association of the Museum of Science with Martin Mystère, an Italian comic book character, is an excellent example of the value to museums of some types of corporate associations and is especially welcome as this is under-appreciated by most museum staff.

Museums have traditionally been good at organizing work which can be done by volunteers. The extension of this practice to web museums can be fairly direct or surprisingly different. In the case study by Kristine Hoff of the development of a web site for a small Danish art museum, the traditional approach of employing real volunteers from the local community is used; the value of this paper lies in the detail in which it addresses the necessary steps. The paper by Paul Marty and Michael Twidale on data quality feedback suggests a more radical use of the web as a vehicle for "virtual volunteers" to help the museum in a way that is most difficult to organize with in-house staff alone. Based on the simple principle that many pairs of eyes are better than one, Marty and Twidale first imagine the potential audience of remote visitors as the ideal quality control staff and then explore the tools that can harness the potential input of thousands of editors. The result is a new social mechanism and a potentially new organizational asset.

Evaluation

Do Museum web sites, Museums on the Web, and Museums and Web Commerce work? And what is meant by "working"? Over the last few years we've witnessed a consistent increase in the number of evaluations of museum web activity. Broadly speaking these are efforts to find out who uses web sites, what they are doing, whether the sites work for them and why. The questions being brought to these evaluations range from highly objective measurements of numbers of interactions to highly subjective assessments of appeal. The methodologies for successful studies are still being developed. Even when definite conclusions can be reached, they often tell us only about a single site or a particular moment in the history of the web.

When we have a better idea of who is using the museum web site, we can begin to ask how they are using it. Joan Nordbotten's fascinating and somewhat disturbing report shows us that we cannot assume that visitors to our sites see what we expect them to see and leave with the message we intend to convey. Indeed, in most web architectures most visitors "enter by the side door", look quickly and furtively only at what attracted them, and leave immediately without necessarily even discovering where they were. While there are technical means of preventing visitors from coming to the museum site to look for a single item on a single page (pointed to be a search engine), it is not clear that museums want to prevent this very high proportion of their "visitors". On the other hand it is very clear that knowing how most visitors come and what they do when they arrive is crucial to the design of sites that will meet the museums objectives.

What makes visits satisfying? As the previous study documented, the user must minimally be able to use the site. But a site can be minimally usable an yet unsatisfying. Yvonne Cleary explores the role of subjective issues in the usability of a web site from a critically important perspective – that of the culture of the visitor. If the web is to be an international medium, what do we need to do to ensure that visitors from different cultures will have a positive experience at our sites? Using the Louvre Museum web site, a heavily visited site that attracts users from around the world and presents itself to these users with their up-front choice of language, Cleary asks how well the site works for Spanish, Japanese, French and Irish visitors. Her findings of extreme variance

in satisfaction based on subjective cultural features will not surprise any students of anthropology, but they can be very helpful in the design of the next generation multi-lingual interfaces – communication is not necessarily or even primarily about words.

Indeed, using the web, and benefiting from museum web sites, is a learned skill. Evan Dickerson and Susi Peacock explore how the web is used, self-referentially, in a university course on the economics and technology of the culture industry itself. Online museum culture becomes the subject of online coursework at Richmond, the American University in London. Evaluating the course and evaluating the museum experience of using the web, interact.

Interaction, between and among virtual museum vistitors, and with virtual museum objects is the desired end in the exceptionally rich and complex environment at the Milan Science Museum. Thimoty Barbieri and Paolo Paolini report most encouragingly from the bleeding edge of web technology on the actual visits to the virtual reality Leonardo exhibit which they first reported as an experimental implementation at MW99. While the technical requirements for visiting the site kept the numbers of visitors relatively low, and some of those who came were unable to experience the site at all, the those who had a satisfactory visit to the virtual site, alone or with others (the site being a collaborative workspace in which visitors could potentially interact with each other) stayed for an almost incredible average of 53.5 minutes.

One implication is that evaluation needs to be done on an on-going basis and that every web program should have evaluative elements in its plan. The article by Semper, Wanner, Jackson and Bazly best exemplifies such a long-term evaluation plan and reports on how each evaluation cycle can be used not just to test current hypotheses but to improve methodologies, refine questions, and identify issues for future evaluations. The Science Learning Network, for which this study was conducted, recognizes that museums are in a very longterm process in making uses of the Web and that establishing baselines, creating assessment mechanisms, and developing analytic tools are necessary steps we can take today. Their preliminary answers to the fundamental question – "who's out there' will be relevant to any other museum.

Museum Applications

Sharing the Experience: The Building of a Successful Online/On-site Exhibition

Scott Sayre, Minneapolis Institute of Arts, USA

http://www.artsmia.org/restoration-online

Abstract

In September of 1999 the Minneapolis Institute of Arts "MIA" opened an eight-week exhibition, "A Masterwork Restored" allowing the public to observe the process of restoring a 300-year-old painting. Unique to this exhibit was not only the visitors on-site access to the physical restoration of the 12' x 7' masterwork, but the opportunity for the public to view the "real time" progress of the project on the web. Conceived as an on-site/online project from the beginning, this was the first project of its type to be composed of collaborators from different departments and organizations within the museum. The resulting web program "Restoration Online" (www.artsmia.org/restoration_online) became one of the most popular projects to date. This paper will describe the process of developing this site, the factors that led to its success and the perspectives of the primary participants.

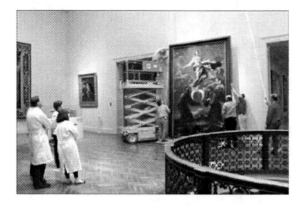

The re-hanging of the restored masterwork

History and Conception

Over the last decade The Minneapolis Institute of Art's Interactive Media Group (IMG) has produced over a dozen award winning educational multimedia programs for installation in the museum's galleries. With the development of the museum's web site in late 1993, the IMG explored the development of a wide variety of online educational units and resources for teachers and students. Through the internal and external recognition for these successful projects and the curator's personal interest utilizing interpretive technology, the Restoration Online project was born.

During a casual meeting in the spring of 1998 the Institute's Paintings Curator Patrick Noon described an idea for a unique eight week exhibition focusing on the restoration of a very large 17th Century Italian altarpiece *The Immaculate Conception with St. Francis of Assis and St. Anthony of Padua*, by the artist Giovanni Benedetto Castiglione. The painting had been in the museum's collection for over 30 years and was in serious need of both structural and cosmetic conservation. Because of the painting's scale and the public's interest in the process of art conservation, Noon was very interested in securing a gallery space in which the restoration could take place as an alternative to the smaller conservation laboratory. He was also interested in finding a way to utilize the museum's web site to promote and document the project. This concept was also of great interest to the IMG staff, as it would allow them to develop their first online exhibit tied directly to an ongoing on-site exhibition.

Exhibition Planning/Development

Soon after the Restoration project's exhibit and gallery were approved, a number of exhibition planning meetings were held where the on-site and online aspects of the exhibit were introduced and discussed among the exhibition planning staff and conservators. During these initial meetings the online aspect of the project was still widely misunderstood. Most of the staff had little or no point of reference for such a project other than the online promotion of previous exhibitions. Since the needs of both the on-site and online components overlapped in a number of areas, strategies were developed to re-purpose and share information and graphic resources as efficiently as possible. Plans were made to coordinate the work of the designer developing the didactics for the gallery with the graphic requirements for the online component. Plans were also set in place for collecting and developing the curatorial and conservation information to be used in the exhibition.

Because the exhibition focused upon an ongoing, developing restoration process, the text and images for both the online and on-site exhibits needed to be designed to accurately interpret the events as efficiently as possible. Two methodologies were developed to address this need. The curator and conservators identified images and generated text describing the standard steps in painting restoration and the known history of the work of art itself. At the same time, more dynamic systems were developed for visually documenting the process and generating up-to-the-moment text throughout the duration of the exhibition. These systems depended heavily upon technologies that were not commonly used in on-site exhibitions.

Digital Methods

A number of new tools and techniques were incorporated into the exhibit process allowing for the efficient, cost effective documentation of the ongoing process including digital still and video cameras, as well as a non-linear video editing system. The commercial quality digital still camera proved to be one of the most indispensable tools, allowing the MIA's staff photographers to shoot and "process" images on a ongoing basis. These digital images were transferred to, organized and archived on an internal shared server where both the IMG and the Design department could easily access them for gallery and online applications. An IMG Multimedia Specialist used an industrial quality, digital video camera to document the process as well as to conduct ongoing interviews with the curator and conservators throughout the duration of the exhibition. These video segments were then inserted into and appended onto a dynamically changing video program using the IMG's non-linear digital editing system. A computer-based "webcam" was also installed in a fixed position with the gallery space to provide documentation of the overall process. The high quality, low cost and efficiency of all of these digital systems provided for a uniquely flexible production environment that could respond any time an opportunity presented itself. Each time a portion the painting was changed or a discovery was made, detailed audio and visual documentation could be quickly generated.

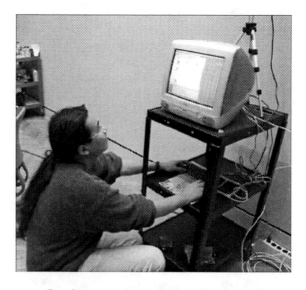

Configuring the in-gallery "webcam"

The On-site Exhibit

The on-site exhibition took place in series of special exhibition galleries off of one of the museum's main corridors. The space consisted of a small introductory gallery, a larger exhibition space and a video viewing room.

Upon entering the introductory gallery visitors had the opportunity to study a large reproduction of the unrestored painting, a panel describing the scope of the exhibition, a panel devoted to the history of the artist and the painting, and some preparatory sketches. Immediately off of the introductory gallery was a video viewing space containing benches and a 30" video monitor. The short video program shown in this space was designed to provide an up-to-date overview of the restoration process, including the painting's deinstallation from the gallery, laboratory x-rays, and transport into the adjacent exhibition gallery. In addition, the program contained a general outline of the restoration process. This outline was designed from the onset to allow documentation of the actual process to be inserted into the program as the project restoration progressed. The video program was run on a repeating loop during public museum hours to present the prior steps in the process to current museum visitors and to provide more life to the exhibit for those

visitors viewing the painting when the conservators were not present. This same video program was also made available through the project's web site (http://www.artsmia.org/restoration-online).

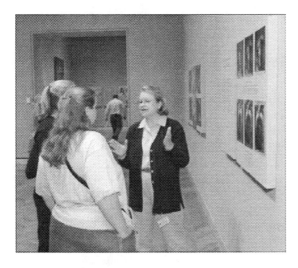

Museum docent referring to the didactic panels in exhibition

The Central exhibition space was divided to provide public space as well as a partitioned work area for the conservators and the painting. Didactic text, graphic and photographic panels wrapped the walls of most of the public space. These didactics included an outline of the steps in the restoration process, schematic diagrams of the painting's physical structure and x-rays of areas of damage and earlier restoration. One wall contained a set of numbered procedural panels designed with spaces reserved for images of the completed steps or phases in the restoration process. An iMac computer was installed on special counter with two chairs in one corner of the public area. This computer provided access to the online portion of the exhibition using a Netscape web browser running in kiosk mode. The computer served to both extend the available project information within the gallery as well as to market the fact that the ongoing project could be viewed and followed from any computer with internet access.

For most of the conservation treatment the painting was placed on a large movable easel in the center of the partitioned conservation space. Special lighting was installed and a power lift was used to assist the conservators in working on the huge painting.

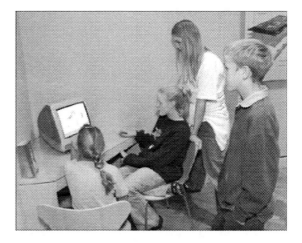

Young visitors using the "Restoration Online" internet kiosk

A small railing was installed to keep the visitors at a safe distance while allowing them to be close enough to view the detailed work of the conservators and ask them questions. Gallery benches were placed on the public side of the railing to allow visitors to sit comfortably while observing the progress of the restoration. Museum docents and volunteers were stationed in the gallery during heavy traffic periods to assist the conservators in answering the many questions posed by the visitors.

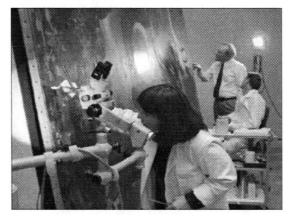

Conservators and the curator examining the painting

Both the conservators and the docents directed the public to the online portion of the exhibition as a way to access in-depth answers to commonly asked questions and to follow the project beyond the visitor's on-site gallery experience. Colorful bookmarks promoting the related online exhibition were made available throughout the exhibition.

Demand for these bookmarks was so high that they needed to be reprinted three times during the length of the exhibition.

Designing Online Exhibit

The online exhibition was created with three goals in mind: 1) to provide an online version of the events and information for visitors who aren't able to attend the on-site exhibition; 2) to provide extended information about the painting, the subject of art conservation, and the restoration process; and 3) to document and archive the process for later reference and educational applications. In order to achieve these goals a great deal of preparation and planning needed to take place prior to the onset of the exhibition.

After reviewing all of the didactic materials to be produced for the gallery, interviews were scheduled with the two senior painting conservators Joan Gorman and David Marquis who would be executing the restoration. Both of these conservators work for the Upper Midwest Conservation Association (UMCA), a non-profit regional conservation laboratory located within the MIA's building. The focus of these interviews was to elaborate upon the physical history of the painting being restored and the details and a timeline for the conservation process. Interviews were also held with Paintings Curator Patrick Noon and Assistant Curator of Paintings Susan Canterbury to identify key resources related to the history of both the painting and the artist. The information gathered in these interviews was combined with existing didactic information to provide an overall structure for the online program. A prototype of the structure and design of the program was developed and then reviewed and approved by both the conservators and curators before proceeding with production of the final program. The resulting program was made up of five main sections: an intro or homepage; the Daily Log, Life of this Painting, and Frequently Asked Questions, What's Wrong with this Painting?.

The Project Homepage

The projects homepage was designed to serve a number of purposes: to introduce the overall project, to promote the on-site exhibition, to describe the importance of art conservation in the

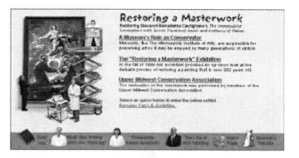

The Restoration Online Homepage

MIA's mission, and to provide basic information about the Upper Midwest Conservation Association. Users could choose to pull-up "live" webcam images of the painting being restored, view "before and after" images of other recently restored MIA paintings or link out to UMCA's web site to find out more about this independent association. Along the bottom of the homepage were links to the main sections of the site, represented by photographic icons of the conservators and curator.

Daily Log

One of the most dynamic sections of the site, the Daily Log, provided users with a virtual journal of the day-to-day progress of the project. The Daily Log contained photographic images, notes, video segments and a glossary which were generated on a daily basis by Multimedia Specialist Mike Dust, who

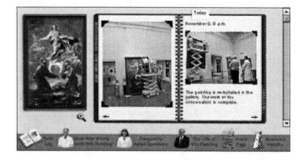

The "Daily Log" section

was also producing the ongoing video documentation of the project. A customized set of templates was developed using Alaire's Cold Fusion software to facilitate the efficient maintenance and expansion of the Logs content. These templates aided in managing the "expanding book" metaphor with a minimal amount of additional markup. Each afternoon, Dust would review the days events with the

conservators and browse the images shot by the MIA Photo Services department. He would then use the information and images to compose sometimes lengthy log entries describing first-hand the most recent progress and discoveries. Dust would also include links to the webcam and other sections of the site where he felt they to be helpful.

What's Wrong with this Painting

"What's Wrong with this Painting" presented viewers with detailed information on the painting's technical problems. The section was designed to look like a series of manila folders containing text, photos and illustrations. Documents such as condition reports and proposed treatment procedures which are normally not accessible to anyone other than

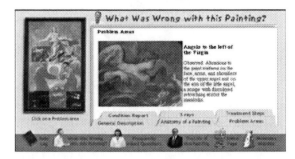

The "What's Wrong with this Painting" section

conservators and curators were available (in an edited form) within these folders. Other folders contained x-rays of the painting, photos and descriptions of damaged areas, interactive schematic diagrams examining the physical construction of a painting and a glossary. Most of the information in this section was gleaned from interviews with the conservators and through interactive enhancements to the didactic gallery information.

Life of this Painting

Upon entering the "Life of this Painting" section, the user is presented with a timeline from the 16th century to the present . The timeline contains both text and imagery and is interactive. By clicking on centuries or decades, the user can walk through time exploring key events that hold a direct relationship to the painting being restored. The methodology is designed to expand the visitor's context for the restoration by highlighting items such as the

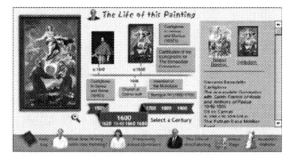

The "Life of this Painting" section

life and travels of the artist and painting, technological developments in conservation and related art historical events. The painting's curators and conservators generated the information contained within this section. Members of the IMG further enhanced this information through additional research.

Frequently Asked Questions

The "Frequently Asked Questions" section was designed to serve as a catch all for the numerous questions posed by the public throughout the exhibition. The public was invited to submit new questions to the conservators via an online form. IMG staff members managed the process of collecting and posting the responses to these questions. In

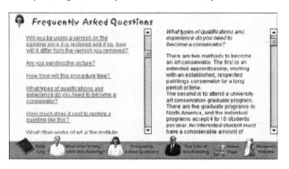

The "Frequently Asked Questions" section

order to get a jump on the anticipated barrage of questions; members of the IMG staff surveyed friends and colleagues about questions they had about the conservation project in advance of the exhibition. The two dozen questions collected in this initial survey allowed the conservators and curators to answer the majority of the common questions before the exhibition began. The existence of these initial questions and related answers also gave

online visitors a greater perception of on-going interaction between the museum and its public. Throughout the duration of the exhibition the conservators and docents found this section of the program indispensable for addressing repeat questions.

Public Response to the Exhibit

The public's response to both the on-site and online restoration exhibits was overwhelmingly positive. The uniqueness of the exhibition and the warm and engaging personalities of conservators drew large with many repeat visitors. At times, weekends in particular, the number of interested visitors slowed the conservators progress with many questions and insightful discussion. Attendance was constant

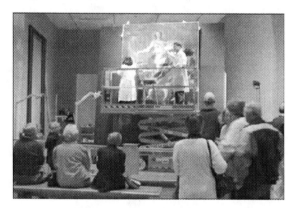

Visitors observing the ongoing restoration in the gallery

throughout the duration of the exhibition with from a half dozen to one hundred visitors observing the ongoing process at any one time.

After a number of discoveries, the most significant being the discovery of Castigliones's overpainted signature, a number of dedicated "groupies" emerged. The conservator's felt that the level of the public's personal access to the project gave some visitors a special sense of ownership in the project. Gallery conversations showed that these enthusiastic visitors made regular visits to both the online exhibit as well as to the gallery. The "Daily Log" and webcam were found to be the most useful in remotely following the project.

User statistics for the MIA's web site (www.artsmia.org) in which the project site is lo-

cated, increased dramatically over the duration of the project. From the date of the exhibits opening to its close, user session more than tripled to over 2000 users per day. The majority of these online visitors were accessing the Restoration Online exhibition.

Even within the exhibition gallery, many visitors spent time further exploring the project using the web kiosk. The kiosk had advantages over the print-based didactics since it offered a historical overview of the project from its beginning with dozens of detailed photographs and notes. Graphics and diagrams which were static on the gallery didactics

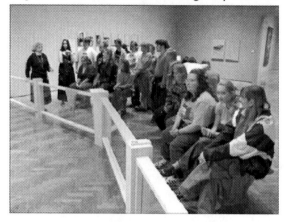

A school group and docent visiting the exhibit

were interactive in the online program.

School children were particularly interested in the idea that the exhibit could be visited through the internet. Even though very few tour guides and teachers permitted students to use the kiosk in the gallery, many children responded enthusiastically when told about the web site. Most children left with a promotional bookmark in hand, some expressed excitement over the opportunity to visit the online exhibit at home with their parents.

The Conservator's Experience

While the museum staff and many of the visitors had a significant amount of experience with both web and interactive multimedia educational programs, the UMCA painting conservators had very little of these experiences personally or professionally. They were accustomed to working in a quiet, private laboratory setting with little or no interaction with visiting public.

The prospect of executing a large-scale restoration of a major painting in public was provided enough unusual challenges, never mind having a computer kiosk in the gallery with them. And while they were very cooperative in providing extensive amounts of information for the online portion of exhibit, both were concerned that the media would not be flexible enough to document all the unpredictable twists and turns in the treatment process.

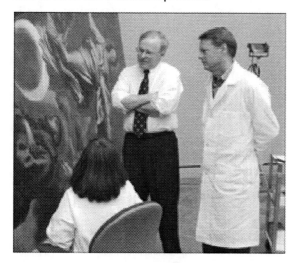

Conservators discussing their work with the curator

Once the conservators had viewed the prototype for the online program, both began to see the possibilities this new technology provided for illuminating an important yet predominately unknown technical aspect of the museum's operations. As conservator Joan Gorman states "... we felt ownership in the site to a degree. Here was the project, the information we imparted to you (IMG) - but wow! It was interesting, visually compelling, fun even." And as the project continued to unfold their concerns related to the flexibility of the technology diminished. During one phase of the project the painting had to be taken off view for a number of days to be spray varnished. In this instance the technology proved to be unexpectedly flexible as the webcam allowed gallery visitors to remotely view the painting as it was worked on in the well ventilated conservation laboratory.

Throughout the duration of the gallery exhibition the conservators grew more and more enthusiastic about the site. They were amazed by what they saw as the "overwhelming response of the public

to the web site" and the technologies' ability to make information, like the discovery of the artists signature, available to the world almost instantaneously. At times when the painting was face down or difficult to view, the conservators found it useful to direct visitors to the kiosk to see what was currently not visible in the gallery.

By the conclusion of the gallery exhibition both conservators had been in their own words "converted" by the educational potential of the web. Gorman summarized "... the web is a wonderful tool, accessible to a very wide audience, an extension of the project (and long after the project was complete), and a good marketing device. To this day I refer people to the site to see our work. It affords an informed, easy to use means of accessing a complicated subject like conservation. In a very real way, the web site de-mystifies conservation, one of my great goals as a conservator."

Both conservators see the field of conservation as slow to embrace new technologies, particularly for educational purposes. The positive response they have received from their colleagues over the online aspect of the project may begin to change that. The "Restoration Online" site was featured on the front page of the American Institute for Conservation's web site. With this type of professional recognition and the positive aspects of the project's visibility, the field is positioned for change.

After the Exhibition

As the exhibition drew to a close and the newly restored painting was rehung many UMCA and MIA staff members began to debate what would become of the online project. The museum's docents and education staff had become quite fond of the web site as a means to explain the "behind the scenes" process of art conservation. The museum's web site statistics were at an all time high. The Restoration Online site was finally flushed out to the point where it could tell and illustrate the entire process of restoring a painting from beginning to end. An entire educational program had been dynamically created in real-time. Was this the end or just the beginning?

With this continued interest mind, a proposal was made to the Museum's Director Evan Maurer to permanently install the "Restoration Online" pro-

gram in the museum's permanent collection galleries. An existing media space in close proximity to the restored painting was freed-up to accommodate the final program. Didactics from the exhibition gallery where the painting was restored were reinstalled in the media space and a panel was written to describe the program's connection to the nearby painting. To complete the connection, an extended label was written for the painting which described its recent restoration and directed visitors to the educational program.

Meanwhile, on the museum's web site, the Restoration Online program was given a permanent position as an online exhibition. The program continues to attract a great deal of attention and in February, 2000 was reviewed as a wonderful web site for children on the web magazine *Surfing the Net with Kids* (www.surfnetkids.com) .

Summary/Recommendations

The "A Masterwork Restored" exhibition and the "Restoration Online" web site were both highly successful. Part of the reason for this was the subject matter itself. Art museums rarely find opportunities to present live, production related exhibits, something the general public is often starved for in museums full of static objects. The first goal of ex-

tending project through an online resource proved to be crucial to the project's success as subject matter was presented through interactive online materials contributed the popularity of the project.

Beyond the subject matter itself, the tandem formatting of online and on-site exhibitions mutually benefit from their own cross marketing. The project's initial goal of providing an online version of events and information for visitors who weren't able to attend the on-site exhibition was expanded as on-site visitors went to the web to keep up on the project while online visitors become interested in the real thing and were drawn to the museum.

The third and final goal set for the online project was to document and archive the restoration process for later reference and educational application. This goal was achieved immediately when the program was permanently installed in the museum's galleries.

Unfortunately, static online exhibitions related to static on-site exhibitions are less able to compete with the continuing intrigue of more dynamic ones. Online, on-site or both, the success of this project begs the question "Why don't art museums do these types of exhibitions more often?" And the answer is "We should."

Re-casting Our Net: Broadening Information Access at the National Maritime Museum

Sarah Ashton and Sophia Robertson,
National Maritime Museum, UK

Abstract

Following the launch of the Centre for Maritime Research at the National Maritime Museum, Greenwich, UK, the Museum has enhanced the collections databases already available on the Web with the addition of an impressive range of new services and repackaged content. This paper looks at major online developments to date: the Search Station collections resource and Port the maritime information gateway. Produced using FileMaker Pro and Web technologies, the Search Station is a multimedia resource providing thematic access to almost two thousand exhibits from the Museum's collections. This paper will outline the production and extent of the content, examine the user profile, and highlight the future potential of the system. Port – an information gateway for maritime studies – employs the open source software toolkit ROADS (Resource Organisation and Discovery in Subject-based Services) to provide a searchable and browseable catalogue of maritime-related Internet based resources. Hosting considerations and the Web-based administrative features of Port are examined, together with the gateway's development and marketing.

The National Maritime Museum (NMM) encompasses three public sites - the National Maritime Museum, the Royal Observatory Greenwich (ROG) and the Queen's House. It houses an unrivalled maritime collection of over two million objects, including 64,000 prints and drawings, 4000 oil paintings, 270,000 historic photographs, 50,000 charts, 5000 scientific instruments and globes, 7000 uniforms and weapons, and four miles of manuscripts. These collections relate to every aspect of ships, seafaring, astronomy and time, from prehistory to the present day.

The NMM is very much a self-reflective institution that continually reassesses its role and purpose in the museum world. In recent years the Museum has redefined itself to attract new audiences and to maintain its appeal in today's competitive leisure industry. In April 1999, the NMM completed a major redevelopment programme. This resulted in the creation of a dramatic new architectural space enclosed within a glass roof, and the production of sixteen new galleries. The Museum also aims to reposition 'maritime history' as a subject and to improve access to its collections in order to attract researchers from a range of disciplines. To facilitate these developments, the Museum's Centre for Maritime Research (CMR) has harnessed the very latest information and communication technology (ICT) to transform and substantially 'recast' its information services on the Internet.

The NMM was one of the first UK national museums to establish a web presence early in 1996. Searchable text catalogues of the library, manuscripts and prints and drawings collections were

Figure 1: Setting the nets on the coast of North Wales, Henry Moore (BHC1274).

made available online soon after. The approach of the new millennium prompted a re-evaluation of the museum's information and research services. ICT is seen as integral to the NMM's digital policy, allowing the Museum to work towards fulfilling the demand for online access to its information resources from a UK and worldwide audience. In this paper, we will look at the CMR's two flagship projects to date: the Search Station collections resource and Port, the maritime information gateway. These key projects are essential 'building blocks' towards making the NMM's collections and resources fully accessible online, and both have been commended in a recent report for Britain's National Museum Directors' Conference. The projects involved technical collaboration with a multimedia production company and a university-based electronic library project respectively. We will describe our experiences as project managers, the resulting developments and future applications.

The Search Station

The Search Station is a collections resource providing thematic access to over 1800 objects. It opened onsite in April 1999 and offers the public ten touchscreen and mouse-operated work stations. It was launched online (http://www.nmm.ac.uk/searchstation) in early December 1999, allowing the public worldwide access to highlights of the Museum's varied and vast collections. From original idea to onsite launch and then to online access, the evolution of the Search Station is interesting to consider as the project was achieved with limited resources but using a variety of new technologies.

Planning and Creating the Content

The Museum began to computerise its collections using the Multi-Mimsy collections management system in 1996, and it was one of the first national museums in England to establish advanced in-house scanning facilities in early 1997. This provided a basis for the Museum to improve public access to its collections, particularly those that could not be displayed, in readiness for the opening of the new Museum. The refurbishment had secured over 20 million pounds in lottery funding and the majority of staff were working towards its completion, so both staff time and money for other projects were in short supply. In addition, a future-proofed public access system for collections was unavailable in the UK at that time, and Multi-Mimsy the collections management database required a great deal of interpretation before it could be made available to the 'visiting' public. So the Museum decided to create multimedia presentations, highlighting key areas in the collections, which would both inform and entertain. This pilot project formed the first stage of making the Museum's collections accessible electronically to the public. The Search Station idea was born and the challenge was to put the idea into practice.

The tight timeframe demanded rigorous planning if the project was to meet its deadlines. Funding was secured through Museum project funds and sponsorship from Research Machines plc, the Royal Bank of Scotland and Silicon Imaging. This, although adequate, did not allow for lavish production techniques. The Director of the CMR together with the Head of IT at the Museum were responsible for overall control of the project, the choice of technology and installation, whilst the content project manager was responsible for the day-to-day operation of producing and managing the content and system design. Six themes were chosen for production (three for completion in April 1999, and the remaining three in September 1999). These six themes provided a good cross-section of objects from the collection and were chosen to complement the new Museum galleries. The themes were: Nelson, Passengers, Trade and Empire, Exploration, Maritime Art and Sea, Stars and Time.

The themes were divided into topics and sub-topics, and researchers were chosen internally and also appointed externally to develop each theme. Researchers were asked to provide object information and associated topic text for each item they chose within a topic, to order the objects within each topic and to provide topic overviews. Thus the Search Station provided factual information on a variety of topics, for example The Slave Trade, alongside the usual object information - date, maker etc. Researchers' guidelines were produced to provide helpful information on writing for multimedia applications and to ensure consistency in style and form. With links to the National Curriculum in mind and in view of the Museum's own preferred reading age for labels, all text was aimed at the 11-14 age group. A template was produced for the collections information and full object lists for each topic were passed to the Museum's Photo Studio for photography and scanning. All submitted data was checked and text edited by both an education specialist and a copy-editor.

Production and Delivery

Whilst the content was being created, the Museum put the production contract out to tender. This was awarded to Cognitive Applications Ltd, Brighton (http://www.cogapp.com). Production began with the immediate collection of materials. Content data was entered into a source database online using an HTML form and Perl script. This enabled data to be collected from a number of contributors at once into one text file. It also allowed the producers the ability to develop the system whilst material was still being collated or refined. At a fixed date, the text file data was exported into Filemaker Pro databases. These different databases - including

theme, topic, exhibit (text and title) and asset (object information and media files) - were of varying size and complexity, and formed the master database for the Museum's onsite system and website. The database was thus used to manage all the data for the system - text, images, animations, audio, film, atlas, timeline, glossary entries, quizzes and design data. Image files were collected in batches and routine programmes were written to accelerate their collection and management from the Museum's server. The database and system structure continually developed as the project progressed and particularly as new materials were added. Early on, in addition to the object and contextual information, a variety of extra features were added to make the system more entertaining and informative to the user. Different storyboards, maps, quizzes and materials were assembled from which the producers created many stand-alone features in Dynamic HTML, QuickTime, Java applets and Macromedia's Shockwave and Flash. The design for many of these items followed the constraints of working with touchscreen delivery but producers were aware that all materials would be reworked for the Web. The onsite version was delivered using Filemaker Pro Web Companion and Microsoft's Internet Information Server.

In order to turn the onsite Search Station into a website, there were a number of considerations. The Search Station needed to run trouble-free on as many browsers and platforms as possible, so two versions of the site were created – a 'text and images only' version and an 'advanced version' which included the features and plug-in content. The site was designed to work with Version 3 browsers and above. There were three options to choose from for transferring the master database to the Web. Firstly, it was possible to host the databases with a Filemaker internet service provider who offered a database service. But this option would have been expensive and difficulties may have arisen with server reliability and ease of access for updates and bug-fixing, plus it would have delivered a slow system. Secondly, the website could have been compiled from the source databases to produce a static site. This would have required the programming of a tool for compiling a static version of the website from the source databases. Although this could be hosted on the NMM's server, it would have involved the licensing and integrating of a standard web en-

gine into the site, and again was costly. The third option, and the one that was finally taken, was to deliver the system via a custom Perl script. This method was preferable as delivery would be faster, the site could be hosted on the Museum's own server, updating would be simple and it was known to be reliable. As one of the most common programming languages used for CGI throughout the Web, Perl has been used widely to programme electronic web forms and as the glue and gateway between systems, databases and users.

Having decided on this route, the producers exported all the fields needed from the master database into a number of text files (themes, topics, exhibits, assets, quizzes, atlas, timelines and glossary). Then a Perl script was written that retrieved the information needed to display elements of the website - the page layout, screen titles, text descriptions, asset data, images, image sizes, quiz questions, timeline entries, index information and multimedia content. The information was subsequently turned into web pages using a small number of HTML templates. At the same time as allowing the system to build itself quickly, this also enabled global design changes to be made independently of the underlying data.

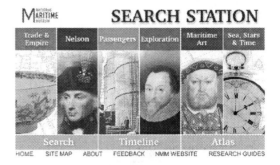

Figure 2: Search Station front screen.

Much of the content had to be reworked for the Web, both in editorial and technical terms, and the main areas included:

1. *Images:* All the images had to be resized and reprocessed. Digital watermarks were added and higher compressions were used to gain quicker download times.
2. *Design:* A new streamlined design was created that ensured navigation remained clear and simple, and followed good web practice. In addition a frontage was produced using animated gifs to provide

the 'Search Station online' with its own identity within the NMM website.

3. *Theme and Topic screens:* These screens were revised to incorporate overviews, image montages and content lists. 'View as list' and 'View as thumbnails' options were essential additions to the topic screens in order to gain quick and easy access to the object data.

Figure 3: Maritime Art Theme screen

4. *Exhibit screens:* The Exhibit screens were resized and glossary items included as pop-up windows. The magnify option, originally created using Java, was produced as a pop-up also.

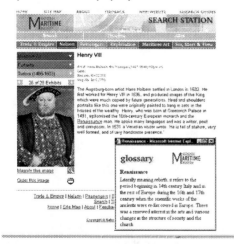

Figure 4: Henry VIII Exhibit screen with glossary

5. *Search Engine:* The Search facility onsite had been a three-part section including a 'topic index', 'category index' and 'text find'. For the website, the 'topic index' intuitively became the sitemap and the 'category index' and 'text find' were formed into a search engine to offer users an established searching format.

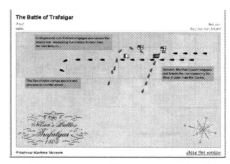

Figure 5: Search Engine screen

6. *Maps:* A number of animated maps produced in Flash were resized, and fonts were embedded to ensure that the correct fonts were displayed across all browsers. All maps were duplicated as static images for inclusion in the text only site.

7. *Other Features:* A variety of items, such as the Battle of Trafalgar animation, Bugle Calls and Ship Sails produced originally using Shockwave were resized and, where necessary, files were reworked to reduce their size and so ensure reasonable loading times.

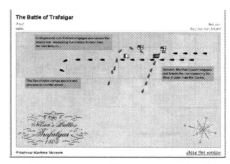

Figure 6: Battle of Trafalgar animation screen

8. *Audio Items:* The sound files were too large for the website, so Shockwave streamed audio was used to allow the files to be heard as they are downloaded.

9. *Trade and Empire, and Exploration Quizzes:* All the images in the quizzes were resized, and the Java programming rewritten to overcome cross-platform problems. Also a browser specification check was added to files. This indicates if a user's browser is incompatible and thus ensures that users do not find an unworkable feature.

10. *Copyrighted items:* A number of items were in copyright with reference to Internet access, so the databases were tagged to ensure that any object images that were not to be accessed were excluded from the website.

11. *Film Clips:* Over thirty film clips were included in the onsite Search Station using Quicktime. But these have not been included in the current website, as the files are too large and put too much of a drain on server resources, so a decision was made to delay their inclusion until they have been streamlined.

Figure 7: Trade and Empire Quiz screen.

In all the Search Station consists of over 2000 pages, and currently includes six themes, 72 topics, 1884 objects, a search engine, 2 quizzes, 6 timelines linking to key exhibits, an atlas section with 14 maps linking to key exhibits, 7 Shockwave features, 83 recorded eyewitness accounts, a pop-up glossary, a sitemap, an 'about' section with credits, copyright and general information, a feedback form, links to the NMM and ROG websites, Encyclopedia Titanica (a Titanic website produced independently of the Museum but licensed for inclusion within the Search Station), and Research Guides available on the Port website. The system is working well and no major problems have been reported. Furthermore, maintenance and corrections have been minimal to date.

User Profile and Future Developments

The Search Station has been online for a comparatively short time but so far public reaction has been extremely positive. Even at these early stages it is possible to identify distinct user profiles from the feedback forms. The subject matter tends to attract a predominantly male audience, and this is born out in results so far. Schools and universities are also emerging as regular users. The feedback has indicated that people find the material both educational and interesting, the system delivery quick, and the design and navigation clear. Users also emphasise that the content organisation is both innovative and engaging. Monthly website logs will be implemented shortly, and these will provide more detailed information about the usage of the content and which themes and areas are most popular.

Figure 8: Search Station website feedback

Users actively want to access collections information and are fascinated to see the breadth and depth of our collections, but they also want integrated resources and interactive services. Some of these have been provided, but there is much more still to develop within the Search Station. In the coming twelve months, planned additions will include: teacher resources linked to the National Curriculum, a support CD-ROM created specifically for teachers, default Search Links throughout the NMM website to help publicise the ships' plans collection, manuscripts collection and picture library, and new content, including the outstanding film clips.

Museums in the UK are now actively being encouraged to create digital museums providing access to their collections and to join government schemes such as the National Grid for Learning (aimed at schools) and People's Network (aimed at lifelong

learning). Pilot projects like the Search Station have been well received by museum professionals and public audiences alike, and greater resources are being made available for the consolidation or growth of many such projects. Many UK museums including the British Museum are working towards their own public access systems and SCRAN (Scottish Cultural Resources Access Network) is the UK's prime example of just what can be achieved when substantial funds are invested.

The NMM is building on the success of the Search Station to begin the second stage of providing electronic access to its collections with a fully comprehensive public access system of its own. There are many issues still to consider including free and subscription access, rights management and associated multimedia publishing, but the NMM feels that its experience with the Search Station can only assist in providing what the public wants and pointing the way for future developments. With over two million objects within the Museum's collection there is obviously a long way to go but the Search Station certainly has shown that something very worthwhile can be achieved with limited resources in a relatively short period of time.

Port(http://www.port.nmm.ac.uk/)

"Although sufficiently wide the channel on either side was environed by reefs and detached rocks upon which the heavy swell rolling in broke heavily. Young and I were aloft nearly the whole forenoon looking out that we avoided these dangers. I did not fear them with a commanding breeze..."
(McClintock's expedition in the Fox, Papers of Admiral Sir Leopold McClintock, MCL/18)

The rapid expansion of the Internet and global networked information makes it increasingly difficult for users to locate useful material. To tackle the problem of finding quality information resources on the Internet, in recent years a number of subject-based information gateways have been developed, in subject areas such as the social sciences, history and medicine. The aim of Port is to facilitate access to high quality networked information resources for maritime studies, to be McClintock's "commanding breeze". Port is based on the model developed by other UK subject-based information gateways as part of the Electronic Libraries Programme (eLib) (http://www.ukoln.ac.uk/services/elib/) funded by JISC (http://www.jisc.ac.uk/), the Joint Information Systems Committee for the university sector. These subject gateways provide catalogues of Internet resources which users can search or browse. As they relate to a specific subject area, they are far more focussed than the large search engines and often contain a range of associated materials and services.

For Port, maritime-related Internet resources are identified, assessed, organised and described by a Librarian or Subject Specialist at the Museum, and cataloguers are also employed on a temporary basis to populate the database from time to time. This skilled human involvement is crucial to quality control: only resources which fall under the Port Scope Policy and also fulfil criteria according to, for example, currency, relevance and authority are included. A meaningful description of the resource is written and keywords are assigned which are appropriate for the end-users wanting to locate such resources. Effectively Port staff carry out the time-consuming tasks for users: they join discussion lists, monitor sites, perform searches and filter out items which are irrelevant, out-of-date or of poor quality. In addition to the catalogue of high-quality resources, Port extends access to related materials developed by the CMR, such as a series of self-help research guides which provide information about the Museum's collections and about other sources for research into maritime history. The development of some of these materials was generously supported by London's Baltic Exchange.

Port employs the open source software toolkit ROADS (Resource Organisation and Discovery in Subject-based Services). To the best of our knowledge, the NMM is the first museum in the world to exploit this set of Internet-based software tools. ROADS (http://www.ilrt.bris.ac.uk/roads/) was originally a project from the Access to Networked Resources section of eLib and the software has been developed by a consortium of leading-edge developers in the fields of metadata (especially Dublin Core), cataloguing, indexing and searching. Although this project has now finished, the software continues to be developed and is used by service providers around the world.

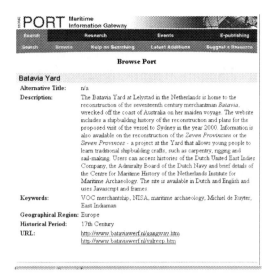

Figure 9: Sample record.

ROADS is a set of software tools which enables the set-up and maintenance of Web-based subject gateways, for example it looks after all the indexing of resources, creates a search mechanism and checks links automatically. The 'toolkit perspective' means that developers can select which parts of the software they wish to use. The software consists of a package of Perl modules which can be downloaded as a bundle and installed on a Web server. ROADS runs on any modern version of the UNIX operating system, such as Linux. ROADS uses the Whois++ directory service protocol. This presented the Museum with a problem. At the time, the NMM's website was hosted by an Internet Service Provider (ISP) and that ISP was unwilling to house scripts written by anyone else. A further problem was that ROADS requires that a Whois++ server be run on the web server. The Whois++ server is not a CGI script, it is a daemon that is started up and allowed to run continuously. Unlike a CGI script (which typically is fired up when it is triggered from a web page, runs and dies), a continuously running daemon presents a higher risk to a web server. A daemon may also use more resources than is reasonable for a single user or it may interfere with other server processes. Several randomly selected ISPs were contacted and the Museum found two who were potentially willing to host the gateway. Soon after this, the NMM website was transferred to a server administered by the Museum's IT Department. However, at the time the Museum did not have the technical skills

(UNIX and Perl) to develop and support the ROADS software in-house. Coupled with this, the dynamic nature of the software and the remote access to the server required by ROADS developers was considered a potential security risk to a proposed e-commerce system which would run on the same server. The decision was therefore taken in June 1998 to accept a proposal from the Institute for Learning and Research Technology (ILRT) at Bristol University to host and provide technical support for Port.

The ILRT is one of three project partners that developed the ROADS software. A Project Manager and a Technical Officer were seconded by the ILRT to liase with the full-time Port Project Manager at the NMM. This arrangement has worked extremely well and the success of Port owes a great deal to this partnership. The Museum has been fortunate to be able to draw on the ILRT's experience of working on established gateways: both the social sciences information gateway, SOSIG (http://www.sosig.ac.uk/), and the business and economics gateway, Biz/ed (http://www.bized.ac.uk/), are based at the ILRT. Throughout the planning and development stage of Port (July - November 1998), a number of face to face meetings took place in Bristol and Greenwich. Generally, however, the Project Team communicated via email. A timetable for website design and content development was established to fit in with the launch date of Easter 1999. The most time-consuming part of the project - inputting resources into the database — began in November 1998. This process was assisted by the Museum's appointment of a temporary Project Assistant. Also in November, work began on the look and feel of the Port website which was designed with low resolution users in mind. This part of the project was delayed in order to incorporate the NMM's new corporate identity, a separate project linked to the Museum's physical redevelopment programme. Between November 1998 and the end of March 1999, materials were developed by the CMR for the events and research sections of Port. Port was completed on schedule and was launched at Easter 1999, containing some 600 resources in the database. This figure has risen to more than 1000 to date, with an average of 50 new resources being added to the database every month.

The password-protected ROADS Administration Centre gives the gateway maintainers control over the day-to-day running of the gateway. It contains the tools needed to create and edit templates, together with an automatic link checker, statistical counters, record validators and online documentation.

The tools all have a Web front end and – from the point of view of the maintainer – consist of nothing more complicated than Web forms. Templates are used to add records to the database of Internet-based resources. They allow records to be entered individually and carry out certain validation and indexing tasks. The resource description (or metadata)

Figure 10: ROADS Administration Centre.

format of the ROADS templates is based on Internet Anonymous FTP Archive (IAFA) templates. ROADS templates are defined for different resource-types, for example document (for cataloguing a single piece of information such as, an electronic journal article) and service (for collections of information, such as company websites). The templates consist of simple attribute-value pairs displayed as a series of text boxes. Administrative metadata (such as unique identifying number) are assigned automatically by the software, whereas descriptive metadata (such as the resource URL, title, description and keywords) is added by the cataloguers. There are mandatory fields (such as title and description) which must be completed for the template to be accepted into the database and optional fields (such as administrator's email address and language of the resource).

These can be left empty but in practice are completed as fully as possible. In order to create browseable listings for the end user, each template requires the subject descriptor field to be used. As no maritime-related subject-specific scheme exists, the Port subject categories are based on the UDC (Universal Decimal Classification) scheme used in the Museum's Caird Library. To ensure consistency, authority files are used to select pre-set options for subject categories, geographical coverage and historical period.

The software is highly configurable and this flexibility meant that it was possible to tailor the software to the Museum's requirements. For example, the standard ROADS configuration files were altered to include the option to browse resources by historical period and an 'email template to administrator' option was enabled whereby an off-site cataloguer can send work to the Project Manager to be checked and activated. The Admin Only interface contains the tools used only by the database administrator to edit these catalogued templates or remotely update the content of Port web pages (for example, the events listings).

Figure 11: Authority Files

Since its launch, Port has seen a steady increase in users: there were on average almost 7200 user sessions per month between April 1999 and January 2000, with each user typically spending 7 minutes on the site. Considerable emphasis has been placed on promoting the service both electronically and

by traditional paper-based methods. The website was registered with the main search engines and metadata included in all the pages on the Port site to facilitate its classification. The site has been marketed through subject- and library-specific electronic discussion lists. The aim is also for there to be a link to the Port site from as many quality websites as possible. For example, the administrators of all websites included in the Port catalogue are notified of their inclusion, and a reciprocal link from their site is requested. At the launch, adverts were placed in key maritime and information journals. Leaflets were produced, together with posters and postcards incorporating the Museum's images. These have been distributed widely - for example to maritime-related university departments - and are available to on-site visitors. Opportunities to demonstrate Port in person have also been taken, for example as part of the Museum's established adult education programme. In May 1999, the Museum's Press Office organised press releases together with a high profile launch for Port and the Search Station.

Port also has strong links with another related online initiative - the Museum's recently launched Journal for Maritime Research (http://www.jmr.nmm.ac.uk) (JMR). The JMR is the first fully refereed electronic journal for maritime research. The journal's content includes substantial essays covering maritime studies in the broadest sense, book reviews, a discussion forum and upcoming conferences listed in Port. As a value-added feature for each journal essay, related Internet resources and news items are identified and added to the Port catalogue. The immediacy of these ready-made reference lists provides readers with rich and timely content, impossible to replicate in the printed form.

The Port Project Manager actively encourages feedback or suggestions and an online questionnaire to find out more about users is planned for Spring 2000. Informal feedback suggests that the speed and ease of use of the Port catalogue and the quality of the related services are greatly appreciated. Port helps promote the Museum's online activities, raising awareness of maritime-related networked information and promoting the use of the Internet to complement existing research methods. Ongo-

ing work to both the catalogue and the website will ensure that the best quality resources in the NMM's subject area are accessible, steering people away from the "reefs and detached rocks" often found on the Internet.

Conclusions

As we have shown in this paper, the Search Station and Port substantially augment the Museum's Web-based collections databases. The two projects combine multimedia and cutting edge technology with well-prepared, well-managed content for a global audience. They highlight what can be achieved through careful planning with limited resources and in collaboration with software developers. The NMM has fully embraced its responsibility in the emerging digital world with these innovative projects. The Museum seeks to engage people with its unique collections, provide access and interpretation of them for enjoyment and learning and enable two-way communication and participation between the Museum and its audience. These flagship projects have established the CMR as a centre for excellence in 'Net'-worked maritime-related information, and this supports its mission to encourage collection-led maritime research and promote the Museum as a centre of study for schools and colleges, academics and lifelong learners.

Acknowledgements

Dr Margarette Lincoln, Director, CMR, National Maritime Museum
Dr Jason Ryan, Multimedia Producer, Cognitive Applications Ltd
Dr Ian Sealy, Technical Consultant (Internet Development) and Martin Belcher, Project Manager (Internet Development), Institute for Learning and Research Technology, University of Bristol

References

National Museums Directors Conference. *A Netful of Jewels: new museums in the learning age.* London, 1999 (http://www.vam.ac.uk/about/natmusa4.pdf)

Integration of Primary Resource Materials into Elementary School Curricula

Nuala A. Bennett, Beth Sandore, Amanda M. Grunden, University of Illinois at Urbana-Champaign, Patricia L. Miller, Illinois Heritage Association, USA

Abstract

The primary focus of the Digital Cultural Heritage Community Project is the digitization of materials from local area museums, archives and libraries for elementary grades' social science curricula. Using teachers' curriculum units and the Illinois Learning Standards for direction, primary source materials are identified by curators and librarians for inclusion in a digital repository. The repository metadata must be complex enough to easily integrate the different forms of metadata currently used by each institution, while, at the same time, being simple enough for facilitation by the elementary school users. Simultaneously, a collaborative agreement was developed to include a set of terms and conditions for digital access to collections, the right to distribute materials and permissions to host materials. We have thus far learned that each school district's interpretation of the state learning standards necessitated additional review of local standards to insure that the project addressed goals and objectives that were pertinent on a local as well as a state level. Curators and librarians have had to be innovative when choosing items to digitize, and teachers must be able to make use of materials in imaginative ways, as it was often apparent that there might not always be a good fit between curriculum needs and the local area museum and library collections. Finally, we are developing a set of guidelines and standards to enable the creation of a consistent database, easily mapping between different controlled vocabularies and organizational data.

Introduction

Digital technology brings the potential for museums, libraries, and archives to play an integral role in the enhancement of learning by providing access to digitized primary and secondary cultural resources as well as more traditional bibliographic and cultural materials. The Digital Cultural Heritage Community Project (DCHC) (http://images.library.uiuc.edu/projects/dchc) at the University of Illinois at Urbana-Champaign is an eighteen-month project that commenced April 1999. The primary focus of the DCHC is the digitization of materials from local area museums, archives and libraries with the ultimate goal of enabling early and late elementary grade teachers to integrate digital cultural heritage materials into the social science curricula.

Access to the digitized materials is available from the database on the DCHC Web site. The database is publicly accessible, although its emphasis will likely encourage only those users with an interest in Illinois social science issues. Our main user is likely to be an elementary school teacher who will integrate the information available on the database into his or her classroom activities.

Collaboration

In order for any collaborative project to be successful, there must be extensive cooperation among participants, and it is no different for the DCHC participants. When the DCHC started, collaboration involved several conference telephone calls, and extensive use of a listserv. Observation and analysis of the listserv discussions led us to believe that most participants were often more willing to respond to specific directed questions rather than general discussions. It was subsequently felt that some sort of threaded email package would be more suitable to the project. We believed that the threaded email, by its very nature, would help in the direction of discussions and lead to more specific exchanges, thereby generating more feedback from all participants.

Using O'Reilly Webboard™ (http://webboard.oreilly.com), we set up a threaded email discussion board, which overtook the listserv. The Webboard now allows us to follow specific lines of discussion much more closely and enables us to much better understand our shared goals for the project. There are many more levels of communication among participants. Formal and informal messages can be kept apart and allow for better understanding of project-related discussions. Similarly, people who are not

interested in a particular discussion now know that they need not follow it as closely as they might another, and the Webboard allows them to distinguish easily between all discussions. It also ensures that decisions about the project need not necessarily be made by consensus among every single project participant, but by those who are following a particular discussion more closely. Figure 1 is a screenshot of the Webboard, where the discussion topics are visible in the left frame, and the details of one discussion are visible in the right frame. Finally, the Webboard also allows us to admit a number of outside advisors to particular discussions while also restricting their access to other topics. This allows us to achieve additional insights and information that can be very helpful to the project.

Figure 1. Webboard, showing discussion of Curriculum Units

Equipment

In order to fully participate in the DCHC, each partner institution needed to have access to appropriate hardware and software. Schoolteachers and partner institutions were given the choice of receiving an Apple iMac or PC, based on their personal and institutional preferences and familiarity with the two platforms. Teachers tended to select iMacs, while the other partners opted for Dell PCs. Similarly, each partner institution was supplied with a flatbed scanner or a digital camera depending on preferences and existing equipment in their institution. The Digital Imaging and Media Technology Ini-

tiative, where the project is based, has large flatbed scanners and a batch processing slide scanner, as well as digital cameras, all of which are also made available to the project partner institutions for imaging.

DCHC staff went to the schools and institutions to set up their equipment, ensure its operability, and provide rudimentary training on the use of the new hardware and software. Email, phone, and regular additional visits to the schools and institutions provide continued equipment support for the participants. A workshop aimed primarily at those who would be doing the most digitizing from the museum, archive and library partners was held on scanner and digitization standards. Participants were introduced to scanner operation and the use of scanning utilities and image manipulation software such as Adobe Photoshop™ (http://www.adobe.com/). They also learned about resolution, color-depth, and quality indices as well as calibration of scanners and monitors for optimal digitization. During the workshop, decisions regarding the number and quality of digitized images were discussed and it was agreed that the DCHC would follow the general guidelines for digitization as presented by the Library of Congress (Fleischauer, 2000) and using the Cornell University digitization formulae (Kenney & Chapman, 1996). This workshop helped to ensure that all partners would be able to produce quality consistent images that would be usable in the final database.

Curriculum Units

The participant teachers in the DCHC teach 3rd, 4th, and 5th grades in East Central Illinois schools. They initially made available to all project participants their lesson plans and curriculum units for social science. There were no restrictions on the number or arrangement of curriculum units, which each teacher would submit. Accordingly, there is much variation in the type and organization of the combined units.

As well as submitting their curriculum units, the teachers included information about which of the Illinois State Board of Education Learning Standards for Social Science (http://www.isbe.state.il.us/ils/standards.html) were covered within each particular unit. Although the individual school districts

can also develop their own specific learning objectives, they all must conform to the broadly stated goals in the state standards. The current Illinois State Board of Education Learning Standards were adopted in 1997. The Learning Standards are statements that define a core of essential knowledge and skills that all Illinois students enrolled in public schools, elementary through high school, are expected to know and be able to do. They are useful in many aspects such as setting uniform expectations of all students, easing the transition of students who move from school to school, and also providing a foundation for defining the knowledge and skills that teachers need in order to provide instruction for students.

Initially, it was proposed that the teachers would submit their curriculum units appropriate to the Illinois Social Science Learning Goals 14-16, and then later submit the units for Learning Goals 17-18. However, we found that the teachers were submitting units, many of which covered several Learning Goals from 14-18, and the distinction between the earlier goals and the later goals has now largely been ignored. We have six detailed curriculum units for 3rd graders, four units for 4th graders, and four units for 5th graders, covering areas of social science such as "How we learn about communities" (3rd grade) or "French in Illinois" (4th grade).

Combined with the curriculum units and the corresponding Learning Goals, the teachers also suggested examples of primary source materials that they might find useful in teaching each particular unit. These materials were chosen by the teachers based on their experience of teaching the units over the past several years and their experiences of what items would be most helpful to the students.

Selection of Materials

Based on their subsequent reading and understanding of the curriculum units, social science learning goals and desired primary source materials, the museum curators, archivists and librarians delved into their collections to search for examples of the types of materials that they believed the teachers would find most useful if digitized for inclusion in a digital repository. There followed much collaborative discussion between the teachers, curators, archivists and librarians to achieve optimal content selection for the digital repository. Final content selection was determined through this detailed and continuous review process where the teachers together discussed the benefits of using particular museum or library images for the curriculum units.

It was at this point that we realized how restrictive working with local area museums and libraries can be for specific subject fields, such as social science. Local area museums tend to obviously have collections that contain many items specific to a local region. Although the teachers at elementary grade levels often teach local interests, or how national topics might relate to local issues, their main coverage in the social sciences tends to more national topics. Thus, it would often happen that a teacher would initially like to see a digitized image of a particularly national artifact, but might have to make do with something that was much more local in nature. As well as the constraints of geography in local museums and libraries, there is a constraint of time periods as well. In particular, in Central Illinois, museums and libraries tend towards collections from the 19th and 20th centuries. As a result, topics such as the Prehistoric Indians can be difficult to cover.

Consequently, the museum curators and librarians had to be particularly innovative in choosing items from their collections. They had to choose items, which would be of use to the teachers in class. More importantly, they had to be innovative in convincing teachers of the use of particular items from their collections. In one case, a librarian suggested that a teacher might find herbals useful, whereas the teacher had never previously thought of such an artifact (for a unit on Native Americans): The librarian explained that "[t]hese are early printed books, from the 1400's, 1500's, to the present, with woodcut drawings of various herbal plants. These books were used by healing practitioners to make herbal remedies. Obviously, the Indians were the source for some of this invaluable information in the herbals written in later centuries". The teacher's response was "I have never heard of herbals! I think it might be interesting to see what the writing and woodcuts look like. We were just talking about shamans today in [4th grade] class, and discussing how the willow bark used by Indians has the same compound in it as aspirin".

Accessibility to Materials

While discussing the proposed content of the database, the participants simultaneously determined the steps necessary to make the content available to teachers and students, and to create the digital repository that will be accessible through the project Web site. In order to create an integrated system usable by each participant institution, several issues are of major concern, particularly the metadata that would be used for the database of images.

Metadata

Firstly, the metadata must be complex enough to easily integrate the different forms of metadata currently used by each participant museum or library. There was a great range of metadata formats in use among the participant institutions. The museum community uses *Nomenclature for Museum Cataloging* (Blackaby, 1995), as well as also using tools such as the *Art and Architecture Thesaurus* (http://shiva.pub.getty.edu/aat_browser/). The library participants, on the other hand, mostly use references for Library of Congress name and subject headings and would have little or no experience of museum methods. The first metadata issue of concern was ensuring that each museum and library would be willing and able to merge its existing content and metadata with the multiple other sources.

The metadata must, at the same time, be simple enough to be easily understood by the participant elementary school teachers and their students. We found that elementary school teachers did not easily understand the concept of metadata, yet they were able to discuss the metadata fields quite easily. Similarly, the museum curators and librarians had different ideas about metadata, so we arranged a workshop where the project participants came together and learned about metadata from a basic standpoint to ensure that everybody had at least some basic knowledge of the issues involved. The metadata workshop closed with the participants agreeing that the museums, libraries and archives would continue examining and utilizing the various digital file formats for access and archival purposes, metadata (indexing and description) formats, and thesauri that are used across the professions.

Following the metadata workshop, lively Webboard discussions followed. Issues that were considered included OCLC's Cooperative Online Resource Catalog (CORC) (http://www.oclc.org/oclc/corc/index.htm) and Dublin Core (http://purl.org/dc/index.htm), both of which had been used extensively during the metadata workshop, as well as EAD (http://www.loc.gov/ead/) and the creation of dynamically delivered HTML and Microsoft Active Server Pages (MS-ASP) (http://msdn.microsoft.com/workshop/server/asp/ASPover.asp) using MS-Access or AltaMira Press's PastPerfect (http://www.altamirapress.com/Pastperfect.html) as a database source.

CORC claims to be "a state of the art, Web based system that helps libraries provide well-guided access to Web resources using new, automated tools and library cooperation. It is a system of automated tools that can be used for the creation, selection, organization, and maintenance of web-based resources". CORC was originally restricted to about 100 libraries, but since January 2000, it has been made available to all libraries. Although the DCHC participants spent some time testing CORC, it was found to be unsuitable at the time for this particular project because of the learning curve, which would have been involved for the participants and also, the version of Dublin Core utilized in CORC was not extensible enough to accommodate our needs. EAD was similarly dismissed for this project, on account of the amount of time it takes to train all participants and become totally familiar with its complexity. Discussions with several people in the EAD community led us to believe, given the combined experience and knowledge of our project participants, that it would take too long for everybody to become sufficiently knowledgeable about EAD to use it comfortably.

Dublin Core, on the other hand, given its simple adaptability would be much easier for everybody to handle. During the metadata discussions, it was agreed that DC would be the metadata format that would be used, and we then set about finalizing the actual DC fields and field descriptions for the DCHC. Dublin Core is a set of fifteen elements, or fields that are intended for facilitation of electronic resources. DC has several characteristics that made it ideal for the DCHC. In particular, its simplicity enabled us to ensure that all project participants

had a grasp of the issues quickly and without too much difficulty. Its semantic interoperability also made it a prime candidate among the project users at several different museums and libraries, the focus of which can be very diverse collections. Finally, its extensibility also allowed us to provide a set of metadata elements that covered the many varieties of project participant institution. In order to ensure uniformity of metadata, we designed a database using the following set of fields, as closely related to DC field names as possible, that we felt would cover as much of the information as possible coming from the partner institutions.

- **File Name / Format** refers to the file type for the image about to be entered into the database. Three versions of each image are submitted by each museum – tiff, jpeg, and a thumbnail image.
- **Resource Type** is the nature, category, or genre of the resource, and for the DCHC, it is likely to be one of five types - Text, Image, Sound, Service, or Event.
- **Title** is the name given to the resource by the creator or publisher - its known title, or object name. The DCHC allows for an image to have several titles.
- **Date** refers to the date associated with the creation or availability of the image, i.e. the date an artifact is scanned or photographed.
- **Coverage** is used to describe the date or period of the resource's intellectual content, referring to the range of time the artifact, object, or document covers.
- **Subject and Keyword** would typically refer to the topic of the resource, such as keywords or phrases that describe the subject content of the resource, or terms related to significant associations of people, places, and events, theme, index terms, descriptors, controlled vocabulary terms or other contextual information.
- This is the most complex field, having several parts:
- **Description** is a textual, narrative description of the resource content, such as abstracts for documents or content characterizations in the case of visual resources.
- **Interpretation** is a textual, narrative interpretation of the artifact.
- **Learning Goals** refers to the Illinois state learning goals that the teachers included in their Curriculum Units.

- **Curriculum Units** are those originally provided by the teachers, and for which a particular image or artifact might be important.
- **Author or Creator** is used for the person(s) or organization(s) primarily responsible for creating the intellectual content of the original resource, for example, the author of written documents, artist, photographer, illustrator or the collector of natural specimens or artifacts.
- **Other Contributor** would then be used for the person(s) or organization(s) in addition to those specified in the Author field making significant intellectual contributions to the original resource but whose contribution is secondary to any person(s) or organization(s) specified in the Author field, such as an editor, transcriber, translator or illustrator.
- **Resource Identifier** refers to the text or numbers used to uniquely identify the resource, for example, the name of the museum/library holding the item. All of the partners felt that this field would be particularly important to enable distinction between items from their own collections and items from other partner collections. Similarly, the teachers wanted this information should they decide to make a field trip to a specific local museum.
- **Rights Management** is the field where a statement concerning accessibility, reproduction of images, restrictions, rights management, usage, copyright holder, security permissions for use of images, Conditions of Use, etc. might be included. Although the DCHC Web site includes a Conditions of Use statement, this field is for rights for a particular image.
- **Publisher** relates to the person or organization responsible for making the image available, such as the repository, archive, museum, library, or university.
- **Source** is used for information about an original resource from which the present resource is directly derived, e.g. name of a parent resource.
- **Relation** is used to describe the relationship of a secondary resource to the present resource, using linkages, such as "IsFormatOf", "IsVersionOf". Alternatively, it might be used to describe the relationship of this resource to a second resource in database, plus the identifier of the second resource. This element permits links between related resources and is also a particularly important field as it is used to signify that something is a part of something else,

such as pages in a document. It allows for connections between two or more images in the database.

- **Language** covers the language of the intellectual content of the resource - the language(s) in which a text is written or the spoken language(s) of an audio or video resource.

Figure 2 shows the interface for adding data into the digital repository. These database field descriptions gave brief details, but in the case of the actual DCHC database, there are considerably longer descriptions for each field to assist the partners in entering the appropriate information. Each field has a link to a detailed description of the field and the data that might be entered therein. A pop-up window will open with the long description as soon as a person clicks on the field name. Similarly, each participant institution was also issued with several copies of a handout with combined detailed field descriptions.

Database Design

The actual database was designed, with the fields described above, using MS-Access 2000. Although several of the participant museums use PastPerfect for their own local database, MS-Access was chosen in preference to PastPerfect because it allowed greater flexibility in the creation of unique fields and in building queries and relationships that would be necessary for the types of searches and compilation of database statistics that the project wished to produce. Also, as the database grows, MS Access would allow easy transfer to a more robust database such as MS-SQL.

MS-ASP was also chosen because of its cross platform capabilities and ability to integrate well with either MS-Access or SQL should the database need to expand in the future. ASP, as a server-side technology, affords greater speed and simplicity for the end user than other scripting languages and is cross-browser compatible. This allows greater access to the database by users of a variety of Web browsing software, which is important given the variation in location and ability of project participants. Additionally, the servers behind the backbone of the DCHC were already able to support ASP development without further modification or installation of proprietary server software.

Integration into Classroom Activity

Primary source materials can assist the teacher in enhancing the curriculum. It is well-known that the use of primary source materials, as well as helping to alleviate boredom in classroom settings, can also help to advance students to higher-level thinking and it can offer experience of collecting, organizing, interpreting, and weighing the significance of factual evidence to achieve a systematic analysis of primary source documents. Students can compare and contrast evidence from different sources and try to identify factual information and separate it from

Figure 2. Database entry screen

opinion, and make justifiable inferences and conclusions (Otten, 1998), (West, 1996).

The teachers who are participating in the DCHC have the opportunity only once or twice a year to visit a museum or library with their students. Being able to access the DCHC database now allows the teachers and students to view materials held in many more local area museums and libraries that they might not otherwise see during the year. They have much more material at their fingertips, and teachers are able to enrich the curriculum by effectively using the images in the database during the course of their teaching a particular curriculum unit.

In parallel with on-line discussions about the content and metadata for the database, we also held a number of workshops to ensure that all project participants had sufficient knowledge and skills to participate actively in all discussions, and more importantly, to make use of the database of images and associated metadata in their classroom settings. The first workshop on material culture, "Integrating Primary Resources into Teaching", proved very helpful to all participants. Through hands-on activities, project participants learned valuable methods for using primary sources to enhance the social studies curriculum using images of authentic artifacts, documents, and photographs. In particular, the elementary schoolchildren of Illinois can liven up certain topics such as "Government in Illinois" by accessing images of items such as judges' robes that were used in famous court cases, or ballot boxes that were used in elections in times gone by. Another advantage of each workshop was that it gave participants a chance to meet face-to-face. Communication was facilitated and improved after each meeting among participants.

Agreements

Intellectual property issues involved in the digitization of images, which are of major concern to the DCHC partners, include the right to distribute materials, permissions to host materials, content that could possibly be offensive to some users, institutional ownership, and conditions of use. Museums and libraries together developed a set of terms and conditions for digital access to their collections.

This agreement ensures that there are no misunderstandings among partners either during the course of the project, or after it is officially completed. Museums, libraries and archives participating in the project agreed to provide selected images and accompanying information in digitized form. The agreement sets out in writing how to make the digitized images, descriptive text and other media available to participating institutions in formats agreed upon by all the participating institutions and it confirms how works are selected for inclusion in the project on the basis of a process agreed upon by the participating institutions. The agreement also covers copyright issues, such as whose responsibility it is to obtain permissions to digitize objects, and confirms that the images and their accompanying metadata remain the intellectual property of the contributing partner.

As well as the collaborative agreement for each partner institution, a "Conditions of Use" statement for the project Web site was also created. In this case, the statement was created for the protection of the project participants and the database users.

Findings

At this point in the project, our interactions have yielded several significant discoveries that may be of interest to other similar endeavors.

Local vs. State

The teachers who are participating in the DCHC work in three different school districts. Each of those school districts has created its own unique interpretation of the Illinois Learning Standards. The standards of one school district made every effort to conform to the state standards and there was little or no difference. In the case of the second school district, the district learning standards were designed to actually reflect what is covered in the classroom, and the teachers believe that the state learning standards are not as comprehensive, and are only later matched up with what is taught. The third district was in the process of revamping its local standards and relied more heavily on the state standards.

While considering the state learning goals alongside the curriculum units, it was also necessary to

constantly review the local standards for each district to insure that the project addressed goals and objectives that were pertinent on a local as well as a state level. In most cases, the local standards did allow for the museum curators and librarians to find more innovative artifacts for the students, and enabled broadening the scope of the search for items to include in the database.

Innovation

Secondly, as teachers made their curriculum units available, it became clear that there might not always be a good fit between curriculum needs and the local area museum and library collections. In order to get over this stumbling block, the curators and librarians must be more innovative when choosing items to digitize. In turn, teachers must be willing and able to make use of materials with their students in more imaginative ways. One example where this happened was a unit on "Communities and Geography", which a teacher used to cover items such as rice-growing in China. None of the local area museums or libraries had anything that remotely covered this industry in another part of the world. However, one of the libraries did have an ox-yoke that was carved by Lincoln. While the ox-yoke is of course important in the teaching about Lincoln, it was also useful for the teacher to show an implement to the children that might be used for rice-growing carried out in another land.

Consistency

Finally, we had to develop a set of guidelines and standards for the museums and libraries to enable the creation of a consistent database, easily mapping between different controlled vocabularies and organizational data. Much discussion took place about the type of database and metadata, which would be used for the images.

It was particularly important that we developed a consistent set of guidelines for every partner institution entering data into the database. The fields in the database were based on the Dublin Core fields, but due to the nature of the partners and their collections, some adjustment of the original fifteen DC fields had to take place. Almost none of the participants had worked with DC before their involvement in this project, so it was imperative that very specific guidelines were set out for all participants to enable their entering data into the database without any difficulty and with complete consistency.

The DCHC is now halfway through its anticipated lifespan. We plan to carry out more research into how the teachers actually use the database images in their curriculum. We would like to look at innovative ways in which teachers may further develop their curriculum units using the database images which the museums and libraries have made available to them. We need to carry out extensive evaluation studies to ascertain how much use the database is actually receiving from our local users as well as users from outside our immediate locality. We are already closely monitoring use of the project Web site, but need to analyze what users are actually doing at the Web site and how they are using the database. We also have set up an Advisory Group of eight experts from various fields and regularly avail of their advice as to how we might improve upon the DCHC and perhaps expand it further for the future.

References

Blackaby, James R., The revised nomenclature for museum cataloging: a revised and expanded version of Robert G. Chenall's system for classifying man-made objects. AltaMira Press, 1995.

Fleischhauer, Carl, *Digital Formats for Content Reproductions*, Library of Congress. Last updated July 13, 1998, Consulted February 4, 2000. http://lcweb2.loc.gov/ammem/formats.html

Kenney, Anne R, Stephen Chapman, *Digital Imaging for Libraries and Archives*, Cornell University, June 1996.

Otten, Evelyn Holt, *Using Primary Sources in the Primary Grades*. ERIC Digest, Office of Educational Research and Improvement, Washington, DC, 1998-05-00.

West, Jean M., Ed. *The Immigrant Experience, 1840-1890. Volume I. Teaching with Primary Sources Series*. Cobblestone Publishing Company, NH, 1996.

Acknowledgements

This work is sponsored by the Institute of Museum and Library Services under its National Leadership Grant Program.

Collaborative Cultural Resource Creation: the example of the Art Museum Image Consortium

Jennifer Trant, David Bearman, and Kelly Richmond,
Art Museum Image Consortium (AMICO), USA
http://www.amico.org

Abstract

The Art Museum Image Consortium (AMICO) made a library of digital multimedia documentation of more than 50,000 works of art available under subscription to educational institutions in 1999. In so doing, it forged a new model of how museums and the educational sector might together create and sustain multimedia digital libraries, respecting copyright and making rich content available at an acceptablecost. In this paper, we examine AMICO's experience to analyze the common challenges that must be faced by any digital library construction project. A digital cultural heritage resource will be built on the collections of numerous repositories - why would these institutions want to collaborate and how can the persuaded to continue to work together? It will digitize only a fraction of the possible material within its scope (especially in its first few years) – how will collection development decisions be made? It will represent existing content in digital form – what standards will it impose? It will create a copyright protected product and typically use copyright protected material – how will it acquire and protect intellectual property? It will be created in order to be used – what delivery systems will be deployed to provide access and by whom/for whom will they be operated? Such a resource will cost a great deal, especially when considered over many years – how can funding be sustained, who will pay for it and how will the funds be used?

Introduction

Despite recent digital develoments, most human creations are physical artifacts and the greater part of our knowledge is still recorded only in analog form. But as museums involved in web site creation and online information delivery know very well, we are at the beginning of an age of digital and virtual culture. Yet socio-economic and technical models for construction and delivery of collections of digital materials – digital libraries – are all still experimental. Today we see commercial, governmental and not-for-profit entities all trying to be significant players in the delivery of quality, persistent online information. The fundamental questions all such organizations must answer are the same. Launching AMICO, a not-for-profit consortium of repositories holding works of art, has revealed some basic issues that must be addressed in the design of any digital library initiative The specific choices AMICO has made, and how they relate to the matrix of options facing any collection 'going digital' are best understood in the context of an analysis of the policy options.

The Art Museum Image Consortium was formed in September 1997 as an independent not-for-profit membership organization of institutions with collections of art. AMICO Members are collaborating to enable educational use of museum multimedia documentation; specifically, they are created a digital library, the AMICO Library™, from their collective resources. They have decided to collaborate to do something no single institution could do on its own, provide a comprehensive service to the educational community. The experience of AMICO as a consortium, of the individual institutions who are its members and users, and of the organizations who are its subscribers and distributors serves as a case study of the issues involved in building multimedia digital libraries. In constructing networked cultural heritage resources AMICO is creating new products and processes. These new activities require new methods and strategies. Together AMICO members are facing social, economic, legal and technical challenges, as they strive to bring their collections together into a coherent and useful educational resource. As well as integrating data, however, we've realized that we're integrating people, institutions, and systems.

AMICO was founded to encourage broad use of museum collections in digital form. Such collections need to be persistent and searchable. While most museums now have a web site, the function of these sites varies from institution to institution; with few

exceptions, they are not designed to be collection catalogs. Most museum sites change content regularly to attract visitors to new museum exhibits or programs. Even when museums have decided to keep a substantial core of collections information available, it is difficult for users with a research objective to search across these online resources, which understandably have a very institutional focus. Technically, most quality museum content that can be viewed on the web, isn't really on the web at all; it resides in databases that are linked to the web rather than in static html pages. As a consequence, standard search engines are most unlikely to reveal these richness. The value of a single source for quality museum content was demonstrated in the experimental Museum Educational Site Licensing Project (MESL) and the institutions which founded AMICO turned that lesson into a permanent program (Getty, 1998a&b).

AMICO also has roots in the need to efficiently administer educational licenses. Museums contain works that are under copyright, they hold copyrighted photographs of works in their collections, and they create intellectual property in publications, interpretive programs, sound, video, and databases. Museums also negotiate with (and often pay) artists and artists estates for rights to reproduce works still under copyright. In a stringent funding climate, museums are wise to want to protect their own assets. They must manage the rights they license to others to ensure that they are able to leverage their investment in the creation of images and information about their collections. But museum licensing can become a cost center rather than a profit center when serving the educational community. The specter of wanting to dramatically increase educational use of digital resources while having to grant rights (often without fees) on a work by work, use by use, teacher by teacher, course by course, basis was enough to spur museum administrators to examine methods of more efficiently administering licenses collectively. Efficient administration also benefits users, for they are not supporting multiple transaction costs.

Museums are not equipped to support digital library services: 24x7 help desks and huge digital content delivery infrastructures are incidental to the museum's mission. AMICO members felt that other institutions, which are in the business of dis-

tributing digital content to a variety of educational institutions, could best develop both the services and the necessary interfaces and tools for effective use of multimedia documentation of works of art.

AMICO Members also wanted to create a forum in which they could exchange information and learn from each other about the technologies and techniques employed in the digitization of collections documentation. Building links among the museum professional staff who were creating museum multimedia resources ensured that the solutions being developed were not reached in isolation, and encouraged a more standards-based and integrative approach to technology strategy. Sharing information also leveraged institutional areas of expertise. Reaching out collectively to the users of museum digital documentation was also appealing. As a consortium we could build links to user communities and learn from them and their use of our collections.

AMICO's Members faced challenges that all creators of multi-institutional information resources encounter. These can be characterized as:

• Building Community and Defining Roles: Why would we want to collaborate? Who does what?
• Selecting Content: What will we compile?
• Defining Documentation: How will it be described?
• Specifying Technology: How do we digitize and provide access to it? What delivery methods should we use?
• Administering Intellectual Property: Do we have the rights to do this? What rights can we offer?
• Understanding Use: Who wants it, and what do they want to do with it?
• Sustaining Economics: How can we (collectively) pay for it?

Each of these inter-related areas affects the design and implementation of a social, technological, legal, and economic system for providing access to networked cultural heritage.

Building Community and Defining Roles

There are many organizational and individual players involved in the social system that enables the creation, delivery and use of a digital library resource. In AMICO's case, member institutions create the

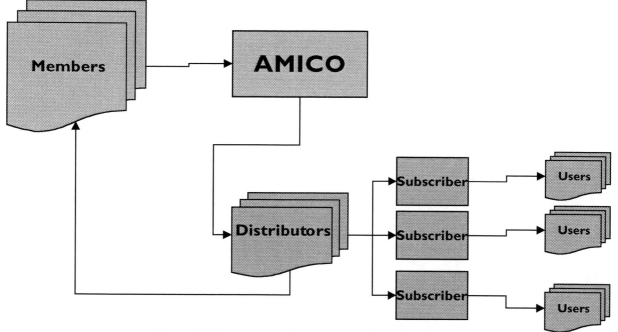

Figure 1: Creating and Delivering the AMICO Library

digital multimedia documentation without additional funding from AMICO or income tied to AMICO use. AMICO staff compile, validate and enhance the data, and pass the compiled Library on to distributors of networked information resources; they operate on income from members and subscribers. Distributors integrate the AMICO Library into their service provision networks, provide access to it, and support subscribers; their value added services need to be supported by their clientele. Subscribing institutions coordinate access for their users, and support their use, possibly by integrating sub-sets of the Library into local systems; this (new) resource competes with other resources for institutional funds. Individual users both search the entire Library online, and integrate selections into their own teaching and research environments. Each of the participants in this chain depends on the actions of the one before, to meet the needs of those who are in turn relying on them. Figure 1 diagrams these relationships.

Consortium Members

The Art Museum Image Consortium was founded by 22 institutions in the fall of 1997 after a six-month, self-funded planning exercise. Membership in the consortium is open and growing. There are now over 30 members in North America. New members are welcome, and we are actively pursuing collaboration with European institutions. One measure of success of any such consortium is its continued ability sustain original membership and to attract new members.

Membership in AMICO has both benefits and responsibilities. Members support AMICO's activities through paying annual dues, scaled to their own budget, that range from $2,500 - $5,000. They contribute catalog records, images, texts, and multimedia files regularly to the Library (in annual increments). In return, AMICO Members gain access to the entire AMICO Library under a museum license (AMICO 1999b), for use in their educational programs, in galleries, their reference library, curatorial research, and other museum activities. They also profit from the technical expertise and assistance of the central staff of the Consortium and attend the AMICO annual meeting. They govern the organization and participate in its Working Committees — Editorial, Technical, Rights, and Users. This participation is itself a major benefit as it serves to develop staff expertise in an area in which all of the members can benefit from each other's experience. Maintaining a commitment of staff in member institutions through building professional and personal

relations is crucial to such enterprises. Membership activities are facilitated though a password-protected web site, and a series of topically focussed mailing lists.

Central Staff

In theory, compilations of distributed resources could be created through implementation of common standards, but in practice digital resources, even in mature areas such as union lists of library holdings (Coyle 2000) require central staff. The central staff of AMICO (now approximately 6 and growing to 8 FTE professionals) assists members in the digitization and documentation of their collections, and helps them make their contributions to the AMICO Library. In addition to compiling the resource, AMICO staff provides advice, training and support on an as-needed basis, and also develops specifications and best practices that serve the needs of all members.

The management of the legal agreements that provide the foundation for AMICO is also the responsibility of its staff. Any multi-institutional consortium is built on such legal agreements and needs to be open to their evolution over time. Each AMICO member signs both a Membership Agreement, providing AMICO with a license to use its digital documentation, and a Museum License, providing the Member with the right to use the full AMICO Library (AMICO, 1999a,b). AMICO also manages agreements with Distributors, who provide the Library to end users, and with Subscribers, who sign license agreements appropriate to their circumstances (AMICO, 1999b-e). AMICO staff has also negotiated a consortium-wide agreement with the Artists Rights Society (ARS) to facilitate the clearance of rights associated with modern and contemporary works that remain under copyright. AMICO administers this agreement and the associated royalty payments on behalf of its members which relieves them of what otherwise would be a significant administrative burden and extra costs.

AMICO compiles each Member's contribution into the AMICO Library, verifying data formats and vocabulary to ensure consistency. To do this, central staff built a series of software tools (a Contribution Management System) which include functionality such as online editing, term lists, biographical

files and term occurrence reports, that help the museums to more consistently edit their own data. AMICO staff also enhance indexing and construct and apply authority files to add terminology that will further enable access for the end user. Image and multimedia files are validated, and record structures and links checked before the assembled digital library is transferred to Distributors.

AMICO Distributors

There are many different user communities interested in access to networked cultural heritage. AMICO recognized at least three fundamentally different audiences based on the academic level, sophistication and age of the users, the political jurisdictions and geographical locations of the subscribers, and the language of the interface.- Rather than assume that we would be able to create distribution systems that catered to all these diverse needs AMICO has contracted with established network information providers to delivery the AMICO Library to their constituencies. Each distributor integrates the AMICO Library into their systems, and provides access through an interface that meets their clients needs. It is, therefore, possible to gain access to the AMICO Library through a number of distinct service providers: The Research Libraries Group (RLG) offers an academic and research focused application. A state-wide consortium in Ohio (OhioLink) has developed a delivery to higher education and will be experimenting with K-12 delivery in the coming year. The California Digital Library of the University of California is exploring more user- focused interfaces for their multi-campus system. Other distributors are being approached for primary and secondary school users, public library users and users in other countries. This strategy enables distinct communities to encounter the AMICO Library in environments they already know, integrated with other data which adds value for their purposes, and with tools that provide for their needs. Our key goal is to have users encounter the AMICO Library content when and where they are searching for information.

AMICO itself offers a "Thumbnail Catalog" freely on the web at http://search.amico.org. Operating as an 'online brochure' this abbreviated version of the AMICO Library, contains only small images (maximum 128 pixels) and a limited selection of

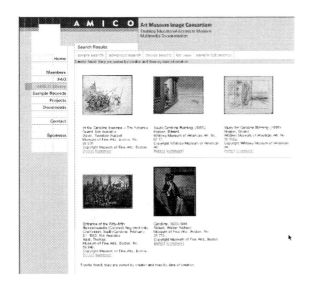

Figure 2: AMICO Thumbnail Catalog Search Result: "Carolina"

Figure 3: A search result in the AMICO Library, as delivered through RLG's Eureka service

the fields of textual description about the work. It allows prospective subscribers to browse the Library, gives the public an overview of the member museums' collections, and provides a facility to comment on particular works. The Thumbnail catalog also contains work-level links to the Rights and Reproductions office of the each museum, so that those seeking rights beyond those AMICO can offer may easily request them. Figure 2 shows a search result from the Thumbnail Catalog.

The first full application delivering the AMICO Library was developed by the Research Libraries Group (RLG – http//www.rlg.org) a not-for-profit membership association of libraries and research institutions. RLG offers bibliographic services, and a series of online resources in the humanities, including abstracting and indexing services, archival resources, and a developing cultural resources service. Integrating the AMICO Library within the RLG environment offered a number of advantages for existing RLG users. First, the interface was familiar: if you could use one of RLG's other files in Eureka, you could use the AMICO Library. The RLG Eureka application provides users with the full data in the AMICO Library, in a number of different views that will seem familiar to users of image databases. Search results are presented in list form, accompanied by a small thumbnail image. A click on any image, opens the full record for that work. Clicking on the image

in the catalog record opens the full image (at one of two pre-defined resolutions). Users may also order the TIFF images through RLG to be delivered offline. Figures 3 and 4 show this dialog.

Subscribers

Figure 4: A full catalog record from the AMICO Library, as delivered through RLG's Eureka service

Educational institutions subscribe to the AMICO Library on behalf of their user communities. Universities, colleges, schools, libraries, museums, and galleries are all potential subscribers, and pay an annual license fee for unlimited access to a growing library. Each user community receives access under a license tailored to their needs. (AMICO 1999e) Development of these license agreements has taken several years – terms for them were originally developed in discussions in the Museum Site Licensing Project (MESL) and adapted through experience in the AMICO University Testbed Project – and represents yet another benefit that AMICO has been able to deliver to its members. The license agreement specifies who can use the AMICO Library (such as faculty, staff, students, researchers, walk-in users and distance education students) and what uses they can make of the content (non-commercial educational uses, including presentations, papers, theses, lectures, and integration into in local systems, if they are access controlled). No AMICO license allows publication, web or other redistribution or commercial use of works in the AMICO Library because these rights need to be granted directly by each rights holder AMICO has provided a shortcut approach to obtaining publication rights by including the link to each members Rights and Reproduction Office. We ask that institutions have a policy on access to electronic resources in place, that includes appropriate measures for sanctioning infringing users, in order to balance the decision not to include technological controls on access beyond user authentication.

Selecting Content

Collections development for networked cultural heritage will remain a challenge for some years. The size and scope of the problem – collections comprising millions of works are not uncommon – requires any solution to be incremental. At about 55,000 works there are more gaps in the AMICO Library than there are strong points – more holes than cheese – and opinion differs as to the appropriate strategy for collection development. In theory, a consortium could "pull" content from its members by requesting specific works, but as a voluntary organization that does not fund the activities of its members AMICO treads a fine line when it recommends strategies for collection development. Since AMICO Members contribute content that they digitize themselves, it is most likely that the

majority of the works chosen for each year's edition will be those that reflect members priorities. This "push" strategy has some unsuspected advantages – content currently being used by the museums not accidentally intersects with the interests of the users: new acquisitions, loans, temporary or loan exhibitions, permanent collection gallery reinstallations, and published works are all those in the public eye. In addition, content being used by the museums in any given year will have the best documentation and the best photography. Push from the repositories is also a more efficient strategy for collections development. Digital documentation (indeed even museum photography) does not already exist for much of a museum collection. Often significant research is required in order to document collections. If other priorities are driving digitization, photography and research, it is most efficient to use the resulting record to build collaboratively constructed resources.

Strategies to construct content by "pulling" what users request or editors suggest, is complicated by the differences in opinions between different users as to what constitutes critical mass or desirable content. In focus group studies conducted by AMICO in 1999, we found tensions between users who want breadth of coverage, and many representative works, and those who want depth of coverage, many images of a particular work along with detailed documentation and accompanying multimedia. We found some potential users wanted works that they were familiar with while others thought it would be more valuable to have obscure works and works from hard to get to collections. In short, the expectations and desires of digital library users will color their perception of networked cultural heritage resources. Collectively they will not seek the same content, for the same purposes. AMICO has accepted that the AMICO Library will grow over time. Vehicles to facilitate communication between users and AMICO Members to identify pockets of broadly useful content may be a way forward.

Defining Documentation

Of course the question about what content to include and how to obtain it does not end with which works should be included. Indeed, choices about content only begin with the identification of which works will be included in the digital resource. The

more significant choices are what documentation of each work to include. AMICO is not a slide library —its value resides in the textual descriptions and other documentation about the work, not just in an images of it. As the range of multimedia about each work in the library increases (sound files, movies, structured texts) and the depth of each of these files increases, the decisions about content multiply. One important consideration is that the content itself will be regularly updated, for technical reasons as well as because the knowledge available about a given work expands. Content itself must be sustainable and extensible. Ideally it will be sufficiently granular to support a variety of views and sufficiently interoperable to connect to other resources. Some of the goals conflict with others.

The data model developed by any digital library project will be critical to its success. But this is not a simple matter of adopting an appropriate standard, because as of yet the museum community and the digital library metadata community are without standard record architectures. If the data model of the digital compilation requires each institution to re-create its existing documentation, significant costs will be incurred and technical problems encoun-

tered that will be barriers to content acquisition. In some relatively small, focussed, and discipline driven projects – such as the Beowulf project (University of Kentucky http://www.uky.edu/~kiernan/ eBeowulf/guide.htm) or the Rossetti Archive (University of Virginia http://jefferson.village.virginia.edu/ rossetti/)– it may be possible for scholarly participants to significantly enhance each item of documentation to make it conform to a new standard. But broader collections will find institutions cannot afford to participate in numerous digital library compilations if each requires different data from what they normally make for themselves and different from that of each other project in which they are involved. The AMICO model has several levels of granularity and few mandatory fields. It does not typically require any new data to be created, but its extensible record architecture creates a relatively rich connection between text, multimedia and computer file documentation

A work in the AMICO library is documented by at least three logically and physically separate parts, diagrammed in Figure 5. The first is the *catalog record* that describes the work of art itself, recording a wide variety of fielded textual information, includ-

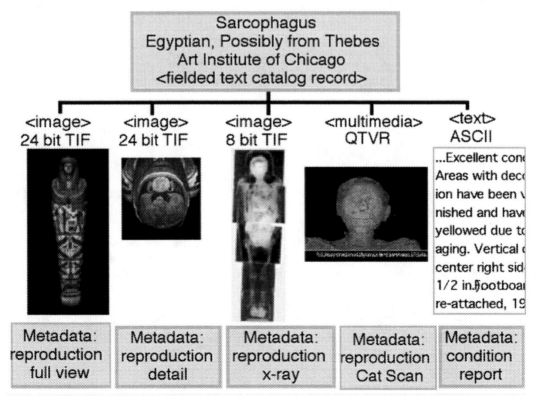

Figure 5: Sample AMICO Library Work from the Art Institute of Chicago

ing its physical description, the circumstances of its creation, information about its creator, past history, provenance, social and artistic context, and providing access points for these details. The AMICO Data Specification (AMICO 1999f) outlines the field structure and format of the catalog record. It was constructed to use data categories defined by the Categories for Description of Works of Art (CDWA, 1995).

Each catalog record must be accompanied by at least one digital image of the work of art, providing critical visual evidence. This image has been defined as a *minimum* of 1024 x 768 pixels in 24-bit color at 72 dpi. The minimum was set based on current display technology and Internet transfer speeds. Members are, however, encouraged to contribute images of much higher quality, and the Library includes files that range in size up to approximately 30 MB. These files come to AMICO as uncompressed TIFF files, and are subsequently sized and sampled for distribution, with the full images available should a user request them.

AMICO Works may also be documented by other associated images, showing details of the work, or views in different lighting conditions (such as x-rays, or raking light views). "Records" may also include linked multimedia files, such as QuickTime videos (with or without sound), sound files from an audio tour including a narration about the work, and extended texts (in SGML, XML, PDF or other format) ranging from condition reports, to catalog entries to articles published about the work. All these linked files may be submitted in any registered MIME type, according to the AMICO Multimedia File Specification.

Each digital object – MIME Type linked to a catalog record – is itself documented by a text metadata record, providing information about its creation, physical and technical dependencies, rights and restrictions and relationships. These multimedia metadata records are essential to managing and interpreting the digital objects both in the compilation of the library and over time, as they provide essential data that is extrinsic to the physical file format itself. The content of Multimedia Metadata records can be found in the AMICO Data Specification (AMICO 1999f).

In the library community, the economics of copy cataloging motivated the adoption of shared standards for bibliographic records. The artifact-based cultural world is without widely accepted and implemented standards for documenting works of art and artifacts because the uniqueness of the objects of study has, until now, denied any economic benefits in sharing their cataloging. Sharing cataloging of digital surrogates could, in theory, change this and lead to greater acceptance of description standards. But even if standards were universally accepted, cultural objects are not self-describing (they lack title pages and ISBNs created by publishers). Since one can rarely catalog the interesting aspects of most cultural objects simply with information from the artifact itself, any two descriptions of the same item will differ. In addition, descriptions will differ as a reflection of the nature of the repository which holds them and their potential users. A local history collection may hold a mass-produced object, collected and cataloged because it was owned by the town's founder. A work of art may offer little evidence about where and when it was created, and its significance may be where it was installed, or who commissioned it, as much as who painted it. In addition, opinions about cultural artifacts often differ, and descriptive systems need to accommodate both uncertainty and conflict in cultural information if they are to reflect the basic requirements of humanistic discourse.

How digital collections represent knowledge is critical to their utility and authenticity. In the cultural arena, simply adhering to "standards" isn't adequate to ensure good documentation. *How* standards are implemented is crucial. AMICO has developed a number of strategies to implement community-based recommendations such as the *Categories for the Description of Works of Art*. For example, the AMICO Data Specification separates display data from access data. This makes it possible for us to respect the nuance of the curator's prose, while providing predictable indexing of its content. Editorial consistency can be improved through shared authority files and indexing rules, but not all institutions are able to implement recommendations to the same level. So AMICO has developed a set of field-level parsing routines that index textual descriptions of dates (such as circa 1876), and some full text strings (such as artists names). Where possible, we do this in conjunction with existing external reference files, such as the *Art and Architecture Thesaurus* and the *Union List of Artists Names* (ULAN).

But these files are not comprehensive, so processes must be put in place to extend them with the new data found in AMICO Library contributions. For example, over 30% of the names in the 1999 edition of the AMICO Library were not found in ULAN. Over the coming years there is a need for collaboration among organizations creating networked cultural heritage information to articulate guidelines for the application of existing documentation standards, to develop means for articulating best practices, and to define them when necessary.

There are also issues in documenting complex multimedia objects that are only now being addressed in fora such as the MPEG 7 discussions. As creators of complex information objects we are in serious need of formats that enable us to describe and maintain sophisticated document structures. Until complex document descriptions in a language such as RDF are widely deployable, we will have to be vigilant in the maintenance of the links between our various multi-part digital information objects.

Significantly, the cultural and humanities communities are just beginning to consider the issues involved in cross-resource discovery and information use. It is still very difficult to move across collections, and to link from original materials to other resources such as abstracting and indexing services, or full texts online in resources such as JSTOR. Most often in our digital collections we mimic the physical arrangement of document storage rather than enabling the intellectual re-organization of knowledge construction.

Specifying Technology

The digital library is a hybrid systems environment, where information moves with great rapidity between and among technological and communications systems. Systems integration becomes a great challenge. Within the AMICO framework:

- Members collections data has been created for and resides collections management systems, image capture and management systems, audio systems, video systems for film, videotape and digital delivery, multimedia authoring systems whose content in delivered to in-gallery interpretive environments and to online/web-based systems and editorial/publication production systems.

- AMICO itself has a central contribution management system which validates image, text and multimedia adherence to AMICO specifications, file format verification tools, and member and distributor support systems.
- AMICO's distributors have database management, indexing and retrieval systems, user authentication systems, and information delivery interfaces and tools.
- Subscribers have local on-campus systems, including online public access catalogs, local image and database resources, course web pages, and other teaching and testing tools, and
- Users themselves have a range of analytical, research and study systems.

The information about works in cultural heritage collections delivered over networks must move freely between and among these systems; cultural heritage information is integrated into systems throughout organizations, each of which supports specific functions. Shared and widely, consistently deployed standards are essential to preserve the integrity of information at a technical and a logical level during these transportations and transformations.

Multimedia file formats and structures are the most vulnerable at the moment, and the most challenging, because they remain un-standardized. The verification and maintenance of links within and among complex objects relies in part on consistent and unique resource naming and the establishment of a means of persistent identification. But consistent information capture and description standards are just as critical for the creation of digital cultural heritage information with integrity. Without them, we can't expect comparable results across collections.

Cultural heritage institutions must also address the twin requirements of user authentication and resource authenticity. Authentication is a matter of maintaining systems security, and managing access and use permissions. Authenticity requires the maintenance of trust in the digital environment and in a particular digital representation of knowledge (Bearman & Trant, 1998). Regardless of how secure a system is, if you can't trust, or interpret the information that it contains, it's utility is greatly compromised.

Intellectual Property Issues

Consistent intellectual property terms and conditions, that enable a wide range of educational and scholarly purposes, are critical to the creation of viable and useful networked cultural heritage resources. Frameworks are required that provide for the distinct needs of different kinds of communities, and that recognize the varying levels of risk inherent in particular uses.

Many creative works are under copyright, and we need to find ways to ensure that history and scholarship do not stop with the public domain. It is possible to craft agreements that work for copyright holders while respecting the economic realities of education, as AMICO's agreement with ARS has shown. But the way forward is not denying these rights, for that will only result in intransigence on the part of the rights holder. Instead, we must negotiate away from fixed per-work fees that impede the construction of large collections, towards more flexible frameworks that respect the changing realities of digital publishing, and varying kinds of digital uses

There are many ways to protect intellectual property in the networked environment, and we have to be careful that we are not impeding use through protection. For example, some types of 'watermarking' interfere with digital images in such a way as to make them useless for certain kinds of analysis (Bissel et.al., 2000). Closed distribution systems prevent the incorporation of digital content into new creative or analytical environments. A range of social, legal, and technological protections are going to be required to support the variety of users and uses of cultural content in the years to come.

Understanding Users

Digital resources are created for their end-users, but until they have been made and distributed, we can only imagine (and hope) who these users might be. In reports from participants after the University Testbed Project which AMICO conducted in 1998-1999 (AMICO 1999g), AMICO members were delighted to learn that the users of the AMICO Library came from a wide range of academic departments and disciplines. Creative faculty and students integrated cultural content throughout the curriculum. As might have been expected, strong use was

Figure 6: Students at the University of Alberta use the AMICO Library in their Canadian Art History class

made in Art History departments, as images were projected in class, used in student assignments and assigned for in-depth study. Art Studio students also used the Library as a resource, browsing it for works that represented particular concepts and using them as inspiration for their own work. One of our goals in structuring access to the AMICO Library institutionally was to encourage new and unexpected uses by non-traditional users. In a Cultural History course taught by Professor Marc O'Connor at Boston College, works from the AMICO Library provided visual context for text and music, as Dürer's *Large Passion* series of prints was show along with J.S. Bach's St. Matthew Passion, and Martin Luther's *Freedom of a Christian*. (see Figure 8). In Technical studies works from the AMICO Library challenged students in image database courses and in a School of Printing.

One lesson of the Testbed experience of relevance to any networked cultural heritage digital resource is that teachers need help in imagining how to use new resources, and time to adapt their teaching and research methods to new media, in addition to upgraded facilities in classrooms and software tools provided by Academic Computing centers. Changing educational methods does not follow directly and inexorably from publishing digital libraries.

As the preceding description of AMICO Library creation, distribution, and use shows, there are many players in this system. Each of these stakeholders is struggling with similar issues about the content of the Library, its documentation, the technology used to create, distribute and use it, the intellectual property framework, and economics of networked information distribution. These players are also engaged in community building, discovering areas of

Figure 7: An example of AMICO Library works applied to Cultural History study. Professor Mark O'Connor, Boston College

common interest amongst previously disconnected and different groups.

Sustaining Economics

Creating quality digital cultural heritage is expensive. The richness and complexity of the information that managed in cultural collections adds to the pressure on our already stretched economic systems. Enabling long-term access requires attention to self-supporting economic structures when projects are designed. We must be realistic about funding sources. Often grants get projects started but few sources are available to support on-going operational requirements, AMICO was designed to be a self-supporting not-for-profit, that operates without dependence upon grant funding for its core activities.

There are costs and benefits throughout the information creation and use chain. Our goal was to find a balance, where all institutional participants have a financial stake. Within the AMICO model, no money is returned to members for their participation in the consortium. Members dues and subscription fees support the new costs involved in the collation and distribution of the AMICO Library. Where possible AMICO leverages members' contributions and encourages members, distributors, and subscribers to develop tools to enable use of the Library and to add value to it. (This is allowed by all the AMICO Licenses).

Key in our financial model is the principle that access remains free at the point of use. Pay per view

models act as inhibitors of the widespread use of cultural information that we wanted to enable. Rather, we're looking at the costs, benefits, and investments made by all participants, and trying to create a balanced system, that enables participation by all. As a not-for-profit organization, AMICO has a set of fixed costs that it has to recover for the compilation and distribution of the Library. These do not increase in direct proportion to the overall number of users. Rather, as is the case with much digital information, the first copy costs are substantial, and subsequent users represent a modest cost increment. So the more subscribers there are to the AMICO Library, the lower the cost is to each one.

Conclusions

AMICO's success to date has been based on its ability to craft a successful collaboration built on a shared educational mission and the recognition that what AMICO is trying to do could not be accomplished by any member acting alone. Throughout our planning and first years of operation we've strived to create open and consistent terms for participants. Each member and subscriber signs a common, public, formula-based agreement: there are no special deals. We've used the web to foster open, multi-way communications between and amongst members and subscribers. All AMICO specifications are public, and we've avoided using proprietary technologies.

Collaboration has enabled the members of AMICO to share both the risks and the benefits of groundbreaking work enabling access to museum multimedia. By sharing their past successes (and failures) and making some future decisions in concert, individual members of the consortium can leverage the knowledge of others. Together, all members are raising their level of expertise and awareness.

This climate of collaboration benefits AMICO members, as they have access to a wide range of support on technical, economic, legal, and organizational issues. It enables the activities of AMICO, ensuring that we can create a useful and viable AMICO Library. It enables our distributors to incorporate a new stream of previously unavailable content into their electronic resource offerings. It provides subscribers with unprecedented access to the collections of member museums, and it enables users to

build their knowledge of the objects in our care. Most critically, collaboration in AMICO has ensured that together we can create a strong place for culture in the digital library of the future.

References

AMICO, 1999a Membership Agreement http://www.amico.org/docs/Membership.Agr.html

AMICO 1999 b, AMICO Library Museum Agreement, http://www.amico.org/docs/AMICO.Museum.pdf,

AMICO 1999 c, AMICO Library K-12 Agreement, http://www.amico.org/docs/AMICO.School.pdf

AMICO 1999 d, AMICO Library Public Library Agreement, http://www.amico.org/docs/AMICO.Public.Library.pdf

AMICO 1999 e, AMICO Library University Agreements, http://www.amico.org/docs/AMICO.Univ.Agr.pdf (long) and http://www.amico.org/docs/AMICO.U.Short1.pdf (short)

AMICO 1999 f, AMICO Data Specification, 1999, hhttp://www.amico.org/docs/amico.dataspec.1.2.pdf

AMICO 1999 g, Testbed project report. http://www.amico.org/projects/u.mtg.99/u.results.html

Bearman and Trant 1996. David Bearman and Jennifer Trant, "Museums and Intellectual Property: Rethinking Rights Management for a Digital World", Visual Resources, vol.12 p.269-279

Bearman & Trant 1998. David Bearman and Jennifer Trant, "Authenticity of Digital Resources: Towards a Statement of Requirements in the Research Process", D-Lib Magazine, June 1998 (ISSN 1082-9873) http://www.dlib/org/dlib/june98/06/bearman.html

Bissel 2000. Torsten Bissel, Manfred Bogen, Volker Hadamschek, and Claus Riemann, Protecting a Museum's Digital Stock through Watermarks, in Selected papers from Museums and the Web 2000, David Bearman and Jennifer Trant, eds. (Pittsburgh, Archives & Museum Informatics) http://www.archimuse.com/papers/bissel/bissel.html

CDWA 1995. Categories for the Description of Works of Art, the report of the Art, Information Task Force, Jennifer Trant, ed. (Los Angeles J. Paul Getty Trust) http://www.gii.getty.edu/cdwa/

Coyle 2000. Karen Coyle, "The Virtual Union Catalog, A Comparative Study", *D-Lib Magazine*, March 2000 Volume 6 Number 3 (ISSN 1082-9873) http://www.dlib.org/dlib/march00/coyle/03coyle.html

Getty 1998a, Getty Information Institute, *Delivering Digital Images: Cultural Heritage Resources for Education, The Museum Educational Site Licensing Project, Volume 1,* Stephenson, Christie and Patricia McClung, eds., (Los Angeles, J. Paul Getty Trust)

Getty 1998b, Getty Information Institute, *Images Online: Perspectives on the Museum Educational Site Licensing Project, The Museum Educational Site Licensing Project, Volume 2,* Stephenson, Christie and Patricia McClung, eds., (Los Angeles, J. Paul Getty Trust)

Techniques
& Methods

Creating Online Experiences in Broadband Environments

Jim Spadaccini, Ideum, USA

Abstract

The emergence of broadband technology has changed the Internet experience for millions of users. Faster Internet connections create opportunities and unique problems for Web developers. More compelling resources can be created for broadband connections—larger and/or more graphics, better quality video, and more interactivity are a few of the options. Most Web visitors, however, don't have a broadband connection. The tension between taking advantage of the latest technology to create the most compelling experiences possible and creating resources that are accessible to a broad public audience is not a problem unique to developers in the museum world. But it is one that is particularly sensitive given the fact that most museums receive some sort of public funding and have a mission to serve the community at large. Unlike the museum floor, users' experiences with online resources have always differed due to factors such as connection-speed and the capabilities of their computers. The emergence of broadband (and faster computers) has made this problem more pronounced. So what are the options? What are the advantages that broadband presents? How can museums take advantage of what broadband offers without leaving other visitors behind? What technologies and techniques can developers use to create compelling online experiences that are "scalable" for visitors connecting at different speeds?

Introduction

The term broadband is used in this paper to mean more bandwidth—which means faster connections for Internet visitors. This differs from the definition found in *Webster's Dictionary*: "of, relating to, or being a communications network in which a frequency range is divided into multiple independent channels for simultaneous transmission of signals (as voice, data, or video)." If you took this out-dated definition and applied it to the Internet, it would be defined as a broadband environment regardless of the connection speed. Broadband can include multimedia (sound, video, images, etc.), but the speed of the connection is what differentiates it from dial-up Internet access. Cable modem or DSL (digital subscriber line) connections are the most common types of "consumer" broadband connections.

How Fast?

Cable modems and DSL connections range from 385 Kbps all the way up to 40 Mbps. These connections are roughly 10 to 1200 times faster than a 56K modem connection. In addition, cable modem and DSL connections are on all the time—there is no "dial-up." This a fundamental change in how users interact with the Web: for broadband users, the Web is not only faster but "always on."

How Many?

According to the Yankee Group (http://www.yankeegroup.com/), a technology research company, residential high-speed Internet services will grow to 3.3 million subscribers this year. The number of subscribers is expected grow to 16.6 million by the year 2004.

Spurring the growth of broadband connections is the trend toward more multimedia on the Web. According to the report, "Beyond T1/E1 1999-2000, North American Residential Broadband Access Market Opportunities," published by Communications Industry Researchers, Inc. (CIR) (http://www.cir-inc.com/), the average file transfer from the Web is now 60Kb, which is 15 times larger than it was a few years ago. This not only makes broadband connections seem more attractive, it renders dial-up connections increasingly inadequate.

While the number of individuals with high-speed access is estimated to grow considerably, only a small percentage of the total U.S. Internet population is currently connecting with broadband technology. According to the Computer Industry Almanac (http://www.c-i-a.com/), there are 110 million Internet users in the United States at present. This means that less than 3% of Americans are connecting using cable modems or DSL connections from home, which, of course, doesn't include school visitors or people who surf at work with high-speed connections. Still, the number of visitors connecting with broadband is much smaller than those signing on with dial-up.

Interestingly, the CIR report also predicts residential broadband connections will top 31 million by

2003. This is significantly higher (and a year sooner) than the Yankee Group's estimation of just over 16 million by 2004. So while Internet researchers disagree on the numbers—the increase in broadband subscribers will be significant by any estimation.

Webcasting

Webcasting is the first technology to take full advantage of broadband on a wide scale. Large commercial Webcasting sites have, in the last year, developed their own "broadband sections" trying to appeal directly to users of the technology. Webcasting giant Yahoo! Broadcast, for example, has a broadband category (http://www.broadcast.com/broadband/).

Webcasting is a technology in which audio or video content is digitized, encoded, and "broadcast" through the Internet. The content can be accessed live or on-demand. The technology is capable of delivering different rate streams depending on the users' connection. In other words, someone connecting with a 56K modem may receive a different quality stream than someone connecting with a cable modem, DSL, or another broadband connection. The higher quality broadband streams began appearing on the Internet in 1999. Before that, most content providers (and developers of the technology) didn't bother with high-bandwidth streams because the audience just wasn't there.

Webcasting is the perfect technology for the emergence of broadband. It's completely scalable: You can create one program and deliver high-quality video to broadband users, a few frames-a-second video to 56K dial-up users, and even an audio stream to a user with an antiquated 14.4K modem. In creating these different streams, you're not only reaching virtually every Internet user who wants to tune in, but, in creating the broadband stream, you're providing a way for future users to see a relatively high-quality archive of the program. So while broadband users may be few in number now—the broadband stream may be the one most-accessed in the future as more and more users connect at higher speeds.

Much of my own experience comes from helping to create broadband streams for Webcasts held at the Exploratorium in San Francisco. In August 1999, the Exploratorium sent a crew to Turkey to film the solar eclipse and send back video via satellite. This signal was encoded and one of the streams was designated for broadband visitors (http://webevents.broadcast.com/exploratorium/solareclipse/). The broadband stream was encoded at 300 Kbps or roughly at 9 times the rate of an encoded stream for a 56K modem. With a higher data rate, there is higher quality. The video seems less jumpy (more frames per second), clearer (less "lossy" compression), and has a larger window size. Following the Eclipse Webcast, The Exploratorium conducted a Webcast for the 10th anniversary of the Loma Prieta Earthquake (http://www.exploratorium.com/faultline/remembering.html) and a program on the Science of Wine (http://webevents.broadcast.com/exploratorium/wine1199/). Both of these programs have broadband streams. The Loma Prieta Webcast has a T-1 stream which is about 100K per-second (which, it could be argued, is not a "true" broadband stream). The Science of Wine has a 300K stream. For almost all major Webcasts, the Exploratorium now routinely creates at a 100Kbps—if not a 300Kbps—stream.

The only drawback to creating high-band streams is cost. Most of the expense is the cost of bandwidth. One hundred people connecting to a 300K stream are going to use 9 times the bandwidth that 100 people connecting to a 56K stream will use. Creating the broadband stream itself is simple—it just requires that such a stream is encoded. Which may require an additional computer to facilitate the encoding for a live broadcast.

On Demand

Streaming video can also be delivered "on demand." Video clips can be integrated into Web sites, and different versions can be delivered to visitors with different types of connections. RealNetwork's (http://www.real.com) new "G2" format allows developers to encode video clips which are automatically "scaled" based on the speed of a visitor's connection. The RealPlayer, which is used to play RealVideo files on the visitor's computer, contains settings that alert the server to the type of connection. RealNetwork calls this "SureStream" technology.

Recently, I developed a site for the Exploratorium and NASA's Sun-Earth Connection Education Fo-

rum focusing on this year's Solar Maximum. SolarMax 2000 (http://www.solarmax2000.com/) contains video clips of interviews with solar scientists that utilize G2 technology. During the encoding process I specified which types of connections were to be supported. Each encoded file contains optimized "versions" for 28K, 56K, 80K, and 180K connections. Obviously, the quality of each version improves as the amount of data increases.

Since the SolarMax 2000 site is meant to reach a mass Internet audience, any broadband content needs to be scalable so as not to turn away potential visitors. The streaming video fulfilled this primary need, while providing broadband visitors with better quality video.

Broadband-Only Sites

Due to the relatively small number of current broadband users, there are only a few examples of museum sites created specifically for that audience. In the commercial realm, Quokka.com (http://www.quokka.com) has developed a reputation for providing Web-based broadband content. Other sites such Intel's Web Outfitters (http://www.intel.com) also provides a few content sites geared toward visitors with high-speed connections (and faster processors). These sites and others are free to pursue what is at the moment a "niche" market. Museums for the most part, with a mission to serve the public at large, have so far not pursued the emerging broadband market.

High-Bandwidth, Low-Bandwidth

Museums have created broadband sites—but have been careful to include low-bandwidth versions as well. A recent example is the Virtual Smithsonian (http://2k.si.edu/), whose high-bandwidth version utilizes a variety of interactive and multimedia technologies. The low-bandwidth version, not surprisingly, uses these technologies much more sparingly.

While creating two versions of the same site is one way to insure that a site can reach all visitors, there are some drawbacks. Some broadband visitors may still choose to visit the low-bandwidth version anyway. Many visitors with slower connections may feel that they are missing out by not being able to access the more media-rich, high-bandwidth versions.

Also, some new users of the Internet might not know the difference between high-bandwidth and low-bandwidth and may not know which choice to make.

Another significant drawback is the development time required to produce these sites. Obviously, creating two versions requires additional time. Also, there are more time requirements and costs involved in updating and maintaining two sites.

Broadband sites themselves generally use more interactive technologies such as Java (a platform independent programming language) and/or Shockwave or Flash (interactive animation and multimedia authoring programs). To develop using these technologies, specific technical expertise is required. Hiring or contracting a Shockwave or Java programmer or a Flash animator can be very expensive. The cost of developing a high-bandwidth site can be much more expensive than creating a low-bandwidth version.

With all of these drawbacks, developing multiple versions of sites is sometimes the only way to adequately present the content. In 1998, I developed an online exhibit entitled, "A Memory Artist" (http://www.exploratorium.com/memory/magnani). This exhibit contains drawings and paintings created by artist Franco Magnani and photographs by Susan Schwartzenberg. The paintings and drawings are of a small town in Tuscany and are done entirely from memory. The exhibit compares these works of memory with actual photographs of the same scene. In order to compare these images, each one needed to be large enough so that viewers could adequately observe the details. Also, each image needed to appear on the same screen. Those unable to view the exhibit or unwilling to wait for the images to download were given the option to view the text article (which contained fewer images).

The "Memory Artist" exhibit utilizes JavaScript, which is a language developed by Netscape that allows Web authors to add interactivity to pages. A simple Java script was used to create a pop-up window. This was done to maximize the amount of screen "real estate" available. The pop-up window removes the browser tool bars, thus providing the extra necessary space. Some older versions of browsers either don't support JavaScript at all or

don't fully support it. Users of these browsers are unable to access the pop-up window that contained the exhibit. Instead, these users were given the option of visiting the text article. In 1998, when the exhibit was posted, about one-quarter of visitors to the Exploratorium site used browsers that didn't fully support JavaScript. If we could have found another more inclusive method of appropriately presenting the content we would have pursued it.

To a certain extent, the "Memory Artist" exhibit automatically detected the capabilities (although certainly not the bandwidth) of visitors, providing them with the "exhibit" that best suited them. More complex "auto-detect" scripts can tell if visitors have multimedia capabilities by detecting browser types and versions, as well as plug-ins (which expand the multimedia capabilities of browsers).

A Web visitor provides this information to every site he or she visits. Auto-detection can make the user's experience more seamless, providing fewer choices and directing visitors toward multimedia technology that their computer is set up to handle. One example of an auto-detect script at work is the Exploratorium's "Which Embryo Is Human?" exhibit. (http://www.exploratorium.edu/exhibits/embryo/). An auto-detect script checks the browser version, sending visitors to the JavaScript version or the non-JavaScript version automatically.

While multimedia capabilities can be automatically detected, the method is not foolproof and it cannot detect the speed of the visitor's connection. Such a development would certainly simplify the creation of multiple versions of sites. As the gap between broadband Web users and dial-up users continues to grow, a method for detecting the speed of a visitor's connection becomes more desirable.

It's certainly possible such a development could come to pass in the near future. Perhaps, in fact, browsers will be able to communicate with servers in the way the RealPlayer does—by letting them know what type of connection they have.

Broadband Extensions

Considering the problems that exist in developing multiple versions of sites, perhaps the best method for designing sites is to create sites that are flexible and contain scalable media elements. These elements may scale automatically (like some streaming media) or the user can select different versions of media files. In other words, the structure and some of the contents of sites are available to everyone—but some of the individual media files may require or work best with broadband connections.

Providing the visitor with choices for high-bandwidth or low-bandwidth media (or other components) means the overall structure of the site can be inclusive (and one version), while video, audio, images, and even interactive components can be scaled. These components would be one "click away" from the general structure of the site. Another benefit of this approach is the amount of flexibility it provides. Low-bandwidth visitors can easily browse the overall structures keying in areas of particular interest—if they are willing to spend the time downloading a high-resolution image or a large video file. Or they may view a "low-res" version, and then decide to view the higher quality one.

As we've seen, streaming video (both Webcasting and "on-demand") provide a scalable solution that doesn't require the visitor to have to choose between versions and, importantly, doesn't require extra work for the developer. QuickTime video (generally a "non-streaming" high-quality digital video standard) and images cannot be "automatically" scaled. Different versions of these files would need to be created. Links to these files would be offered as choices to visitors.

Thumbnail images linking to high-resolution images have been used extensively on the Web for many years. The visitor can make the choice to view the larger image; generally the size of the image is listed, letting the users know what they are getting into. Broadening this to include the option of viewing even larger images with more detail is an obvious extension. In the museum world, visitors could view super-high-resolution artwork or scientific illustrations.

This technique can also be extended to audio or video. Streaming audio is already "scalable," but other audio file types and QuickTime video are not. It's easy to provide the user choices between high-quality or low-quality versions of the same clip. Creating additional versions of these files does require

extra work and extra file management and storage. However, creating and editing the clip is usually the most time-consuming aspect of audio or video production. Saving different versions of the clip is easy and having a high-quality version provides more "value" for the time invested in creating and editing.

Sometimes "non-streaming" audio or video can also be used as a high-quality alternative to streaming media. One example of this technique is "Life Along the Faultine," a Web site which I helped design for the Exploratorium. The article on Loma Prieta (http://www.exploratorium.edu/faultline/loma_prieta) uses RealVideo and QuickTime to present news footage from the 1989 San Francisco earthquake. The RealVideo is scaled so that broadband visitors see better quality video than dial-up users do. The QuickTime versions allow broadband users to view even better quality video (low-bandwidth visitors can still download the clips, but it takes some time). All Web visitors, regardless of connection type, can still read the article and view the images—many of which are "clickable" to higher quality versions. The structure of the site is as flexible as possible, providing the user with options for interacting with video and images.

As I mentioned, creating different versions of media files does require more work on the part of the developer (with the exception of G2 RealVideo files). But compared to the amount of time involved in creating two versions of a site, the costs are minimal. Having these "broadband extensions" in place provides more options to current visitors and ensures that future ones will be able to view or interact with higher quality files. It should be mentioned that variations of this model are found in many places on the Web. In many ways, it's a common-sense approach. You build a structure that is completely accessible and then provide choices for visitors, offering content that takes advantage of new technologies only when it's the best way to present the material.

The model I've presented doesn't allow for "immersive environments." These are sites that create "virtual spaces" on the Web. These types of environments are created using interactive technology such as Java or, more often, Shockwave for navigation and the "building" of the space. Such tools can provide compelling navigation systems and interesting "spaces" for exploration, but the sites lack flexibility for low-bandwidth and "low-tech" visitors. Even if some of the contents of the sites could be "usable" for visitors, they need to meet the technical requirements of the navigational structure (the Shockwave plug-in and broadband connection) for visitors to view or interact with the contents.

Developing these immersive environments can require a considerable amount of resources. Space is important, but with limited museum resources it makes sense to focus on the exhibits or other content. Good Web design (just HTML and images), may not provide the visitor with as powerful an experience as an immersive environment, but good design can create "space" as well, and in most cases it is more functional, and it is always more accessible.

Conclusion

As the number of potential users with broadband connections increases, museums need to find compelling ways to reach them. As I've mentioned, some commercial sites already cater to these visitors, and certainly more sites will follow. If museums ignore broadband visitors, they risk losing many of them to more compelling experiences elsewhere on the Web.

At the same time, focusing too much energy on broadband visitors can be dangerous. With limited resources, museums need to focus on creating resources that are flexible and inclusive. The Web by its very nature is an "exclusive" environment. According to "Falling Through the Net: Defining the Digital Divide," a report by the National Telecommunications and Information Administration (http://www.ntia.doc.gov/ntiahome/fttn99/), more than half of the U.S. population, particularly poor urban and rural individuals, do not have access to the Internet. Obviously, creating additional barriers such as bandwidth restrictions or the use of emerging technologies further reduces your reach.

There is a real tension between creating compelling resources that take advantage of the latest technologies that the Web offers and reaching the public-at-large. Museums should be places where experimentation and innovation take place—but they

also need to reach their audiences. In addition, the realities of limited resources and few online revenue models for museums can't be ignored.

The challenge for developers is to balance these competing needs and not be carried away by all the hype surrounding the broadband revolution. Common sense, compelling design, and thoughtful uses of new technologies can provide rich experiences for online visitors—regardless of their connection speed.

Bringing the object to the viewer: Multimedia techniques for the scientific study of art

Michael Douma, Institute for Dynamic Educational Advancement and Michael Henchman, Brandeis University, USA

Abstract

Often, topics can be taught online that are unteachable in other media. One such topic is materials science and art — an increasingly popular topic for art museum visitors. This is a visual subject, which requires visual materials for teaching and learning. Books, articles, slides, videos are often unavailable, inaccessible or in an unuseable form, and the physical nature of museum objects generally precludes side-by-side comparisons. To identify the underdrawing of a painting, one must be able to superimpose infrared and normal photographs of the painting. To authenticate a particular Greek kouros, one has to be able to view it from all angles for comparison with authentic kouroi. Pictures in books, and discreet kouroi in different museums will not accomplish that. The material must be made available in a useful form.

We are now completing a 1 1/2 year project (an NSF sponsored partnership between Brandeis and the National Gallery of Art), for an interactive web site about Bellini's Feast of the Gods. This exhibit should be online in late January. Our exhibit, Investigating Bellini's Feast of the Gods, considers a single painting. Within the period 1514-29, it was painted and overpainted three times. Scientific data are presented, enabling the viewer to reconstruct interactively the various versions and reasons for the overpaintings. The viewer discovers the chemistry of the pigments and their degradation, how the scientific investigation was performed and how to identify the various painters. Uniquely the exhibit allows the viewer to manipulate images—magnifying, superimposing, and comparing. The painting is examined in great detail.

Our paper addresses the specific technologies and pedagogical approaches which we have used that may have direct application to other art-and-science web sites. For example, a common challenge is to make one exhibit that is useful to many different audiences. It is important not to lower the common denominator too low, or the exhibit will be useless for all. This is easier to accomplish in an online exhibit than in a physical one because whole sections on a site can be geared toward more knowledgeable visitors without disrupting the experience for others. Another approach — which has been very successful for us — has been to limit the scope of our subject matter. By focussing on depth rather than breadth, often experts and non-experts alike are able to wholly follow a narrow topic without being overwhelmed with too many academic concepts. We are thus able to keep the level of sophistication quite high.

Increasingly, new scientific techniques are being applied to the scientific study of art. These deliver an *embarras de richesse* but the data are only useful if they are accessible to the individual evaluator. How can one interpret an X-radiograph of a painting unless one can compare the two images directly, in a situation where both magnification and contrast can be varied? The availability of digital images and their ready transmission over the Internet has provided an exciting solution to this problem. Today, with convenient access to the primary data, each one of us can render individual judgements on the pressing issues of the moment. No longer are we limited by the printed page and by the information fed to us by the *cognoscenti*. Instead, we are open to the widest possible range of input from a complete spectrum of attitudes and vantage points.

This new horizon is revolutionizing teaching and learning. Hitherto, the medium of instruction in this visual field has been the slide. The slide is the degraded image of another degraded image — a figure in a book. Comparing a painting with its X-radiograph was then a comparison between two doubly degraded images. It is difficult to evaluate what can be accomplished thereby. Worse, the comparison is often only a fleeting instant in a lecture, incapable of being recalled by the audience. Comparison of singly degraded image within in a book, is subject to a different limitation. One will be on one page; and the other, in general, will be on another.

We were brought face to face with this *impasse* when teaching a course on the scientific aspects of art to students of Fine Arts (art historians and studio artists) at Brandeis University. We were delighted to be able to use, as a central case study for the course, the remarkable restoration and investigation of the painting, dating from 1529, *The Feast of the Gods* from the National Gallery of Art in Washington, D.C. For fifty years it had been known that this sensational painting held beneath its surface evidence of an unusual complexity. But it was only in the late eighties that investigative techniques became sufficiently developed that the interior of the painting could be explored. The ultimate success of the project, which took five years, was due to the extraordinary skill of the two people responsible — David Bull, head of restoration at the NGA, and the late Joyce Plesters, head of conservation science at the National Gallery, London. Based on three types of physical evidence — an X-radiograph, an infrared reflectograph and 22 paint cross sections — they were able to establish that *The Feast of the Gods* had not one paint layer but three. They were then able to map the two underlying layers, thereby revealing how the painting would have appeared in 1514 and 1522 according to the two artists responsible, Giovanni Bellini and Dosso Dossi, respectively.

This fascinating "archaeological dig" has been documented extensively in a monograph published by the NGA and in a delightful film made by the award-winning director David Sutherland. While this — the account, the interpretation and the background — could not have been of higher quality, it did not and could not provide us with the evidence we needed to make the complete scientific case. We needed to be able to superimpose the X-radiograph, the infrared reflectograph and a detailed image of the picture. Whereas Bull and Plesters had had continuing microscopic access to the picture, we did not. We therefore required images which were almost as well defined as the picture itself.

We not only needed the scientific data in great detail, we needed it in a form for students to be able to use for their own interpretations. Their need is to be able to manipulate the data at will, to use the data first to formulate hypotheses and then again subsequently to validate or invalidate them. We realized that Bull and Plesters' data were only of use

to us if it could be manipulated ... and we were astonishingly fortunate that David Bull supplied us with raw data which we could then digitize.

In presenting the data in a form suitable for students to interpret, the challenge has been, on the one hand, not to direct that interpretation while, on the other, providing enough background — about the painting, the period, the structure of paintings, the technique of painting and the scientific methods of investigation. More discussion of this is given below. We were particularly concerned, as scientists, to school our artist students in the types of (scientific) statements which the data would allow us and in the types which the data would not.

Finally there was the question of the form in which the digital data should be transmitted to our students and to other teachers of other students. Three years ago, we were convinced that the proper medium was the CD-ROM. We did not anticipate instant wealth but projected an income sufficient to cover costs. At that time there were still publishers marketing CD-ROM's of appropriate quality but in the subsequent three years, that situation has changed. Moreover we now realize that we could have never even recovered the necessary image licensing costs. It is now therefore available at no cost on the internet <*http://www.webexhibits.org/feast*>.

Specific techniques

We have successfully utilized a number of techniques for visualization that have direct application to many types of projects. These techniques use well established internet multimedia techniques and should be accessible to the vast majority of web visitors:

1. The spyglass

Issue: How can visitors compare multiple versions of the same image?

In the physical world: In an actual museum or laboratory, your visitors might lay the images side by side. They could then compare the images as a whole. They also might view the images in detail through a loupe, switching back and forth between comparable features in each image.

On the internet: Images can be overlaid in layers, and visitors can switch what layer they are viewing. Additionally, we can put a "hole" in an image, revealing the image layer beneath it. This creates an effect like a searchlight, or spyglass being moved around the image, allowing details of each version to be directly compared.

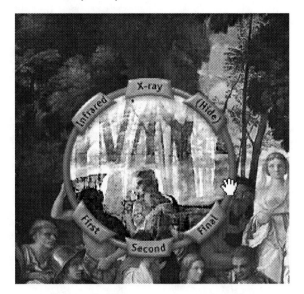

Figure 1. We see evidence for a forested background in the X-ray image of Bellini's Feast of the Gods.

Technical details: Using Macromedia Shockwave. 1) Prepare images in an image editor (such as Photoshop), to be exactly the same dimensions. You may need to rotate, resize, and skew your images. To maximize sharpness, you should stretch oversize images, then downsample to final size when you are through transforming them. 2) Using Shockwave, create a one bit mask for each image, apply mask ink. 3) While the mousedown, adjust the spyglass sprite loc, and move the mask regpoint the opposite direction. 4) Export shockwave movie, with images dynamically imported.

2. The zoom view.

Issue: How can you look at an image in great detail?

In the physical word: A viewer will look very closely, or use a magnifying glass.

On the internet: Small portions of the image can be viewed in detail. The visitors can adjust their view vertically and horizontally, zoom in and out, or click on a thumbnail image to re-center their view. Often the visitor can see the image in greater detail than they could in a museum, where they might not be able to reach all portions of the image, for example, it is hard to see the top of a large painting in detail.

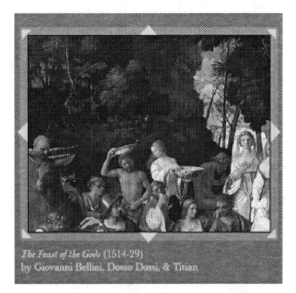

Figure 2. Detail of the Feast of the Gods is viewed in considerable detail.

Technical details: Using server scripts or JavaScript. 1) Divide image into hundreds of rectangles using Adobe ImageReady to define equally spaced guides, and define slices based on guides. Choose, perhaps, a 10x10 or 30x30 matrix. 2) Display the rectangles within an html table. 3) You may either generate the page or frame via a server-side script, or dynamically change the image.src with JavaScript. Use modular arithmetic to calculate the frame numbers. 4) Re-center the image using a simple input image.

3. The floating descriptions

Issue: How can you describe the many details of an image?

In the physical word: In a museum, a curator can give a tour, pointing to different portions of a painting, and describing different aspects, such as artistic style, or the painting technique. In a book, sometimes numbers are overlaid on an image, with descriptions to be found in a table next to the image.

The reader correlates the number with the description.

On the internet: The image can be divided into dozens or hundreds of invisible regions. When the visitor points their cursor at a region, a description is displayed next to the cursor. Thus, a mass of data is navigated. The visitor only sees the image and one description at a time.

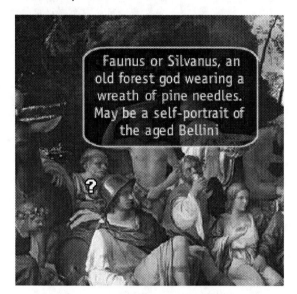

Figure 3. We learn Silvanus might be a self-portrait of Bellini.

Technical details: Using Macromedia Shockwave: 1) Create a false color version of the image with regions of flat color overlaying the image. Anti-aliasing off. 2) Reduce the image size be at least 1:4 in each dimension. Nearest neighbor sampling. 3) Export the image as raw format. 4) Place the raw file on the internet. 5) Load the image as a text file with Shockwave, getNetText, into a global variable. 6) During mouseover, calculate the mouse position, relative to the sprite image. Calculate corresponding pixel number, counting row by row. Divide by 16 (1:4 x 1:4). 7) Determine integer value of corresponding character in the text file. 8) Correspond the character to a table of descriptions, using a case statement. 9) Place the description into a text member, and position the sprite next to the cursor.

4. The image rollover information.

Issue: How do you identify what pigments were used in a painting?

In the physical world: In a book, dozens of numbers are printed over a painting, corresponding to tables of pigments on another page. The reader flips back and forth between the image and the data tables.

On the internet: The visitor views the painting, and next to it are a number of colored pigment squares with the pigment name and color. As they glide their cursor over the painting surface, the pigment squares flicker on and off, depending on what pigments correspond to the point just under the cursor.

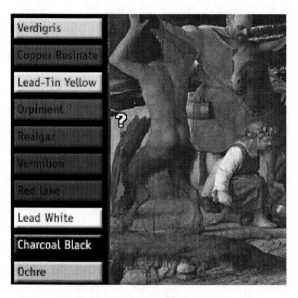

Figure 4. Bellini painted this grassy area on the left edge of the painting with: verdigris, lead-tin yellow, lead white, charcoal black, and ochre.

Technical details: Using Macromedia Shockwave. 1) Similar to item 3 above, except you will probably want to map only about 5 pigments per image. Use transparent inks in PhotoShop to create intersection regions. 2) Create a few raw files, as above, and concatenate them into one file with a text editor (getNetText can only open one file reliably). 3) Find characters, adding the offset of the number of chars in the single raw file to extract data for each image. 4) Note that you can reduce file sizes by using half bytes instead and bit math.

5. The pop-up images

Issue: How does one readily analyze painting cross sections?

In the physical world: In a book, several numbers are printed over a painting, corresponding to sample locations. On other pages in a book, photos and descriptions of the cross sections are described.

On the internet: The visitor uses a screen with a painting sample locations labeled. As they point their cursor at a sample location, the corresponding cross-section and description is displayed. Only the painting and *one* cross section are viewed.

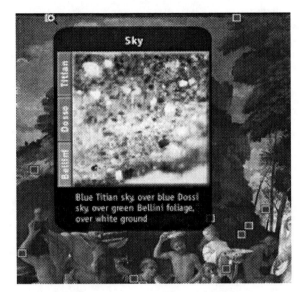

Figure 5. In this paint sample from the top left corner of the painting, we see several layers. At top is blue Titian sky, over blue Dosso sky, over green Bellini foliage, over white ground. The yellow layers were masking layers.

Technical details: Using Macromedia Shockwave (or Flash).
1) Numerous sample sprites are distributed on the painting surface. 2) Sprite names correspond to the sample image name. 3) Load sample image from online jpeg file. 4) Load sample description from a case statement. 5) Position the image and the description over the painting, near the cursor.

6. The virtual reality scene

Issue: How do we explain the historical context of artwork?

In the physical world: Visitors go to historic museums and walk around, view video, or view pictures.

On the internet: The visitor navigates a virtual reality scene, looking up, down, and around.

Technical details: Using QuickTimeVR. 1) If the place exists, a series of photographs can be stitched together with software like SoundsaVR or VRWorx. 2) If the place does not exist, collect a series of images of the artwork, the likely architecture of the original location, and photographs of related scenes. Recreate the scene, and export a panoramic movie to be processed into a mov.

Figure 6. The Feast of the Gods is seen in this virtual reality reconstruction of Duke Alfonso's camerino in 17th century Ferrara, Italy.

Conclusion & Future Directions

The above techniques have been very successful in helping make vast amounts of visual data accessible to our visitors. Our current research is focused on a related problem of condensing information when the data is more quantitative.

We are assembling an extensive database of pigment usage data for several hundred paintings. How can this mass of data be accessed? We are still working on solutions, but the goal is similar to above: display only a small portion of the data at a time. Our primary solution has been to extract "slices" from the database by performing sophisticated statistical analyses that summarize, for example, the difference between Monet's and van Gogh's typical

palette. Moreover, we find that it is very instructive to have numerous "predefined" database queries to answer questions like "When was Cobalt Blue used?" by clicking one button. Our current work in this area may be viewed online at *<http://www.webexhibits.org/pigments>*.

Acknowledgments

The authors wish to acknowledge the outstanding research performed by David Bull and Joyce Plesters. Our "spyglass" was inspired, in part, by the *Codex Analyzer* developed by Corbis, and the *Magic Window* developed by Xerox.

Sources for further information

Bull, David and Plesters, Joyce, *The Feast of the Gods: Conservation, Examination and Interpretation*, Studies in the History of Art 40, Washington, D.C., 1990.

The Feast of the Gods, a video, National Gallery of Art, Washington, D.C., 1990.

Is Bigger Better? Web Delivery of High-Resolution Images from the Museum of Fine Arts, Boston

Maria Daniels, Perseus Project, Tufts University, USA

Abstract

At the turn of the twenty-first century, the first stage of museum digitization is now well underway. Many museums have initiated and made headway on projects to put their holdings on-line, package their collections management databases into Web sites, and produce curatorial content for a worldwide, on-line audience. As institutions move into the second phase of these developments, which emerging technologies show the most promise for museums and their audiences? Which principles should form the core of a museum's digitization strategy over the long term? How will improved access to museum collections affect research possibilities for a broad range of people, both in academia and among the general public?

Working together since 1997 to digitize an important collection of Roman art, the Perseus Project and the Museum of Fine Arts, Boston, have addressed these and other questions. This paper will focus on the development of a new archive of photographs, and discuss the decision-making and technical processes behind delivering high-resolution images of museum objects via the Web. Copyright protection, storage and delivery of many large files, interface, the viewer's experience, curatorial concerns, and other issues have been important considerations. Underlying our efforts has been the belief that, in the new environment of networked access to museum resources, museums have an opportunity to transform education.

Perhaps one of the most frustrating things about working on the content side of a digital library is knowing how many resources in the library are not yet published and available to the world. Like a museum curator with limited gallery space and a storeroom full of artworks, a digital librarian is always thinking of the day, some time in the future, when the unknown parts of the library will have their turn in the limelight. This is why we are particularly happy to be able to present the work on high-resolution images of Roman coins which the Perseus Project (http://www.perseus.tufts.edu) has carried out in collaboration with the Museum of Fine Arts, Boston (http://www.mfa.org), with its curatorial staff in Art of the Ancient World, John Herrmann, Mary Comstock, and Pam Russell, and the museum's Director of Information Resources, Nancy Allen. This collaborative effort with the MFA forms part of the continuing research and development at the Perseus Project, an effort now in its thirteenth year, at Tufts University. Our work represents another major step toward the electronic delivery of scholarly-level museum resources in a permanent, standardized, flexible way.

The limitations of electronic resources, especially for scholarly use, are well known to all of us; I outlined some of them in another Museums and the Web conference paper (Daniels, 1997). At that Los Angeles session, Prof. Charles Rhyne of Reed College made explicit the particular problems of teaching art history using inadequate visual materials, and

stressed, as he has in many of his publications, the necessity for scrutinizing technical details, such as brush marks, or small parts of an object, like the dozens of tiny figures on a 12-foot-long Japanese screen (Rhyne, 1997). We agreed that scholars, students, and teachers would not truly be able to take advantage of the electronic environment for their work until more, higher-resolution images were made available. At Perseus, we had always concentrated on the *quantity* of images we included, up to 109 detailed views of a single Greek vase (http://www.perseus.tufts.edu/cgi-bin/imbrow?type=vase&query=Name%20%3D%20%27Harvard%201960.367%27). However, in the back of my mind was the annoying knowledge that the Perseus Project did, in fact, have an archive of scanned and digital camera photographs at a much higher resolution than the minimal, 640x480 pictures we freely published on our web site. What was impeding the distribution of images of a significantly higher quality? Could these high-resolution pictures be the analytical tools our users still lacked?

Later that year, as we embarked on the Perseus-MFA collaboration that continues today, the question of delivering higher-resolution pictures was foremost. Work over the past two years has culminated in the electronic publication of a major catalogue of Roman art, including 780 Roman coins and medallions, with a series of Perseus enhancements including a tool enabling viewers to zoom in on 18-megabyte photographs, examining the coins at up to 25

times their actual size. This paper will begin by discussing the principles which guided us, then continue with a short description of our working methods. Finally, it will venture to suggest some of the earliest results of this work. The question of the title, "Is Bigger Better?" is really a question for you, the audience of museum professionals, art educators, and everyone interested in electronic access to cultural resources. How can these big images be integrated into an electronic museum experience, and what potential do they hold for the transformation of museum collections into complete educational resources?

As Skidmore & Dowie (1999) point out, educators implementing technology do best to begin by articulating the educational objectives which need to be served. At the outset of our work, members of the team, including curators, museum educators, technical staff, and university faculty, worked together to clarify the educational goals of this project, and, further, to express a set of principles which would apply not only to the instructional uses of the data, but also to its longevity and utility over time. It was particularly important that the collaborators started with a discussion of the project's objectives; otherwise, differences between the museum and the university perspectives might have led to difficulties, had we failed to articulate our individual interests and work together to integrate them into a single approach at the outset.

The first, and most important, principle guiding our work with the MFA coins was the understanding that these objects are transformative. A coin portrait of a Roman emperor like Trajan, a depiction of the Mausoleum of Hadrian, a personification of Gaul being speared by a Roman warrior, issued during Caesar's conquest of Gaul — all of these representations have the power to change the way people understand the ancient world. Yet I am not making a special argument for Roman coins, even though coins are among the hardest to view in a gallery setting, the most challenging for curators and educators to label and explain, and the easiest to overlook when they are surrounded by a building full of larger, more emphatic art works. At the outset of our collaboration, we agreed that the experience of seeing a Roman coin could be enlightening, and we therefore included coins in our plans to digitize the Roman collection. We also included glass, pot-

tery, mosaics, jewelry, portable altars, mirrors, statues, tomb reliefs, clothes pins, pieces of buildings, and other objects. Our approach, in short, was that if an object is worth collecting, it is worth digitizing. This principle was tested by the usual limitations of time and money, of course, and we used a few broad themes, such as daily life and Roman gods, to help direct our selection of objects. However, we avoided a "greatest hits", "sculpture only", or other such limiting approach to the collection, as much as possible, opting instead to represent as wide and as deep a sample as we could. The work presented here on coins is being extended to all 1,055 of the art works we have documented thus far.

A second principle was that of integration, not only of the different sources of information within the museum, but also of the newly digitized material with existing resources at the MFA and in the Perseus digital library. Written documentation for the Roman coins came from extensive curatorial records which had not yet been added to the museum's collections management database, and the museum insisted that this digitization project, and all others, should produce data useful for their main database. On the Perseus side, we were hoping to find added value for the new objects by placing them in context with the other holdings in the Perseus digital library, including photographs and descriptions of Roman sites, an atlas of the ancient world, and the texts of Cicero, Caesar, Josephus, and other authors. One other consideration was the integration of several existing publications of the art works, where possible, in order to avoid reduplication of efforts, and to bring new users to the scholarship already in publication. The only exception to this integrative approach was the creation of new photographs, which were deemed necessary in order to provide consistent coverage of the collection. Many objects had never been photographed in color, or never had detail photographs made; the coins themselves were all photographed with a centimeter scale, in order to convey their relative size.

A third underlying principle was one which hardly needs elaboration here: control of ownership. Everyone involved agreed that protecting these new resources, by asserting copyright, watermarking data, and attaching ownership and credit information to the photographs, was important. From the start, our goal was to publish the catalog of coins on the World

Wide Web, and make it freely available to the general public. However, we chose to implement several safeguards, to ensure that the pictures would not be separated from their descriptive data. In the usual Perseus collaborative arrangement, the MFA retained ownership of the data we produced, in exchange for allowing it to be published freely on the Web. Thus, we had an obligation to protect the data, even as we sought for it a wide general audience.

Several more principles guiding us in this work related to the data collection process in a more technical way. First, we determined to adopt and conform to existing standards, for the data itself and for its structuring, as much as possible. Controlled vocabularies, standardized spellings, TEI-conformant SGML tagging, standard image file formats and processing, and compatible database structures at the MFA and at Perseus all played roles in making our data coherent, and in allowing this work to scale successfully. The curators invested their time and expertise in determining whether the quality of existing documentation was adequate, and, if not, creating new catalog information that would meet their standard. Time spent building tables of credit lines for objects, compiling alternate names for the same representation (e.g. Castor and Pollux, the Dioscuri (Perseus Lookup Tool, http://www.perseus.tufts.edu/cgi-bin/sor?lookup=dioscuri)), marking up bibliographic references, and employing standard vocabulary sources, like the Getty Art & Architecture Thesaurus (http://shiva.pub.getty.edu/aat_browser/), contributed to the robustness of the data, and ultimately saved some effort in the processes of data entry and production for the web.

It is worth noting that in some cases, standard classification systems have not yet developed to include the highly specialized data sets relevant to our work; as Jörgensen (1999) indicates in her thorough survey of image retrieval systems, it is still a struggle to understand how people search for images, let alone to build adequate generalized systems to aid those searches. An example is the Getty Thesaurus of Geographic Names (http://shiva.pub.getty.edu/tgn_browser/), which does not yet include all of the geographic data from the Mediterranean which would be useful in classifying the assorted geographic attributes of the art objects, including their findspots, depictions of places, inscriptions naming places, or the sources of the objects' raw materials. To address this problem, we have sought help from classification schemes of other specialized sources, including field-specific publications and other archives of ancient art, and in some cases developed structures ourselves, based on the Perseus-specific content.

A second, critically important technical principle was longevity of data. One of the paradoxes of digitizing two-millennium-old art works was the knowledge that they themselves were likely to be legible long after our databases and our digital cameras crumbled into dust, if we failed to make the data portable. While the Web is the immediate delivery mechanism for our work, all of the data is structured so that it can be republished in emerging formats for years to come. The Perseus Project has a long experience in developing this type of portable data; for almost a decade, the project developed back-end data in powerful relational databases and structured SGML, but delivered the material on CD-ROMs in a low-cost, widely available HyperCard front end. With the advent of the Web, we were able to take this same data and port it to a Web front end within a matter of weeks. We have also successfully built delivery software for the same data for a platform-independent version of our CD-ROMs (Crane 2000).

The last technical principle we kept fixed firmly in mind was a focus on automating the digitization process. So much of the work necessarily had to be done by hand: the positioning and lighting of each object for photography; the review of catalog information, and writing of new materials; the checking to ensure images were correctly attached to the corresponding objects. Yet in every possible instance, we looked for automated tools which might speed the process, from batch image-processing software to database error-checking scripts to automatic tape backup.

Our final two requirements as we commenced this work were seemingly disparate principles that have proven over time at Perseus to be actually quite complementary: we sought to promote scholarship and also to distribute our work to the widest possible audience. In pursuit of the former goal, we adopted the highest academic standards in compiling digitized resources; in pursuit of the latter, we

recognized that the distribution medium for our work already far outstrips the distribution network for traditional scholarship, and labored to provide the interface, organization, and tools that would facilitate the material's usefulness to a broader range of users.

> The change in less than a decade from reliance on publication solely through hundreds or perhaps thousands of physical copies to a network reaching tens of millions of machines has no clear historical precedent. For the first time in history, it is possible to conceive of providing a vast number of people with an extensive set of tools and documents, facilitating types of exploratory learning once possible only at the greatest research centers. An audience for these tools and documents does exist; on the Perseus Web site, we already see concrete examples of the ever increasing audience that electronic publication can reach. (Crane, 1998)

The range of testimonials we constantly receive from site visitors, preliminary analyses of Web logs, and the sheer quantity of page requests the site receives (currently hovering around 200,000 page requests per 24-hour period), together indicate that a digital library has the demonstrable ability to simultaneously serve scholarship and reach an emerging broad audience. We will be able to evaluate site usage, to learn more about our audience for the high-resolution images; for instance, by comparing image use at Internet 1 and Internet 2 schools, we will be able to investigate how having the infrastructure for large downloads will affect use of those resources.

To summarize, the principles informing our approach to this work included:

- a broad inclusion of objects;
- integration of resources;
- control of ownership;
- adherence to standards;
- emphasis on data longevity and portability;
- automation of the digitization process;
- promotion of scholarship; and, finally,
- acknowledgement of a wide audience in the general public.

From the principles we developed a fairly stream-lined work process that has taken advantage of many current standards in digital library work. In addition to the standard classification systems and data formats outlined above, we chose a range of software and hardware with a preference for robust, open-source solutions. Written documentation was produced in a FileMaker Pro database designed to be compatible with both the Museum of Fine Arts' collections management database, in FileMaker Pro, and with the Perseus art and archaeology databases, in 4th Dimension. After completion, this data was transferred into PostGres, an open-source SQL database program running on a Linux server, which allows us to run certain indexing functions, automatically generate cross-links with the rest of the digital library, and publish the data on the Web. Thanks to these automated functions, Perseus can immediately associate terms in the new coin documentation with existing terms in the digital library, and lead curious readers to a wide array of additional information; for instance, when a site like Ostia is depicted on a coin, the word "Ostia" in the coin's description automatically links to other Perseus resources on Ostia in the Lookup Tool, including an article on Ostia in the *Princeton Encyclopedia of Classical Sites*, links to other objects depicting or coming from Ostia, a set of pictures which include "Ostia" in their captions, an atlas page that will plot Ostia on a map, and bibliographic sources on Ostia (http://www.perseus.tufts.edu/cgi-bin/sor? lookup=ostia).

On the imaging side, the only stumbling points in a very smooth process have been, first, the proprietary format of the digital photographs as the camera initially stored them, and second, the acquisition of enough hard disk space and RAM to manipulate, store and deliver these quantities of visual information. Digital photographs were made using a Kodak DCS 460 camera, chosen for its relatively high resolution images, its compatibility with our existing system of Nikon lenses, and its efficient work flow, with sufficient storage on removable cards. Once the images were captured and backed up, they were converted to standard TIFFs, a time-consuming process run under the Photoshop Acquire mode which would have been greatly assisted by automated conversion software; we were unable to develop this tool in-house, and Kodak did not produce it, but fortunately a third party vendor, DSL Consulting Inc., has written an AutoAcquire

script that finally addresses this problem (http://www.kodak.com/cgi-bin/US/en/developers/ solutions/search/webSolutionsSearch.cgi?Submis sionID=588&drgCurrentState=2).

Once the images were converted to their delivery format, we employed an assortment of identification and marking measures. Although current watermarking programs are not impervious to attack, they are a perfect mechanism for linking museum identity with each image. As Peticolas & Anderson (1999) explain the current technical outlook, "although most [watermarking] schemes could survive basic manipulations... they would not cope with combinations of them or with random geometric distortions." Still, visible and invisible watermarks are demonstrably useful tools that can be employed first, to link ownership information to image files, and second, to ensure that each image is difficult to separate from this identifying metadata.

In order to deliver large files across the net in a reasonably short time, we chose to tile the coin files into scrollable windows (http://www.perseus.tufts.edu/cgi-bin/zoomer? lookup=1997.03.0019); the largest tiles are c. 475K in size and compress down to about 36K as JPEGs, due to their limited color palettes. Like GridPix (http://now.cs.berkeley.edu:80/Td/GridPix/), a tool developed at Berkeley, and other tiling programs, the Perseus tiler allows users to interactively zoom in to parts of an image and scroll around it, while minimizing the waiting time for tiles to appear. We are constantly reminded that many visitors to Perseus dial up over slow modems, log in from geographically far-flung places, and compete for bandwidth with hundreds of others using the same service providers. To speed access, we generated all the different sizes and tiles in advance, not on the fly, and stored the thumbnail size, small (600x400), medium (1530x1018), and large (3060x2036) versions of the images in parallel directories on our server. A database keeps track of what resolutions exist for each image. For implementation, we first used standard archiving software to retrieve the high-resolution, 18 megabyte digital photographs from a tape archive, then employed open source image packages, including PNM and ImageMagick, to convert them into their assorted derivative images.

An important innovation of the Perseus tiling program is a random rotation feature, which delivers each tile slightly rotated a random amount either right or left, within a narrow range. While not affecting the look of the displayed image, the random rotation protects the tiles from re-use, by making it very difficult to reconstruct them into a single, high-resolution image file.

A late improvement to the scrollable image window has been a side-by-side image display tool (http://www.perseus.tufts.edu/~maria/MW00/ compare.html), still in the final stages of development, which allows for simultaneous display of two images at the series of available resolutions. We strongly agree with commentators like Skidmore and Dowie (1999) that side-by-side image presentation is a core pedagogical approach in art history that has been sadly ignored by new technologies up until now. In a 1997 evaluation, one of Rhyne's students commented that a setup presenting two images provided "distinct advantages" for her study, making "manipulation and location...easy" and facilitating "side-to-side comparisons impossible in the museum." Her summary opinion: "The scant hour of frantic sketching and note-taking in a crowded room has few advantages over these clear, beautiful, easily maneuvered and compared images which students can investigate individually." Our intention is that the Perseus image display tool will serve as a vessel for teachers to construct and save sets of images in Perseus, just as they now save sets of slides for the left and right carousels of their slide lectures. This tool, like other Perseus resources, has been built generically, so that it will be able to handle a variety of image inputs, from coin pictures to page images of texts to custom maps.

How will access to these big images affect research possibilities for a broad audience? We feel much the same curiosity expressed by Schwartz (1999), but enough confidence in what we have built to be able to say we have indeed "provided tools for accessing more (or more meaningful) information than was previously available." The museum staff are pleased to have created a new public platform for the scholarship on so many objects in their collection, which has until now found only a specialized audience. Users' first responses to the image dis-

play tool and the high-resolution images have ranged from delight to glee. Proper evaluation, both by internal groups of teachers, museum educators, and advisors, and external evaluators, will take place as part of a grant from the Digital Library Initiative, Phase Two, from the National Science Foundation, the National Endowment for the Humanities, and other government agencies. With this support, the Perseus-MFA collaboration is also continuing, and the ongoing focus will be to build generic digital library tools for the humanities which will be made accessible to the wide audience. This set of tools is applicable not only to works of ancient art, but to other humanities sources, such as a First Folio of Shakespeare, a Renaissance Italian dictionary, the physical remains of ancient Rome, and a series of Giza mastabas replete with hieroglyphic inscriptions. Visitors to the Perseus web site will have the ability to examine high-resolution images of any of these resources, using the same image tools developed for the Roman art of the Museum of Fine Arts.

We may not be able to judge right away whether, as Schwartz asks, "the site provide[s] a window of introduction that will make the use of the museum...more meaningful," even if it might seem clear that giving visitors an improved capacity for scrutinizing art in a way that is difficult to do through the vitrines, under the spotlights, or among the crowds in the galleries, would necessarily bring more nuance and meaning to their understanding of the works they see. My favorite story on this subject is the true one of the Perseus web site user who printed out catalog entries from the exhaustive Caskey-Beazley publication of Greek vases in the MFA, came to Boston, and walked around the galleries with printouts in hand, gaining appreciably more information from looking at the objects in tandem with the thousand-word curators' essays than he ever could have from the 300-word labels.

Yet even with insufficient evidence to judge whether the physical museum's use becomes more meaningful, we can be certain that the museum has been transformed into a place now accessible, for the first time, to a new constituency. Virtual visitors, who might never travel to Boston, can now see the collection from the Ivory Coast, from Brazil, from Italy, from Singapore, from other parts of our own country, and from hundreds of remote places. These visitors embody the same attitude Dierking & Falk

(1998) have observed in actual museum visitors: they "profess high to moderate interest in the subjects presented" — they have sought the subject on the Web — but at the same time profess "low to moderate knowledge" — they have come looking for information. The virtual museumgoers already demonstrate that providing on-line documentation of the museum's resources, particularly high-resolution images, transforms the museum and its collection from a local storehouse open 60 hours a week to an internationally available educational resource open 24 hours a day, allowing more people to have an in-depth experience with the art works than ever before, and democratizing the opportunity for a thoroughgoing educational involvement with the collection.

In closing, I would like to thank Charles Rhyne for his challenging questions three years ago at this conference. I titled my paper with a question, not because I can provide a simple answer, but because I hope the collaborative work of the Perseus Project and the Boston Museum of Fine Arts will prompt your own questions, comments, and ongoing discussion about how high-resolution images can change our way of learning with art, by enhancing the way we are able to see it.

Referernces

Crane, G., Jacob, R., Taylor, H., Scaife, R., and Allen, N. (1998). A Digital Library for the Humanities [online]. Funded proposal submitted to the NEH-NSF Digital Libraries Initiative, Phase II. http://tantalos.perseus.tufts.edu/Props/DLI2/dli2.html. (February 15, 2000).

Crane, G., ed. (2000). *Perseus 2.0: Interactive Sources and Studies on Ancient Greece. Platform-Independent Version.* New Haven: Yale University Press [forthcoming].

Daniels, M. (1997). A Wish-List of Web Resources for Humanities Scholarship [online]. Paper delivered at *Museums and the Web 97.* Available: http://www.perseus.tufts.edu/~maria/MW97.html. (February 15, 2000).

Dierking, L. & Falk, J. (1998). Understanding Free-Choice Learning: A Review of the Research and its Application to Museum Web Sites. In D. Bearman & J. Trant (Eds.) *Museums and the Web 97-99: Special Edition Proceedings.* CD ROM. Archives & Museum Informatics, 1999.

Jörgensen, C. (1999). Access to Pictorial Material: A Review of Current Research and Future Prospects. *Computers and the Humanities 33*, No. 4, 293-318.

Rhyne, C. (1997). Images as Evidence in Art History and Related Disciplines. In D. Bearman & J. Trant (Eds.) *Museums and the Web 97: Selected Papers* (pp. 347-361). Pittsburgh: Archives & Museum Informatics, 1997.

Rhyne, C. (1997). Student Evaluation of the Usefulness of Computer Images in Art History and Related Disciplines. *Visual Resources: An International Journal of Documentation, XIII*, No. 1, 67-81.

Petitcolas, F. A. P. & Anderson, R. J. (1999). Evaluation of Copyright Marking Systems. *Proceedings of IEEE Multimedia Systems '99*, vol. 1, 574-579.

Schwartz, D. (1999). Museums and Libraries in the Age of the Internet: Lessons Learned from a Collaborative Website. In D. Bearman & J. Trant (Eds.) *Museums and the Web 97-99: Special Edition Proceedings*. CD ROM. Archives & Museum Informatics, 1999.

Skidmore, C. & Dowie, S. (1999). Camera Lucida: AMICO in an Art History Classroom. In D. Bearman & J. Trant (Eds.) *Museums and the Web 97-99: Special Edition Proceedings*. CD ROM. Archives & Museum Informatics, 1999.

Protecting a museum's digital stock through watermarks

Torsten Bissel, Manfred Bogen, Volker Hadamschek, Claus Riemann, German National Research Center for Information Technology, Germany

Abstract

As long as the copyright issue is not solved in a satisfying manner, museums may not offer open access to the digital information of their collection. Watermarks have been used since centuries to prove the genuineness, authenticity, and authorship of documents or certain products of different crafts. In this tradition digital watermarks are used for copyright protection today. They are bits inserted into a digital image, audio, or video file to identify the file's copyright information. They have to be robust against different kinds of manipulations and attacks. Unfortunately, no watermarking tool on the market produces digital watermarks as robust as needed, experts negate its existence at all. Alternate solutions are needed. An infrastructure with or without watermarking the original has to be established. This paper describes related problems and directions to solve them so that a museum can publish parts of its collection with no harm.

Introduction

Basically, museums have only limited possibilities to ensure their existence and to secure their funds: by sponsors, by donations, by visitors, and by selling copies of their collection in form of copyrights. While the first two (external) are almost completely out of their control, they have major influence on the visitors' acceptance by keeping their collection together, by enlarging it, and by making it attractive (internal funding). This has been well understood for years. By granting copyrights to other parties and by publishing parts of their collection in the Web, museums touch the essence of their stock and they have to enter a new technology realm at the same time. As long as the copyright issue is not solved in a satisfactory manner, museums may not offer open access to the digital information of their collection. Granting copyrights based on secure technology will become more and more crucial in the near future as unallowed duplication will be facilitated which will harm the museums' funding essentially. Digital watermarks may offer a solution.

This paper is not about intellectual property rights in general, copyright policies, or about copyright laws. We will talk about copyright technology based on digital watermarking. Ideally, all scans should have integrated header information including author/creator of the object, title, date, owner, copyright owner, and some usage patterns (sale or license agreements). This information has to be protected against manipulation and destruction. Robustness is needed urgently.

This paper is structured as follows: Section 2 provides an introduction on digital watermarking in general, a watermarking infrastructure needed and requirements for watermarking tools. Section 3 is about robustness of watermarks, attacks, and existing watermarking tools. Section 4 describes visible watermarks as one possible solution in more detail. An alternate approach of copyright protection without watermarks is finally described in section 5, before concluding with practical recommendations for museums.

Digital Watermarking

In the history of mankind watermarks have been used to prove the genuineness, authenticity (Bearman and Trant 1998), and authorship of documents or certain products of different crafts (e.g. paintings or carpets). Today a well-known example is watermarks in banknotes which make it difficult to counterfeit them and which improve the detection of faked ones.

ZDWebopedia (2000) defines digital watermarks as:

> A pattern of bits inserted into a digital image, audio or video file that identifies the file's copyright information (author, rights, etc.). The name comes from the faintly visible watermarks imprinted on stationery that identify the manufacturer of the stationery. The purpose of digital watermarks is to provide copyright protection for intellectual property that's in digital format.

Digital watermarks may be visible or invisible. They may identify the originator of the material and the

owner of the copyright or they may identify the recipient (e.g. a publisher, an end-user, another museum) to whom the material was given for special purposes (fingerprint). All possibilities mentioned make sense depending on the application in a museum itself and the boundary conditions.

When talking about watermarks for digital media (especially for pictures and videos) one has to distinguish between three categories of watermarks with different purposes:

- Visible watermarks are often used to hinder the unauthorized copying of digital images and films by inserting visible copyright symbols. This can also use them as an advertisement for the originator. The copyright symbols are selected in a way that the whole image is covered, nevertheless details are visible. Efforts to erase the copyright symbol should result in a decrease of quality and be costly.
- Fragile hidden watermarks are used to ensure the integrity of digital data. Changes or manipulations of an image should result in the destruction of that watermark.
- Robust hidden watermarks are meant most often. The aim is to embed hidden copyright messages ("watermarks") or hidden serial numbers ("fingerprints" or "labels") in multimedia objects (e.g. pictures, video sequences, 3D-models). Fingerprints (see fig.1) shall help to identify copyright violation, the former allow to prosecute violators.

Fig. 1: Two-dimensional barcode: a visible fingerprint (barcode from Institute of Scientific Information's Electronic Library Project)

In this paper our concern is especially in robust hidden watermarks. Digital watermarks for copyright protection are part of the wider discipline of information-hiding techniques which has got increasing attention from the research community and from industry in the last 10 years. Although there have been several conferences and a lot of papers pub-

lished on the subject of watermarking still images and videos today only few products are available on the market. A good collection on products and patents can be found at (Petitcolas, 2000).

Finding the right solution

As mentioned above our paper is not about intellectual property rights in general, copyright policies, or about copyright laws. We do not want to discuss whether digital watermarks are necessary or whether copyright laws are sufficient. Our experience is that a lot of people responsible for museums feel uncomfortable by enabling access to their digital information without additional protection mechanisms.

Apart from the products available today a few questions have to be answered beforehand and can function as a basis for future evaluations:

- What information should be imbedded into an image to improve copyright protection?
- What does a museum need besides a watermarking tool?
- What are the key criteria in evaluating a watermarking tool?

We want to give a short answer to the first question by reflecting publications on the subject and show solutions available today. The second question deals with the necessary infrastructure. There is a close relationship between the first and this question. The main subject in answering the third question is the aspect of "robustness". Without the ability to embed robust watermarks all efforts must be insane. This will be considered later.

Components of a watermark

To assert and protect someone's rights in an image it is necessary to embed information about the owner/originator, the end-user, and the rights a user has in the image. In (Franz & Schoenfeld, 1999) the minimum requirements are described as:

- detailed information about the originators: originator, work to protect (e.g. a hash value), date of registration of creatorship (or authorship), registration office, exploitation right of the originator

- user specific data: user name, date of allocation of exploitation, exploitation rights received, limitation of exploitation rights
- general data (like signatures)

It is obvious that this information consumes too much space when embedded into an image. Apparently the literature (Kutter & Petitcolas, 1999) reached an agreement that 100 Bits is the maximum length of a watermark which can by inserted into a typical image without making changes human's normally can notice. This will lead us to a framework similar to the well-known ISBN system (ISO Standard 2108) we all know from identifying books.

It should be possible to extract some public information (e.g. the originator information and the ID of the image) from the watermarked image so it is possible to lookup which company or person has the rights in that image. The mapping between originator number and the real company should be handled by an independent trust center, which also could pay attention to give this or other information (like the rights the originator might have on this document) only to an authorized questioner. Some companies now offer such needed authentication and certificates services like VeriSign™ (http://www.verisign.com/). A very similar system is described in (Delaigle, 1996).

Components of a watermarking infrastructure

The ability to embed robust watermarks in digital images does not necessarily imply the ability to establish ownership. Nevertheless robust watermarks offer added value especially if they are used for fingerprinting. Robust watermarks must be combined with hash functions and time stamping mechanisms and be embedded in a framework of trusted third parties for registration and time stamping to fit the requirements mentioned above.

At present such an infrastructure is not established. Instead we find some vendor specific solutions, which means that the vendor of a watermarking product acts as a registration office by offering user identification numbers and granting access to this database. The originator himself must manage individual fingerprints. In addition there are efforts to develop special search engines that crawl the Internet for watermarked data.

A museum using such a system has to pay for the software, mostly a yearly fee for a registration ID, and has to establish its own database to manage used fingerprints and the combined exploitation rights. By accessing the publicly available database of registered IDs knowledge of the originator of a work can be obtained. The knowledge about the copyrights of specific persons or organizations is not publicly available. Such knowledge, is of course, available in visible watermarks (see Visible Watermaring, below).

Requirements for watermarking tools

The crucial requirement is robustness against data manipulation (see next section). Watermarks ideally should not reduce the quality of a multimedia object significantly. A watermarking tool should therefore embed marks in salient parts of the data. This will improve its robustness. Besides this there should be the ability to decide on the "strength" of an embedded watermark which regulates the amount of embedded data according to individual needs.

Watermarking tools must have the ability to be integrated in existing production environments, ie. especially when used for "fingerprinting". The importance of performance considerations is increasing with the growing amount of accesses or by offering huge amounts of data.

Ideally everyone should have the ability to extract the originator ID to gain knowledge of copyright information. This can be achieved either by integrating the needed functionality in common software for image or video processing or by offering a Web interface where data can be submitted for checking. The second solution is not appropriate for high quality images since their size is often very big.

Robustness of Watermarks

A good watermark should survive many different operations on the image that carries it. Some operations could be called 'attacks' while others occur in the normal day-to-day work with an image

to be published.

Geometric transformations are considered as 'unintentional' attacks on the image. Rotating, scaling, flipping, shearing, mirroring, or cropping a watermarked image are normal operations on an image and should easily be survived by a watermark. Also the conversion into another graphic format (especially JPEG) and the beautification of an image (sharpen, histogram modification, gamma correction, color quantization, adjustments in brightness or contrast) should have no effect on the watermark. Rather intentional attacks are the deletion or addition of lines or columns inside a watermarked image, printing and scanning the image, adding noise to it, and applying low pass filters.

However, there also exist even more sophisticated attacks; we will list only the most important ones:

- Mosaic Attack (presentation attack): A watermarked image is chopped into very small pieces which are placed (on paper or on a Web page) at the correct places so humans eye could not see any difference. Using this attack prevents any WebCrawler searching for special watermarks in images from finding it.
- Collusion attack: Having access to more than one watermarked image of the same content it should be not possible to remove the watermark by just comparing the images and create a new one by statistical averaging them.
- IBM-attack and over-marking: Having a watermarked image it should not be possible to add a new watermark (of the same or different kind) to the image in such a way that the old watermark is removed. When embedding other watermarks it should be clear which one was first.
- Reengineering: Reengineering of the algorithm by conspicuousness inside the image should be impossible
- Oracle attack: If checking for the existence of a watermark inside an image is too easy or takes too short time, it is possible just to test which attacks in which order will destroy the watermark.
- StirMark and UnZign: These are not attacks but two programs able to use most of the attacks mentioned in this paper to remove watermarks from an image. Specifically StirMark (Petitcolas & Anderson & Kuhn, 1999; Petitcolas & Anderson,

1999) is able to remove the watermark from any known watermarked image without requiring a lot of energy. Both tools are in the Public Domain (that means you can use it more or less for free) and can be downloaded via the WWW. (StirMark is available from http://www.cl.cam.ac.uk/~fapp2/watermarking/stirmark/ and UnZign from http://www.altern.org/watermark/)

- Philosophical attack: In the absence of a formal correct proof that a watermark is robust against any attack we must consider a watermark robust if it survives a selected set of possible attacks. If any watermark survives all known attacks this does not exclude that some day a new attack (or a new combination of attacks) is conceived that will be able to remove the watermark. Another unanswered question is the possibility of inventing a 'perfect' image format, which will eliminate all those redundant and useless bits from an image, so that an invisible watermark will be removed automatically.

Another important aspect for the robustness of a watermark is the human behavior, which should not be ignored. The infrastructure for the insertion process of the watermark should be very safe. At no point should it be possible for anyone to have illegal access to one of the components in the process (e.g. the original image or the watermarked image before it received a time stamp from the registration office).

Evaluation of existing systems

Nearly all vendors and developers of methods to embed watermarks in multimedia data claim that their method is robust. But seldom there is a definition of "robustness" and an explanation how it is tested.

In seeking an appropriate tool for one's needs there is the difficulty to compare different tools according to certain criteria in an easy manner. Especially (Petitcolas & Anderson, 1999) attended to this problem. By developing a "fair benchmark for image watermarking systems" they laid the basis for an objective comparison of different systems and products. They developed a tool called "StirMark" (Petitcolas, Anderson, and Kuhn, 1998) with which all the image manipulations mentioned above can

be done in a performant and reproducible manner. StirMark is available for free. Together with a set of commonly available test images being representative for several demands, every product vendor and every interested user can do his own tests and comparisons.

Petitcolas and Anderson (1999) tested several available products and published their results. EIKONAmark (http://www.alphatecltd.com/), Giovanni (http://www.bluespike.com/), and SysCop (http://www.mediasec.com/products/index.html) lack the demanded robustness on "normal" image

Fig. 2.1: Original

Fig. 2.4: Visible watermark added by H20marker

Fig. 2.2: Watermark added by Digimarc

Fig. 2.5: Digimarc's watermark removed by StirMark

fig. 2.3 Watermark Added by SureSign

Fig. 2.6: SureSign's watermark removed by StirMark

transformations. Digimarc 1.51 (http://www. digimarc.com/) and SureSign 3.0 (http://www. signumtech.com/) had better results. Nevertheless there are attacks that destroy embedded watermarks without disturbing the image quality so much
.

Applicability

The results achieved by Petitcolas and Anderson are based on an election of five different pictures. These images may not be typical for a museum. There may be museums offering only black and white pictures. Others have colored images with rich details. We have chosen such an example (see figure 2). Normally the strength of an embedded watermark has to be chosen appropriate to the individual needs of a chosen picture and the planned use. In spite of the fact that several human perceptual models are described in literature and some are already available, only trained experts are able to decide on the quality changes.

In our example, we used Digimarc as Adobe PhotoShop Plugin Version 1.6.84 and SureSign Version 3.1. We choose maximum robustness. As a test candidate, we took a picture from the Beethoven House collection in Bonn, showing a theatre in Vienna ('Theater an der Wien'). Figure 2.1 shows the original image ('Theater an der Wien' published by Tranquillo Mollo, 1830). Figure 2.2 shows the same image after the watermark insertion (ID=162905) by Digimarc's product. For a human eye there is no noticeable change in the image. Figure 2.3 shows the image after insertion of a watermark (User ID=99-ZZ-99 and Image ID=AA00001) by SureSign's product. As in Figure 2.2 no change is noticeable. Figure 2.5 and Figure 2.6 show both watermarked images after going through the program StirMark mentioned in chapter 3 (without giving any of the many possible options). The images are somewhat bended. (By tuning some of the possible parameters of StirMark you will be able to produce a de-watermarked image without this bending effect. This is only an example how easy it is to remove a watermark.)

This trivial example shows that invisible watermarks are far away from what the customer wants them to be. There is no commercial product available capable of surviving all of the known possible attacks. Although scientific research has found new

ways in inserting watermarks (e.g. Kutter, Bhattacharjee, and Ebrahimi, 1999), a solution in the near future is not foreseeable.

Figure 2.4 shows the image with a visible watermark inserted by the product H^2Omaker (http://www.kagi.com/EquitySoft/maker.html). Because the watermark is now a real visible part of the image, it is not that easy to remove it. Also the usage of the attacks mentioned above cannot remove the watermark. If the image is manipulated and it is not possible to recognize the watermark by human eye the image itself has no longer a real commercial value. Regarded in this way visible watermarks are a good choice, but there also exists some problems with them: They are visible! Possibly this is not acceptable. Another problem might be the rapid evolution in the area of pattern recognition and image editing which might allow the removal of those visible watermarks through sophisticated tools. Further studies will be done in this area to ascertain the feasibility of this new technologies.

Visible Watermarks

Digital images with visible watermarks can be used for advertisement purposes. Combined with a low-resolution image quality, these images can be given away for free. Only after purchasing an authorized copy of an image, the high-resolution quality without

Fig. 3: Example of a visible watermark

a visible watermark or a tool/software package/key to eliminate the visible watermark will be provided by a museum. By this, robust visible watermarks establish ownership. However, even this simple scenario leads to some challenging requirements for the robustness of the visible watermark.

In (Mintzer, Lotspiech, and Morimoto, 1997) two different approaches for visible watermarks offered by IBM are described:

> The visible image watermark embeds a visible mark onto a gray or color photographic image. This technique was developed at the request of the Vatican Library as part of a project that made images of their manuscripts available through the Internet; here the intent was to make clear, to all who would see the images, that they were the property of the Vatican Library, without detracting from their utility for scholarship. This use of the watermark, like a copyright notice, identifies the ownership of materials and reminds viewers of their limited copying rights.

> Another form of visible image watermarking developed at the IBM Tokyo Research Laboratory is called Reversible Visible Watermarking for applications such as on-line content distribution. Here, the image is marked with a Reversible Visible Watermark before distribution or posting on the Internet, and the watermarked image content serves as a "teaser" that users may view or obtain for free. Then, the watermark can be removed to recreate the unmarked image by using a "vaccine" program that is available for an additional fee.

Mintzer, Boyle, Cazes, Christian, Cox, Giordano, Gladney, Lee, Kelmanson, Lirani, Magerlein, Pavani, and Schiattarella (1996) describe the first approach in more detail:

> When a pixel is changed by our watermarking, the brightness is reduced, while the hue and saturation are held constant. Changing only the brightness, we feel, makes the most visible mark on the image for a given degree of obtrusiveness. The use of a watermark that is thematically related to the materials themselves, in this case the Vatican Library

seal, also adds to the unobtrusiveness of the watermark. In applying the watermark, we adjust the watermarking's change of brightness to darken image pixels by the same amount perceptually, whether the pixels are light or dark. This "uniformly perceptual" darkening is only approximate, and it can only be accomplished if the underlying pixels are bright enough to be darkened by the desired amount. It has been our experience that this technique does produce watermarks that are equally obtrusive on many images.

> The watermarking software reads the watermark as a monochrome TIFF image and applies it to the manuscript image. The amount of processing needed to apply a watermark is quite small. Where the watermark image indicates that no darkening is to be applied to the image, the image pixel is unchanged. There is a natural conflict between unobtrusiveness and protection; in this project, we have chosen to use watermarks that are large, nearly centered, and fairly unobtrusive. As the presence of color tends to visually mask the watermark, we tend to use greater darkening for color images than for monochrome images, but this leads to a similar perceived obtrusiveness.

Apart from IBM, there are a few products for visible image watermarking on the market only. We made some tests, see figure 2.4, with the product H20marker.

An Alternative Approach

The argument against the use of watermarking for protecting property rights in general is well-known (see for instance Dittmann & Steinmetz, 1999). The watermarks shall contain the information, which are necessary to prove ownership and they are embedded in the original image, i.e. they modify the original. Moreover, they must not mar the intrinsic information given by the image, so they are redundant by definition. Therefore, as mentioned in our description of the philosophical attack, theoretically it will always be possible to extract the watermarks without disturbing the image. Ideas that tend to weave the watermark with the image, which makes

it not efficient to destroy the hidden information, often refer to the success of cryptographic methods but they lack the proof of concept.

The functionality of watermarking

The watermarking workflow is always the same, regardless of the specific methods used. First, the image of interest is patterned (see fig. 4). There are a variety of different algorithms, which are described below. All methods claim to give the best possible summary of the picture's content. This filtered information, which we call attribute vector from now on, must represent the knowledge mediated by the image. So converting, compressing, and attacking the image should not change the vector ideally. In the next step, a redundant mapping between the ID and

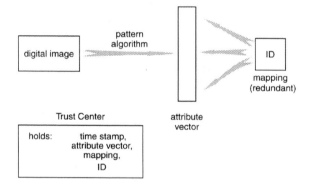

Fig 4: Framework without marking the original

the attribute vector is developed. Because this mapping embeds the ID in the picture and therefore changes it in common watermarking methods, it has to be as smooth as possible. For instance the frequency analysis maps on those coefficients which seem not to be essential for the human eye to recognize the picture. Indeed, only the least significant bits can be changed.

Many authors (e.g. Kutter & Leprévost, 1999) agree that there must be a third party (let us call it a trust center) which verifies the date of embedding a watermark by time stamping. In proving the ownership the trust center must also get an inscription which makes sure which pattern method was used to get the appropriate attribute vector and a description of the mapping to extract the ID. The trust center also saves the ID to get a connection between owner and image.

Without marking the original

If the pattern algorithm and the mapping to the ID must be deposited there is no need to mark the image. The owner proves his rights in alluding to the data at the trust center by his ID. The image of interest will be patterned according to the method deposited and afterwards, the mapping to the attribute vector will be executed which must lead to the claimer's ID.

This approach goes beyond the use of simple hashing because the attribute vector is robust against attacks and the mapping makes use of redundancy in extracting the ID. Furthermore, it is better than watermarking because it leaves the image unchanged and therefore there are no restrictions in finding a mapping, otherwise there is no possibility for using techniques of fingerprinting. This registration can also be used as an input for robots, which search the web for the protected image.

For the success of the described method, the quality of the pattern algorithm is decisive. Here we can fall back on a lot of different techniques, which are also used in the context of watermarking because the first step of both methods is the same. (Hartung & Kutter, 1999) give a summary of common pattern algorithms. These techniques make use of the spatial or a transform domain. Their robustness against attacks must be checked.

Recent research has shown that watermarking techniques which operate in the wavelet domain are more successful than those using the discrete cosine transformation (Wolfgang, Podilchuk, and Delp, 1998). In other works (Kim, Kwon, and Park, 1999; Kutter, Bhattacharjee, and Ebrahimi, 1999) the combination of wavelet transformation and Human Visual System is promising.

Conclusion

Today museums often can not avoid presenting digital copies of their collections using the internet or CDs/DVDs, because they have to attract potential visitors and to gain additional funding. In doing this the risk of unauthorized copying is not disputable and disturbing.

Unfortunately evaluations of available products and techniques show that there are no solutions available today that fit all requirements for increasing copyright protection. In our paper we used the example of pictures to prove this. We mentioned possible starting-points for solutions and showed essential evaluation criteria that allow us to find appropriate solutions without finishing up in an expensive blind alley. In particular restricting options to a certain method a priori (e.g. invisible, robust watermarks) without evaluating special needs and business models is not wise. Visible watermarks must be considered as a legitimate alternative since they can be used to identify a museum's ownership, also in form of a reference to a museum ('we have the source'), and to tell an end-user that he/she has only limited usage rights. *Reversible Visible Watermarks* can be used as a starting point ('teaser' or 'appetizer') for an authorized and copyrighted usage later on. Finally we must state that the search for adequate methods and solutions is still ongoing.

References

Anderson, R.J. & Petitcolas, F.A.P. (1999). *Information Hiding - an annotated bibliography*. last updated 13. August 1999. consulted February 1, 2000. http://www.cl.cam.ac.uk/~fapp2/steganography/bibliography/

Bearman, D., Trant, J. (1998). Authenticity of Digital Resources, Towards a Statement of Requirements in the Research Process. *D-Lib Magazine*, June 1998, ISSN 1082-9873

Cox, I.J., Kilian, J., Leighton, T., Shammon, T. (1996). A Secure, Robust Watermark for Multimedia. In R.J. Anderson (Ed.) *Information Hiding: first international workshop*, vol. 1174 of Lecture Notes in Computer Science, Isaac Newton Institute, Cambridge, England, May 1996. Springer Verlag, Berlin, Germany

Delaigle, Jean-Francois (1996). Common Functional Model. CEC: AC019-UCL-TEL-DR-P-D12-b1. Tracing Authors' Rights by Labelling Image Services and Monitaring Access (TALISMAN)

Dittmann, J., Steinmetz R., (1999). Digitale Wasserzeichen: Möglichkeiten und Grenzen der versteckten Wissenschaft zur Sicherung von Copyrights für digitales Bild- und Tonmaterial. In: *Bundesamt für Sicherheit in der Informationstechnik: IT-Sicherheit ohne Grenzen? Tagundsband 6*. Deutscher IT-Sicherheitskongress des BSI 1999, Ingelheim: SecuMedia Verlag S. 343-354

Franz, E. & Schönfeld, D. (1999). Geschäftsmodelle für Watermarking, *DuD - Datenschutz und Datensicherheit* 23 (1999) 12, 705-711

Gladney, H.M., Mintzer, F., and Schiattarella, F. (1997). Safeguarding Digital Library Contents and Users, Digital Images of Treasured Antiquities. *D-Lib Magazine*, July/ August 1997, ISSN 1082-9873 (see also: http://www.dlib.org/dlib/july97/vatican/07gladney.html)

Hartung, H. & Kutter, M. (1999). Multimedia watermarking techniques. *Proceedings of the IEEE (USA)*, vol. 87 no. 7 pp. 1079-1107

Kim, Y., Kwon, O., and Park R. (1999). Wavelet based watermarking method for digital images using the human visual system, *Electronics letters*, 18th March 1999, Vol.35, No.6

Kutter, M. & Leprévost, F. (1999). Symbiose von Kryptographie und digitalen Wasserzeichen: Effizienter Schutz des Urheberrechts digitaler Medien. In *Bundesamt für die Sicherheit in der Informationstechnik* (Eds.) IT-Sicherheit ohne Grenzen?, Tagungsband 6. Deutscher IT-Sicherheitskongreß des BSI 1999 (pp. 479-484). Ingelheim: SecuMedia Verlag, Germany

Kutter, M., Bhattacharjee, S. K., Ebrahimi, T. (1999). Towards Second Generation Watermarking Schemes. *Proceedings 6th International Conference on Image Processing (ICIP'99)*, volume 1, pp. 320-323

Kutter, M. & Petitcolas, F. (1999). A fair benchmark for image watermarking systems. *Proceedings of SPIE: Security and Watermarking of Multimedia Contents*, Volume 3657, pp. 226-239, San Jose, California, January, 1999

Mintzer, F.C., Boyle, L.E., Cazes, A.N., Christian, B.S., Cox, S.C., Giordano, F.P., Gladney, H.M., Lee, J.C., Kelmanson, M.L., Lirani, A.C., Magerlein, K.A., Pavani, A.M.B., and Schiattarella, F. (1996). Toward on-line, worldwide access to Vatican Library materials. *IBM Journal of Research & Development,* Vol. 40, No. 2 - Services, Applications, and Solutions, © 1996 IBM

Mintzer, F., Lotspiech, J., and Morimoto, N. (1997). Safeguarding Digital Library Contents and Users, Digital Watermarking. *D-Lib Magazine,* December 1997, ISSN 1082-9873

Fabien A. P. Petitcolas, Ross J. Anderson, Markus G. Kuhn. Attacks on copyright marking systems, in David Aucsmith (Ed), *Information Hiding, Second International Workshop,* IH'98, Portland, Oregon, U.S.A., April 15-17, 1998, Proceedings, LNCS 1525, Springer-Verlag, ISBN 3-540-65386-4, pp. 219-239

Petitcolas, F.A.P., Anderson, R.J., Kuhn, M.G. (1999). *Information Hiding - A survey. Proceedings of the IEEE* (USA), vol. 87 no. 7, pp. 1062-1078

Petitcolas, F.A.P. & Anderson, R.J. (1999). Evaluation of copyright marking systems. *Proceedings of the IEEE Multimedia Systems '99,* vol. 1, pp. 574-579

Petitcolas, F.A.P. (2000). Watermarking & Copy Protection - Companies. consulted February 13, 2000. http://www.cl.cam.ac.uk/~fapp2/steganography/products.html

Wolfgang, R., Podilchuk, C., and Delp E. (1998). The Effect of Matching Watermark and Compression Transforms in Compressed Color Images, *Proceedings of the IEEE International Conference on Image Processing,* Chicago, Illinois

ZDWEBOPEDIA: http://www.zdwebopedia.com/Multimedia/digital_watermark.html, 2000

Contextual Links and Non-linear Narrative: A Virtual Rashomon

David Greenfield, Skirball Cultural Center, USA

Abstract

The mission of the Skirball Cultural Center is to celebrate and cultivate the links between American democratic values and the Jewish heritage. Through our museum exhibitions and public programming, the Center strives to deepen the understanding of the origins of American families and their role in strengthening American society. Currently the Center is redesigning its web site to transform it from an electronic brochure to a more content-driven site. One feature being developed relates to family histories and the immigrant experience. To more fully portray the immigrant experience and to illustrate the relationships between different communities, we are collaborating with other cultural institutions to create a virtual "Rashomon" - to tell similar narratives but from different voices. The method we are developing involves creating contextual hyper-links within a non-linear narrative that connects a partner institutions' web site. Hyper-links generally follow a linear model where a user enters a particular site, selects a link to navigate within or to another web portal. We are creating links with partner institutions' sites that occur within the context of the actual narrative. On our site for example, we tell the story of a Russian Jewish family that immigrated to Los Angeles in the 1920's and had neighbors who were Japanese immigrants. The Japanese American National Museum web site tells the story of this Japanese family. Within the narratives on the different sites, there are anecdotes and stories about the interactions and relationships between the families. These interactions provide the context for direct links between the individual family stories that reside on the various partner web sites. There are several goals for our virtual "Rashomon" project, including celebrating positive attributes of the immigrant experience, promoting collaborations between institutions and communities, developing technology that will access and create on-the-fly content and utilizing the computer as a creative tool in the storytelling and the narrative process.

In Grandfather's Virtual Kitchen

Imagine this- you are sitting with your family at the kitchen table after a big meal and discussing the family history and legends. Grandfather, an immigrant, is entertaining everyone with stories about his experiences as a greenhorn in this country where the streets were supposed to be paved with gold, but in reality, people were lucky if they were paved at all. At one point he says: "Remember that other family who lived across the street from us? They were from another country from us, but my, how we had fun with them at their holiday picnics. I wonder what happened to them?" And then, at that moment, you find yourself magically transported (or beamed) over to the kitchen table of that family, where they are discussing their family's stories and how much they enjoyed celebrating a holiday with your grandfather. What you have just experienced is an example of a contextual link in a non-linear narrative. Although it is impossible to experience this in real life/space, with research, thought and planning you can make these excursions in the digital world. But before we make these journeys, we must first define the concepts of non-linear narrative and define contextual links. In some ways, the concept is easier than the answer. The short description is that it is a method of telling multiple viewpoints of a story across multiple web sites with multiple entrance portals.

History of Non-linear Narrative

Non-linear narrative is not really a new idea, so it would be interesting to take a brief, subjective overview of its history along with examples of how it appears in different media.

The first example of non-linear narrative is text based: the Talmud, the Jewish books of law and commentaries. The Talmud as a physical entity is a set of 63 volumes originally compiled around 500 C.E. in Babylonia to preserve generations of analysis and discussion by rabbis and scholars. It contains extra-legal and anecdotal material relating to all aspects of life- such as dietary laws, marriage, divorce, religious ritual and agricultural laws. Although at first glance the books seem similar to an encyclopedia, they are far more complex. The breadth and organization of Talmud is similar to random-access type memory organization of the web. One of the reasons for this is that the Talmud contains one of the primary functions of non-linear narrative – hypertext (a term invented by Ted Nelson, a few short centu-

ries after the Talmud was compiled). The physical structure of a page of Talmud (Figure 1) facilitates a non-linear process. It consists of a main text block in the center of the page surrounded by several smaller text block in different font styles and sizes.

Figure 1

Detail of the first Page of volume one, "Benedictions" of the Steinsaltz Edition of the Babylonian Talmud.

The main text is located in the center of the page and usually addresses a particular problem, dilemma or question in the form of a story. Surrounding this block are comments by different scholars and rabbis also written in the form of stories, and comments that address the main text unit. Additionally, these side comments often refer to text blocks and commentaries located in other volumes of Talmud. A person studying Talmud does not simply pick up a particular volume and read. It is necessary to jump from point to point, page to page and often volume to volume to understand any one section.

Several centuries after Talmud was compiled, the printing press was developed. After some fits and starts pertaining to the use of this new machine, a form of narrative story was developed called the novel. Early forms of novels were presented in a linear manner. In her wonderful book *Hamlet on the Holodeck*, Janet Murray describes an early exploration of non-linear form. She uses the example from the 18th century novel *Tristram Shandy* written by Laurence Stern in which the narrator: "...inserts black pages, numbering chapters as if they have been re-arranged, claims to have torn out certain pages and sends us back to reread certain chapters. In

short, he does everything he can to remind us of the physical form of the book that we are reading". Although Stern came up with some very interesting literary devices, the basic format of the book still remains rooted in linear methodology. The reader turns page after page.

This century also has its forms of non-linear media, a recent example being the interactive-audience-participatory-theater-experience. About 10 years ago I saw (or more realistically, participated in) a play called *Tamara*. The play was performed in a large veteran's hall in Hollywood that had been an old mansion and was furnished in a 1930's art deco manner. Upon entering the "theater" I was handed a ticket designed as a passport and led into a large foyer cocktail party where the servers were all members of the cast. The theme of the play was about a group of actors, fascists, and anti-fascists, gathered in a mansion in pre-WWII Italy. At a certain point, the cocktail party ended and the play began as the actors shifted from servers into their roles. We the audience ("party guests") were divided into groups and began to follow cast members around the mansion, up and down staircases, through passages and in and out of rooms as they interacted with other cast members, acting out separate, but connected plots. Although the audience was encouraged to stay with one or two particular characters, we could shift to other groups of actors if one particular story line looked more interesting. The timing of the actors was amazing! Because of the complexity of the story, it was virtually impossible to understand the complete story, so each member of the audience was presented with just one small view. Intermission was in the dining hall, and as we ate, we all exchanged information to get a better picture of what was happening. Multiple attendance of the play was encouraged by reduced ticket prices for each subsequent viewing. I think the fourth or fifth visit was free. Although it was at times a bit unbalancing trying to figure out what was happening, it was a fascinating, entertaining and fun experience to participate in breaking the boundaries of the medium.

The development of cinema has also increased the exploration of non-linear narrative. Popular movies such as *Back to the Future, Groundhog Day*, and the more obscure *Head* (the 1968 movie by the Monkees), or the German film *Zentropa* play with

our sense of time and place. The audience is not a passive observer, but must become an active participant to assemble the various plot threads of narrative to a coherent story. In *Hamlet on the Holodeck*, Murray writes about two significant terms necessary in the discussion of non-linear narrative – "multiform stories" and "active audience". She defines "multiform stories" as "…written or dramatic narrative that presents a single plot line in multiple versions…" and "active audience" as the result of a "…writer expands the story to include multiple possibilities, the reader assumes a more active role".

Kurosawa's cinematic masterpiece *Rashomon* is a wonderful example of multiform stories" to promote an "active audience". The story revolves around a large gate in the middle of a forest in which two peasants are discussing an incident involving a samurai, his wife and a bandit. Something took place in which the samurai was killed, the bandit was arrested and the wife may or may not have been raped. The story is told through multiple voices (including the dead samurai as channeled by a medium!). The audience cannot sit by and idly watch the film. It is necessary to pay close attention to detail to attempt to discern the true facts. Because there is no concrete resolution at the end of the film, the audience is left in a rather ambiguous position. The beauty of this is that each member of the audience must come to his or her own conclusion that satisfies his or her individual interpretation of the events presented.

Introduction to Non-linear Theory

As much as these books, films and theater explore non-linear narrative, utilizing devices such as the cinematic flashback, they are limited by the individual strengths and weaknesses of their particular media and can only be presented in a linear fashion (page-after-page, scene-after-scene). There is though, one distinct idea that connects all of the examples. In one manner or another they are all procedural experiences. Although the conclusions may be gratifying, what makes these examples compelling and interesting is their dynamic nature. They are all about how you arrive rather then actually arriving. In their on-line manual, *The Digital Cookbook*, Joe Lambert and Nina Mullen describe this form of story telling as "the journey". While other forms of stories use

the traditional literary devices to set a premise, then to create tension as characters move along a path to achieve specific goals (get the guy/girl, solve the crime and find the culprit, slay the dragon, etc.), the goal of the journey is *the journey*. The experiences and lessons learned are the central forces behind the journey. In some ways, whether the hero/heroine achieves his/her goal is secondary to the route that they pass through. This form of story telling can be unfulfilling because of the lack of any concrete resolution, although this is really not the case in the previously mentioned media (except for Talmud). Conversely, the journey story can also be a compelling, exciting and even addictive experience. The movie serials in the early days of cinema, or the soap operas of today command huge audiences because of the fact that there are no real conclusions. Characters come and go, adventures happen day after day and the audience is continually drawn back to part of the process.

At this point, the age of computer and World Wide Web enter the picture. From the campfire, to stages, pages and silver screen, storytelling has always reflected the primary media of a specific time period, and the computer age is no different. Currently, we are in the infant stages of investigating the results of the intersection of form (digital content) and function (technology). There are several specific elements that differentiate the medium of computers and Internet from earlier media. The most important one is that this particular media is incredibly dynamic both in terms of the development of technology and how it is used. It is interesting to note that movies and books have an *audience* but the world wide web and CD-ROMS have *users* and that these users are active participants in choosing their own paths and journeys (much like real life). This could lead non-linear stories to be rather chaotic experiences. Ultimately, stories require a basic framework and structure to be satisfying and compelling. A story properly planned and executed will allow a user to travel along a dynamic path of a general topic for exploration and adventure. Imagine being able to enter a story and choose which character you wish to be the narrator, and then being able to choose another character to experience the same adventure from a different viewpoint, or to choose different characters' paths and journeys to the same incident or location.

The two technical elements that allow for this kind of interaction are 1) the recognition that the computer is an engine; and 2) the relational database. Simply put, every computer on this planet can hold multiple databases. The computer, as an active engine, can theoretically access these databases and publish real time web pages that display discrete quantities of relevant content.

How This All Fits Together

Exploring family stories is not new to the web, with many interesting examples. One interesting example site is *My History is America's History*, a project of the NEH. This educational program teaches people methods of gathering family stories and then encourages them to post their favorite family stories on the web. Another is Abbe Don's wonderful site called *Bubbe's Back Porch*. This site has an area for a digital story bee along with requests for submissions of individuals family stories and photos. Both of these examples require active participation- gathering and posting information along with surfing the site. Ultimately though, they are presented in a linear web format. A visitor enters the site, explores one or more particular stories within the site and then exits.

Our project is tentatively called, *Grandfather's Virtual Kitchen* because people tend to congregate in the family kitchen and that is where some of the best stories are told. We want to tell the stories of immigrant families and the relationships that existed within different communities. Although immigrant groups have naturally tended to reside together in neighborhoods, there has been one unifying force among the different communities- they are all "strangers in a strange land". It would be false to say that there were no problems- there are plenty of examples of the conflicts, stress and tensions that existed (and still exist) between various communities. This is not the purpose of *Grandfather's Virtual Kitchen*. Our purpose is to portray the stories of immigrant families and how, over time, positive relationships between different groups have developed. It is far more interesting and relevant for us to illustrate examples of how communities can co-exist with tolerance and mutual respect.

A sentence found in our mission statement sets the tone for *Grandfather's Virtual Kitchen*: Just as the American immigrant experience is different for each group and individual arriving on these shores, the Skirball Cultural Center provides an unrivaled rainbow of programs and opportunities to enrich each visitor." This idea is manifested both in the core collection of the museum component of the Skirball Center, which focuses on Jewish history (especially the American Jewish experience) and with our various other programs, including musicians, speakers, theater, dance (and more) that highlight and celebrate cultures and communities from around the globe. Additionally, our education department has been involved in some creative community projects such as *Finding Family Stories*. This project was developed by the Japanese American National Museum and was a collaboration with the Santa Barbara Museum of Natural History, the Korean American Museum, Plaza de la Raza and the Watts Towers Arts center. The goal of *Finding Family Stories* was "grounded in the belief that cultural institutions, representing different ethnic communities, could learn from one another- both organizationally and culturally- through the process of developing, implementing and working on a project together". With a basic understanding that no community or cultural institution operates in isolation, these five institutions created a model that "would not only reflect a single cultural experience, but expand and open the doors to the experience of others as well". The main activities of *Finding Family Stories* were a series of collaborative workshops at partner institutions over a three-year period, culminating in concurrent exhibitions at partner institutions that highlighted "contemporary artists of each community who incorporated and interpreted family stories within their work."

Grandfather's Virtual Kitchen expands on the themes developed in *Finding Family Histories* and begins to apply a non-linear narrative and contextual links theory to practical applications. By using the Internet as the medium and the web as the delivery platform, site visitors become active participants in exploring the family stories and community interactions, rather than simply being observers. As visitors to a particular site explore the stories, photographs, video and sound clips of an individual family representing a particular community, they will discover anecdotes about interactions with families of other communities. These anecdotes provide the links to the other families stories that are located at the partner institutions' web sites.

The collaborative process needed in producing this project – to find partner institutions, develop content, technology and links results in a process that is concurrent with the goal- collaboration between communities.

General Process

As with any other interactive project, the process of creating *Grandfather's Virtual Kitchen* is as non-linear as the end product. Each issue, question and decision uncovers a new series of issues and questions requiring a new series of decisions (a can of virtual worms). The problem of the chicken-or-egg syndrome then arises: what comes first? The answer to this question is: *the question.*

The answer to the question of what comes first in creating a non-linear narrative is also relatively simple- it's the idea. In our specific case, it is the creation of a virtual space that allows visitors to actively explore discreet family stories along with the interactions and relationships between members of different communities.

The decisions and production process that follow this simple idea are not quite so simple. It is necessary to first identify and enlist partner institutions, followed by determining production teams and the infrastructure. With a core team together it is possible to begin to define the scope of the project. With this done, the actual production process begins. Part of the beauty of the dynamic nature of the web is that a project such as this can be developed incrementally, initially involving three or four partner institutions, expanding as the narrative and are developed.

Partner Institutions, Teams and Infrastructure

Collaboration is the order of the day, so it is important to identify institutions and individuals that share common goals and interests. It is not necessary for an institution to confine itself to one particular niche. For example, although the Skirball is a cultural center and museum, we do not need to limit our partners only to other cultural museums. With a bit of imagination and creative thinking, it is possible to expand collaborations to other types of institutions. For example, if a member of our digital family is a

scientist, we can create a partnership with a science center/museum whose site has an area that celebrates this individual's contribution to the scientific community. Nor is it necessary to be confined to a single geographic area. Links can be created with institutions across the country and world to show the journeys of individual families. One possible scenario for us is to begin our story with our virtual grandfather's arrival to America with a site/link to Ellis Island. Then, via links with museums and cultural centers across America, we follow his path to Los Angeles.

Case Study- Overview

As previously discussed, there are many issues that need to be examined when producing an interactive project. Here are several examples of questions that we have encountered and how they have currently been resolved.

First, creating *Grandfather's Virtual Kitchen* is basically a three-part process: 1) research; 2) gather content and media; and 3) production.

The first step of Part 1 is one of the most crucial elements of the process. The partners decide between two styles of story telling- the composite story or exclusively true story. True stories are the most compelling, but research can be difficult and cost prohibitive. For our prototype, we have decided to develop stories closer to a model of historical fiction, taking stories from selected primary sources and weaving them together to create a narrative that matches our goal. For example, our virtual grandfather is a Russian Jewish immigrant whom we shall call "Ben". Ben had a dairy route with a horse and wagon. One of his customers was a Japanese immigrant family whom we shall call the "Kurosawas" and who owned a nursery. During World War II, the Kurosawas had to leave their nursery when they were sent to an internment camp in the California desert. The streets may not have been paved of gold, but Ben's heart was. He watched over the nursery and returned the keys to the Kurosawas when they returned home after the war.

The events of this story are true, but the composite is artificial. We have examples of righteous people who assisted Japanese Americans during the war. We have the story of a Jewish immigrant family who

had a dairy wagon, Japanese customers and a strong sense of ethics and justice. And we know about a Japanese American family who owned a nursery, were sent to an internment camp and had a neighbor who watched over their nursery while they were interred. What is lacking is the direct link between these specific families. By creating a composite of multiple family stories, based on true events we can illustrate how people of different communities were able to assist each other during times of adversity.

Composite stories based on historical fiction can be powerful, but they require the site to have clear labels. There are two additional components necessary to insure that the stories retain their power and interest, and that visitors understand that they are exploring historical composites. It is fundamental to have extensive online bibliographies along with descriptive labels throughout the sites informing visitors about the content

Style and Content

One of the issues relating to the actual design is whether or not each partner will use the same visual template. We want to create an illusion of the experience of visiting peoples' homes, so specific graphics and designs are created by the individual partner that best reflect the sensibility of the community. The key issue is that there must be a thematic continuity to site content. This requires creating a structural template to insure that each partner's site contains the essential to the creation of contextual links.

Technology

Our first concern is to make this site as accessible to both visitors and to partner institutions. It is an unfortunate aspect of the non-profit world that not all institutions have the technology or infrastructure to participate in this project. For this reason, we have chosen to begin development with several local institutions that have a basic level of technology, a presence on the web and are enthusiastic about the idea. To keep storage requirements minimal the initial family stories are relatively small, and the contextual links are limited. We also decided to keep the design relatively simple to allow for a greater number of visitors using older browsers and systems. As we develop content, infrastructure and

methodology, our stories and links will also grow, as will the introduction of more sophisticated forms of media (video, audio). Plans exist for outreach to other institutions that have entry level technology to assist them with increasing the capabilities of their systems and helping them develop a more solid web presence.

Future Growth

Grandfather's Virtual Kitchen is being built in components. This will optimize the ability to expand the stories as associations with new partner institutions develop. Additionally, discussions have begun about school outreach programs, so those students can research and create their own family stories and links (between schools and other institutions).

It is our hope that *Grandfather's Virtual Kitchen* will evolve along with technology. In time, there will be web-casts about cultural events and real-time discussions or moderated chat-rooms to share stories and ask questions.

Conclusion

We believe that the stories of families and immigrants are a vital component of the American experience. These stories teach real-life lessons about tolerance, understanding and respect that can be applied to communities around the world. Additionally, the method of contextual links and non-linear narrative provides a dynamic mechanism for story telling that makes the user an active participant in exploring. It is not necessary to worry about a virtual grandfather in a virtual kitchen replacing a real grandfather in a real kitchen. It is difficult, if not impossible to replace the spontaneity and vitality of an actual storyteller. But, virtual grandfather can emulate the story-telling experience in a manner that captures the essence of a story and experience. By using the web to tell these stories, the visitor base increases exponentially and the audience expands from the local to the global. The thousands or millions of visitors will share in the journeys through cyberspace while being entertained and educated about the uniqueness of individuals along with the shared experiences of the communities.

References

Don, Abbe. *Bubbe's Back Porch* (http://www.bubbe.com/). Last updated June 20. 1999 PST. Consulted February 11, 2000

Fraser, Glen D. (1999). Real-time Interactive Storytelling. *Computer Graphics, Vol. 33, Number 4,* 14-16

Lambert, Joe and Mullen, Nina. *Memory's Voices – A Guide to Digital Storytelling. Cookbook and Travelling Companion.* (http://www.storycenter.org/cookbook.html). Last updated July 15, 1999 PST, consulted February 14, 2000

My History is America's History (http://www.myhistory.org/). Consulted February 11, 2000

Murray, Janet H. (1997). *Hamlet on the Holodeck-The Future of Narrative in Cyberspace.* New York: Free Press

Sobral, Claudia. (1998) Introduction. In *Finding Family Stories* (pp. 5-6). Japanese American National Museum, Santa Barbara Museum of Natural History, Skirball Cultural Center

Steinsaltz, Adin (1977). *The Essential Talmud.* New York: Bantam Books

3D-Temporal Navigation on the Web: How to Explore a Virtual City along Multiple Historical Dimensions

Francesca Alonzo, Franca Garzotto, and Sara Valenti; HOC-Hypermedia Open Center, Department of Electronics and Information; Politecnico di Milano, Milano, Italy

Abstract

Many virtual worlds available on the web provide reconstructions of urban environments – either real or imaginary. Still, they do not exploit the temporal dimension, i.e., they do not enable users to change the time context as exploration proceeds and to dynamically adapt the virtual environment to different temporal frames. We support this kind of experience, which we call *3D temporal navigation,* in a web site under construction at Politecnico di Milano called "Milan through the Centuries". This site provides multiple, 3D representations of Milan in different periods of its history. According to time selections and "movements" of the user in the virtual world, these representations can dynamically evolve along two dimensions: the space, while user navigation proceeds in the virtual city, and the time, when user changes the current temporal context. The paper discusses the concept of 3D temporal navigation and its integration with 2D "standard" web browsing, reports examples from "Milan through the Centuries" , and introduces the general software architecture of the system.

1. Introduction

Can you imagine how a contemporary city was many centuries ago, say, in the Renaissance, or in the Baroque period? Did you ever desire to explore it not only as it is now, but also as it was in the past, in the meantime getting historical, social, architectural explanations of what you are seeing while you proceed in your exploration?

The web site "Milan through the Centuries", under development at Politecnico di Milano, allows users to try this experience in a virtual world on the WWW. Our system integrates a number of 3D virtual reconstructions of the urban structures of a city (e.g., streets, squares, buildings, parks, etc.), each one representing Milan in a different period of time. Users can not only navigate each virtual space, e.g., "walking" along a street or getting into a building of the virtual town in a given period. At any point, users can experiment a kind of "Zemeckis' Back to the Future" (Zemeckis 1985) effect: moving back or forth in the time, they find themselves in the same place but in a different century, which they can virtually explore. This original form of interaction with virtual worlds, which we call *3D temporal navigation*, exploits two dimensions of virtuality: the virtual *space*, reconstructed via 3D graphics, and the virtual *time*, achieved by the possibility of switching between different temporal frameworks.

In "Milan through the Centuries", 3D temporal navigation is smoothly integrated with 2D temporal navigation. At any point of space and time (i.e., in any spatial context in any time period), users can jump into a "traditional" 2D information space - a conventional web site - and explore, by means of standard web navigation, textual or multimedia web pages concerning what they are currently exploring. In the 2D space, users can visit information related to different town areas, switch the time context, or contextually return to the 3D representation.

The idea of the overall approach is depicted in figure 1. The three axes of the diagram refer to the possible navigation dimensions: in the 3D space, in the 2D space, and along the time (T). For each time

Figure 1: Schema of 2D and 3D temporal navigation

period, e.g. '500, '200, etc., there are 3D reconstructions of the town, related to 2D descriptions (a set of inter-linked HTML pages of a conventional web site).

To implement 3D and 2D temporal navigation in "Milan through the Centuries", we have defined a general software architecture, which can be used to implement temporal navigation for any urban context, once 2D and 3D contents are provided in the appropriate format.

The rest of this paper will first discuss more precisely the user interaction paradigms for 3D and 2D temporal navigation, using examples from "Milan through the Centuries" web site. Then we will outline the general software architecture underlying the system and mention the line of our future work.

2. User interaction in 3D Temporal Navigation

In conventional web navigation, user exploration of a web site usually starts from an entry point (e.g., the "home page") or from a page selected by some search mechanism, and proceeds by selecting the available links connecting to the various pages of the site. In 3D or 2D temporal navigation, user have a number of additional choices, corresponding to the three navigational dimensions: along the 2D space, along the 3D space, and along the time.

In principle, one may start by selecting a starting point in each of these three dimensions. Still, in "Milano along the centuries" the first choice offered to the user is temporal, i.e., he or she must first select the time period of interest, and then choose the town zone. Since Milan has radically evolved and expanded along the centuries, the notion of "town zone" depends on the time period, have different granularity depending on the time, and therefore the sets of space representations of Milan in different time periods are not totally "isomorphic" (i.e., not all the possible combinations "town area-time period" make sense). In the thirteen century, for example, only the central area existed (around the Duomo square), and the town zones available in that period are sub-zones of the central area. On the contrary, contemporary Milan includes many other areas among which users can make their first selection.

Once users have made their temporal choice, they are presented with a 2-dimensional city map (we have tried to use historical maps of Milan for each time period, as shown in figure 2). From here, users can either identify a starting point for navigation, or select a sub-area when available.

By default, the virtual exploration of a selected place starts in the 3D world, but the switch to the 2D world may be invoked at any time. In this section, we discuss 3D navigation, while 2D navigation is introduced in the following section.

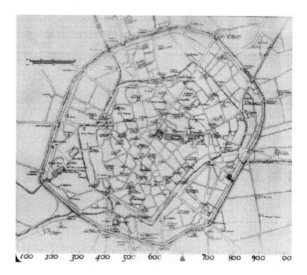

Figure 2: Historical map of Milan in the 13th century

There are two paradigms ("modes") of virtual navigation in the 3D environment, named "*walk*" and "*fly*". The "walk" mode mimics the conventional way humans explore a real town – by walking along the streets. During a "walk", the town is progressively disclosed to the user eyes along a bottom-up perspective. As exploration proceeds, monuments and buildings are progressively shown, and an increasing level of detail as the user moves closer (with the cursor) towards the corresponding objects in the virtual environment. Users can penetrate (some) buildings and explore them inside, or proceed along the street.

The "fly" mode mimics the way we perceive a town from an aircraft and provides an aerial, top-down perspective of the town: users are allowed to fly over the town and to view streets and buildings from the sky. The system supports a smooth transi-

tion from "fly" to "walk" mode (and viceversa): by moving the cursor, users can fly horizontally and vertically, progressively focusing their view of a place up to street level, or progressively taking-off and enlarging their view.

Two space representations are active during navigation (in both modes): the virtual 3D environment currently explored by the user, and the space context, i.e., the 2D map from which navigation has started. Both representations dynamically evolve as navigation proceeds. The 2D map highlights the changing position of the user in the area, and the 3D world changes as discussed above. Users can maintain both contexts simultaneously visible on the screen ("dual context view"), as shown in figure 3, or zoom the 3D view up to the full screen size ("zoom view"), as shown in figure 4 and figure 5 (both figures refer to "walk" mode).

During navigation, also the temporal context remains active, as indicated by the time bar on the bottom of the screen. At any point in space, users can select a different time period and experiment the "Zemeckis' Back to the Future" effect: if the representation of the current space context is available for the chosen period, they are "projected" into a 3D virtual world in which the town is reconstructed as it (presumably) was in that time, and they can continue navigation from the same space position. If no urban structure existed for the current place in the selected period, users find themselves in the middle of "nowhere" - a green land with nothing around. They can try to "return to

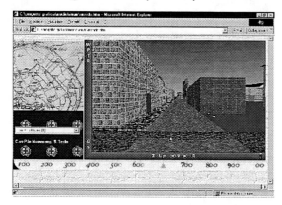

Figure 3: 3D exploration of Corso di Porta Nuova (from Santa Tecla church corner) dual contexts view – walk mode (seventeenth century)

town" by either navigating the desert 3D space in some direction, or by accessing the (historical) map of the town which corresponds to the current period, selecting a new entry point in space.

Figure 4: 3D exploration of Sempione Park - zoom view– walk mode (seventeenth century)

3. User interaction in 2D Temporal Navigation

From a town map, or at any point during 3D navigation, user can access information related to what they are currently exploring. The 2D world is a conventional web site which presents multimedia content related to monuments, buildings, streets, squares of Milan – not only existing now, but also in the past. It also include information about the his-

Figure 5: 3D exploration of historical palace - zoom view – walk mode (seventeenth century)

tory of a place and its architectural aspects, about the historical and social context in which it was built, about anecdotal events, curiosities, and relevant personages related to it. An example of 2D web page in "Milan through the Centuries" is shown in figure 6.

In the 2D information space, content is organized along two dimensions: time and space. Each urban

object is presented in an historical perspective and has multiple contents associated to it, to describe it as it is now and as it was in different time periods. Similarly to what happens in the 3D space, the temporal context is always active during 2D navigation, to allow users change the temporal perspective of

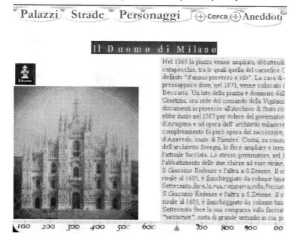

Figure 6: A conventional 2D web page in "Milan through the Centuries"

an object description. The navigation in the space dimension is achieved by providing links from an object to the objects that are (or were) physically close to it. At any point, users can switch to the 3D world, and find themselves embedded in a virtual reconstruction of the place in which the object they are visiting is (or were) located.

4. The software architecture

The software architecture that implements 3D and 2D temporal navigation in "Milan through the Centuries" is depicted in figure 7. It provides a general, flexible implementation framework, which allows developers to reuse the modules developed for our specific case study and to easily adapt them in order to implement temporal navigation in any urban context, once the representations of 2D and 3D objects are provided in an appropriate format. The core idea of our technical approach is that both the 2D and 3D environments are generated *dynamically* as user navigation proceeds. The main modules of the architecture are:
- the *user interface*
- two *generation engines*
- the 3D and 2D *databases*, to store the source content of the application

The user interface is the channel through which users interact with the 2D and the 3D worlds. Its purpose is to display 2D objects (web pages) and 3D representations of the current spatial context, to intercept user requests (link selection, movements in the 3D space, change of temporal context), and to pass them to the appropriate engine. The 2D interface that visualizes 2D pages and accepts user-generated events is based on a standard

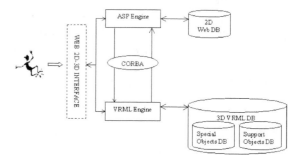

Figure 7: The general software architecture of "Milan through the Centuries"

Web Browser. To visualize the 3D VRML objects and to intercept user movements in the 3D space, the user interface uses Cosmo Player or World Viewer (both work well).

Based on the user requests sent by the user interface, the generation *engines* retrieve the appropriate contents from the data bases, and aggregate them to generate the 2D or 3D representation that are then displayed by the 2D and 3D viewers. The communication layer among the user interface and the engines, and between the two engines, has been implemented with CORBA, and, in particular, the events generated and sent by the 2D world to the 3D world are managed by the EAI (External Authoring interface) (Lewandowski, 1998).

The 2D Web pages are dynamically generated by the *ASP engine* (Active Server Pages Site, 1999), which imports information elements from the 2D database (selected according to the current user position in the 2D space, the current temporal context, and the current link selection), and aggregates them according to the structural relationships stored in the 2D data base. The 2D data base stores all the information needed to build the web pages: 2D content elements - maps, texts, images, sounds and videos, and the structural relationships among different source elements that define which ele-

ments must be aggregated together in the different pages. The database also provides developers with a user friendly interface to allow them to insert, modify, or cancel information elements and as well as the structural relationships them.

The 3D engine creates the 3D VRML representations of the city as user exploration proceeds. It calculates the user position, identify the 3D objects - streets, palaces, churches, fountains, etc. – that must be visualized in the current context, and defines how they must be placed in the 3D world, generating the portion of the city which is relevant for the current user perspective, either in "walk" or "fly" mode, in the current temporal context. To identify how the reconstructions of urban elements must be placed in the 3D space, the VRML engine exploits a set of *spatial relations* among 3D objects, which define the dependencies between the different space contexts and different objects within each context. The 3D database stores the basic 3D VRML objects and their space relationships, and also provides developers with a user friendly interface to allow them to insert, modify, or cancel objects as well as their spatial relationships.

The objects in the 3D data base are typed according to their urban role: Buildings (e.g., houses, palaces, villas, industrial building,...), Church (churches, abbeys, cathedrals,...) and Miscellaneous, which collects all other urban elements, such as trees, fountains, streets, walls, and similar.

The objects are also organized in two categories, depending on their role in the generation process: Special Objects and Support Objects.

Special Objects are the urban elements which has a particular historical or architectural relevance, and therefore characterize each particular portion of the city in a given period. Special Objects are active, in the sense that they can users can perform a number of operations on them. Special Objects can be zoomed- in/zoomed-out, or explored inside (when this operation makes sense). They also include anchors to reach the Web pages in the 2D world which describes the details of each object.

Support Objects are used to fill the virtual space around Special Objects, i.e., of creating the urban context for them. Support Objects are "generic",

anonymous urban elements, such as generic houses, trees, grasses, streets, and similar; they have no special relevance from a cultural perspective but, like the generic building blocks of a Lego, they are needed to complete the virtual reconstruction of a space context. As such, Support Objects are often repeated in the visualization of a space environment. Furthermore, Support Objects are static, i.e., users cannot interact with them, and the designer cannot modify them.

Conclusions and Future Work

This paper has discussed the concept of multiple space temporal navigation, i.e., virtual exploration in a 3-dimension or 2-dimension information space that explicitly takes into account the notion of history and time, and allows user to modify the temporal context of what they are seeing, as well as the space dimension in which they are navigating. We have also proposed a general software architecture that allows developer to build, in a modular way, 3D and 2D information spaces integrated with temporal navigation.

The main application domain we acknowledge for temporal navigation is in the virtual reconstruction of historical towns, since the proposed approach discloses the possibility, for the user, of experimenting the virtual exploration of a urban context along multiple historical perspectives. In particular, we are applying the proposed approach to a web application that concerns Milan through the Centuries, where we provide multiple reconstructions of the town in different periods which can be navigated in a conventional 2D world as well as in a virtual, dynamically created 3D space.

Still, temporal navigation can be applied to any cultural domain in which the content has a strong historical, or, and, more generically, temporal dimension. Even the objects presented in a virtual museum, for example, can be presented in along multiple temporal and space perspectives: as they appear now in the museum, and in the space and temporal contexts in which they has been originally conceived (e.g., a church, a private house) or used during their time life.

Our future work will proceed in two main directions. On the one hand, we are completing the "Mi-

lan through the Centuries" application, to include a larger set of urban contexts (so far, limited to the central area) and to enrich the set of 2D information associated to them. On the other hand, we are working to extent the interactivity of the system, by supporting a *cooperative* way (Billinghurst, 1994) of 2D and 3D temporal navigation. In the current approach, user interacts with the system individually, as a lonely activity on the net, since no mechanisms is provided to visit a 2D-3D temporal navigation environment together with other users. We are investigating the possibility of applying the WebTalk technology for cooperative access of the web (Barbieri, 1999) to temporal navigation, in order to allow multiple users to simultaneously access a 2D-3D information space and to navigate in group, rather than individually, along multiple space and temporal perspectives.

Acknowledgements

This work has been partially supported by the CNR project "Virtual Museum of Italian Computer Science History". A special thanks goes to Luigi Zanderigli for their support to the system architecture implementation.

References

Active Server Pages Site (1999), www.aspsite.com

Active Worlds Web Site (1999), http://www.activeworlds.com

Barbieri, T. Paolini, P. (1999). WebTalk: a cooperative environment to access the web. In *EUROGRAPHICS'99*, Milano.

Billinghurst, M. Baldis, S. Miller, E. Weghorst, S. (1997). Shared Space: Collaborative Information Spaces. In *HCI International*. http://www.hitl.washington.edu/publications/p-96-5/p-96-5.rtf

Kalawsky, R.S. (1993). The Science of Virtual Reality and Virtual Environments. *Addison-Wesley.* Wokingham.

Lewandowski S. M. (1998). Frameworks for Component-Based Client/Server computing. *ACM Computing Surveys* (Vol.30, No.1, 3-27).

National Museum of Science and Technology "Leonardo da Vinci", Virtual Leonardo Web Site (1999), http://www.museoscienza.org/leonardovirtuale

Paolini, P. Barbieri, T. et al. (1999). Visiting a museum together. In Museums and the Web99, Pittsburgh, Archives & Museum Informatics.

Roehl, B. et al. (1997). Late Night VRML 2.0 with Java Ziff. *Davis Press.* Emeryville

Zyda, M. Singhal, S. (1999). Networked Virtual Environments. *ACM Press.* New York.

Zemeckis, Robert "Back to the future", movie, USA 1985

WebTalk Web Site (1999), http://webtalk.elet.polimi.it

Virtual Objects and Real Education:
A Prolegomenon version .1

Glen H. Hoptman, Jonathan P. Latimer, Marsha Weiner,
The Lightbeam Group/Studio, USA

Abstract

Since the material and informational assets of our cultural institutions are now liberated from bricks and mortar, the challenge facing museum professionals and educators is how to best apply technology to fulfill the needs of the general population and the aspirations of the institutions. Against the backdrop of the popular PBS production, *The Antiques Road Show*, Prolegomenon version .1 integrates the foreword thinking of James Burke's work *The Knowledge Web*, and presents how the traditional museum-based orientation of artifact-as-history can finally fulfill our highest democratic ideals of education, once stated by John Dewey. Those ideals now have an opportunity to be fulfilled in the triune function of CONTENT, CURRICULUM, and COMMUNITY, a credo that is embraced by efforts like bigchalk.com, sponsor of our current work in this arena. Prolegomenon version.1 projects a blueprint as to how the cultural assets of museums can provide a true interdisciplinary approach to learning that will reflect Burke's suggested," glimpse of what a learning experience might be like in the twenty-first century." It is the beginning of a community-based dialogue related to evolving an enhanced philosophy and practice of education

Introduction

For decades the revolution of personal computing has been equated to that of the impact of the printing press. Some zealots even went so far as to equate the worldwide, life-changing power of personal computing with that of writing itself. Regardless, such revolutionary times demand the skills of inquiry and reflection, especially when developing a strategy of how to apply the revolutionary tools now available for K-12 education.

The grandfather of both modern, democratic and Progressive education, John Dewey, reminds us:

> The primary school grew practically out to the popular movement of the sixteenth century, when, along with the invention of printing and the growth of commerce, it became a business necessity to know how to read, write, and figure. The aim was distinctly a practical one; it was utility; getting command of these tools, the symbols of learning, NOT for the *sake* of learning, but because they gave access to careers in life otherwise closed."

Once education got beyond the practical mandate, educators then returned to the struggle of providing a democratic education that had cultural components, "to put into the hands of people the key to the old learning so that they might see a world with a larger horizon.

Such is the challenge in applying today's technologies to bringing museum assets to classrooms. Hence, Prolegomenon version .1

But first, an aside. Though *"The Antiques Road Show"* may curdle the corpuscles of some museum professionals, in it's fourth season on Public Broadcasting, 333 PBS stations carry the show. It is PBS' top rated ongoing series, with an average audience of 6.43 million.

Here's a description for those unfamiliar with the program: A group of professionals, most of whom work as antique dealers, auctioneers and appraisers, not museum professionals, bring their well-announced tent to town. Locals are invited to bring family heirlooms or treasures found at flea markets, garage sales or purchased in galleries. The fleets of professionals, in various categories, are available to appraise the value of the presented objects. Throughout the program there are breakout segments when the audience sees an individual, with their object, sitting opposite a professional in a lighted area. The professional, with the command of Regis Philben, asks, "How did you come by this?" After the tale is told, the professional asks the more pointed question, "What do you think it's worth?"

After listening, the expert nods with acknowledged concern, and then describes, in stunning detail, details about the object. Through the expert's descrip-

tion the audience learns about lost techniques, artisans and craftsmen, historical preferences, economic forces, manufacturing challenges and progress, fashions, and fads. Finally the expert evaluates the object and the cultural spelunker exits, feeling somewhere between confirmed that their object truly is a treasure, or disappointed. Regardless, the collectors leave enlightened—they've learned something.

One breakout segment was unique. Sitting opposite an expert in Early American painting was a 12-year-old girl. With her legs rhythmically swinging from the seat of the chair, the expert learned that the painting before the audience, a portrait of a woman of an indeterminate age, was recovered from a dumpster by the girl and her mom. The child confidently gave her explanation of the painting including, the era it came from, information about the painted interior, the subject's costume, her status and that of her family, and more.

The expert generously beamed surprise, pride, and approval at this young collector. When asked how she knew so much, she commented, with comfortable enthusiasm, (I'm quoting from memory)," I just love this show and all my family knows it. So now when I watch I've got a whole lot of books to look through. I've learned how to look at stuff and find out what it means. I just think this show is great."

The segment was:

- In some ways it was an educator's dream. It showed a child who has the *means* to follow her enthusiasm, a child who has *resources at hand from which to learn more.*
- It was a successful use of media that suggests an adaptation of museum assets to web-based education.

To address that: Prolegomenon version .1

Prolegomenon is a collection of readings or exercises that will lead to further understanding and development that will advance a way of thinking on a particular subject. A present day prolegomenon that addresses new technology and a new approach to knowledge is James Burke's *The Knowledge Web.*

In his book Burke presents ten different journeys "across the great web of change." Though the reader can read the book from cover to cover, Burke also offers "gateways"— notations in the margins that lead the reader to other places in the book where the timeline of one inquiry crosses the timeline of another. Such crossings reveal, for example, how the products of a nineteenth-century perfume-spray manufacturer and the chemist who discovered how to crack gasoline from oil came together to create the carburetor.

The result is a sense of the connections between knowledge, events, thoughts, and serendipity. It is, in Burke's own words, "a glimpse of what a learning experience might be like in the twenty-first century once we have solved the problem of information overload." He even goes so far as to suggest that our brains are hard-wired for such higher level, pattern-recognition which yields the context and relevance of information.

The book, both in its content and layout, is begging to be free of the page. The content is begging to be applied to the tools now available:

- interactive communication tools which allow a user to traverse various timelines
- in media rich environments,
- which are linked to data resources that will illuminate each step of the looping timelines, along with the ability to communicate about one's findings anywhere in the world.

The same tools suggested by Burke's *prolegomenon* can be applied to museum assets to liberate the intellectual wealth of cultural institutions and to help fulfill the artfully crafted Mission Statements shared by many institutions; *to educate and uplift our democracy.* And in what better arena to deploy those liberated resources then education.

When interactive museum resources are joined with educational requirements and communication technology, the public then gets a golden triune function: *CONTENT, CURRICULUM* and *COMMUNITY.* These are the three foundations upon which bigchalk.com has evolved it's approach to the development of educational resources. It is in association with bigchalk.com that this paper was written, and it is with them that we at Lightbeam are designing a series of educational modules that embody the spirit of this paper.

- The CONTENT comes from some of the most highly regarded institutions together with the extensive reference assets of bigchalk.com
- Databases allow the means for interdisciplinary connections to be made across the entire CURRICULUM.
- And the COMMUNITY of teachers, parents, and students can communicate and interact via communication technologies.

bigchallk.com has at its core this triune function:
CONTENT of the highest, most trusted level.
CURRICULUM to provide a framework of inquiry.
COMMUNICATION tools to involve family and community in the education process.

Relevance to Education

One of the unfortunate aspects of formal education today is that in many places it is still carried out much the same way that it was in the 19th century. Students are still gathered together in a school and moved from one room and grade to another according to a rigid schedule. They sit in orderly rows and use standardized textbooks that do not recognize the differences in learning styles, interests, needs, or abilities of each individual student. All of the limitations associated with the factory approach to manufacturing are inherent in the current educational system. It's even run on a calendar based on 19th century agricultural practices.

But the introduction of the Web and other information technologies into the classroom turns this traditional paradigm for education upside down. It changes many of the most basic relationships, including the:

- link between time and studies;
- connection between the teacher and the student;
- role of the teacher;
- content of the curriculum; and the
- approaches to delivering information.

These changes are based on a new relationship between humans and information that is swiftly evolving.

1. Information is no longer a scarce commodity. In the past, information (facts and ways of manipulating those facts) was difficult to obtain. It required seeking out someone with the proper training and knowledge to learn from (a wise man or magus) or enrolling in and academy or school (a teacher or professor).

2. Information is no longer expensive. Obtaining a good education can be prohibitively expensive, especially if a student wants to attend a first-class school or college. Even textbooks are far more expensive than other books with a similar trim size and page count. But, information is available on the Web low-cost.

The wide availability of information (as opposed to knowledge and wisdom) is forcing a complete reorientation of the concept of teaching and a redefinition of education. Quality education acknowledges the innate curiosity of children and their desire to understand and master their environment. It also recognizes that children have different interests and learning styles, and that they progress at different rates. While the acquisition of basic skills (reading, writing, mathematics, and the scientific method) still needs to be stressed, the emphasis is on individual achievement and challenge. A child is encouraged to learn skills at a pace appropriate to that student regardless of standardized norms or grade level. Technological tools such as the Web allow for this kind of individual instruction, but it also presents a series of challenges for all concerned.

1. For the first time students have easy access to all kinds of information, some good, some bad. The challenges for students are:

- How to seek and request information
- How to evaluate sources of information
- How to separate good information from bad
- How to open new pathways and new connections in information

2. The challenges for teachers are:
- How to give students the skills to seek and evaluate information (reading, writing, speaking, listening and thinking)
- How to help students open new connections for information;

- How to treat children with respect for their individuality. Children have different interests and learning styles, and that they progress at different rates.

3. The challenges for information providers/publishers are:
- How to package information to make it appealing to students and teachers: instructional design, editing,
- How to make sure the information is accurate: editing, fact-checking.

The Impact of the Web

Taken together, these challenges require a reexamination and rethinking of the nature and goals of education. As things now stand, most of this thinking has resulted in applying old solutions to the new technologies. For example, placing a book on the Web is not much better than reprinting it on paper. In fact, a book may be harder to read on the Web. But what if we don't stop there? If that book can be made interactive, if readers can ask questions and comment on the book, or if the book's parts can be linked to other information on the Web, it suddenly becomes a richer, more useful (and more attractive) tool. Then suppose that much of that information the book is linked to is contained in museums around the world, that single click would take the user to a related object or display. Think how much richer that book would become. Imagine what that little girl on The Antiques Road Show could do with that.

The Internet and World Wide Web provide the opportunity, if issues of the various equal access "divides" are adequately addressed, to be the great democratizer of education. With the comprehensive wiring of schools…ultimately to the desktop of each and every student…the opportunities that information access presents can be realized by everyone. And with the proper tools and interfaces …I earning is liberated from the classroom.

For the purposes of this Prolegomenon, here are some of the possibilities the Web present:

Exploring the Frontiers of Knowledge

The Web offers an opportunity for creative expression and problem solving that go beyond established bodies of knowledge. An emphasis on innovation is necessary if students are going to learn to adapt to a changing world and ultimately take part in shaping change.

Getting the Most out of the Time Available

Once issues of equity and teacher proficiency in the design and use of digital resources has been properly addressed then time is no longer the major structuring element for students use of the Web. As students proceed at their own pace, time becomes more generalized, less specific. Learning can take place anytime, and anywhere, not just during a specific class period

Measuring progress also becomes individualized

Any student can approach any lesson or take any test at any time. Teachers can measure progress in terms of milestones, goals, or objectives, rather than in terms of periods, days, or weeks. The spectrum of possible "correct" answers can be expanded exponentially to reflect the expressive and representational tools used by the students and saved in their respective portfolios.

Individual Learning

Learning is a life-long process, not an activity associated only with institutions. Many schools promote the passive acquisition of knowledge. The Web allows individuals to become responsible for their own learning. Properly used, the Web can teach students to use reason and logic and to apply these tools to engage with the world. Teaching basic skills and content areas can be enhanced by using the Web for a wide variety of activities including Virtual Field Trips, Virtual Science Labs for all ages, and student activities such as a Math Team, Mock Trial, Science Olympiad, or Chess Club.

Collaborative Learning

We live in a culture that stresses individual self-fulfillment, sometimes at the expense of others. Some schools err on the side of stressing the competitive and private nature of learning. The World Wide Web allows learning to become a cooperative effort in which shared ideas enhance each student's experience and understanding. Teachers can compare notes and share best practices with teach-

ers around the world. They can also compare their student's performance with other classes.

Diversity

Because the Web is an opening to the world, it allows students to experience the racial, ethnic and cultural diversity they might not find in their local classroom. Perceiving the needs and caring about the welfare of others is fundamental to becoming a mature person.

Social Responsibility

Because of its remarkable ability to inform, the Web offers a unique opportunity to encourage social responsibility in students. This encompasses compassion for other individuals and responsibility for working on solutions to the problems of the immediate community and of the larger national and international community.

The Opportunities for Museums

The Web and other information technologies offer an unparalleled opportunity for museums; libraries, zoological parks, and other institutions devoted to the acquisition, conservation, study, exhibition, and interpretation of objects of artistic, historical, or scientific value. Many of these opportunities parallel those listed above for education.

Extending a Museum's Geographic Reach

First, a museum's range will be extended beyond anything imagined in the past. Geography no longer matters. The audience doesn't need to come to the museum; the museum can go to the audience.

Getting the Most out of the Time Available

As with educational institutions, museums will no longer be restricted by time. On the Web, museum collections can be reached anytime. People will be able to spend as much or as little time with each exhibit or each object as they need. They will not have to put up with crowds or obnoxious patrons, and neither will the staff.

Collaborative Learning

Information can be traded through the Web in ways that were impossible in the past. Museums will be able to pool their information, easily comparing objects from different collections and sharing their interpretive expertise. They can even [ask] call on their audience for help when the occasion calls for it, as has been done very successfully by the National Museum of American History at the Smithsonian. Curators put objects that they couldn't identify in a small cabinet near one of museum's entrances. They marked it plainly with a request for help [from] form their visitors. Patrons loved it. Here was something that stumped the experts. But on several occasions patrons knew what the object was—they recalled seeing one in grandpa's barn or grandma's kitchen. Everyone won: the museum solved a mystery and their visitors felt involved.

To show one way in which museums can enrich and enliven a student's education; here is a concept for developing an interactive, electronically mediated curriculum. Each of the modules to be developed for this program would be significantly enhanced by access to museum collections.

Conclusion

In places the physical classroom is disappearing. Instead, a class consists of students scattered across the globe, connected electronically. For example, students from many countries have participated in virtual expeditions, explorations, investigations, and discussions. They have traveled together to the ocean abyss by submersible, to Mayan ruins by bicycle, and into the atmosphere of Jupiter with the Galileo probe.

In Dewey's terms, even though students share these virtual experiences vicariously through electronic means, they can be very educational. He postulated that the experience that educates best is shared inquiry. Shared inquiry involves communication, which for Dewey is inherently educational. As he wrote in *Democracy and Education* (1916), "...all communication (and hence all genuine social life) is educative. To be a recipient of a communication is to have an enlarged and changed experience..." More than any other medium, the Internet offers an enormous opportunity for communication and sharing inquiries. The Web is a universe of rapidly evolving virtual worlds populated by people with shared interests who can be located anywhere in the "real" world. Thousands log on every day to ask questions.

Chat rooms, bulletin boards, FAQ's, and Web sites devoted to arcane subjects abound. If the information exists, it is probably on the Web.

Dewey also said (again in *Democracy and Education*) "The educator's part in the enterprise of education is to furnish the environment which stimulates responses and directs the learner's course." In an educational setting, one of the goals of student research is to find the best and most accurate information available. Museums and their sister institutions are the custodians of much of the best information and best objects created by human beings. Making that content available to classrooms over the Internet will create a whole new audience for each museum's collections. In the long run, it may also create new knowledge as well.

So let me give you a glimpse of the future of interactive, electronically mediated education. Dewey gives a hint of what this might be like in his 1903 pamphlet, *Logical Conditions of a Scientific Treatment of Morality*. In it he points out that:

> Students of logic are familiar with the distinction between the fact of particularity and the qualifications or distinguishing traits of a particular— a distinction which has been variously termed one between the "That" and the "What," or between "This" and "Thisness." Thisness refers to a quality which, however sensuous it be (such as hot, red, loud) ... [i]t is something a presentation *has*, rather than what it just *is*. ...The selection of any particular "This" as the immediate subject of judgment is not arbitrary, however, but is dependent upon the end involved in the interest that is uppermost. ...Purely objectively, there is no reason for choosing any one of the infinite possibilities rather than another.

In a classroom, finding connections between the qualities of "Thisness" offers avenues for discovering whole new ranges of knowledge. With the availability of information from the entire world, knowledge will become broad, contextual, and interdisciplinary. Imagine working out concepts such as redness or loudness— or frogginess. Imagine the possibilities and join us in developing a new epistemology which, in a period of time that may be much shorter than we imagine, will lead to a "*New Progressive Education.com*."

References

Burke, James. (1999). *The Knowledge Web*. New York: Simon and Schuster.

Dewey, John. (1900). *The School and Society*. Chicago: University of Chicago Press.

Dewey, John. (1903). Logical Conditions of A Scientific Treatment of Morality. In *Investigations Representing the Departments, Part II: Philosophy, Education* (3: 115-139). Chicago: University of Chicago Press.

Dewey, John. (1916). *Democracy and Education*. New York: Macmillan Company.

Gardner, Howard. (1993). *Multiple Intelligences*. New York: Harper Collins.

Gardner, Howard. (1999). *The Disciplined Mind*. New York: Simon and Schuster.

Leonard, George. (1987). *Education and Ecstasy*. Berkeley: North Atlantic Books.

Manguel, Alberto. (1996). *A History of Reading*. New York: Viking Penguin.

Murray, Janet H. (1997). *Hamlet on the Holodeck*. New York: The Free Press.

Olson, Lynn. (1997). *The School -to-Work Revolution*. Massachusetts: Addison-Wesley.

Organization
& Management

Meta-centers: Do they work and what might the future hold? A case study of Australian Museums On-line

Kevin Sumption, Powerhouse Museum, Australia

Abstract

The Australian Museums On-Line (AMOL) project is six years old. During this time it has established a reputation as both an innovative and highly popular, Internet-based gateway to Australian museums and galleries. A recent study showed that from February 1998 to July 1999, AMOL received over two and a half million hits from 138,380 users, averaging out at more than 270 unique users a day. As well as individual users AMOL has also attracted a growing number of significant museum and gallery collections. But what have been the tangible and quantifiable benefits of this use and representation? Has the AMOL meta-center approach increased access to cultural resources and communications tools, in ways that have meaningfully benefit both museum professionals and the general public? The AMOL project team was mindful that it was time such questions were answered. Particularly when the number of Australian museums developing their own expensive OPACs grows and they begin to question the usefulness of a meta-center approach. In an effort to examine these issues and chart a way forward, AMOL commissioned the first of two summative evaluations in 1999. In this paper I intend looking at the results of the first quantitative evaluation and development of the second qualitative evaluation, as well discuss a range of marketing, promotional, educational and technological strategies the process has spurred.

Cyberspace: a consensual hallucination experienced daily by billions of legitimate operators in every nation, by children being taught mathematical concepts...A graphic representation of data abstracted from the banks of every computer in the human system.
William Gibson, Neuromancer, 1984. p67.

The 'consensual hallucination,' imagined by William Gibson is now a reality. Over 150 million people last year used the internet. Far from being a mere teaching medium, the Internet has evolved into a ubiquitous publishing, communication, design and research tool beyond the bounds of any single government to control. Over and above the 60,000 interacting networks that constitute the Internet, this epiphenomenon cannot physically be perceived or meaningfully located in space or time. In cultural terms the Internet is truly a place where disembodied souls find freedom in a myriad of chat rooms, multi-user dimensions and news groups (Wertheim, 1999). Last year over three million Australians partook of this consensual hallucination and a further 3.9 million (ABS, 1999) visited a museum. Although to date no single study has established a correlation between museum visitation and Internet use, the Australian heritage sector has reacted with nearly 25 percent of all private and public museums now operating a website. In an effort to provide a gateway to these, as well as information on Australian museums and their collections, Australian Museums On Line was formed in 1995, the same year private access to the Internet became widespread in Australia.

Australian Museums On Line (AMOL) is a joint Commonwealth and State funded website that has established a reputation, both nationally and internationally, as a highly innovative gateway to Australian museums and galleries. Its mix of information products, specially created for both museum workers and the public, gives the site a wonderful eclecticism. Collection descriptions, contact details and images of nearly 1100 Australian museums, sit alongside half a million item level collection records, discussion forums and a variety of on-line journals. Initially proposed by the Heritage Collection Council as an electronic register of moveable cultural heritage material, the AMOL project has attempted to keep pace with changing public and professional needs, through a series of redesigns. In six years AMOL has undergone three major redesigns, each of which has progressively thrown off the shackles of a centralised information repository, and embraced the potential of the meta-center. This metamorphosis has been gradual and not surprisingly parallels that experienced by many museums, as they made the sometimes perilous journey from collection to information centered institutions in the 1990s.

The AMOL project emerged as a direct response to the information explosion experienced by many Australian museums in the nineties, as first collection records and interactives were digitised, then finally the Internet was embraced. This rapid adoption of information technology tools by some museums was inadvertently 'pushed' in Australia by government moves towards greater fiscal self-suffi-

ciency (Sumption, 1999). The introduction of admission charges by many Australian museums in the early 1990s, required museums to more closely align themselves with market forces. At the same time financial pressures to be more cost effective ushered in a period of stringent appraisal of some of the museums' more costly functions, like collection care and management. So it's not surprising that the 1990s witnessed a rapid up-take of computerised collection management systems. The unanticipated effects of this technological assimilation was the creation of a myriad of digital, text, graphic, photographic and video databases. And whilst technological determinism and fiscal expediency 'pushed' the process of digitisation in museums, the popular explosion of the Internet after 1995 in Australia, provided the 'pull' to make these resources publicly available.

The Internet's popularity in museums is no accident and is just as much a consequence of museums' new visitor orientation, as it is technological appetite. Superficially its rapid adoption suggests museums were from the outset caught up in the techno-evangelism of the Infopreneurials and Digerati (Robotham, 1996) This small select group have for some years espoused a simple but persuasive rhetoric: the Internet will change the way we live, work, play and even think; it will deliver us from the routine of office work via telecommuting and unleash us from the one dimensional interface of traditional educational mediums. However on closer examination it is clear many first generation museum websites, including AMOL, adopted a less ambitious brief, deciding instead to use the medium to market the *real* museum and its *real* collections.

Three emerging meta-center typologies

Consequently the vast majority of first generation museum websites were conservative in both the presentation and quantity of information they were willing to make public. What little they did was invariably centralised, highly abridged and only browsable. However in the last two years the technological and political landscape has changed markedly, particularly here in Australia. A voter backlash against the marginalisation of regional Australia prompted many governments and museums to reinvigorate outreach programs. Consequently this decentralisation impetus, together with the emer-

gence of new metadata standards like Dublin Core, spurred the development of more user-centred website typologies. With its ability to create a more comprehensive information environment via interoperable databases and known item or explanatory searching, the meta-center model is now gradually being adopted in Australia, North American and Europe. But because of cost and technical considerations, heritage sector meta-centers are still rare, however even in these early stages I have observed a number of typologies emerging.

Most common are what I term *institutional meta-centers*. These are the websites of organisations like the Natural History Museum (London), National Library of Australia and Australian War Memorial. Characteristically each of these has extensive collection holdings, numbering in the hundreds of thousands, or even millions. Importantly each has over a number of years developed a close working relationship with a vast research fraternity, for whom most provide in-house research facilities. Consequently most of these *institutional meta-centers* are in the process of adopting metadata solutions to create database driven websites that will ultimately act as surrogates of corporeal research centres.

Less common are *public meta-centres*. These are the websites created for, or by, heritage sector advocacy, administrative, coordinating or governance bodies. Institutions like the Institute of Museum and Library Services, the American Association of Museums and the Museum Documentation Association (UK). These agencies fund and develop *public meta-centers* like The 24 HourMuseum (www.24hourmuseum.org.uk) and American Strategies (www.americanstrategy.org), to increase public awareness of *real* museums, their exhibitions and to a lesser extent collections. However these initiatives are still extensively experimental and are primarily a response to the perceived increased use of the web by the museum going public. Again as there are few examples of this typology it is difficult to discern a definitive set of characteristics. However one of the most advanced is the 24HourMuseum. Designed as a public gateway to information on British museums, the sites developers have used a sophisticated combination of e-zine format, heritage trails, collection level and institutional contact databases, as well as children's pages. The result is a fun, entertaining and informative site with broad appeal.

The third emerging meta-center typology I have identified is that of the *Professional meta-center*. Here the term 'professional' describes the primary audience for whom these sites were designed. In the case of AMOL and CHIN, those working directly in paid or unpaid heritage positions. This is not to suggest that *professional meta-centers* are not public-friendly, however there is little doubt that the information architecture, search format and content is intended primarily for users from the heritage sector.

The establishment of organisations like CIMI (the Consortium for the Computer Interchange of Museum Information) in the early 1990s is testimony to the heritage sector's awareness of the inherit benefits of meta-centers and allied enabling metadata standards. In the proceeding years projects like CIMI's Dublin Core metadata test bed project, and more recently EMIN (European Museums' Information Institute), have all actively sought to develop standards for museums and galleries. Along with organisations like CHIN (Canadian Heritage Information Network), the MDA (Museum Documentation Association) and AHDS (Arts and Humanities Data Service), AMOL has been an active participant in many of these projects. More importantly AMOL, like CHIN, has also been an early adopter of recommendations and in turn pioneered this, the most ambitious of meta-center typologies.

Meta-centers: Artefactual versus Interactive Multimedia Simulacrum

Whilst I acknowledge that each of the three typologies deploys a wide range of products to service a diverse clientele, they also have a remarkably similar way of describing and presenting the activities of museums. In essence each typology is dominated by what I refer to as an *artifactual simulacrum*. That is they characteristically discuss museums, their collections and exhibitions, via images of artefacts and item level descriptions. Even *public meta-centers* have adopted this approach as a very 'pragmatic' way of developing online exhibitions. Typical is the American Strategies, Northern Great Plains online story. (http://www.americanstrategy.org/america/home1.html). Rather than a story with a complex narrative structure similar to that of a book, exhibition or interactive multimedia (IMM), the exhibition is made up of a discrete collection of 900 individual photographs and descriptors. Its authors have neither sought to broadly contextualise the set of images and descriptions, or even related one to another. Instead the story has simply usurped the presentational structure of a database. In so doing the story has avoided using contextual information systems like interactive multimedia (IMM), audiovisuals, sub-theme labels etc.

I believe this *artifactual simulacrum* is a natural reaction to the political and museological concerns of the last decade when for many simply making the contents of one's often unseen storehouse visible was a priority. After all there is little doubt that the web can release individual museums from the economic and spatial constraints that limit both collecting and display in the *real* world. Even in my own museum, the Powerhouse Museum, it is estimated that as little as 3% of the total of 380,000 objects in the collection are on display.

However I believe that if the three meta-center typologies are to keep pace with user expectations we need to know that this *artifactual simulacrum* is indeed what both the public and professional sector desire. This is a critical question because we know that in the *real* museum, visitors are not content with such a fractured and decontextualised approach. After all if visitors and museum professionals were merely concerned with passively viewing artefacts, then there would have been little need for the complex interpretive and presentational techniques that have come to dominate today's modern museum. It goes without saying then that if the heritage sector was committed to using the web as an extension of contemporary practice as expressed in current exhibition media, then meta-centers would equally be populated by a plethora of dynamic interactive experiences, just like *real* museums. In essence they would equally embrace a model based around the dynamic and two-way potential of interactive multimedia (*interactive simulacrum*) as they would the artefact.

However this argument presupposes that all meta-center users have the same needs as visitors to the *real* museum. What's more it presupposes users are motivated to visit a meta-center because it provides an experience analogous to the *real* museum. However even if this motivation were true, we know that the social and cognitive complexity involved

with a visit to a *real* museum, cannot in its entirety, be currently replicated on-line. As Falk and Dierking observed when defining the parameters of an effective educational visit, each is determined by the visitor's unique personal, physical and social attributes and contexts. In turn each one of these attributes is mediated by senses activated by the material reality of the visitor's social and physical surroundings. Thus the direct correlation of *real* with *virtual* experiences is questionable. But where does this leave us? Without definitive feedback on user experiences it is hard to gauge the effectiveness of current artefactual meta-center simulacrum. Thus what we decided to do at AMOL, was conduct an evaluation that could help us determine the effectiveness of our current approach.

The need for a summative evaluation

The adoption of a *meta-center* approach by AMOL has been a slow process. After all as Neimanis and Geber (1999) point out the journey from centralised information repository to meta-center, involves constantly re-building the network of connections among site components as well as communication relationships between these resources and users. Since its launch in 1995 AMOL has not shirked this responsibility, and has regularly rebuilt part or all of its architecture in-line with changing technological, museological as well as user expectations. An important milestone in this journey was the redesign and re-launch of AMOL in late 1998. The redesign had four principle objectives:

- To streamline information into three sections;
- To improve navigation and interface functionality;
- To increase contextual information on the site via a series of stories;
- To begin the implementation of Dublin Core metadata standards.

This redesign took two months and eventually the AMOL site was re-launched in October 1998. Exactly nine months later the On Line Working Party (OLWP), responsible for overseeing AMOL, decided to initiate a summative evaluation. Critically the evaluation was seen as a strategic means of exploring new directions for the coming eighteen months,

a critical time for the project for a variety of reasons. It's a period when the efficacy of the Heritage Collection Council (HCC) and its projects, including AMOL, will be closely examined. To facilitate informed discussion it was decided thereafter that we needed to access performance data. Ideally this data needed to be of both a qualitative and quantitative nature and as such a two-stage summative evaluation, focusing on three areas was initiated:

1. Participation rates

To ascertain whether or not any of the new features had encouraged new or repeat visitation we needed to measure and compare the site's usage prior to and after the re-design. In particular we wished to examine the effectiveness of the more 'graphic' interface and new information architecture and whether or not they reduced user frustration and fatigue.

2. User profiles

As *a professional meta-center* AMOL had been principally conceived to service the needs of those working in the Australian museum sector. So it was important to establish that this group was actually using the site. Just as importantly we also needed to know who else might. If as we suspected inbound international and interstate tourists were regular users, or indeed students and educators, a summative evaluation would also help us identify which AMOL resources they preferred. This data would then allow us to examine the feasibility of supplementing the site with additional education or tourist specific resources.

3. User experience

Detailed, qualitative information on program satisfaction was also critical for the purpose of improving certain AMOL services. We needed to be able to gauge the current level of satisfaction with new programs like the Open Museum Journal and costly resources like the contextual stories. There was also a need for information on program quality; an issue which from time to time sparked heated debate on AMOL's Listserve AMF (Australian Museums Forum).

Decoding the visitor

Whilst it has been relatively easy to evaluate the success, or otherwise, of some of AMOLs non-web programs via feedback from *AMF* subscribers and workshop and grant program assessments, evaluation of the usage and effectiveness of the website was more daunting. This is because of a lack of an appropriate, and methodologically rigorous, model around which to formulate an evaluation. So we turned to the *real* museum. Traditionally a summative evaluation of a museum program involves the cross-referencing of visitor tracking studies with focus group discussions, or visitor questionnaires. Likewise we decided upon a two-stage model that used both *positivist* and *postpositivist* approaches to collect and analyze data. The first, a *positivist* approach, analysed statistical data gleaned over a seventeen-month period from the log file reporter WebTrends. These log file tools allow for the compilation of data sets that, when analysed, can aid in the development of participation trend models built around country of origin, referring site and active organisation statistics. Similarly these tools can also provide important indicators of user experience, through their logs of average time per session, entry points, top path and most accessed directory data.

These log file analysis tools are *positivist* as they focus on the quantification of outcomes and thus on measurable performance indicators, effectiveness and efficiency. As Darrell Caulley (1992) reminds us, this kind of reporting of human behaviour has an important function as it responds to the accountability demands of people who expect quantitative and 'value-free' information. In this regard a *positivist* evaluation was deemed appropriate for reporting back to AMOL's senior political managers, who require this kind of quantitative information to make budgetary decisions or confirm overall use/worthiness. This positivist study was carried out by the Powerhouse Museum's in-house evaluation specialist Carol Scott and was completed in October 1999.

The second stage of the evaluation process is about to get underway. Instead of statistical data this *postpositivist* evaluation will utilise an on-line questionnaire and voluntary tracking study to elicit qualitative data. Unlike a *positivist* approach, which tends to yield data of little worth to project managers like myself, we hope this approach would glean important demographic details about individual users such as gender, age, country of residence, type of work etc. This kind of information is particularly useful in helping determine future directions based on current project successes or failures.

Findings from stage 1 – participation rates

Not unexpectedly the statistical analysis of WebTrends data demonstrated distinct fluctuations in AMOL's use. Diminished use over the Christmas and other holiday periods pointed to the seasonal nature of AMOL use. These findings also underscored the fact that a significant proportion of AMOL users were in all probability Australian museum professionals, many of whom took holidays over this period. This summation is indeed backed up by additional WebTrends data on top referring sites. Among the top 20 referring sites over the seventeen-month period, cultural organisations made up over half, indicating that the site is being used extensively by the heritage sector.

There was irrefutable evidence that overall there has been a pronounced increase in the number of hits on the website since the introduction of the new design. From February 1998 to July 1999 the site received over two and a half million hits from 138,380 users. This averages out at more than 270 users a day, browsing/researching for an average of around twelve and a half minutes. This compares to fewer than 200 users per day spending around 9 minutes online before the redesign. Further evidence of AMOLs growing popularity is the number of participants in AMOL's discussion groups. When the current AMOL coordination unit took over in 1998, only 115 people subscribed to the AMOL discussion group *AMF*. *AMF* participation has now increased to 465 and a further two discussion groups have been added: *electricmuse* and *Craft Curator*.

Most interestingly AMF membership is now drawn from eleven countries including Australia, the United States, Canada, the United Kingdom, Japan and Germany. When the logs of user sessions were examined it was found that these countries consistently account for the top 5 or 6 user sessions. Most significantly the evaluation showed a strong correlation between countries accessing AMOL, and those countries that account for the majority of inbound

tourists to Australia. With some estimates of over 5,000,000 inbound tourists heading to Australia annually by 2000, this correlation is hard to ignore. Especially when you consider that despite some cultural aberrations, approximately 30% of all inbound tourists visit a museum or gallery (Scott, 1995). This finding suggests that there is a strong probability that AMOL is being used by tourists to plan their itinerary.

The analysis of WebTrends data also highlighted the success of the new intuitive hierarchical navigation scheme and accompanying information architecture. One of the significant innovations of the redesign was the restructuring of the site and its information into three main streams: Museum Craft, Museum Guide and Open Collections. Prior to this new architecture, the top 10 entry pages accounted for only 37.88% of the total user sessions. These figures suggested that users were spending considerable time finding their way into and around the site before arriving at their destination. However, since the re-design the top 10 entry pages have gone up to an average of 71% of user sessions. Thus we concluded that the division of information in three major categories, was well received and an improvement on the previous architecture.

User experience

As quickly as AMOL usage can fall between 5% and 10% during holidays, it climbs between 15% and 20% whenever we feature a high-profile event like the Pandora Expedition. The Pandora Expedition (amol.org.au/pandora/pandora_index.asp) was one of the new contextual stories designed to add value to collections and individual objects and so far has been the most popular story with 35.64% of total story top entry pages. Unlike the other 14 stories, The Pandora Expedition was not only well publicised, but also exhibited two critical attributes that captivated and sustained public interest: a subject matter that had broad appeal, namely a maritime archaeological dive on an eighteenth century wreck; and its deployment of interactive multimedia. Although the story ultimately didn't deploy the full panoply of streaming media, it did allow divers working on a boat 30 metres above the wreck to post photographs of artefacts recovered to the website, as well as answer emails from AMOL users. As such the Pandora Expedition tried as far as is currently

possible, to adhere to Andy Lippman's criteria for truly interactive multimedia (Ryder & Wilson, 1996).

In recent times, critics like Andy Lippman have often lamented the inherent lack of genuine interactivity in contemporary IMM. As is the case with many closed, museum-based IMM, the ability for museum visitors to create and customise their own content is very limited. To avoid this and provide a genuinely engaging and appropriate use of media like the web, Lippman has suggested we should attempt to develop experiences that can accommodate:

- *Interruptability - the ability of either participant to interrupt the other at any point.*
- *Graceful degradation - the ability to set aside the unanswerable questions in a way that does not halt the conversation.*
- *Limited look-ahead - the quality that makes it impossible to predict the ultimate outcome of a conversation by either party.*
- *No default - a quality which allows the shape of a conversation to develop naturally, organically, without a pre-planned path.*
- *The impression of an infinite database - the quality of limitless choices and realistic responses to any possible input.*

Although the Pandora Expedition is but a single story amongst hundreds of AMOL resources, it is one of the few to attempt to embrace Lippman's criteria and so successfully exchange the *artifactual* for the *interactive* simulacrum. Superficially this exchange may seem of little consequence for the vast majority of AMOL's current patronage, who at least in quantitative terms, seem largely satisfied with the site. However I believe the lessons learnt from Pandora are critical if the AMOL project is to not only attract new educational and tourist users, but also maintain heritage users in future. By definition the meta-center concept has evolved as a response to users desires for more responsive, easy to find and authoritative information repositories. But as the public's appetite for multimedia experiences like streaming audio and video grows, the types of information, as well as presentation mechanisms employed by meta-center's will likewise need to expand. As such in the not too distant future meta-center developers will need to consider ways and means of incorporating the vast as yet untapped

museum audiovisual and interactive holdings. Reassuringly this seems to already be underway with CIMI currently investigating the feasibility of an XML test bed project. In addition if tomorrow's meta-centers are to truly embrace the *interactive simulacrum* they will also need to negotiate the difficult shift from information provider to information broker. This again is easier said than done. Where the current open architecture of some affordance technologies like IRC, CuSeeMe and artificially intelligent MUDs (multi user dimensions), makes this possible, large parts of the heritage sector are still very reluctant to 'give-up' or 'compromise" authorial control!

The major challenge will be to evolve meta-center typologies to a point wherein imagery, objects text and speech are more widely available. In addition we will need to look to encourage the development of information composition, creation, editing and curatorial tools that can genuinely customise information to meet the unique needs of users. Admittedly we are still some way off achieving this utopian meta-center, but perhaps in the not too distant future a visit to AMOL might be a little more engaging…

Imagine you have just clicked on AMOL's new 'Living Museum search facility.' Before beginning you enter a few personal details onto a specially designed page: age, education, interests, how many times you have visited the site previously etc. An avatar then asks you what kind of resources you are seeking. You respond by indicating an interest in indigenous music. Drawing upon AMOL's array of textual, graphic and video databases you are then presented with a number of potential stories. You select the *ngaramang bayumi* story, which examines contemporary indigenous music and dance. Seconds later a streaming video complete with embedded images, text and sound appears. At any stage you can tunnel into the video, acquire individual information sources, and then later on retrieve these as a newly constituted and uniquely personal composite record. Importantly you are not alone in this microworld, simultaneously a school student studying Aboriginal land rites and a German tourist planning a holiday to Arnhem Land, are present as animated avatars. Using IRC or speech synthesis software you can converse with either. However you keep to yourself and instead are drawn to a showcase wherein Tiwi Islander music and a spinning artefact have been activated by your presence. As you move in close you notice a headdress rotating and the Tiwi islander descant fades to a single voice explaining the process of making the headdresses. The system has recalled that on a previous visit you spent time exploring the construction of African masks. Thus it determined that similarly you may be interested in this specific sub-story. Moving along you notice some images of Tapa cloths, which as you scroll over activate an avatar that recounts their provenance. The avatar's voice and indeed actual Tapa cloth imagery have all been supplied by a collector based in Phoenix, Arizona.

References

Australian Bureau of Statistics. (1999). *Australia Now - A Statistical Profile: Culture and Recreation Museums and art museums.* http://www.abs.gov.au/

Caulley, D. (1992). Overview of Approaches to program evaluation: the five generations. *APS Pathways to Change in the 1990s – Program Evaluation in the Public Sector Conference*, 6 & 7 April, Sydney.

Neimanis, K., & Geber, E. (1999). *Come and Get It" Seek and You Shall Find: Transition from a Central Resource to an Information Meta-Center.* Museums and the Web Conference, New Orleans.

Robotham, J. (Feb 6, 1996). *The Digerati*, Sydney Morning Herald, p1. The term Infopreneurials, or digerati, refers to a prominent businessperson working in information technology or the information industry and includes the likes of Bill Gates and Steve Jobs etc and domestically Sam Mostyn, Steve Vamos and Rupert Murdoch.

Ryder, M., & Wilson, B. (1996). Affordances and Constraints of the Internet for Learning and Instruction. *Association for Educational Communications Technology Conference*. Indianapolis, Feb. 14-18.

Scott, C. (1995). To market, To market: the inbound tourist and Museums. Paper presented at the *Museum's Australia* annual conference, Darling Harbour, Sydney.

Sumption, K. (1999) *Virtual Museums - primitive rebirth or synthetic recovery? An examination of the role and value of <u>real</u> museum experience in the development of on-line education programs at the Powerhouse Museum.* Master of Arts thesis, University of Sydney.

Wertheim, M. (1999). *Pearly Gates of Cyberspace: A History of Space from Dante to the Internet.* Los Angeles, W.W. Norton & Company.

Building the Next Generation Collaborative Museum Shopping Site: Merging e-commerce, e-museums & entrepreneurs

Chris Tellis, Antenna Audio, and Rebecca Reynolds Moore, MuseumShop.com, Inc., USA

Abstract

In March of 1999, MuseumShop.com and Antenna Audio formed a new strategic partnership. The objective was to leverage the product awareness of bricks and mortar museum shops throughout the world into an innovative partnership between museums, the leading museum e-retailer, and the leading audio tour provider. On its first year anniversary together, the site has experienced dramatic growth and achieved recognition by Gomez.com as a leading online gift-shopping site. This paper examines the successes and failures of the initiative and its impact on museums using the Web. How has the consumer market and museum industry responded? How has the financial and interactive community responded? The paper describes what synergies emerged from the partnership and how interactive and public media is used to maximize museums' e-commerce initiatives. The authors will describe the overall state of museum e-commerce in North America and Europe, what products have been successful, which museums have benefited and for what reasons.

Museum Store Growth...a Brief History

At the inaugural Museums and the Web Conference in 1997, some museum professionals expressed concern that online exhibitions would deter visitors from their physical museums. Three years later museums accept the fact that their online exhibitions attract new visitors from all corners of the world and help to build global recognition of their physical exhibitions.

Today, museum leaders are now concerned that they are missing out on the Internet commerce gold-rush. The museum world has historically experienced a strained relationship between exhibition and merchandising initiatives and the Internet can exaggerate this rift. Museum stores managers are notorious for being considered as the stepchild of museum staff and are still viewed by curators and educators as "money changers on the steps of the temple of knowledge". Even purist museum visitors often sniff at the "inevitable" retail stores positioned at "blockbuster show" exits and the proliferation of Mondrian ties and baseballs signed by Cezanne. The Internet can be used as a tool to quell the conflict between curators' drive to educate and museum retailers' drive to grow revenues by turning merchandising into educational outreach.

Turning Merchandising into Educational Outreach

Markets and commerce are a vital part of public life. At their best, museum stores can serve as extensions of exhibition spaces, whose educational and artistic inspiration can directly influence purchases. Like museums, shops are public forums where people mingle to exchange ideas and compare esthetic (albeit often materialistic) values.

Consumers' desire to buy goods and services can provide a gateway to the core mission of the parent institution, beyond the simple purchase of an exhibition catalogue. Back in the 1970's and 80's, the Museum of Modern Art in New York spread its "brand" around the country by distributing it's products in upscale gift shops nationwide. And newer museums, like MOMA in San Francisco, have placed their commercial side on the street level and facade of the institution, so that shoppers and cafe dwellers can slip right through the merchandising interface into the core of the museum.

The goods and services museums provide are more than simple revenue generators. In their best form, the products are commercial ambassadors that project the museum's trademark into the outside world, promoting the institution and suggesting the

virtues of a visit. In their worst form, "museum-like" products without genuine connection to museums' exhibits risk exploiting museums pristine image and actually turn-off to visitors; possibly the greatest fear of museums.

Commercial Partnership Prudence

For this reason museums are very careful about the products they develop and the commercial partnerships they form. Museum's commercial activities are eternally bound by the educational mission and the purist aesthetics of each institution and it's target audience. The Metropolitan Museum of Art would not allow a Burger King franchise in its cafe, yet across Central Park, kids and adults delight in consuming "Dino Fries" at the American Museum of Natural History. At the same time, the AMNH will not sell a Buzz Lightyear doll in its Rose Space Center.

To help mediate this balancing act, museums can form strategic partnerships with firms that have experience straddling the for-profit and non-profit world and that understand the sensitivities required to successfully market educational products and information. The most successful partnerships shield museums from the financial risk and capital investment necessary to develop large commercial activities, while carefully leveraging the museums' products and services through collaborative initiatives.

An E-Commerce Case Study

One example of a new form of strategic partnership was launched by Antenna Audio and MuseumShop.com in 1999. Antenna Audio is a fifteen year veteran of museum services, providing audio tours for most of the world's major museums, including, the Vatican the Louvre, The Metropolitan Museum of Art, Museum of Fine Arts, Boston and the J. Paul Getty Museum of Art. MuseumShop.com is a two and a half year old "dot com start-up", and already is the largest provider of online stores for museums, linking together the products of over forty North American and the major European museums.

The goal of this alliance was both to combine the international sales force and museum network of Antenna with the Internet and E-commerce exper-

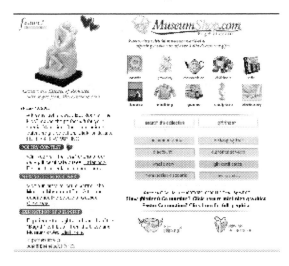

tise of MuseumShop.com, and to partner with museums globally. The partnership was based on an understanding that there would be restrictions on the products sold; only those products developed or distributed by partner museums were to be displayed and sold on the MuseumShop.com Web site. Similarly, all of Antenna's audio tours are produced in direct collaboration with client museums' educational and curatorial departments.

Museum Reaction

Although the joint venture is only nine months old (an eternity in the Internet world), it is clear that this product and content exclusivity is key to its success. The Internet projects museums into a vastly larger potential audience than ever before, and the partnerships developed in cyberspace are critical to assuring museum buy-in. Museums reactions have been favorable to a Web site that combines and leverages the product and content that has already been developed by fellow museums in a complementary manner.

Consumer Reaction

Consumer reaction has also been favorable to the display of thousands of products and content from a consortium of museums and products that have never before seen together; and in ways that are not possible in click and mortar stores. This is a prime example of how the Internet now is forcing museums to think in new entrepreneurial ways about promotion and the relationship between and the collection and the commercial products. The

MuseumShop.com Web site provides consumers with a gateway to museums in new and powerful way.

MuseumShop.com attracts visitors who are looking for gifts. Yet they have click-through potential to the Museum in ways that would never be available to a Crate and Barrel shopper who picks up a MOMA teakettle. This is where Antenna enters the equation. In the last five years, random access players and digital audio have led to the development thousands of audio messages linked to specific images. With the museum approval, digital images and digital audio can now be linked and distributed through a variety of different platforms, including the Internet. MuseumShop.com was rated in Fall of 1999 by Gomez.com #1 in Online Resources and # 5 overall for their Internet Gift Store Scoreboard < http://www.gomez.com> and in February 2000 by Forbes.com as a Best of the Web in the Perfect Gifts category < http://www.forbesbest.com>.

Financial & Internet Community Reaction

The financial and Internet community has been enthusiastic about the partnership's growth, in part projected by press such as Internet.com's rating of MuseumShop.com as one of the Top 20 Internet Companies for 2000 < http://boston.internet.com/views/article/0,1928,2011_299291,00.html >.

How the E-Commerce Collaboration Works

Every partner museum on MuseumShop.com benefits from a custom home page or "Microsite" that provides information and links to the museum's primary Web site. For those museums that are interested, Antenna and MuseumShop.com display audio-visual highlights of representative works from each museum's permanent collection. When visitors click on representative images, the screen fills up and plays the associated descriptive audio message. The visitor hears selected educational audio clips about the images that are identical to the ones they would hear if they visited the museum in person.

Antenna and MuseumShop.com also produce exhibition spotlights for museums' temporary exhibitions. These mini-Web experiences display sound and images often with introductions by the museum Director or exhibition curator, along with information pages describing the exhibition, links to ticketing, and selected thumbnail images, again expandable by clicking through to bring up the image and hear the audio stop.

The net result is a simple-to-use online multimedia experience that allows Web shoppers from around the world to sample and consider a visit to the host museum. The exhibition spotlight repurposes content, already developed and funded by the audio tour programs, into an effective format that attracts visitors to the site and informs them about the parent institution. The audiovisual productions currently require a Flash 4 plugin and offer a link to download; today Flash 4 is bundled on most 4.0 and higher browsers. The content programming for each of the sites is financed by Antenna and MSC.com and is provided free of charge to partner museums for use on their site.

The first online spotlight was designed for the Bugatti exhibition at The Cleveland Museum of Art.

Even though the exhibit closed in October, the exhibition spotlight has been popular and Cleveland's product sales were among the highest on the site during the Christmas season. Antenna and MuseumShop.com are now producing exhibition spotlights and features for the *Faces of Impressionism: Portraits from American Collections* exhibition and its permanent collection, as well as the permanent collection of The Minneapolis Institute of Arts, the Whitney Museum of Art and several major European Museums (to be publicly announced in March of 2000).

Online Merchandising: A Different Beast

The new form of audiovisual merchandising and cobranding on MuseumShop.com duplicates in the virtual world in way that is similar to the proliferation of physical satellite stores within and outside of museums. Yet it is important to emphasize that the transition of physical retail stores onto the Internet is not seamless and requires very different skill sets. The media frenzy over the success of the Internet and the speed of its growth and metamorphasis has left many museums convinced that they are missing out on a huge opportunity but baffled as to how to develop an Internet strategy that does not compromise their mission.

In their effort to quickly establish an Internet strategy, most museums underestimate the true capital and human resources required to build, manage, and market a sophisticated online store. Few museums understand the extremely high expectations of online customers (most expect next day delivery

of orders and 7 out of 10 customers will contact the museum via phone or e-mail to inquire about their order) . Few museums understand the complexity and cost of providing superior shipping and customer service logistics on a large scale. And even fewer museums understand or can respond to the flexibility of business models required to survive in the Internet world. The entrepreneurial structure of MuseumShop.com allows it to assess and adjust its business model according to the changing Internet tide.

The objective is to build a site that will allow armchair travelers to sample and shop from museums around the world. In the highwire world of the Internet, after only two years, MuseumShop.com is already a veteran. In the early fall of 1999 MuseumShop.com closed its first round of venture financing that enabled them to proactively address several areas.

E-Lessons Learned

One example of this was managing e-commerce shipping logistics. Initially, all MuseumShop.com products were "dropped-shipped" to customers directly by each museum partner. As the volume of orders increased exponentially and as customers increased their orders from multiple museums, customers began to experience high shipping costs and inconsistent fulfillment across museums. Since many museum partners did not have permanent staff to handle Web shipping initiatives, the museums had a challenging time keeping up with the inevitable holiday shipping influx. To address this, MuseumShop.com decided to manage its own warehouse and

fulfillment center. Now museum partners' products are shipped directly to the Ohio warehouse, which enables MuseumShop.com to guarantee to customers same day shipping of orders received by 2pm (EST) and next business day shipping of orders received after 2pm (EST). This makes e-customers happy.

In order to defray the costs of bringing on new museums, MuseumShop.com initially charged an annual set-up/networking fee that was prohibitive for some museums. This fee is now waived for all museums with over 750,000 visitors annually, and reduced for all other museums. All museums are eligible for exhibition previews and benefit from MuseumShop.com's public relations and marketing initiatives.

Portal and Marketing Plays

All museum partners benefit from MuseumShop.com's active marketing and positioning on the major shopping portals including Yahoo! and Excite as well as through affiliate marketing programs powered by LinkShare and other online bots. Additionally, partners benefit from public relations and promotional initiatives.

How Museums Participate & Benefit

The process of becoming a partner museum is simple. MuseumShop.com either purchases products from the museum partner at wholesale or consigns products from the museum partner giving the museum partner a commission when the product sells. Most museums opt to sign up for the wholesale relationship as it is no different from setting up a bricks and mortar outlet. MuseumShop.com handles all aspects of the production of the partner's Microsite, all secure credit card transactions, customer service via e-mail and phone support, and all refunds and credits. This relationship makes it very easy for museums to participate and join the ranks of the growing collaborative including 40+ museums across the world.

Overcoming Resistance to the Collaborative Model

Any resistance to joining the venture primarily comes from museums that wish to go it alone or museums that have not yet determined how they should participate in the e-commerce world. Some museums fear that they may miss a cyberspace opportunity or that MuseumShop.com will cannibalize their own online shop's sales. However MuseumShop.com attracts a fundamentally different visitor from those visiting a museum's own online store. As demonstrated by Jonathan Bowen's paper, Time for Renovations: A Survey of Museum Web Sites, at last year's Museum and Web conference <http://www.archimuse.com/mw99/papers/bowen/bowen.html> which measured visitors to museums' Web sites and discovered that the vast majority of visitors to museum Web sites seek museum collection and exhibition, and schedule information, while only a fraction of a percent of visitors click on the museum's store (The percentage of those that purchased products was not measured). Visitors to a museum's Web site may take a path from a Monet exhibit to a Monet scarf, but very rarely start at the scarf itself. MuseumShop.com's objective is to attract the visitor who is seeking a scarf to the Monet exhibition that inspired the scarf's design on its partner museum's Web site; and simultaneously to sell the Monet scarf. MuseumShop.com targets its marketing initiatives to online shoppers seeking gifts with cultural significance.

History Repeats Itself: Outsourcing Makes Sense

Antenna Audio's experience in the early days of audio tours is telling. Many of the major museums initially spent significant resources attempting to set up their own audio tour divisions. But the distractions and complications of not being thoroughly in the audio tour business caused all of these ventures to eventually die. Like the audio tour business, e-commerce is difficult and expensive to manage on a large and sustainable scale. Millions of Web sites compete for visitor's attention with the largest 10 sites comprising over 50% of Web traffic. Single destination sites will have an extremely difficult time attracting visitors and customers. Those e-commerce sites that survive will amalgamate a critical mass of affiliated sites in order to defray the exorbitant cost of financing the ever-changing technology, promotion, advertising, and logistics needed to be successful. Museums will end up collaborating with entities and outsourcing much of their e-commerce activities.

E-Competition

New competitors to the museum Web industry proliferate daily. There is a new outpouring of Web sites claiming to be the next museum "portal" including museum.com; destinationblvd.com; museumnetwork.com, and wwar.com, and even bricks and mortar retailers like The Museum Company. Many of these sites have links to individual museum's Web store pages. All that is required to create links to museum Web sites and store fronts is basic html skills. Providing a single point of ordering, customer service, and logistics for a consortium of museums is far more complex. There are also a preponderance of art and poster sites wooing museum merchandisers including art.com, barewalls.com, posters.com, and ImageExchange .com; each with a different approach. Finally, it has now become inexpensive for anyone to develop a store on Yahoo! and benefit from the high volumes of traffic and reporting tools; but in order to effec-

tively sell products online, museums still need to invest in Web designers and staff to continually update the site, manage inventory, handle secure credit card transactions, provide real time customer service, and ship individual products to each customer. The far greater challenge is developing large scale museum partnerships that effectively merchandise through educational outreach.

Conclusion

The Antenna/MuseumShop.com/museum partnership is a unique business model that promotes the products of museums retail, curatorial, and educational departments in a new collaborative model. This model builds on the collective brands of all the participating museums while providing new visitors and sales. This collaborative e-commerce model is generating encouraging results that should provide valuable lessons for museums that seek to expand their audience and revenue-generating opportunities on the Web.

Canada's Digital Collections: Youth Employment Opportunities and Canadian Content On-line

Nora Hockin, Information Highway Applications Branch, Industry Canada, Canada

Abstract

Since 1996, *Canada's Digital Collections* (CDC), a federal government program, has been helping organizations across Canada build a stock of high-quality Canadian content on the Internet. The central focus of the program has been to provide on-the-job experience in information technology for young Canadians. Using an innovative approach to youth skills development and employment in the information technology sector, CDC provides funds to museums, libraries, archives, firms, schools and other organizations to hire teams of youth to digitize significant Canadian holdings and create dynamic multimedia web sites. One of the most important sources of Canadian content on the Internet, *Canada's Digital Collections* currently houses over 350 web sites. Subjects range from treasures of Canadian institutions, such as the National Library, the National Archives and the Museum of Civilization to the local histories and way of life of Canadian communities. Visitors to the CDC web site use materials from the collections at a rate of one and a half million pages per month.

This paper will present an overview of *Canada's Digital Collections* as a model for digitization of museum holdings and materials. Three key aspects will be highlighted in particular: the use of alternative fiscal resources (youth employment-allocated funds) as a means funding of digitization projects; the development of an accountable and economical program design to facilitate digitization; and the fostering of partnerships among governments, cultural institutions and entrepreneurial youth as a means of leveraging value-added results in digitization. Examples are also provided to demonstrate successful new programs created from the CDC model.

Canada's Digital Collections and the Canadian Museum Community

Canada's Digital Collections (CDC), a youth employment program of the Government of Canada, has played a major role in helping Canadian cultural institutions develop web sites to fulfil their public education mandates. Since its inception in 1996, the program has supported over 400 projects. 76 have been completed using resources from museums (Appendix A). Over 350 web sites – "digital collections" – are currently available through CDC's portal site. The number of visitors to CDC collections grows by the day, with the latest data indicating that over 1.5 million pages are downloaded monthly. Also increasing steadily are the number of awards won by both CDC collections and the CDC site itself.

The digital collections themselves vary substantially in size, sophistication and subject matter. Some of Canada's largest museums have participated in the program. These include the Government of Canada's *Museum of Civilization, National Aviation Museum and National Museum of Science and Technology* as well as provincial museums such as the *Maritime Museum of British Columbia*, the *Royal Ontario Museum* and *the Nova Scotia Museum of Natural History*. At the same time, smaller institutions such as the *Fraser-Fort George Regional Museum*, the *Huronia Museum* and the *Ukrainian Cultural and Educational Centre* have also used CDC support to present local or regional content.

The great variety among participating institutions is mirrored in the diversity of the subjects presented. Collections cover materials from all disciplines, including fine arts, sciences, education and political science. Indeed, many collections address Canada's heritage and history.

Below are some examples.
- *The Point Ellis House Collection of Household Victoriana* from British Columbia provides viewers with a glimpse of the past, as they explore Point Ellis House, a Victorian mansion and gardens restored to their former glory.

- The *Tom Thomson Memorial Art Gallery* collection from Owen Sound, Ontario gives all Canadians an opportunity to view the works of one of Canada's greatest artists.
- *Donation Maurice Forget* is the electronic version of a catalogue of 400 works of modern and contemporary Canadian art donated by Montreal art collector, Maurice Forget, to le Musée d'art de Joliettte. According to Museum Director France Gascon, this CDC web site has earned rave reviews from artists, art historians and the general public.
- Several sites focus on Canada at war. The award-winning *Jack Turner's War*, for instance, features an extraordinary collection of photographs taken by a Canadian soldier on the front lines during the First World War.

Those who love science will find plenty to look at:
- *Nova Scotia Fossils on the Web*
- *Science World's Exhibits On-Line*
- *Virtual Maritime Museum*

The unique histories, culture and environment of Canada's regions, peoples and small settlements are also prevalent:
- *The Tignish Museum* (Nova Scotia)
- *The Luxton Museum of the Plains Indians* (Alberta)
- *Bush Flying in the Development of Western Canadian Aviation*
- *The History of Lumby - From Grassroots to Treetops* (British Columbia)
- *The Potato Then and Now* (Prince Edward Island)
- *Les Clercs de Saint-Viateur à Joliette: la foi dans l'art* (Quebec)
- *The Newfoundland Salt Fisheries* (Newfoundland)
- *Old Crow: Land of the Vuntut Gwitch'in* (Yukon)

Canada's national museums and major heritage institutions are well represented on the CDC web site. The *Canadian Museum of Civilization* has participated in several projects, including *Virtual Storehouse*, a site which provides a behind-the-scenes view of the museum in more than five hundred images. The *Canadian Museum of Civilization* also contributed objects to an experimental project in three-dimensional imaging. The *Canadian Museum of Nature* created *Natural History Notebooks*, a digital version of

one of the museum's most popular publications. *High Flyers: Canadian Women in Aviation* is only one of several digital collections produced by the *National Aviation Museum* (NAM). In this case, NAM successfully employed a team of young, single mothers on the project. The *National Archives of Canada* worked with a school in the Northwest Territories to create *The George Back Collection*, which presents watercolours from the notebooks of George Back, who was a member of the first two expeditions of Sir John Franklin in the Nineteenth Century. The *National Library of Canada* has also worked with *Canada's Digital Collections* to produce a number of web sites. Two of these collections, which could equally well have been produced by a museum, are the *Glenn Gould Archive* and *North: Landscape of the Imagination*.

Whether national, regional or local in focus, collections must all be about Canada and of a broadly educational nature. The result is a rich source for Canadian content on the Internet, enhanced, in many cases, by teaching and learning resources in the form of activities, teaching units and educationally-endorsed materials. A number of these educational components were produced by student teachers at Faculties of Education with CDC support. For example, *Queen's University* developed curriculum modules covering topics from Social Sciences to Fine Arts for a variety of grade levels.

By Spring 2000 a data base of CDC educational resources will be available on-line, permitting direct access to specific activities based on any or all of the following categories: subject matter, grade level and region of interest. In another welcome development, custodial institutions are partnering with provincial ministries of education to ensure that the web site they produced receives official endorsement for use in the school system.

Origin and Evolution of the *Canada's Digital Collections* program

Although CDC has become one of the largest on-line repositories of Canadian content, developing web sites is actually a by-product of the program, whose mandate is to offer employment opportuni-

ties to young Canadians in the multimedia sector. Indeed, the CDC model demonstrates how much can be achieved by creative, yet appropriate, uses of public programs. CDC's origins can be traced to an Industry Canada project undertaken in 1995 to demonstrate that materials could be digitized in an economical way using youth labour. Canada's *Books of Remembrance* were selected as a trial case. Housed in the Peace Tower of Canada's Parliament Buildings, these books record the names of all of Canada's war dead from the Nile Campaign to the Korean conflict. Each day a page is turned in each book. This means, of course, that should anyone wish to see a specific page, he or she must plan a trip to Ottawa to coincide with the date on which the page is visible. A photocopy of the page can also be requested.

In collaboration with *Veterans Affairs Canada* and the Sergeant-at-Arms, custodians of the Books, Industry Canada contracted with two Ottawa-area high schools and a middle school in Newfoundland to digitize the Books, using full-colour photocopies as the source material. The resulting digital collection remains CDC's most popular site. Moreover, since the Books have been on-line, requests for photocopies of pages have jumped.

Having proved that economical digitization was feasible, Industry Canada then tested this approach further in a pilot phase. Other federal government departments and agencies, including the *National Archives*, the *National Library* and major Government of Canada museums, were asked to participate. The results were, on the whole, impressive and these departments and agencies continue to seek support from CDC to help in their on-going digitization efforts. Some 21 federal departments and agencies have partnered with CDC.

The completion of the pilot project coincided with the introduction of a new federal initiative—the Government of Canada's *Youth Employment Strategy* (YES)—which offered a potential opportunity for continuation of CDC. YES was created in 1996 following cross-country consultations with young Canadians to discover their views on their employment situation and to identify potential barriers to securing jobs. "No experience, no job and no job, no experience" described the biggest barrier they face in getting career-related jobs: there needed to be a better transition from school to initial employment opportunities. In response, the Government of Canada developed YES, which is delivered in partnership with business, labour, industry, not-for-profit organizations, communities, and provincial and municipal governments. Since 1996, CDC has received YES funding to provide short-term (maximum 16 weeks) employment to over 2,300 young Canadians, 15 to 30 years old.

CDC Program Model

The basic CDC program model is straight forward. Contracts of up to $25,000 are available to create web sites with Canadian content, the funds to be used to pay the wages of the young people who undertake the digitization and web site development work, plus a premium for administrative costs. Custodial institutions may compete for a contract to receive funding to hire the young people, and other potential contractors like schools, non-governmental organizations, firms or teams of young people may partner with a custodial institution but submit the proposal themselves. In the latter case, letters from custodial institutions are required to ensure the necessary access to materials and the continuing professional supervision of the content of the collection. Contractors are required to ensure that they or their custodial partners own copyright to the materials to be digitized or have secured permission to include the materials in the digital collection. Copyright in the digital collection itself remains with the legal entity that owns the copyright to the original materials.

Proposals are submitted at three deadline dates a year and selected for support through a competitive process. All proposals are reviewed by one of three independent, arm's-length adjudication committees from the archival, library and museum communities.

CDC Benefits to Participating Institutions

Since $25,000 is not a large amount of money, it may be asked why and how this program has managed both to attract the participation of so many cultural institutions and other contractors and produce so many publication-quality web sites. There are two key reasons apart from the obvious one that institutions are financially-constrained. First, a felicitous mutual benefit is at work. Museums, libraries, archives, universities and other custodial institutions want to produce web sites. Teams of young people need material to work on. Hence, custodial institutions both benefit from and contribute to CDC. Youth receive cutting-edge employment experience and have the opportunity to enrich their knowledge of Canada by working on the project. Second, CDC offers participants a highly structured support system and detailed program and project guidelines. An in-house technical team monitors the progress of every site under development on a weekly basis and provides assistance at any time by e-mail or telephone. Similarly, CDC program officers monitor the development of the content on a weekly basis and ensure editorial and quality control (e.g. navigation of the site is easy and logical, writing is of a good standard with proper grammar and spelling, appropriate references are made, content is acceptable for general public viewing). Current CDC officers include professional archivists, librarians and editors.

This concept of on-going review was introduced following the pilot phase of the program. As the pilot came to a close and sites were examined, it quickly became apparent that contractors had underestimated the amount of time needed for editing and that a substantial amount of clean-up work was needed on many collections if the web sites were to be published on a federal government site. Weekly monitoring catches problems in the early stages when remedial action can be undertaken easily and cheaply. It also enriches the business and technical experience of the young people working on the project.

Experience with the pilot resulted in two improvements to the program guidelines:
* the requirement that 10% of the project budget and time be reserved for use at the end of the project for final editorial and technical corrections; and
* the requirement that a storyboard be submitted prior to receiving the first installment of funds to ensure that proper planning for site organization and navigation is undertaken.

CDC also provides a number of on-line documents useful to both applicants and contractors. Along with the program guidelines, the most important documents include:
* *Model Proposals* (successful project proposals) so applicants can better understand the nature and level of information to provide;
* a *Development Guide* and *Design Guidelines* that lay out technical specifications; and
* *Projects for Libraries and Archives* that provides assistance specific to the needs and interests of these institutions.

This combination of documentary and professional CDC staff support means that no team or institution is obliged to try to complete a project all on its own. This is especially important considering that CDC projects represent first experiences in web site development for most youth team members and many contractors. Although the multimedia knowledge and skills of young people and in cultural institutions today is vastly superior to that of 1996, the value of CDC's support systems in ensuring quality control is demonstrated daily.

Youth Entrepreneurship

In addition to providing youth employment opportunities and on-line Canadian content, CDC has spawned the development of several youth-run multimedia firms. Here are two examples.

Troy Whitbread is a young man from British Columbia who worked on two YES-funded CDC projects under contract to the *BC Department of*

Museums and the Web 2000

Small Business, Tourism and Culture. The experience gained on these projects helped him set up his own multimedia firm, *Heritage Alley Internet Productions*, which is running successfully today. *Heritage Alley* has in turn been parent to five other grassroots Web design companies in British Columbia. Several of the sites on which Troy worked have received awards and accolades from a wide variety of sources, including Yahoo Canada and the BC government. Troy is currently working at the Smithsonian Institution in Washington, D.C., where he has developed "Moving On-line: Crossing the Digital Divide," a program to train museum technicians in Internet and HTML skills for digitization of holdings.

At the other end of the country, in Prince Edward Island, a group of young people recently established a new media firm called *Silverorange*, based on its experience with CDC projects such as *The Potato: Then and Now*. This firm designed the new look for *Veterans Affairs Canada* web site in the summer of 1999.

Canada's Digital Collections as an Exportable Program Model

The CDC program design has been used as a model for other programs at the Canadian federal and provincial levels. The pilot *Aboriginal Digital Collections* program (ADC) was the first exported use of the CDC program model. Introduced in the 1998-1999 fiscal year, ADC aimed to increase the number of collections focused on Aboriginal topics and developed by Aboriginal contractors and youth. The reasons for pilot testing a targeted program were several. First, there were few proposals submitted to CDC by Aboriginal groups and on Aboriginal topics of importance to the community. Second, there was an urgent need in Canada to ensure improved communication of Aboriginal concerns, history and culture both among Aboriginal groups and to the broader public. Third, the proportion of young people within the Aboriginal community as a whole was much higher than in the rest of Canadian society. These young people will soon be coming on the labour market and need opportunities to gain skills and experience if they are to find meaningful employment. This is especially critical because the unemployment rate among Aboriginals is also much higher than in the Canadian population as a whole.

CDC implemented this pilot program in partnership *Aboriginal Business Canada* (ABC), a special operating agency of the Industry Canada. ABC was interested in collaborating because the program met a variety of its own objectives e.g., aboriginal youth employment, entrepreneurship training, establishment of youth-run firms in the information technology sector and dissemination of information about aboriginal business on the Internet. The pilot proved very successful with some 130 proposals submitted, 38 contracts issued and 152 Aboriginal youth employed. Over 30 resulting web sites are displayed on the ADC web site (http://aboriginalcollections.ic.gc.ca) and *Spirit of Aboriginal Enterprise* web site (http://sae.ca). The *Aboriginal Digital Collections* pilot is being evaluated. In the meantime, CDC is accepting proposals for projects of the type funded under the pilot project.

A second spin-off is the recently launched *BC Heritage Web Sites* program. This program is a collaborative effort of *Industry Canada*, *BC Heritage Trust*, the *BC Ministry of Small Business, Tourism and Culture* (MSBTC), *the BC Ministry of Education* and the *BC Museums Association*. One of its goals is to encourage more web site development by smaller and rural cultural institutions in BC in order to encourage a stronger regional on-line presence in the province. The *BC Heritage Web Sites* program follows the CDC model in most respects, including its focus on youth employment, but offers a maximum of $15,000 per project. The first competition was held in January 2000. Further competitions will be held throughout this year. This partnership between federal and provincial governmental organizations is a prototype that, it is hoped, will lead to similar arrangements with other provinces.

Design of the CDC Program: Objectives, Components, and Delivery

The remainder of this paper explains the CDC program design in greater detail for readers who may be interested in implementing a similar program.

CDC Program Objectives

The *Canada's Digital Collections* program aims to:
- provide young Canadians in all parts of Canada with initial work experience in the multimedia sector;
- provide wider access to Canadian content of public interest via the Information Highway;
- promote the development of the Canadian multimedia industry and, in particular, position new youth-run enterprises for success in the marketplace; and
- demonstrate the economic benefits of digitization.

CDC Project Proposals

Canada's Digital Collections holds three competitions per year for distribution of project funding to organizations via contracts. Prior to submission of project proposals, applicants are required to develop detailed plans for the execution of projects. This planning is somewhat time-intensive but ensures that proposals are immediately realizable. Proposals may be submitted by custodians of material to be digitized or by third parties acting in partnership with custodians. Third parties include multimedia firms, public and private institutions, organizations, and individuals. Custodians may act as contractors and manage the digitization teams as well. The level of support and funding that custodians or other partners contribute to a project is taken into account in selecting the projects to be supported. Maximum leverage of the federal investment is sought.

CDC funding only covers the youth wages and a small administrative overhead. Consequently, participating organizations must also provide financial and/or in-kind contributions such as equipment, infrastructure and salaries. These contributions from partners or program participants ensure leverage of 100% to 250% of CDC funding and help make CDC a cost-effective government program.

CDC Documentation

Key program documentation is described below and may be found at: http://collections.ic.gc.ca/E/program.asp:

1. *Call for Proposals*: This document explains CDC program objectives and program description, proposal requirements for eligibility, copyright, project description, time frames, selection process, terms and conditions.
2. *CDC Project Development Guide*: This document guides teams in the development of their proposals and covers scope, project design and functionality of project proposals; project team capabilities and training requirements; hardware and software necessary for digitization, and Internet access and server provisions.
3. *CDC Design Guidelines*: These guidelines define the site structure, site look and feel, page content, credit and graphics requirements for all CDC projects and specifies the limits for the size of image that may be digitized and stored.
4. *CDC: A Typical Project Cycle*: This document explains what a CDC contract involves, including the processes for adjudication, contracting, hiring, orientation, payment and sign-off, and specifies the contractual deliverables.
5. *Event Planning and Media Relations Guide*: This component is a step-by-step guide on how to promote the contractor's digital collection. All news releases must be approved by CDC.

CDC Competitive Selection Process

Proposals are subject to a competitive selection process. CDC is able to fund approximately one-third of proposals. Submissions are judged by three arm's-length evaluation committees composed of experts on content in the archival, library and museum fields. Committees rank order all proposals submitted to a given competition, taking account of

the following criteria:

- the assurance of sound team management and technical leadership;
- the contractor's ability to guarantee a high-quality product;
- the significance of material to be digitized;
- the suitability of the material for inclusion on the CDC web site;
- the design of the proposed digitized collection.

Industry Canada then makes a final selection, taking account of the need to assure regional balance and of each project's potential for youth employment, enhancement of local economic initiatives and private sector development.

CDC's Fee-for-Service Contracts

CDC funding is provided through contracts of up to $25,000 between *Industry Canada* and an institution, organization, private firm or individual. Monitoring of contracts is rigorous and follows established business practices. This approach ensures that CDC experience provides the youth team members with business skills and knowledge in addition to multimedia expertise.

There is no provision for advance payments under CDC. However, the first of three payments, 20% of the contract value, can be paid based on two weeks of satisfactory progress and submission of youth entry surveys, project storyboard and a detailed project time line. The second payment of 40% of the contract value is made at the mid-point of the contract provided that the contractor's survey, the home page, site navigation and content indicates acceptable progress. Final payment of the remaining 40% is made only on CDC approval of the final product.

Youth hired under the terms of the contract must submit both initial and exit surveys. Contractors must submit interim and final reports, including survey questions, to allow CDC to evaluate the program. These surveys and reports are deliverables incorporated into the terms of the contract. Funds may be used only for youth salaries and a 20% over-

head to cover statutory benefits. Members of the digitization teams are paid $8.00 per hour. Young people with significant previous experience who are hired to manage projects and provide technical support to digitization teams are paid up to $12.00 per hour. Only one such senior youth may be hired per contract.

CDC Time Frames and Quality Control

The time required for digitization depends upon the number, nature and complexity of the material to be digitized, as well as on the number of youth team members. CDC experience shows that a team of four to five young people works well for most projects. Team members generally work an average of 450 hours or 12 weeks full time. The maximum period of employment is 16 weeks full time or an equivalent number of hours of part-time employment. This ensures that the limited funding available to the program, some $3 million per annum, provides employment to a large number of young people.

To receive the initial payment by CDC, the contractor must provide a storyboard and timeline within the first two weeks of the project. These deliverables are reviewed by the technical and content specialists on staff at CDC. Where necessary, suggested improvements to the storyboard and timeline will be forwarded to the contractors. Midway through the project, teams must transfer their homepage and content to the CDC development site (a password-protected site). The content and navigation of the web site are reviewed by the technical and content specialists to ensure that the publication quality standards of CDC program are met. Contractors are informed if there is inadequate editing and proof-reading of the content. In some cases further assistance is given to contractors with projects showing extensive grammatical errors or bibliographical citation problems. Project teams themselves are asked to edit continuously throughout web site development but also to set aside 75-80 hours of each team member's work plan for final edit and quality control. It is the contractor's responsibility to submit a fully edited publication-quality web product for review by the CDC officers and technical support.

CDC Web-to-Database Transaction Processing and Data Management System

Canada's Digital Collections has developed a leading-edge, web-based data management system which generates detailed statistics and creates reports that evaluate program impact and delivery. Project officers use the data to create lists and reports for managing their projects. This efficient data management system eliminates routine data entry so effort can be directed towards service delivery. The software used is the Relational Data Management System (RDMS), SQL version 7, and the Crystal Reporting System. The information in the database comes from the following forms and reports:

- Project Proposals Submission Form;
- Initial Contractor Survey and Interim Progress report;
- Contractor Exit Survey and Final Report;
- Initial Youth Employee Survey;
- Exit Youth Employee Survey;
- Contracts;
- Posting Notices; and
- Default E-mails to Contractors.

CDC Staff Resources

In addition to the structure and the documented technical guidelines that enable even novice participants to execute publication-quality web products, CDC provides contractors with guidance and expert advice throughout the process of developing a Web-based product. Each project is assigned to a project officer and to a member of the technical team. Program staff are available to provide assistance whenever needed.. Frequent project reviews by the technical and project officers ensure that novice web workers are given assistance and on-the job training throughout the whole development of their web sites leading to the consistently high quality of the CDC web sites.

Web Sponsorships: How Museums and Private Companies Can Play Together in a New Playground

Giuliano Gaia, Museo Nazionale della Scienza e della Tecnica "Leonardo da Vinci, Italy

Abstract

One of the things that make the web exciting for museums is that setting up virtual exhibitions is so easy. You don't need much money, nor do you need to alter the physical structure of your museum in any way. This fact is going to change the way museums and private companies collaborate: you don't need "heavy" sponsorships to make your ideas come true. Moreover, new kinds of sponsorships are coming to life. Private firms can give you money, but not money only: they can give you visibility on their websites; they can give you graphic artists or programmers you could never afford; they can host your pages on powerful servers with fast connections. Now that the Internet is booming all over Europe and private companies have started investing more money on their web operations, web sponsorships are growing in importance, and getting companies' attention is becoming easier for a museum. Web sponsorships can also be important as a first step in establishing collaboration; positive results can lead to sponsorships for the real museums. On the other hand, you have to take web operations very seriously, in order to make your sponsors happy. The Milan Science Museum web staff has been setting up this kind of sponsorship since the earliest days of the website; some of them have proved successful, while others have produced little or no results. By presenting some of these case-histories, we hope to provide other museums ideas for their own web-based sponsored operations.

The Milan Science Museum Website

Why should a Museum open a website, and invest in it a relevant fraction of its budget and of the energy of its staff? We at the Milan Science Museum have found four main answers to these basic questions.

To get new audiences

A website can reach new categories of people, who are either physically far away, or out of the usual target of Museum initiatives.

To help the visit

The website is intended as a tool to prepare for the visit to the actual museum, in order to understand better the importance of the objects and to give the visitor the possibility to prepare his own itinerary according to his tastes and interests. Itineraries are a necessity when visiting a 40,000 square meter museum with sections varying from Leonardo to clocks, from ships to trains, from bicycles to aeroplanes.

To experiment with the Virtual Museum

By trying different kinds of "virtual exhibitions" we want to investigate the fascinating problem of the relationship between the museum, the audience, the real objects and their representations. Experiment-ing with the Virtual Museum will teach us something about the deep nature of the real museum.

To enjoy ourselves

Enjoyment is a part not to be forgotten when deciding whether or not start an activity. The web is amusing; you can use your imagination, experiment with many kind of different things, and have an intense feedback from your visitors.

The third point, the virtual museum, is perhaps the most important, and influences also the way we consider web sponsorships. Our Home Page was recently changed in order to emphasise this crucial point. In the centre of the new Home Page there is the image of one of the XVI century cloisters of the

Fig. 1 - The Home Page of the Museum Web Site http://www.museoscienza.org

Museum, divided in two parts: the one on the left has links to all the sections and pages regarding the *Real Museum*, its activities and its collections; the other one, on the right, represents the same cloister in a wireframe version, and is linked to all the sections of the website composing the *Virtual Museum*.

In our vision the website should do on the Net what the real Museum does in the real world: conservation and communication. A few examples of our "virtual" initiatives will clarify what we intend by using the word "conservation" in the Net context.

Links

To link a website from a Museum is saying that that website is valuable on a certain subject among thousands of others on the same subject. The Museum acts as a sort of "certifying institution" of the interest of the content of websites. In this sense we conserve: we try to make the most relevant websites emerge from the big ocean of the Net.

Special sections

On the Italian part of our website there are a dozen special sections treating various subjects, from computer history to naval weapons technology. The content of some sections was not created by the Museum, but found on the Net and hosted in mirror on the Museum website, or, as in the case of the beautiful Atlas of Cyberspaces (www.cybergeography.org), translated from English. We intend this mirroring as a valorisation of valuable websites, in a way stronger than the normal link. Hosting in mirror is also a good way to open new sections of the website with a frequency impossible to maintain if we had to produce all the content ourselves.

3D experiment

One of the most innovative parts of the website is Virtual Leonardo, an experimental co-operative 3D environment allowing visitors to explore a virtual world. Like in a real world situation, a visitor can see where the other visitors are currently located, where they are going, and what they are doing. Visitors can interact with 3D objects, sharing the ex-perience of the interaction with other visitors and "talking" with them through a chat window. (Paolini et al. 1999) Experimenting with new forms of communications is part of the mission of a science museum. A science museum should be not only a place to show the history of science, but also new possibilities for the future; the same should happen on its website.

This focus on the website as a virtual museum has led to an important consequence: that we see our website as an autonomous entity. This autonomy reflects also in the internal organisation of the museum: the webmaster now interacts directly with the director and does not answer to the Exhibitions Dept. or to the Communication Dept.; during the year 2000 a specific department will be created, the "Virtual Museum Department".

As an autonomous entity with an autonomous cultural activity, we try to have autonomous relationships with private companies, since we believe that in the play of sponsorships we are different players from the real museum, and that the playground is different too.

A different playground: a "light" playground

The Milan Science Museum usually operates as a classic museum in two different communication spaces, both of them "heavy":

a) the "real" space (in most cases the museum itself, or outside spaces like schools), in which you can communicate directly with the public, with collections, temporary exhibitions, interactive laboratories, special events, etc. Operations in this space are "heavy": events are slow and difficult to create, and much effort is needed, even economic, to make ideas become true. Every initiative has to be planned in advance and suffers from many limitations of space, cost, reachable audience...

b) the media space (TV, newspapers, etc.) this kind of space seems to be light, since it's so ephemeral and does not involve any physical operation; but due to the high cost of the media space, it becomes heavy too. In fact you have to invest of money to produce your own TV program or magazine, or you have to invest much large

amounts of time to get the volatile attention of journalists. The consequence is that even in this space ideas are usually difficult to realise.

The web space is much different. It is a light space, in many ways. Costs are low, compared to usual media space; things are easy and fast to set up. Audience is light: you can talk with your site visitors without mediation (differently than in most of the media space), but they can leave your website with a single click, while getting out of the physical museum is not so easy.

This new kind of playground also generates different players: in Italy most museums are seen to be very rigid institutions, tied with bureaucracy; marketing or communication practices which are very common in countries like USA or UK are only now starting to arise. Also philosophically Italian museums are usually focused more on conservation than on communication.

On the contrary, virtual museums can be much faster than their real counterparts; there's no bureaucracy and little costs (web operations are affordable also for low-budgeted museum). In other words, the web is a place where the distance between idea and reality can be much thinner than in the real world. This is good for private companies, who have often been frustrated by the slow pace typical of museums.

There is also another thing: the web is a very competitive field, in which different web sites and portals have to face fierce fighting to attract visitors. We know that we have one very valuable thing to offer: content. Content is king in getting audience (Harden 1999). Besides, we have an image of seriousness and independence, that is attractive for a company to be linked to.

Different kinds of sponsorships

Even in this different playground, main rules governing the sponsorship are the same as in the real world. You have to ask yourself: "What do I need?" and then "What can I offer?"

We needed:

- Technical support (hosting, hardware and software for developing the website)

- Web pages (art direction, graphics, special effects such as Flash, CGI and Java programming) and in some cases, even the content of the page.
- Communication (links, media promotion, gadgets, etc.)

We could offer:

- Communication on the Net: links and logos on our website, promotion in our mailing lists.
- Communication in the real museum: posters, plates, media coverage from our press office, co-created events for journalists and general public, distribution of gadgets, etc.
- Free use of our conference rooms for a certain number of conferences.
- Possibility of mentioning the Museum as a partner in the company's external communications.

All of this has an economic value, even if difficult to define with precision, except for the third point, the conference rooms, which have a prefixed booking price.

We will now present four different sponsorships, in which needs and offers combine themselves in different ways.

Telecom Italia: an example of "multi-level" sponsorship

Telecom Italia, the most important Italian telecommunications company, covers many of our technical needs, as well as some promotional aspects.

Telecom Italia offered us:

- Web hosting for our website
- An ADSL connection for our Internet Lab
- 100.000 CDs with our site printed on for free distribution to museum visitors.
- Some funding and press office support to organise a presentation of the new home page of the website at the Museum

We could then define this as a multi-level sponsorship, in two senses: it is not only centred on the website, but also on the Internet lab, and it covers both technical and promotional aspects.

We will now detail more the four aspects of the Telecom Italia sponsorship:

Web hosting

Today you can get web space with your domain at very low cost, and for a Museum is very easy to get it for free, just by offering a little banner on its homepage. In fact we were already on a free web hosting with our registered domain museoscienza.org with a small Milanese provider; we had direct FTP access to our pages for update. Telecom Italia offered us a worse situation, because we would not be able to have a direct FTP connection any more due to internal rules of the provider, and had to use complicated procedures to have our updates online. In fact we decided to accept this hosting for two main reasons, which are valid for many technical sponsorships:

Telecom Italia was going to become the only provider for the Museum, since it offered for free the ADSL connection of the Internet lab and some dial-up connections for the offices, so we had to give them the website hosting too. In fact the website is becoming an important help to sponsorships regarding the real museum: promising advertising on

Fig. 2: The Internet Lab

our website is something which is being done more and more by Museum officials during sponsorship negotiations.

In a sponsorship the "quality" of a sponsor is an important factor. Our previous provider was a small provider, while Telecom Italia is the biggest and most important provider in Italy. Being sponsored by Telecom Italia means being an important website, and that was a valuable image advantage for us.

Internet lab connection

The existence of the Internet lab was an important factor in obtaining sponsorships for the website. The Internet lab is a room with twelve Personal Computers connected to the Internet where students can learn how to surf the net, how to use a search_engine, and other basic aspects of the Internet. During weekends the Internet lab offers free access to museum visitors. The Internet lab, opened in March 1999, has had considerable success, both among students and the general public (foreign visitors are very pleased by the possibility of using e-mail). In fact the Internet lab played an important role in obtaining sponsorships for the website since it provided our sponsors a point of visibility inside the museum. Moreover, the public of the Internet lab consists largely of schools, one of the most important target for potential sponsors. Telecom Italia provided an ADSL connection for the lab; this was good for promotional purposes, because it set up the Internet lab as a technology showcase (the ADSL connection was not used in Italy yet), and this gained the lab much attention from technical magazines.

We would also like to experiment with another kind of web sponsorship using our Internet lab. During lessons we make students visit certain websites; this means that these websites receive a substantial number of visits from a perfectly defined group of people; every advertiser's dream. We do not want to "sell" our students, but would like to use this to convince large, popular websites (such as music websites) to create some educational pages aimed specifically at our students.

Promotional Events: CD-ROMs and conference

Promotion of a website also includes outside-of-the-Net events and initiatives. Telecom Italia has financed two of these: the making of 100.000 CD-ROMs with the website for free distribution to museum visitors, and a conference at the Museum to present the website and the Internet lab to the press. This last move was important to get media attention, since many journalists still need a physical event to point their attention to a website.

Martin Mystère: a pure "web" sponsorship

Martin Mystère is a well-known Italian comic character, who investigates mysteries beyond the limits of official science, such as UFO or the Bermuda triangle. Martin Mystère appeared to be an interesting partner for a web-based operation with the Museum because of its popularity among young people 20 to 30 years old, a category which usually is not interested in our normal Museum activities.

Fig.3 The Sea Legends website http:// www.bvzm.com/misteri/

Sea legends such as phantoms or ill-fated ships were a good subject for a website with Martin Mystère: they're fascinating and pose interesting scientific problems, such as the effective dimensions of sea monsters like giant squids. Moreover, in the Museum we have a huge section of naval history, with a whole 62 meter long sailing ship, in front of which it is easy to let yourself dream of the Flying Dutchman. We wrote some texts and then obtained from the editor of two books about sea legends the permission to use images from the books as part of a link-exchange agreement between the two websites. Then we contacted the agency who designed the official site of Martin Mystère proposing this agreement to them: we were to supply the content, they were to create the pages and to ask the owners for the permission to use the image of Martin Mystère. The problem of who to contact first when proposing a partnership is a difficult one. When you haven't had any previous contact, you usually have two possibilities: contacting the owner of the website directly, or the web-agency which is creating it. Both solutions have advantages and disadvantages. Contact with the owners is more direct but often diffi-

cult to get; contacting the web-agency can have two advantages: getting this link to the owners, and gaining the web-agency as an ally, if they feel you're offering them a way to make some extra money on the website. On the other hand, if they're not interested in the project, they can freeze the whole project (we have experienced this).

In the Martin Mystère case the contact via the agency worked well and the author gave permission to use his character and to host the pages on Martin Mystère's official site. This hosting was an important part of the operation, since it allowed us to have a visible presence on a large website. In fact we are trying to make our website borders less and less defined opening as many as possible pages with our content and our logo on important websites all around the Net. Our final goal is to transform the Museum website into something spread, a galaxy, according to the open nature of the Net.

The resulting website is visible at the URL http:// www.bvzm.com/misteri/ : it consists of 14 legends and an entire comic which is readable on the net thanks to Flash technology. Certainly it is a small website, but it is a good example of a "light" sponsorship, with a plurality of sponsors and no money exchange involved, since everyone agreed to work for free (even the web-agency), something made possible only by the low cost of web-based operations. The absence of money exchange sped up all the operations considerably, since sponsors are usually more willing to give away services than money.

Fig.4 The Home page of Apogeonline http://www.apogeonline.com

Apogeo: a "content" sponsor.

Apogeo is the most important publisher of computer books in Italy. It has recently opened a website with news and articles about IT, and is trying to re-define itself from "technical publisher" to a larger "IT culture publisher". We contacted them in December 1999 with a proposal, consisting of three points:

Books: Apogeo provided the Internet lab with a small IT library with their books, free copies of "Internet for Dummies" book and T-shirts for students visiting the lab and discounted books to be sold in the Museum bookshop.

Conferences: Apogeo and the Museum were to organise conferences at the Museum on IT subjects with the participation of some of their authors, who are well-known in Italy.

Website: Apogeo was very interested in starting a co-operation between its online review, *Apogeonline*, and the Museum website. In this case the interesting fact for us was that Apogeonline could offer not only communication, but content too. Their authors could well create valuable pages about the IT subjects. We proposed to them some pages about the development of the personal and home computers during the Eighties, from the Commodore 64 to the IBM PC. The pages would be hosted on their website with the Museum logo, like in the Martin Mystère website.

In this case, what emerges once again is the importance of a two-level proposal: to a publisher which has two main fields of action, real and online, we offered two different operational level: the real level, with the Internet lab and the bookshop, and the web-level, with the co-operation between the two websites.

Web Portals: "communication" sponsorships

Gaining visibility on the Net is one of the most difficult and important things to do for an important website (Streten 1999). In getting new visitors' attention web portals like Yahoo! are very important. In our Museum we had already experienced their importance as audience-raisers. During 1998 and 1999 every time Virgilio (www.virgilio.it) or Yahoo! Italia (www.yahoo.it), two of the most important Italian web portals, put our website on their Homepage we saw spectacular peaks in our access counters (Gaia 1999).

Basing ourselves on this fact, in January 2000 we decided to try a web sponsorship with one of these web portals. The idea was to propose a section on the web portal to which the Museum would have supplied content. Content is what web portals desperately search for, in their effort to overwhelm each other in terms of audience. In Italy there are 7-8 big portals fighting each other in what seems to be a win-or-die situation – experts think no more than three generalist web portals will survive. Every portal is backed by a different "real" Italian company (such as the car maker Fiat) or by big international portals such as Lycos and Yahoo!. Each one of this backing companies is pouring tens of millions of dollars in its own portal, hoping that it will become "The" portal. This quite Darwinian scenario seemed suitable to us for trying to get the best visibility we could.

Deciding what web portal would fit most has been a difficult decision. Portals are similar but have slight differences in terms of editorial profile, target, etc. At last we decided to contact the most "cultural" ones, i.e. the most content-oriented and the most high-profiled, thinking that our content would fit better in such a context. As for the content, it had to be suitable for our customer. It had to be:

- of broad interest; web portals are broad-casting websites
- dividable in many little sections, to publish with a pre-fixed frequency; web portals are oriented towards continuous updating to have people returning to their websites. Their communication model is the brief news more than the long dossier.
- "Light": in language, in length, in bytes.

The Leonardo section of our website looked the most suitable; it is composed of more than 100 pages, each one describing a different invention. Our proposal to the web portal would have been to publish every day a different machine: "The Invention of the Day". A problem arose before we could submit the proposal to the two web portals we

identified: the text of the pages was too difficult to understand for the large audience of a web portal, so we had to re-write all the pages, and that's not an easy thing to do in a always under-manned and under-budgeted institution like a museum. That slowed down the developing of the project, which we hope to have online by summer 2000. In fact, it taught us that sometimes "suitable content is King".

References

Harden M. (1999), *Directing Traffic to Your Website*, paper presented at Museums and the Web 1999 http://www.archimuse.com/mw99/papers/harden/harden.html

Paolini P., Barbieri T., Loiudice P., Alonzo F., Gaia G., Zanti M. (1999), *Visiting a Museum together: How to share a visit to a virtual world*, . In D. Bearman & J. Trant (Eds.) *Museums and the Web, Selected papers from Museums and the Web99* (pp. 27-35). Pittsburgh: Archives & Museum Informatics

Gaia G. (1999), *Promoting a Museum Website on the Net*, In D. Bearman & J. Trant (Eds.) *Museums and the Web, Selected papers from Museums and the Web99* (pp. 230-238). Pittsburgh: Archives & Museum Informatics http://www.archimuse.com/mw99/papers/gaia/gaia.html

Streten K. (1999), *If you build it they will come…won't they? Marketing a web presence*, paper presented at Museums and the Web 1999, http://www.archimuse.com/mw99/papers/streten/streten.html

Additional readings and resources on the topic

Galluzzi P. (1999), Musei Virtuali, Istruzioni per l'uso, *IF* 2

Antinucci F. (1998) Musei e nuove tecnologie: dov'è il problema?, *Sistemi Intelligenti* 2, 281-306.

Good Italian and international bibliography on online museology can be found on http://www.museoscienza.org/musei-it/

A good Italian reference for web marketing is the magazine *Web marketing Tools* and the website http://www.mktg.it

The Small Museum Web Site:
A case study of the web site development and strategy in a small art museum

Kristine Hoff, University of Aarhus, Denmark.

Abstract

This paper presents a case study of the development of a web site for the Vejen Art Museum, a small art museum in Denmark, and it aims to investigate how an art museum with very limited resources might realistically make use of the web for publishing information. It is the hope, that this research will be of use to other small art museums contemplating the development of a web site, as it will give an idea of how to calculate the costs involved (both in relation to financial investment and manpower), thereby helping the museum professional define a project and if necessary apply for appropriate funding.

Introduction

All art museums, small or large, share the same mission to communicate to the public about their collections. A web site is a publishing tool and may be used to further this mission. Small art museums in that respect share the same goals as larger institutions, but their circumstances are very different. They are most often understaffed and managing on very limited financial resources, and these circumstances must be expected to impose some limitations on the amount of time, money and effort they are able to devote to developing and maintaining a web site. The goal of this paper is to take a closer look at the problems of small museums with regards to this new medium, by presenting an example of how they may be solved. It presents a case study of the development of a web site for the Vejen Art Museum, a small art museum in Denmark, and it aims to investigate how an art museum with very limited resources might realistically make use of the web for publishing information.

The Vejen Art Museum, which is situated in the south-western part of Denmark relatively close to the German border, was built in 1924 to house the works of the local sculptor and ceramist, Niels Hansen Jacobsen (1861–1941). His production still forms the core of the collection, which was, however, soon extended to include works of art by a range of other artists. Today the Vejen Art Museum is specialising in Danish symbolism and art nouveau. At present, the collection holds some 1500 works of art, including both sculpture, painting, graphic art and ceramics. There are around 12,000 visitors annually, a number which the curator would very much like to increase. The museum has two full time employees, the curator and a museum assistant. Part time staff consists of two weekend attendants and a handyman. The museum is publicly funded. However, for any expenses out of the ordinary the curator must put an effort into private fundraising.

The aim of this case study is to investigate three central points:
1. How may a web site fit into the general information strategy of the museum?
2. What are the minimal requirements in relation to financial investment and work effort?
3. How is the work best organised in order to make the process as effective as possible?

The paper is practically oriented. In order to throw light on the above issues it describes the development process and the decisions made, and ultimately assesses the success of the project. In conclusion, answers to the three points of investigation are considered. It is the hoped that this research will be of use to other small art museums contemplating the development of a web site, as it will give an idea of how to calculate the costs involved, thereby helping the museum professional define a project and if necessary apply for appropriate funding.

The Development Process

Initiative

The initiative to develop the museum web site was taken by the curator. The handyman at the museum had basic HTML skills, but he did not have enough training develop a museum web site, nor did his duties leave him time for the task. The author of

this paper volunteered to build the site as a project for an MSc Thesis in Information Science.

The timeframe

- Preliminary discussions started as early as January 1999.
- Project start: June 1st 1999
- Project conclusion: the web site was supposed to be finished on November 30th, but in fact the site wasn't fully completed until the end of January 2000.

The stages of the production

In order to get an overview of the tasks involved in developing a web site, it makes sense to divide the process into stages. This overview may serve as a plan which will make it easier to manage the work, but in reality the stages will often overlap. The following description of the development process is based on the account given by Patrick Lynch and Sarah Horton in their book: *Web Style Guide: Basic Design Principles for Creating Web sites* (Horton and Lynch 1999).

Stage 1: Site definition and planning

An informal assessment of the information strategy of the museum formed the basis for a development of a strategy for the web site. The requirements for the site were specified by the curator and the volunteer in co-operation. At this stage it was also specified who would be in charge of what chores. The large task of finding, editing and authoring the content of the site was divided between the museum staff and the volunteer.

Stage 2: Information architecture

The information architecture of the site was created using diagrams sketched out by the volunteer, and approved by the curator. Lists of content material to be created were drawn up by the volunteer, and it was specified what each person would contribute. Copyright clearance was the responsibility of the curator.

Stage 3: Site design and content creation

The visual design of the site was created by the volunteer and approved by the curator. The design of the content material was left up to the person in charge of that particular piece of text, even though

the curator remained content expert, and had final say on all content. Image scanning was the responsibility of the volunteer.

Stage 4. Site Construction

The volunteer created the actual web pages, and published them on her personal web site, so that the museum could follow the process online. During this stage a usability evaluation was carried out in order to test the appropriateness of the site for the intended audience. After the evaluation the architecture was refined. Proof reading and fault finding was done by the museum assistant.

Stage 5. Site marketing

The marketing of the site using electronic means – registering with search engines etc. - was the responsibility of the volunteer, while the museum staff had the responsibility of marketing the site in other ways, e.g. including the address in print publications etc.

Stage 6. Tracking, evaluation and maintenance

By the end of the project the maintenance and tracking of the site was the responsibility of the museum staff. An online questionnaire should provide useful data about the audience.

Equipment

The basic equipment needed to build the site was:
- PC connected to the Internet
- Image scanner
- HTML editor
- Graphics package
- Photo editor
- Browsers

As the volunteer had all the equipment to build the site at her disposal the museum was not immediately required to invest in any hardware or software. It was necessary to have a repro company digitise transparencies. For the future updating of the site it may be necessary for the museum to invest in equipment.

Server space

The museum was offered free server space on the local government server. This came with the condition to use a common design identifying the mu-

seum as a municipal institution. This idea did not appeal to the museum curator, who had quite a different audience in mind for the museum site than the one planned for the municipal web site. Furthermore, it looked like the plans for the municipal web site would not be realised for a long time yet. After a certain amount of lobbying, the museum was allowed to temporarily publish an individual site on the server of CultureNet Denmark (www.kulturnet.dk), which is run by the Ministry of Cultural Affairs. CultureNet has agreed to host the site free of charge. When the local government web site is realised the museum site may have to be moved.

Information Strategy of the Museum

An analysis of museum activities and publications was conducted in order to assess the information strategy of the museum. This assessment formed the basis of the development of a strategy for the web site.

Assessment of the museum's information strategy

It was found that the museum was very successful in promoting its activities and exhibitions in the local area. The institution was well known and well liked, and posters, press releases and 'word of mouth' functioned very well in advertising special exhibitions. What was lacking was a reliable way of promoting the museum and advertising special exhibitions in other parts of the country and abroad. Even though press releases were sent out to national newspapers regularly, they were not published frequently enough for them to be a reliable means of promotion. The museum did not have the budget to buy advertising space. Promotional brochures were distributed in tourist centres in the local area, not in the rest of the country, much less abroad.

It was an ambition of the curator to propagate knowledge of Danish symbolism in Denmark and abroad, both among the general public and among the international community of art scholars. However, she lacked funds to publish the her research results. The curator would like to improve services for school classes, mainly by providing better facilities at the museum, but also by publishing material about the works of art in the collection.

Web site strategy

It was decided, that the primary goal for the web site should be to promote the museum in Denmark and abroad. It should further the awareness of the museum and hopefully fill the gap in the information strategy by advertising the special exhibitions outside the local area and abroad. The web site was to supply practical information (address, contact numbers, etc.) and a taste of what the museum was all about. Programmes of exhibitions and events were content essentials. It was decided to post annual programmes on the site. This way updating could be done just once a year if necessary.

It has not yet been established whether museum audiences are also web users, and whether museum web sites work well in attracting visitors. However, surveys have shown that museum professionals are positive that they are good promotional tools (James 1997; Oono 1998). It was the opinion of the museum curator and this author that the WWW will increasingly be *the* place where people find information. It is convenient, accessible from the homes of potential visitors, and it is potentially able to reach a large international audience.

The full site had to be available in English as well as Danish in order to serve an international audience. Some information must also be made available in German and Dutch, as most of the foreign tourists who find their way to the museum are from Germany and Holland. The reason for not creating full versions in German and Dutch was simply lack of resources for translation of material. However, the curator felt that a little information would be better than none, and it was decided to publish the texts from an existing museum brochure.

The secondary goal of the site was to contribute to the educational mission of the museum. The curator would like to use the web site not just as a promotional tool, but as a resource of information about Danish symbolism. However, any material demanding regular work on the site had to be avoided. Therefore the museum could not plan to have online exhibitions on the site, and it was decided to concentrate the efforts on the permanent collection. It was decided to include a catalogue of Niels Hansen Jacobsens sculptures, a text which was already available in Danish and English, but had not

yet been published for lack of funds. This catalogue would serve as a resource both for school teachers and art scholars.

Target audiences

Characteristics of the primary target audience

- Potential visitors to the museum
- Adults who are interested in art, and used to visit museums, but who may not be familiar with the Vejen Art Museum.
- Familiar enough with the www to feel comfortable using it for information seeking.

The web site had two secondary privileged user groups: school teachers planning visits to the museum and an international audience of art scholars interested in symbolism.

Design requirements

The site must appear as a finished Two issues were important to the curator:
1. whole yet be easily extended, and it must demand as little updating as possible.
2. The design of the site must be presentable and appealing to the target audience, and the architecture must be clear and well-structured. It must be easy and fast for the users to navigate the site, and find the wanted information.

Web Solutions

Information architecture

The homepage is a representative front page, designed to need no updating. It contains very little

information: the museum logo, a photograph of the museum, the address and contact numbers, and four links to the four different language versions of the site.

Many art museums choose to advertise the present exhibition on the home page, in order to catch the attention of potential visitors. In order to minimise updating this was not done on the Vejen Art Museum web site. The web site is available in four languages: Danish and English (full versions), and German and Dutch (single page information versions). The layout of the Danish version is illustrated in the following diagram:

Layout of pages

Once the user enters the site, the layout of the screen is as illustrated in the image below.

The pages consist of 4 frames:

Frames 1 and 2: Visual and navigational framework

The two top frames contain the Vejen Art Museum Logo, and the main menu of the site. This information is present on the screen at all times, and makes up the visual framework of the site. This area was planned as the stable part of the site, where no

updating should be required. Therefore it could be laid out with graphic links, and a JavaScript which makes the links light up on mouse-over. These features require more skills than straightforward HTML to update, but they make the site look more interactive and visually pleasing.

1. Logo	2. Main Menu
3. Sub Menu	4. Main content area

Frame 3. Sub menu

The sub menus contain the links available in each category. The sub menu links are pure text links, which do not look as nice as the graphic links, but they are much more straightforward to update. Because frames were used, the sub menus only have to be created once. The menus might have been included in every content page, but this would make creation of new pages more laborious, and it would have meant that every existing page had to be updated if a new link was added. As the structure is now, the museum will be able to add new content documents and update the sub menus very easily.

Frame 4. Main content area

The content documents themselves are straightforward HTML-documents, and a template will ease the creation of new documents.

Updating strategy

In the future the site should be updated at least once a year, when the programmes for the exhibitions and events run out. However, there may be changes which necessitate updating before the end of the year. The museum had two choices as to who would do the updating.

1. To pay a web author to do the updating once or twice a year. The museum staff would still have to prepare the material.
2. To give the task to a member of staff.

As the museum handyman already had basic web authoring skills it was decided to let him do the updating of the site. This is preferable in that small changes may be carried out when needed. The museum curator will have editorial responsibilities, preparing the material to be published, and the handyman will be in charge of the HTML scripting and publication. This arrangement does place an extra work burden on the museum staff, but hopefully the site structure will make the tasks as minimal as possible. The solution also necessitates that the museum acquire the software and hardware tools to do the updating, so there is a cost involved.

Evaluation of the site

Two forms of evaluation were planned for the site. One was a usability study to be conducted during the production in order to evaluate the layout and architecture of the site. The other was an online questionnaire inquiring into the appropriateness of the content and the information needs of the users. This evaluation would take place after the publication of the site.

Usability Evaluation

The usability evaluation consisted of two steps: a usability inspection conducted by the volunteer and an empirical user test (Nielsen and Mack 1994). The inspection exposed problem areas which were then evaluated in an empirical user test carried out at the museum. Here a PC was set up, and the test subjects either volunteered for the test or were prompted to participate. They were asked their age, gender, familiarity with the Vejen Art Museum and familiarity with the World Wide Web in order to establish to what extent they represented the target audience. They were then presented with 14 test assignments, and observed by the volunteer while performing these. The volunteer took notes and the results were dealt with statistically.

Conclusion to the usability evaluation

The overall result of the evaluation was positive. Most users found the site pleasant and easy to navigate. It was concluded that the overall design and architecture of the site was appropriate for the intended user group. However, the evaluation prompted quite a few minor adjustments to the design and architecture. For example, an alphabetical index of Niels Hansen Jacobsens sculptures was added to the existing chronological one, in order

to make it easier to find a specific named sculpture. The evaluation provided very valuable, useful data, which could be used directly to make design changes, and improve the usability of the site for the target audience. Not only did the user test give answers to the questions posed after the usability inspection, it also brought to light problem areas which had not been apparent to the 'expert' evaluator. Observing the users was very important, as it was observations of behaviour which provided the most useful material. This kind of evaluation would certainly be within the reach of a small art museum, and even with a small user group the results can be very good. Quite apart from providing useful data about the usability, the evaluation had the added effect of advertising the coming of the site.

Planned content evaluation

It is the plan to further evaluate the site after the publication. This evaluation will be in the form of an online questionnaire on the web site for users to fill in, and this time the evaluation will focus on the content of the site and the information needs of real users. At the time of writing results are not yet available.

Assessment of the project

Management issues

One lesson which was learned from this project is how important it is to have someone in charge of the project. A web development project involves a lot of different tasks, often performed by different persons, and it is essential that someone keeps track of what is going on and who is doing what. During the process of development the curator of the museum became very enthusiastic about having a new publication medium and had a tendency to focus on new ideas instead of the tasks at hand. This was probably due to the fact that the volunteer had the responsibility of the overall running of the project.

The success of the project was very much due to the fact that this volunteer had the dual expertise of web authoring skills and art historical training, and was able to take on a lot of responsibility which could not have been given to a web author with no content understanding. The fact that the volunteer

took responsibility for the overall running of the project relieved the museum curator of a great work burden. This, however, may prove to be a disadvantage in the future, as one could fear that the museum staff do not have a realistic picture of the amount of work it actually took to develop the site, and will take to maintain it. It would be preferable to have a permanent member of staff in charge of the project from the beginning. The first stage in the production: *Site definition and planning* is extremely important. It should include an assessment of the amount of work people are able to devote to the project, and at this stage one should make sure that the involved parties are committed to the project and understand their roles and responsibilities. Ambition and work effort must correspond.

Work load

The amount of effort it took to develop the site would have been very difficult to manage for the museum staff. Without outside help, they would have had to build a much more modest site. Outside help also ensured that the site was built within a reasonable time frame. In this case it came virtually free, but if this had not been the case, the curator would have had to spend time raising money. The main task put on the museum staff was content creation. This proved the weak point of the whole project, as the lack of content was *the* thing which delayed the publication of the site. The curator could not find the time to write any texts until very late in the project, and this meant that the construction stage was drawn out, and the marketing and tracking stages have only just begun. It cannot be stressed enough how important it is to start small, and to use already existing content on the site. It is better to have a small site functioning well than a large site which is half finished.

It was decided to take a pragmatic approach to the copyright issues. The images mounted are of sufficient quality to be viewed on screen, but they do not print very well and will not be of serious commercial use. A text on copyright explaining the conditions under which it is permitted to copy the images and texts was published on the site. Most of the art works which are presented on the site are out of copyright, so the main issue was to gain permission from the photographers. The amount of work involved in clearing copyrights for this site was not substantial but this will vary considerably depending on the type of collection.

Luckily the museum handyman already had basic web authoring skills, and will be able to do the required updating of the site. The volunteer has made all efforts to make this as easy as possible. The architecture of the site is open-ended, and templates of key pages have been created. The work load involved in making basic changes such as a new exhibition programme is minimal. The museum curator is hoping to do a lot more and develop the site further, but whether this will happen will depend on how much time she herself will be able to devote to the role of web editor.

Costs

The main cost for the museum has been in an extra work burden. The only actual expense has been the digitisation of transparencies, which had to be done by a repro company. The museum was able to publish the site free of charge, which means that the site will be less of a financial burden. The museum already owns the hardware necessary to update the site (PC and image scanner) but may have to invest in software.

Cost of basic hardware and software: Example prices

- IBM Aptiva 805 PC: US$ 800.00
- HP Scanjet 5200 colour scanner: US$ 249.00
- Adobe PhotoShop 5.5 (photo editor) :from US$ 649.00
- Adobe Illustrator 8.0 (graphics editor):from US$ 399.00
- Macromedia Dreamweaver 3.0 (HTML-editor): US$ 299.00

 (These prices are quoted as of February 2000 on the official web sites of the above companies, and are subject to change.)

Cost of professional help

Scanning of images by repro company cost 65 DKr = app. 9 US$ pr. image.

It is difficult to assess how much it would have cost to have a professional company build the site, as these projects are often offered in tenders, and prices stay business secrets between buyer and seller. However, museums that are not looking for very advanced features may be able to employ one of the many semi-professional one-person companies advertising their services on the net. In Denmark I have seen prices as low as 300 DKr. pr page which is app. 42 US$. (This may not be standard at all and may not correspond to American prices.) If we calculate with this price however, the cost of hiring professional help to build the Vejen web site would have been 60,000 DKr. = app. 8,500 US$ as there are about 200 pages. (This amount equals 3 months salary for an entry level museum professional in Denmark, and this probably corresponds quite well with the amount of effective time the volunteer spent developing the web site.)

Conclusions and Recommendations

It was the aim of this research to investigate three questions: How a web site might fit into the general information strategy of a small art museum, what the minimal requirements in relation to work effort and financial investment are, and how the work is best organised. Hopefully, the description of the case and the final assessment will have thrown light on these areas, but in conclusion the issues involved should be highlighted.

Information strategy

An examination of the activities and publications of the museum should form the basis of a definition of the requirements of the site. Unless there really is a need for a web site, there is no reason to spend time and effort developing one. On the other hand, a well defined project based on a thorough investigation of the museums information strategy might impress those depended on for economical support. In this case it was found that a web site might be a cost-effective way of solving the museum's advertising problems. Whether this holds true can only be concluded from future visitor studies. Any museum will have to assess their own needs and possibilities before entering on a web project.

Minimal requirements: financial investment and work effort

The amount of work and the costs involved in a web development project will vary considerably according to the existing resources of the museum, and the way they choose to organise the project. Unless a member of staff already has web authoring

skills, one can expect a very steep learning curve. It is hard to do it yourself, and it may be more economical to use the efforts on fund raising, and then paying a professional to do the web authoring. Whether to do it yourself must be a decision based on an analysis of the human resources and computer equipment available to the museum. The calculation must consider the following points:

Do it yourself

- Human resources
- Hardware equipment
- Software equipment
- Large initial work load when constructing the site, and continued work in updating.
- Server space

Professional help

- Cost of professional help
- Web editor function of the museum
- Server space (may be part of deal with multimedia company)

Content creation is one of the major tasks of a web site development project, and this work will be the responsibility of the museum no matter who develops the site. The smaller the site, the smaller the work burden. It is a good idea to use existing content whenever possible. The special characteristic of a web site in comparison with a hardcopy publication is that it can be developed after the publication, so one can start out small, and make extensions when possible. A web site should be thought of as an ongoing project, and one should make sure the design is open-ended, so that extensions to the site don't demand major design changes.

Organisational issues

The planning stage of a web project is extremely important. If the ultimate planning is done properly, and everybody sticks to this plan, then everything can be done much more quickly, and with fewer wasted development efforts. It is important to be familiar with the development process before actual work on the project begins, and case studies like this one may serve to this end. It is very important to elect someone to be in charge of running of the project — someone who can hold all the strings together. Preferably this person should be a permanent member of staff, so that the museum doesn't

loose the overview of the project, and the optimal situation is if this person has organisational power so that he or she may speed up the project if necessary.

Any museum will have to take into consideration their special needs, abilities and circumstances when they consider how to make use of the web. Web Sites are expensive to establish, but, and this point is important to include, if the museum can afford to overcome the initial hurdle, and are able to acquire the skills to publish basic HTML-documents, they are actually in possession of a very cheap publication media, much cheaper than print publications. One possible solution model would be to pay a professional company to establish an initial small site, which could be easily added to later by the museum staff themselves. It is easier to update a site than to build it from the ground. The future will show whether the prices of professional help go down or the skills among museum professionals go up.

No matter what solution model is chosen, having a web site is going to demand work — new routines and new responsibilities, and museums must be ready and willing for this change if they want to use the medium. The real strength and value of a case study like this is that the experiences learned may give museum professionals a sense of the tasks at hand.

References

Horton, Sarah and Lynch, Patrick: *Web Style Guide: Basic Principles for Creating Web Sites*, Yale University Press, New Haven and London 1999, chapter 1.

James, Stephanie: *Museum Web Page Survey Results*, http://www.chass.utoronto.ca/~sjames/ museum/survey.htm, last updated March 1997.

Nielsen, Jakob and Mack, Robert L. (ed.): *Usability Inspection Methods*, John Wiley Sons, New York 1994.

Oono, S.: *The World Wide Museum Survey on the Web*, Internet Museum, Japan, http:// www.museum.or.jp/IM_english/f-survey.html, last updated September 1998.

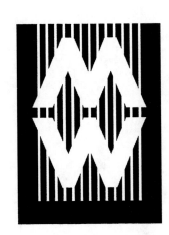

Evaluation

Entering Through the Side Door - a Usage Analysis of a Web Presentation

Joan C. Nordbotten, University of Bergen, Norway

http://www.ifi.uib.no/staff/joan

Abstract

Guidelines for Web site design recommend both hierarchic structures and the use of page descriptors. A hierarchic structure facilitates theme development through initial presentation of thematic context followed by thematic details placed within the structure. However, a presentation with well described detail pages invites search engine entry through the 'side-door', i.e. directly to detail pages within the presentation structure by using the page descriptors. A virtual visitor can quickly get lost, loose interest, and go away, without discovering the context of the retrieved information. This paper presents a 3 + year usage study based on the log data collected from a hypermedia exhibit designed to present a sample of research projects in the social sciences. The exhibit has resided at 3 locations, in a natural science museum as part of a traditional exhibit, as an information kiosk, and currently as an independent Web site at http://nordbotten.com/museum. Users from the general public were free to explore the exhibit at each location. The underlying purpose of the study has been to study *usage patterns of in-house hypermedia and Web presentations*. If the usage patterns observed for in-house presentations are similar to those for equivalent Web presentations, than they could be used as guidelines and prototypes for Web presentation development. Our analysis of page selection data shows little similarity between the off-line and Web exhibit usage patterns. Most, 85%, of the Web sessions were started from a search engine request. Most of these, 76%, started at a detail page. Sessions starting at a detail page were significantly (p=0.00000003.2) shorter than sessions begun at the exhibit's start pages.

Information Retrieval Patterns from Hypermedia Presentations

Public and private organizations are increasingly using Web (World Wide Web) presentations for dissemination of information about their organization and services. Web presentations, structured as a set of inter-linked pages, are supplemented with orientation aids such as indexes, navigation bars, and/or context maps. Guidelines for Web site design recommend both hierarchic structures and the use of page descriptors. A hierarchic structure facilitates theme development through initial presentation of thematic context followed by details placed on pages within the structure. Page descriptors enhance access to the information when using Web search engines. It is believed that the use of hypermedia technology will facilitate information gathering (Bush, 1945; Nelson, 1967; Shneiderman, 1992).

For the general public, gathering information entails retrieval of interesting document sets. Dierking & Falk (1998) and Futters (1997) report that a primary motive for both traditional and virtual museum visits, is a personal interest in a topic the visitor expects to find. Dierking & Falk note further that users of technological exhibits differed from the general museum population only in a somewhat more specific topic interest. From these stud-

ies, one would anticipate that Web users would search museum sites for specific information, rather than use the site for general browsing.

Providing effective support for information gathering from hypermedia presentations requires an understanding of how the intended public retrieves information. However, little is known as to whether the information in Web presentations reaches its intended audience or whether the recipients receive the information that they need and/or have requested (Day, 1995; Futers, 1997). Researchers anticipate a number of problems. As the number of inter-linked documents and path selections increases, user disorientation and cognitive overload may hinder information gathering (Conklin, 1987; Preece, 1994). Link structures may actually hinder location of specific information (MacKenzie, 1996). Hierarchic structures with detail pages, with or without descriptors, can invite search engine entry through the 'side-door', i.e. directly to information within the presentation structure. A virtual visitor can quickly get lost, loose interest, and go away, without discovering the context of the retrieved information.

Actually, little is known about how Web users retrieve hypermedia information. How is the informa-

tion selected? How much is viewed? How long does the user spend with an information presentation? Answers to these questions will enable information providers to improve presentations and tailor presentations to different recipient groups.

Our study is based on the page selection log of sessions for a hypermedia exhibit of social science topics. The data have been collected over a 3 + year period in which the exhibit has been located at three successive sites: as a off-line exhibit in a natural science museum, as an information kiosk in the information area in the school of Social Science, and on the Web. *The goal of the study has been to gather information about user behavior at hypermedia exhibits in order to develop a framework for the design of hypermedia presentations.* We observed that Web users are significantly more thematically focused than users of the off-line systems. Most, 85%, of the Web sessions were started from a search engine request using a keyword search. Most of these, 76%, started at a detail page. Sessions starting at a detail page were significantly (p=0.00000003.2) shorter than sessions begun at the exhibit's start pages.

A Study of Hypermedia Usage

We have studied information retrieval patterns for users of a small hypermedia exhibit, first implemented as a off-line exhibit, placed in the Museum of Natural Science in August, 1996. The exhibit was later moved to the School of Social Science to be used as an information kiosk and, after translation to English, was placed on the Web at http://nordbotten.com/museum.

Participants

Since the goal of this project was to study the information retrieval patterns of the general public,

no recruitment of subjects was preformed. The exhibit has been available to anyone who visited the museum during 1996-1997, the School of Social Science in 1997-1998, or searched the Web from January 1999. Information searchers and browsers determined *if* they would activate the exhibit, which topics they would see, the number of exhibit pages they would retrieve, and the length of time they would spend. Three samples of user populations, summarized in Table 1, were studied.

Visitors to the natural science museum that housed the exhibits for the university anniversary celebration were the subjects of the first study population. We have assumed that the exhibit users had the same age distribution as the general museum population, i.e. that youths dominated during the school year and that adults and tourists dominated during the summer months.

Users of the information kiosk in the School of Social Science, were assumed to be seekers of specific information. We anticipated that this could be observed in topic selection sequences and the use of links to specific detail information. We further anticipated that the social science visitors would find particular interest in an exhibit developed by researchers in the social sciences and thus reflect those Web users seeking specific information.
Only 5 of the Web users, 4%, submitted the exit survey. Of these, 60% were women, 60% were over 40, 40% were under 20, none were young adults, 20 to 40 years old.

Our anticipation that the information retrieval patterns of Web users would be similar to museum visitors was based on the expectation that both groups contain casual browsers, looking for something interesting, as well as goal-oriented seekers of specific information.

Dominant user group	Number	Location
Museum patrons – all age groups	705	Natural Science Museum
Information seekers – Students, visitors, and faculty members	322	School of Social Science
Web site visitor – all age groups	180	http://nordbotten.com/museum.
Sum	1207	

Table 1: Study Populations

Museums and the Web 2000

The exhibit

The exhibit consists of six topic presentations developed by researchers in the social sciences. Each topic presentation is formed in a hierarchic structure, introduced with a general description page containing embedded text and image links to a set of inter-linked detail pages describing particular aspects of the topic. Most topic pages include two images with accompanying text, as shown in the example in Figure 1. Each page is thematically self contained and there was no scrolling on the implementation machine, which was operated by a touch screen. Topic presentations ranged from 2 to 8 pages. All topic pages contain a navigation bar with 5 buttons for <exhibit index>, <topic start>, <next topic page>, <previous topic page>, and <exit>. The <exit> button calls a questionnaire, requesting the following data from the viewer: gender, age group (<20, 20-40, and >40), whether the exhibit was difficult to navigate, and whether the exhibit was interesting.

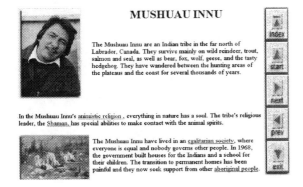

Figure 1: Typical topic page layout. Ex. The initial page of the "Mushauau Innu" topic presentation

In addition to the topic presentations, the exhibit contains a cover page, a two-level hierarchical index, and an overview index. The later, shown in Figure 2, is accessible via the top button on the navigation bar on each topic page. A time out, set at 45 seconds, assured that the off-line exhibits were restarted at the cover page if a user left the exhibit without using the <exit> button.

The <exit> questionnaire had to be discontinued during the museum exhibit because of usage problems. It was reinstalled for the move to the social science information center. However, though the <exit> questionnaire was selected in 53% of these sessions, no questionnaires were submitted. As noted above, only 14 of 180 Web site visitors, 7%, submitted the questionnaire.

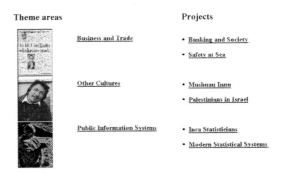

Figure 2: The exhibit overview index

The exhibit was initially implemented on a off-line PC with touch screen input using a WebSite™ server with a Netscape™ browser. User sessions were initiated by touching the cover page causing a transition to the theme index, identical to the left two columns of Figure 2. Thereafter, pages were selected by touching an active image, text, or button link. The two-level index structure required two index page selections to reach the first topic selection, giving a minimum path length of 3 in a topic session. Sessions completed on return to the cover page.

Changes made for the Web presentation include: content translation to English, elimination of the time-out feature, and direct access to the overview index from the cover page rather than the original route through the theme index. This last change reduced the path length from the cover to a project presentation from 3 to 2 pages. The WebSite™ server administers the Web site. Access to the Web exhibit is open in the sense that, in addition to access through the cover page, users can access detail pages directly by using Internet search engines.

Placement of the museum exhibit as a Web site has allowed us to test our underlying hypothesis that users of off-line and Web presentations would use similar information retrieval patterns. The Web location was announced through research workshops and conferences, research papers, and as links from the authors' home pages. In addition, 7 Internet crawlers visited the site over 500 times during the study period.

Data Analysis Procedures

Log data were collected for four periods: two from the museum exhibit in the fall of 1996 and summer of 1997; from the social science information kiosk during the fall, 1998; and from the Web exhibit during the whole of 1999. The browser cache for the off-line exhibits was set to null, ensuring that each page was logged. The Web exhibit log contains only initial page selections, i.e. user backing through his/her local cache is lost in this log. The log data used for this study includes; the name of the requested page, the date and time for its selection, the name of the calling machine, the previous exhibit page, and for the Web exhibit, the initial search string.

Data preparation for the analysis of information retrieval patterns included separation of sessions, generation of a page transition matrix, and calculation of session length in time and number of pages. Development and maintenance sessions were excluded. Session times were dropped from the off-line to Web comparisons due to the characteristics of the Internet that cause long page construction times compared to the off-line presentations.

Table 2 gives the central definitions used for the analyses. Note that *off-line sessions* were initiated by a transition from the cover page since all pages were called from the host machine. *Web sessions* were identified by a change in the calling machine and/or a change in date.

Results

Table 3 gives a summary of the session characteristics for the three study populations. About 35% of the 1207 sessions contained no topic selections or, for Web visitors, only the initial page retrieved by the Web search engine. It was assumed this indicated that the exhibit was considered uninteresting. These sessions were eliminated from further session analysis, leaving 765 sessions in which at least one topic was selected.

Less than 50% of these sessions contain more than one topic. On average, less than four topic pages were selected during a session and less than three pages were chosen per topic. Topic interest, measured in number of detail pages selected, fell from 70% to 50%, 38%, 31% for the second to fourth pages, respectively (Nordbotten & Nordbotten, 1999).

Off-line users

For visitors to the museum exhibit, topic selection was strongly correlated, 0.9, to topic placement in the indexes. That is, topic selection was top-down in the index choosing most frequently the first topic in the first theme followed by first topic in second theme, and so on. 30% of the sessions contained more than one topic. Once a topic was selected, 80% of the detail page selections were selected using the <next> button, indicating that the presentation was *read* in a serial manner.

Concept	Off-line exhibits	Web exhibit
Session start	transition from the cover page to the theme index	Page selection from a new calling machine and/or date, time
Session end	1) transition from any page to the cover page, or 2) Time-out return to cover page	Last page selection before a new session start.
Topic session	a session containing at least 1 topic page	a session with minimum path length = 2, containing at least 1 topic page
Session length	sum of pages requested	sum of unique pages requested
Session time	calculated from the first initiation of the theme index to the return to the cover page. The last page time was ignored if it equaled the system reset time under the assumption that the visitor had left the exhibit.	calculated from initiation of the first page to selection of the last session page. The last page time was ignored since no information exists as to when the visitor actually left the exhibit.

Table 2. Processing concept definitions

Exhibit placement	Sessions				Topic selections				
	Total	Topic sessions #	%		Total topics	Topics / session	Total topic pages	Topic pages / session	Pages / topic
Museum	705	412	58		551	1.3	1377	3.3	2.5
Informatiomkiosk	322	250	78		339	1.4	952	3.8	2.8
Web	180	103	57		122	1.2	323	3.1	2.6
Sums/averages	1207	765	65		1012	1.3	2329	3.5	2.6

Table 3. Session Profiles

Visitors to the information kiosk showed more interest in the exhibit content than the museum visitors. Most sessions, 78%, were topic sessions. Initial topic selection was less dependent on index placement, correlation 0.78. 40% of the sessions contained more than one topic. 45% of the detail page selections used the embedded links. The length of the sessions and number of pages viewed per topic also increased. One characteristic of significant difference, $p=0.000009$, is the use of the embedded links for detail page selection.

Web site users

Most Web sessions, 85%, began from a keyword search using a search engine, the rest started from direct input, benchmarks, or links from other pages. Most of the search engine starts, 76%, began at a topic page. The percentage of Web visitors who selected topic sessions was less than off-line users, particularly when compared to the kiosk users. This can indicate that Web visitors were looking for specific information and were able to immediately identify the relevance of the retrieved exhibit page.

The start page of a topic session significantly influenced the session profile. Only 13% began at the exhibit cover page. These sessions were relatively long, significantly, $p=0.00000003.2$, longer than sessions that began at a detail page, and rich in content. They averaged 5.0 unique topic pages and 1.9 topic selections. 30% contained more than five (up to 13) topic pages with up to five topic selections. There were 90 topic sessions that began at some detail page, thereby entering the exhibit 'through the side door'. Of these, 40% began within a topic presentation hierarchy, thus missing the topic content given in the presentation page. Half of these selected an index, presumably to gain a context for

the original page. Both topic sessions that began at the presentation page and those starting within the presentation, averaged 2.9 topic pages. Only eight sessions contained more than one topic selection and only six contained more than five topic pages, ranging up to eight pages.

Only 14, 12%, of the Web sessions exited using the <exit> button that presented the viewer with a simple demographic survey. Only five survey responses were submitted, which is insufficient to give any picture of the Web users.

Summary

From the above, we can identify two Web user groups, those who search for information about a specific topic and those who browse within a general exhibit. For each group, we sought information about how topics were selected, how topics were navigated, and the length of a retrieval session. A summary of these characteristics is given in Table 4.

Discussion

In this study, we have had an opportunity to study information retrieval characteristics of three, potentially different user groups, at three different locations, in a museum setting, at an information kiosk, and on the Web. Our goal has been to identify characteristics that can help support the design of effective information presentations. Particularly, we have been interested in the possibility of using off-line designs as tests for Web site designs.

Observations and Proposals

The similarities in information retrieval behavior between off-line and Web users, including:

- Less than 50% of exhibit visitors selected more than one theme,

	User type	Topic selection (placement correlation)	Navigation by text link	Topic pages
Off-line	Museum	Index: (-0.9)	20%	3.3
	Kiosk	Index: (-0.78)	40%	3.8
Web	Exhibit start	Index: (≈ 0)	20%	5.0
	Detail start	Search engine	15%	2.9

Table 4. Information Retrieval Characteristics

- An apparent universal tendency to use the next button link, and
- < 3 pages selected per topic,

indicate that hypermedia topics should be relatively short and built in a 'normal' reading style. Further, off-line users select topics from the top of the index, which indicates that particular attention to topic sequence is important.

While Web users tend to *read* selected topics in a serial manner, they start their sessions following a search engine selection of some topic page, thus avoiding the index structure of the exhibit. These sessions are very short, indicating that many viewers may not find information without its context. It appears that designers of hypermedia Web presentations should focus of short, self-contained page sets, where any one could be an entry point to the presentation. Indexes are not necessary as entry guides, but can be useful for the interested viewer to gain an overview of the presentation content.

Similar Studies and Further Research

Our study supports earlier observations of museum users (Futters, 1997; Dierking & Falk, 1998), in that Web users tended to select information on only one topic from our museum site, rather than general browsing. Clearly, any study of user activity needs to be supplemented with demographic and intention data. Unfortunately, our attempt to solicit demographic information from users of the Web exhibit was unsuccessful. More work in this area is needed.

Other structures for presentations can be explored. It is possible to include all topic information in a single file with embedded links to detail sections. Two drawbacks to this structure must be considered, 1) the large page will bring unnecessary information to many viewers and will increase transport and set-up time, thus increasing markedly response times for the user, and 2) it will become more difficult to monitor topic interest and thus adjust topic presentation to the intended user groups.

Conclusion

In conclusion, it appears that studying off-line exhibits, where knowledge of user demographics is possible to obtain, can be used for design of Web presentations, particularly for those visitors that enter *through the front door*, at the top of the exhibit structure. Design of exhibits for *side door* visitors remains a challenge.

Acknowledgments

This project was begun as part of 50- and 25-year anniversary celebration activities for the University of Bergen and the School of Social Sciences, respectively .Thanks are extended to staff, faculty, and students of the Bergen Museum, School of Social Science, and the Department of Information Science for their help in the construction and test of the electronic exhibits. Special thanks are extended to Professor Svein Nordbotten for all project support.

References

Bush, V. (1945). As we may think. *Atlantic Monthly July 176* (1), 101-108.

Conklin, J. (1987). Hypertext: An introduction and survey. *IEEE Computer, 20* (1), 17-41.

Day, G., (ed.) (1995). Discussion. *Proceedings. Museum Collections and the Information Superhighway.* Science Museum, London. http://www.nmsi.ac.uk/infosh/discuss.htm.

Dierking, L.D. & Falk, J.H. (1998). Understanding Free-Choice learning: A Review of the Research and its Application to Museum Web Sites. In D. Bearman & J. Trant (Eds.) *Museum and the Web 97-99: Special Edition Proceedings.* CD ROM. Archives & Museums Informatics. 1999. Also http://www.archimuse.com/mw98/papers/dierking/dierking_paper.html

Futers, K. (1997). Tell Me What You Want, What You Really, Really Want: a look at Internet user needs. *Mda.* http://www.open.gov.uk/mdocassn/eva_kf.htm.

MacKenzie, D. (1996). Beyond Hypertext: Adaptive Interfaces for Virtual Museums. *TAMH Project Report, Tayside, Scotland.* http://www.dmcsoft.com/tamhpapers//evaf.htm.

Nelson, T.H. (1967). Getting it out of our system. In G. Schechter, (ed.) *Information Retrieval: A Critical Review.* (pp. 191-210). Thompson Books.

Nordbotten, J. & Nordbotten, S. (1999) Search Patterns in Hypertext Exhibits. *Proceedings of HICSS 32,* Maui, HI, USA, Jan. 4-8, CD, IEEE ISBN 0-7695-0001-3.

Preece, J. et.al. (1994). *Human-Computer Interaction.* Addison Wesley.

Shneiderman, B. (1992). *Designing the User Interface - Strategies for effective Human-Computer Interaction* (2nd ed). Addison-Wesley.

The Impact of Subjective Cultural Issues on the Usability of a Localized Web Site: The Louvre Museum Web Site

Yvonne Cleary, University of Limerick, Ireland

Abstract

This research examines the role of cultural issues on the usability of the Louvre Museum Official Web site. Much Web localization currently focuses on linguistic translation and technical issues (like time and date conventions and character sets). Often, more subjective features of a site, like color, audience needs and expectations, presentation techniques, and graphics, are disregarded. However, people from different cultures have different expectations and needs, and meeting these needs improves the usability of localized versions of a multilingual Web site. Museums are of interest to, and visited by, people from all over the world. Likewise, a museum Web site must be accessible and usable across cultures. This paper examines general features that make a site more usable. The primary research involves a usability study of different culture groups using the Louvre Museum Official Web Site, available in four languages. The participants, from France, Ireland, Spain, and Japan, were observed and video-recorded during co-operative evaluation sessions interacting with the site as they attempted to complete tasks. Results show that the site's neutral graphics were popular across all culture groups. Participants from all backgrounds admired pictures of the museum's artifacts. However, not all graphic features were usable. Labels and captions on diagrams were not localized. Results also illustrate that the usability of a multilingual Web space depends to a great extent on flexibility. The site is best suited to French audiences, 100% of whom expressed overall satisfaction. Japanese participants were least satisfied with the site.

Introduction

The number of people who access the World Wide Web for entertainment, business, research, and education is growing daily; statistics in February 2000 point to a possible 250 million Web users (Nua, 2000). This represents an increase of 100 million in just over one year.

Horton, Taylor, Ignacio, and Hoft (1996) give the following reasons why people use the World Wide Web:

To share a special skill, knowledge or perspective.

To support learning and intellectual stimulation.

To pursue personal interests.

To shrink distances and reduce isolation of all kinds.

However, only 5 to 10% of businesses (Bussin, 1998) adapt their Web sites for audiences that do not speak English. Even when a multilingual version of a site is available, it is often inadequate. Web localization currently focuses on linguistic and technical issues, but layout, graphics, color, and organization are rarely adapted to suit the needs of international users. Linguistic translation, however, only scratches the surface of localization: cultural experience may have a greater influence on users' reactions (Hall, 1990; Arnold, 1998). People from different cultures do have different expectations and needs, and meet-ing these needs improves the usability of the local-ized versions of a multilingual site.

Good Design Practices for Web Sites

Some design rules apply to all sites; these include:
1. Avoiding loud colors and backgrounds and "gra-tuitous use of bleeding edge technology" (Nielsen, 1996).
2. Including solid content.
3. Making the site structure transparent.

Many sources outline good Web design practice; however, each Web site genre (advertising, informa-tion, academic, fun, and so on) requires design rules that match audience expectations. For example, a museum site should be aesthetically appealing as well as easy to use.

The Web has enormous scope as a visual medium, and people typically find it difficult to read large chunks of text on screen (Horton, 1994). There-fore, graphics are a crucial factor in Web design. Nonetheless, visuals and colors have cultural impli-cations that designers need to be aware of. For ex-ample, symbols that Americans regard as relatively harmless can be offensive to people in other parts of the world. Hand gestures are especially trouble-some (Fernandes, 1995; Subbiah, 1992). In many cases

though, well-designed visuals can transcend cultural and political boundaries.

A multilingual site must be more than visually appealing: it must be usable for all its target groups. Quite aside from linguistic considerations, the site's structure must be transparent for users from all culture groups, regardless of their inherent expectations. Like other hypertext media, the World Wide Web defies the traditional approach to documentation organization and structure — no site with more than one page has a definite beginning, middle, or end. Access devices and content must also be suitable for all members of each target audience.

International Variables

Culture can be defined as "the shared knowledge and values of any group" (Kostelnick, 1995: p. 182). Many models of culture exist to describe cultural experience and influence. The Iceberg Model (see Figure 1) is one of the most popular.

Figure 1: The Iceberg Model Source: Hoft, N. (1995). *International Technical Communication.* New York: Wiley p.59

Just as only 10% of an iceberg is visible above water, only 10% of a group's cultural characteristics are obvious or explicit. The remaining 90% are comprised of unspoken rules (like business etiquette)

and unconscious rules (like non-verbal behavior).

Hall (1989) defines two types of culture: high context and low context. People from high context cultures (including Japanese, Chinese and Arabic people) use context to communicate most information in a message, while people from low context cultures (including native English speakers, German speakers and Scandinavians) expect lots of detail in visual and verbal communication. Other anthropologists look at culture from different perspectives: for example, Hofstede and Trompenaars look at variables such as individualism versus collectivism, masculinity versus femininity and long-term versus short-term.

Practically speaking, how can designers apply knowledge of culture when building international Web sites? Hoft (1995) recommends that designers determine international variables and use these to develop profiles of international communities. A model for developing international Web sites might look at variables like:
1. Color and visuals.
2. Technology.
3. User values and attitudes.
4. National formats (like time, date, currency, and character sets).
5. Information expectations.

This next section outlines a study to determine how these international variables affect the usability of the four language versions of the Louvre Museum Official Web site.

Methodology

The main aim of the study was to discover how culture difference affects how users react to localized versions of the Louvre site. This was possible by determining whether users from different culture groups experienced different problems when using this site (the Louvre Museum Web site). This site is available in four languages: French, Spanish, English, and Japanese.

The Site

The Louvre museum is one of the most famous in the world and its official Web site is well known. The site should be of interest to a range of groups:

people interested in art and art history; people planning a trip to the museum; people who want to buy goods associated with the museum; students assigned a research task; or casual Web users. This site was most suitable for testing because:

- It is available in four diverse languages, so comparisons can be made between language communities.
- Its functionality and layout are similar for all language versions; this consistency facilitates comparison between groups.
- Its subject matter is of interest to a wide audience.
- Its functions are not over-complex; a user of average technical ability should be able to use the site.

The site is very large and includes extensive information on both temporary and permanent collections, a virtual tour, visitor information, contact information, and online booking and order facilities. While the original site was created in the French language, most of the site is available through English. The Spanish and, in particular, the Japanese versions of the site are more limited. For example, information on, and views of parts of, the collections are not available through Japanese.

Co-operative Evaluation

The test approach was cooperative evaluation, possibly the most useful form of usability testing (Nielsen, 1993). A co-operative evaluation session involves an evaluator observing a test participant working with a system. Participants verbalize their thoughts and actions as they work through a task sheet. Tasks reflect actions that a typical user might want to do with the system. A short debriefing session follows the test, during which the evaluator tries to elicit specific information and recommendations from participants. If the session is video recorded, evaluators can recap on the sessions. Tapes are also a valuable source of information about subjects' non-verbal behavior.

Co-operative evaluation, therefore, facilitates the observation of:

- Users working on the site.
- Problems they encounter.
- Steps they take to overcome errors.
- Actions they repeat.

- Their satisfaction with the site's functions.
- The extent to which the site corresponds to their expectations and needs.

Subjects

Subjects from each language group were recruited from the student population of the University of Limerick. To ensure that the results were valid and specific to the research in question, the subject sample was controlled to the greatest degree possible. All were aged between 20 and 30 years, all had previous experience with the Microsoft Internet Explorer 4.0 browser, and all were university students. None had lived in Ireland for longer than one year. To achieve a balanced study, each group comprised the same number of participants: there were 16 subjects, four from each language group, two male and two female to counterbalance any possible discrepancies associated with gender roles.

Procedure

Each observation session took place with a single participant in a university laboratory booked for the study to prevent interruptions. Before each participant arrived:

1. The camera was set up and ready to record each session.
2. The Web site was open on the (French language) home page.
3. The browser history was deleted.

Each session took fifty-five minutes to complete. During the first five minutes, the test was explained to the participant who then read through the task sheet (see Appendix A), and had the opportunity to ask questions about the study. Every effort was made to put the participant at ease and to make him or her aware that the purpose of this research was to investigate the Web site, not the abilities of the participant. Each participant began by spending ten minutes exploring the site, and giving general opinions. After this exploratory exercise, they had to return to the site home page and begin working through the task sheet. Participants had to stop once they had spent thirty minutes working through the task sheet, regardless of whether or not they had completed all tasks. Finally a ten-minute debriefing session followed.

Constraints

It was not possible to test more than <u>four users</u> from each language group due to time constraints. In addition, the subjects were not wholly representative of typical users of these language versions, as they had all spent time living in Ireland and were, to some degree, acclimatized to an English-speaking culture. Testing in the various countries may have produced different results. A further constraint was that the language for all task lists and sessions was English. Although they were proficient in the language, for 75% of the participants English is a foreign language. Finally, while the subject groups were controlled with respect to age, profession, gender, and level of experience, it is a fallacy to surmise that any of the subjects can be wholly representative of a particular group. Even in controlled situations, participants display individual preferences and tastes. Cultural background, while influential, does not eclipse the inherent uniqueness of each user.

Results

This section of the paper outlines the results of the co-operative evaluation tests and debriefing sessions. These tests are a rich source of qualitative information. Subjects express their opinions, and demonstrate their likes and dislikes. The think-aloud protocol is less useful for gathering quantifiable data, although we do achieve concrete information on, for example, the number of tasks each subject completes, and the number of errors subjects make (Figures 2 and 3).

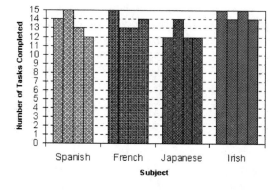

Figure 2: Number of tasks successfully completed

While none of the Japanese subjects completed all tasks, two Irish, one French and one Spanish subject completed all 15 tasks successfully.

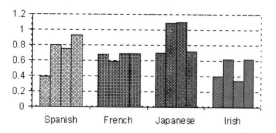

Figure 3: Number of errors per subject per task

As the chart in Figure 3 indicates, Japanese subjects experienced most difficulty with tasks; two had an average of more than one error per task. Of the other groups, Irish participants experienced fewest "errors". Errors correspond to the number of superfluous or erroneous steps that users took to complete a task.

During debriefing participants were asked their favorite and least favorite features of the site, features they would change and features they would add. Table 1 (opposite page) illustrates their responses. Participants were also asked during debriefing to agree or disagree with a number of statements. Their responses are shown in Table 2 (opposite page).

The reasons subjects cited for wishing to use the site again were either to find out more information about the art collections or to view artifacts from the collections. Two subjects who said they would not use the site again remarked that they would prefer a physical visit to the museum than a "virtual" experience. Some overlapping inevitably occurs when comparing usability between groups. There were some problems that affected all, or a large number of, participants. Likewise, participants across groups admired many features of the site. The problems that were most crucial for most subjects, and the features that most subjects admired, are listed below.

Top Five Usability Problems

1. Navigation tools are very inflexible. Users must depend almost exclusively on the main menu to

carry out any task. The navigation bar at the top of each page was meaningless for Spanish, Irish and Japanese users.

2. Menu labels are ambiguous on all language versions, but especially on French and Spanish.

3. Many parts of the site are only available in French. While the English version is almost complete, Spanish and especially Japanese users are forced to work with very limited functions.

4. The organization of the main menu does not correspond to users' expectations in many respects. For example, many users expected Temporary and Permanent Collections to be grouped together.

5. There are no links to diagrams of the museum on any language version. Subjects came upon them by chance, or by random searches through pages. There is no usable diagram of the museum on any part of the Japanese version.

	Spanish	Japanese	French	Irish
Favorite Feature	Pictures of Collections Pictures of Collections Information about Art Information about Art	Pictures of Collections Pictures of Collections Pictures of Collections Speed	Pictures of Collections Pictures of Collections Information about Art Information about Art	Pictures of Collections Speed Speed Layout
Worst Feature	Organization/Layout Navigation Menu Labels None	Organization/Layout Navigation Incomplete Localization Incomplete Localization	Organization/Layout Organization/Layout Menu Labels Menu Labels	Organization/Layout Navigation Menu Labels None
Feature to Change	Navigation Tools Navigation Tools Full Localization Terminology	Full Localization Full Localization Full Localization None	Organization Organization Terminology Terminology	Organization Organization Terminology None
Feature to Add	Search Tool Index Collection of Diagrams None	Improved Diagrams Improved Diagrams Collection of Diagrams None	Links to Similar Sites Links to Similar Sites Search Tool None	Search Tool Search Tool Index Tips for New Users

Table 1: Features subjects liked, disliked, would add or would change on the site

Statement	Group	% Agreement
It was very easy to use this Web site	Spanish Japanese Irish French	25% 25% 50% 75%
Using this site was frustrating	Spanish Japanese Irish French	0% 50% 0% 0%
This site allows me to do all the things I think I would need	Spanish Japanese Irish French	50% 25% 50% 100%
This site is very pleasant to work on	Spanish Japanese Irish French	25% 25% 75% 100%
I would use this site again	Spanish Japanese Irish French	75% 75% 75% 100%

Table 2: Participant Satisfaction with the Site

Top Five Features of the Site

1. Pages are not excessively long, and most users found information with minimal scrolling.
2. Graphics were fast to load. The successful integration of art on this site was noted across all groups.
3. The site has a vast repository of information about artifacts, details of collections, and the history of the museum.
4. The site has a neutral look and feel with no "bleeding edge technology".
5. The site was not offensive politically, culturally, or economically to any of the participants in this study.

Discussion

The discussion of results focuses on the following international variables:
1. Visuals and Color.
2. Navigation and Access.
3. User Values and Attitudes.
4. Information Expectations.
5. Technology.
6. Linguistic Issues.

Visuals and Color

Most visuals on the site are culturally neutral as they depict museum artifacts or photographs of parts of the museum. None of the subjects complained about these graphics. On the contrary, most commented on the utility of featuring examples from each collection.

Figure 4: Reception Area under the Pyramid (English) Source :http://www.louvre.fr/louvrea.htm

In general, there are fewer diagrams on the Japanese version of the site. This proved a severe problem; two of the four Japanese participants commented that they were more interested in browsing through pictures than reading text. Figure 4 shows part of the *Reception Area under the Pyramid* page from the English language site. Figure 5 shows the corresponding Japanese language page, which omits the graphic.

Figure 5: (Reception Area under the Pyramid (Japanese) Source: http://www.louvre.or.jp/

The favorite feature of three of the four Japanese subjects was the *Collections* part of the site, which has not yet been localized into Japanese. During the experiments it was evident that Japanese subjects only agreed to look at the *Collections* through English so that they could complete tasks. Under normal circumstances they would not have used this part of the site at all.

Only one (illegible) diagram of the museum is available on the Japanese version of the site, and those on other versions have French captions. This was most problematic for Japanese users, only one of whom could complete the associated tasks (finding and printing a diagram of the museum).

The colors on the site are neutral — shades of blue and gray, and white. Three Spanish and three Irish users found the color scheme dull and uninteresting. One Irish user commented that the overall artwork on the site does not reflect the purpose or status of the museum and its associated Web site. However, no user felt that the colors were inappropriate or incongruous, suggesting that the colors were unobtrusive, a positive usability attribute.

Navigation and Access

The primary navigation tool on the site is the main menu, part of a frameset, on the left-hand side of each page. This menu is available on all pages of the site, which is a positive navigation feature. However, because this menu is the sole means of information retrieval, users are restricted in:
1. How much information they can find.
2. How they go about finding information.
3. How they interact with the system.

The reliance of most users on the browser's Back button shows that this menu does not match users' needs. When a site is created with a diverse cultural audience in mind, and when the site strives for consistency of layout between language versions, as this one does, then developers should consider providing alternative means of information retrieval that support a variety of user techniques. Forty percent of subjects recommended adding either a search facility or an index to the site to facilitate information retrieval.

The navigation bar on the top of each page was only meaningful for French participants, probably because of the label on other language versions (Menu, instead of Home Page), but also possibly because of its position on the right instead of the left-hand corner of the page (Nielsen, 1997). Furthermore, though not an issue during these tests, users may choose a language version only from the home page. Many users will not access the site directly from the home page, but may be directed, via a search engine, to a page deep within the site. Given that users during these experiments did not recognize the home page link, this could be a serious issue for international users, who have no way of knowing that other language variants are available.

User Values and Attitudes

Although art is not always neutral, and does not always transcend cultural boundaries, no subject involved in this research showed political, social, or economic sensitivity to any information or presentation technique. Nonetheless, participants from different subject groups did display distinctive characteristics.
1. Japanese participants displayed the most distinctive characteristics of all groups. They were more hesitant at the start of sessions, and more wary of making mistakes than other groups.
2. Japanese subjects were also extremely conscientious, three of the four asking at the start of sessions if they should write the answers.
3. All Japanese participants commented on, and appeared pleased by, the association of Shiseido, a Japanese cosmetic company, with the site. Japanese people traditionally value company loyalty (Hoft, 1995).
4. French and Japanese participants showed a strong sense of being personally responsible for errors. Comments such as "I'm sorry. I'm stupid.", and "That was my fault." were common among both these groups. Schriver (1995) notes that learners are often quick to blame themselves for problems that arise from inappropriate presentation techniques.
5. In terms of non-verbal behavior, the Japanese users were also distinctive from the Europeans involved in the study. They were all manifestly reticent during the opening minutes of sessions, but opened up considerably towards the end. Spanish participants were notably talkative from the outset.
6. French participants were most satisfied with the site, possibly because it is best suited to this audience. However, a sense of national pride, and a greater interest in French culture and heritage may explain this trend.
7. Spanish participants were considerably less focused than others; three of the four became sidetracked on more than one occasion.
8. Irish subjects seemed more at ease with the technology than others. This may reflect the difficulty that other subjects had in "thinking aloud" in a foreign language. However, the growth in the Irish technology sector and the comparatively advanced computing facilities at the University of Limerick may also play a role in increasing confidence among Irish users.

Information Expectations

On a well-organized system users should have a clear idea of:
1. How the system works.
2. How the information is organized.
3. How much information is available.
4. How this information can be accessed.

When users make errors or comment that they expected an action to produce a different outcome, it is probable that the organization or layout is incompatible with their own mental model of the system (Ravden and Johnson, 1989). This site's organization proved to be at odds with user expectations on many occasions. The layout of the main menu confused most users who expected, for example, *Permanent* and *Temporary Collections* to be located together on the menu.

The *Collections* menu divides works into categories of art — Paintings, Sculpture, Antiques, and so on. Two Spanish participants were uncomfortable with the temporal arrangement of information within these categories. In the Paintings category, for example, works are divided by century. These participants would have liked a facility whereby they could access all watercolor or still life paintings, or all paintings by a particular artist, directly from this menu. The current format assumes a basic knowledge of art which not all users will have.

The paragraph layout of some pages was useful only for French participants, who may expect information to move from the general to the specific (Subbiah, 1992). Alternative formats such as tables might alleviate problems of users from other cultures. In addition, three Japanese users suggested that a single column spread would be more accessible for Japanese users than the current two-column layout. However, the site proved learnable for all user groups. Despite initial problems with some tasks, participants did not have difficulties performing similar subsequent tasks.

Technology

On the Louvre site, graphics were fast to load and many subjects from all groups remarked on this even before debriefing. Arnold (1998) comments that fast-loading pages are the single most important feature for Japanese users. This study suggests that they are even more important for Irish users, with two of the four naming fast-loading pages as their favorite feature of the site. According to Nielsen (1999) pages that are slow to load are still very frustrating for all users.

Linguistic Issues

Menu labels, especially on the Spanish version proved problematic. For example, the equivalent of the English label "Visitor's Information" is called "How to Use" (Modo de Empleo). The label on the navigation bar that should lead users to the home page is called "Menu" in English. Only French participants used the home page link, which is called Sommaire (summary or menu) in French.

Japanese users wanted to access all parts of the site in their own language version, and would not have used other parts of the site in normal circumstances, even though, 75% liked the Collections part of the site best. This part is not available through Japanese. Considering that many people will use this site to research a holiday or a hobby, and that in the vast majority of cases they are paying for the privilege of viewing the information, users do not want to wade through foreign-language pages. Quite aside from the high costs involved in spending time online, people want entertainment and leisure activities to be hassle-free and, above all, enjoyable.

Conclusions and Recommendations

An increasing number of Web users come from non-English speaking countries. Therefore, localization of Web sites will almost certainly become, if not essential, more important for international business. However, diverse audience needs exceed the limitations of many sites, including the Louvre site. The main problems with this site are ones that have implications for all multilingual sites:

1. Different groups do have different needs and expectations, even from a medium that has developed in a multicultural environment where the lines that separate ethnic groups are continuing to blur. Therefore, multilingual sites need to provide alternative access and presentation devices to facilitate diverse audience needs.
2. Sites that target a multicultural audience should have an international appeal. While most users enjoyed the site, it was clear that French users were most satisfied with the experience, and were most supportive of the content. Ultimately, this site is more suited to one culture group at the expense of others.

3. Confusing menu labels cause severe problems for users who do not know what to expect when they click on an ambiguous link.
4. Users had difficulty locating diagrams scattered around the site, and many stumbled across them accidentally. Japanese users must use alternative language versions to access diagrams, and indeed other important visuals.

The results of this study, together with previous literature, imply some recommendations, both for the Louvre site and for other multilingual sites of this nature. Primarily, designers should provide:

1. Complete localization of all language versions. Where this is not possible, designers should make clear from the outset which parts of the site are not available in any language version, to reduce user frustration. Likewise, the site should encourage users to use foreign language versions if a feature is not available in their language of choice.
2. Neutral graphics with localized labels, captions, and legends, and access to diagrams from the main menu.
3. Alternative ways to navigate a site, including search tools and a site map.
4. Alternative layout features, such as tables and graphics to suit specific audiences.
5. Link labels that make actions predictable for all users.
6. External links to make the transition between sites more fluid for users.

In addition, usability testing with end-users should be a prerequisite to publishing a multilingual site. One recurring theme of this study is that the usability of a site targeting diverse culture groups depends to a great extent on flexibility. The findings of this study indicate that further research is necessary in the areas of multilingual site structure, user navigation techniques, and reasons why sites appeal to one particular audience above others.

On the positive side, the Louvre site demonstrates that neither technology nor art remain a domain for experts. Both can be used and enjoyed by users who have no expertise in either field. Users do not need a strong background in technology to use the World Wide Web. Nor do they need an extensive knowledge of art to appreciate a site such as this one. Sites like this one bring art to communities that would otherwise have no opportunity to partake of a physical visit to the Louvre Museum. Most importantly, this study emphasizes the ability of pictures (as opposed to words or presentation techniques) to transcend cultural boundaries. Users across all groups admired the samples from the art collections.

References

Arnold, M.D. (1998). Building a truly World Wide Web: a review of the essentials of international communication., *Technical Communication* 45(2), 197 – 206

Bussin, R.. (1998). News you can use — emerging trends: multilingual Web sites., *Clear Point Consultants Inc* consulted February 14, 2000. http://www.clearpnt.com/news-candidates/bussin.htm

Fernandes, T. (1995). *Global interface design.* Boston: Academic Press

Hall, E.T. (1989). *Beyond culture.* New York: Anchor Books

Hall, E.T. (1990) *Understanding cultural differences: Germans, French and Americans.* Yarmouth, Maine: Intercultural Press

Hoft, N. (1995). *International technical communication: how to export information about high technology.* New York: Wiley

Horton, W. (1994). *Designing and writing online documentation: hypermedia for self-supporting products.* New York: Wiley

Horton, W., L. Taylor, A. Ignacio, and N. Hoft. (1996). *The web page design cookbook.* New York: Wiley

Kostelnick, C. (1995). Cultural adaptation and information design: two contrasting views., *IEEE Transactions on Professional Communication* 38(4), 182 – 195

Louvre Museum Official Web Site. (2000). Consulted February 14, 2000. http://www.louvre.fr/

Nielsen, J. (1993). *Usability engineering.* Boston: Academic Press

Nielsen, J. (1996). Top ten mistakes in Web design., *The Alertbox: Current Issues in Web Usability* Consulted February 14, 2000. http://www.useit.com/alertbox/9605.html

Nielsen, J. (1997). The difference between Web design and GUI design., *The Alertbox: Current Issues in Web Usability* consulted February 14, 2000. http://www.useit.com/alertbox/9705a.html

Nielsen, J. (1999). The top ten *new* mistakes of Web design., *The Alertbox: Current Issues in Web Usability* consulted February 14, 2000. http://www.useit.com/alertbox/990530.html

Nua Online Relationship Management. (1998). Internet surveys. Consulted February 14, 2000. http://www.nua.ie/surveys

Ravden, S. and G. Johnson. (1989). *Evaluating usability of human-computer interfaces: a practical method.* Chichester: Ellis Horwood

Schriver, K. (1997). *Dynamics in document design.* New York: Wiley

Subbiah, M. (1992). Adding a new dimension to the teaching of audience analysis: cultural awareness., *IEEE Transactions on Professional Communication* 35(2), 196 – 217

Developing a Museum Web Presence for Higher Education: the Evaluation of an Online Course at Richmond, The American International University in London

Evan Dickerson, Richmond, the American International University in London and Susi Peacock, Queen Margaret University College, UK

Abstract

This paper discusses an online module: Museums and Galleries: The Cultures of Display for Junior level, undergraduate art history students at Richmond, the American International University in London (RAIUL). Published on the University's IntraNet, this module is part of a university-wide IT and Teaching Initiative. We specifically address the educational rationale for the project with reference to the institutional context and the impact of such developments on the University's support services.

General Introduction

Richmond, The American International University in London <http://www.richmond.ac.uk> (RAIUL) was founded in 1972 as a not for profit professional and liberal studies university. Based principally on two London campuses with study centres in Florence, Italy and Shizuoka, Japan, it has a student cohort from over a hundred countries. RAIUL'S curriculum currently covers seventeen majors and twenty-nine minors; it adheres to the standard American four-year format with progression through credit accumulation. The University awards BA and BS degrees, in addition to a Masters in Business Administration and a MA in Art History. Its undergraduate programs recently became the first of any international university to be dual accredited by the Open University (OU) in the United Kingdom (UK) and the Middle States Commission for Higher Education and Instruction in Delaware, United States (USA).

The module discussed in this paper, "Museums and Galleries: The Cultures of Display", forms an integral part of the art history program at Junior level in the Humanities Department at RAIUL. Although not a compulsory requirement for the art history degree, this module offers students the combination of theoretical knowledge of the museum and art market world together with practice. This offers insight into the world of professional art historical application post university study. It is a semester in length, runs twice a year and is an introduction to museum and art market studies. Throughout the semester students examine aspects of what has, in recent years, become known as "the

culture industry". The focus of the module is visual culture and specifically upon the purpose, role and practice of museums and galleries and the role and practice of art dealers and collectors, commercial art galleries and of the auction houses. It is structured as two interweaving strands. The first of these consists of a weekly lecture series designed to acquaint students with some of the current issues in museum and art world studies, such as:

- the nature and purpose of the museum in contemporary society; cultural property and the ethics of collecting; the notion of national heritage;
- the role of the museum within education; art world crime; the philosophy, ethics and practice of conservation and restoration, funding and the economics of cultural institutions; museum management and governance; the role of the art dealer and commercial art galleries; the role and operating practice of the auction houses.

The second strand consists of a series of visits to museums and other art institutions, both to sample the various categories of museum and to provide the opportunity to study how, on a practical level, museums deal with the various aspects. We consider such topics as:

- how museums balance their public service role with scholarship and research;
- the use of buildings and facilities; adapting old buildings to current notions of display;
- the use of new technology;
- museum access and the provision of facilities for the handicapped visitor; security and the protection of art;

- how museums "interpret" their collections, museum and exhibition design;
- collateral money-generating enterprises.

The two tracks interweave to provide a theoretical understanding of a number of major issues and the opportunity for students to study at first hand some of the ways in which art institutions confront these issues in practice. Discussion is an important part of this course and students are expected to verbalise their thoughts and perceptions and to develop a critical response to the material under consideration.

In fall 1999, twenty-four students completed the module, twenty of whom were female. During spring 2000, forty-one students are enrolled on the module and thirty are female. Typically 95% of these students are participating on a study abroad programme and have chosen to spend a semester or academic year studying at RAIUL away from their main university in the US.

Rationale

To date, this is the only art history online module available on RAIUL's Intranet (Campus Wide Information Service or 'CWIS'). We specifically selected this module to provide insight into the following:

1. How does an online resource module encourage student-centred learning?

Eighteen months ago, when we started development of the online module, the framework and content of "Museums and Galleries" were being modified for the art history accreditation submission for the OU. There was an awareness of the need for greater integration of teaching and information technology with the aim of developing more student-centred learning, for example, in the Dearing Report (Dearing 1997). In addition, many of the galleries and museums visited during the module have an extensive web-presence. This provided the opportunity to incorporate meaningful external hyperlinks which we hoped would encourage the students to take more charge of their learning, through accessing materials and following hyperlinks (autonomous learning).

2. How will students react to an online module presence?

In earlier iterations of the module, many of the students had demonstrated a high level of Information Technology (IT) competence and high expectations for the use of Learning Technologies (LTs) within the curriculum. Much of the student cohort is from US universities where, in the main, LTs are more widespread than in a typical UK university. However, given our understanding of student competence in IT, we wanted to evaluate how students reacted to our online module.

3. How can an online resource module help faculty?

Faculty expectation at RAIUL, in the main, reflects those reported by Littlejohn and Cameron (1999) believing that teaching and learning will be via centralised resources accessed by C & IT with an increased emphasis on distance and open learning. However, in stark contrast, there is tremendous reluctance to launch into the development of online modules with the increasing demands on faculty time coupled with the belief that online module development is extremely time-consuming

The class size for "Museums and Galleries" has increased with a corresponding growth in the day-to-day administration. Students have sixteen visits to galleries and museums throughout the London area. Prior to the online module development, each week students were provided with hard copy handouts of maps, directions and basic information. This would take, on average:

- four hours per week in preparation by the lecturer
- ten minutes each week in the lecture to distribute

and students would invariably lose these handouts. Therefore, we wanted to ascertain if the development of the online module could relieve the high administrative burden of the module and if there were significant time overheads for faculty in the development of an online module.

4. Is an online module suitable for a subject such as art history?

The development of the module was seen by many of the RAIUL art history department as being a prototype for the kinds of use of this technology within the discipline area. We were most concerned that the online module reflected the subject matter and was mindful of the visually-literate audience. We consciously wanted to develop an online learning presence that contains a sense of aesthetic awareness reflecting the subject.

5. What are the resource implications for a small liberal arts university, such as RAIUL in deploying LTs such as online module?

We wanted to explore:
- The amount of training required for a member of faculty with average-level of IT skills to develop an online module. Also, we wanted to explore the possibilities of the Internet for teaching and learning, as Littlejohn and Cameron (1999) state, "Working effectively within an integrated online learning environment requires the development not only of practical IT skills, but also of pedagogical skills."
- The impact on the support services including IT, the audio-visual services and the library to support online module development.

Many American universities are attempting to find a model that will effectively support the deployment of large-scale LTs. At EDUCOM 98, Christoph, Culp, Kerns, Koffenberger and Kumar (1998) presented a number of possible models to support the growing use of LTs within their respective institutions. Culp described the centre for instructional technologies at the University of Texas at Austin. This helped faculty with multimedia production, instructional design and in their technical skills. In comparison, at George Washington, there was a more phased approach: in the initial stages supporting full-time faculty to develop LTs and then gradually using these early adapters to support other faculty in experimenting with LTs. By the development of this online module, we wished to explore the type of support required for faculty at RAIUL in developing an online module and to advise senior management on the way forward to support large-scale development of LTs.

Methodology

Both of the writers are engaged in a self-reflective, critical enquiry, which could probably fall under the title of 'action research' As Kemmis and McTaggart (1998) state,

> the linking of the terms 'action' and 'research' highlights the essential feature of the approach (action research): trying out ideas in practice as a means of improvement and as a means of increasing knowledge about the curriculum, teaching and learning.

Another essential element of action research is the collaborative: involving colleagues so they may benefit from the research. A strong element of the project was dissemination to:
- our art history colleagues
- all members of RAIUL
- those within the wider educational community.

The immediate impact of this approach is change. The online module is constantly changing and has a major overhaul at the end of each iteration reflecting our experience, the comments of the students and our colleagues within and outside the art history department.

The First Iteration

1. Development

Initially the online module was developed in a very limited format and had four sections:

Course Outline

This includes course description, objectives, learning outcomes, weekly breakdown of visits, lectures, follow up reading for each week and assigned texts Most of this material had already been generated in Word and was transferred into HTML format. The only modifications to this were the addition of navigation links, as found on the default page, and the standardisation of visual appearance, as discussed in the next section (see image one and two).

Museum Specific Pages (for each weekly visit)

Each page, specifically created for the online module, contains a description of institution and con-

Figure 1 Course information

Figure 2 Course outline details

Figure 3 Example of a museum specific page

tents, location (all with maps provided), nearest public transportation, opening times, entry charges, facilities at the institution and, most importantly, a link to the Museum's Internet site (see image three).

Online Resources

This started as a set of links to useful, relevant websites. There was much debate about what should be included here; we did not wish students to become so complacent as to ignore the mass of in-depth museology information that is only provided in monthly printed journals and other more traditional academic resources. This section has since

Figure 4
Some of the online resources section. It shows links to art crime websites and where to contact Museum Personnel.

developed to include links to online lists of museum personnel email and snail mail addresses, which students utilise to obtain interviews for primary research material for the semester research project. There are also links to specialist museums discussion lists, for example; The Group for Education in Museums (see image four).

Class Messages

This area is used to keep a running history of messages displayed throughout the semester on matters such as: assignment deadlines, changes to visits, notification of major museums-related news and new relevant journals or online sites. They are lecturer-generated. At RAIUL, our email system is based on Microsoft Exchange but we specifically selected a messaging system within the online module to ensure that the students returned on a regular basis throughout the semester.

As we have stated earlier, the appearance of the online module has always been important. We wanted to give a positive and attractive visual per-

spective of the module to our student users, and to make a statement about the potential for visually sensitive and aesthetic webpage creation. As a matter of principle, all the material is presented in a forthright and matter-of-fact manner; we did not wish to undermine the seriousness of the material itself in students' perceptions.

The central image of the home page (see image five and six) is an ornate gilt picture frame containing a "painting" of the logos and photographs of institutions visited. The overall image was generated using Adobe PhotoShop. Permission was sought from the

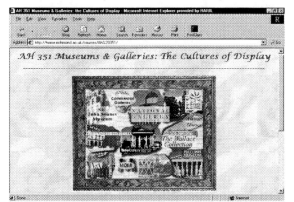

Figure 5
This shows the front page of the online module with gilt picture frame and links to the institutions visited.

Figure 6
This shows the lower section of the home page. There are links to class messages, assignment information, museums of the week and information about the tutors. This has changed over the three iterations.

museums and galleries prior to using their logos and images in our module. The gilt frame image was scanned in from a catalogue about frames and the canvas background JPEG was downloaded from a royalty-free site on the Internet. This part of the process consumed about a day's work from the educational resources unit at RAIUL.

To ensure consistency throughout the site each page has a common appearance

- The Title is in Lucinda Calligraphy font, red and bold text
- Hyperlinks to other pages of the site and externally are given in black (also Lucinda Calligraphy font)
- Page text is in black Arial, for ease of readablity and standard distribution on our internal network.

2. Student Introduction to the Online Module

At the beginning of each iteration, faculty demonstrate the online module to students. Faculty expectation of student usage is clearly defined - students should make full use of the appropriate online pages and explore the museum's web site in detail prior to each visit. The faculty also explain the rationale for the online module. For example, students are told that we wish to use to the full the time in the museums and galleries to explore specific issues as opposed to administration details. Hence all information about the visits are online. We also explain that we want to help them develop critiquing skills for assessing websites and develop student autonomy.

3. Student and Faculty Reaction to the Online Module (after the first iteration)

As we have already stated, action research links action and research. After each iteration, we spoke with students and faculty and the online module began to take on a life of its own. Following the initial iteration of the project, much time was spent correcting inconsistencies that had crept into the online module during the semester. Most of these were due to the speed and short notice with which changes were often enacted. Some additions simply meant modifying existing pages of the site or creating links to other items already published on RAIUL's CWIS.

The majority of the students were happy with the level of access, content and communication offered to them by the site and welcomed its continued development. Issues were raised by the students that resulted in some rethinking and organisation of the online module. Subsequent developments were made which included:

1. Additional information about assignments

Students particularly requested this. Notification of assignments are given during the lecture sessions but specifics are only available online. For example, the design project in which students have to propose their ideas for the redesign, interior decoration, display methodology, lighting, security and public information given in the Islamic room at the Victoria and Albert Museum. Their understanding of the conventions employed throughout the institutions visited, combined with their own imagination for

Figure 7
This shows the assignment page detailing the design project in the Islamic room at the Victoria and Albert Museum.

redevelopment in sympathy with the artefacts form the basis of the methodology in this assessment component. In this instance the information is presented in the form of a competition entry brief that all students are invited to enter, as "designers sympathetic to current concepts of room redesign" (see image seven).

2. Faculty Contact Details

A large percentage of students wanted faculty contact details, office hours, and email. Therefore, links were created to faculty profiles on the CWIS and the provision of email links from the default page.

Other additions were made after our discussions with our art history colleagues and included:

A "Museum of the Week"

This is a hyperlink to the site of a gallery or a museum that we do not visit, a museum-related body or a specific site of interest. These have included: the Freud Museum; <http://www.freud.org.uk>, the Science Museum <http://www.nmst.ac.uk>, The Museums Association <http://www.nmst.ac.uk> and the Evening Standard newspaper's online archive of articles by the prominent art critic, Brian Sewell <http://www.thisislondon/briansewell/>.

We had specifically included this area to broaden the horizons of interest for our many study-abroad students on the module who can simultaneously expand their knowledge of museums and enjoyment of London this way. At the end of the second iteration, 44% of students reported having visited two or more of these institutions after visiting the web site in fall 1999, or having learnt more on a specific issue.

Additional Resource Links

Links were added to other sections of the CWIS detailing use of the CD-ROMs of the National Gallery, London; Galleria dell'Uffizi, Florence, the Musee D'Orsay, Paris and Cities of Europe; available from RAIUL's Library for student and faculty use.

The Second Iteration

After the second iteration, we again interviewed students and faculty. Most of the changes required some more 'fine tuning' but there were two significant new features.

The Conversion of the Extensive Research Bibliography

Compiled over the last ten years this bibliography aims to be an extensive listing of conventional printed source material applicable to the content of the module and the requirements of the final research paper. Currently it lists over three thousand books, scholarly articles, newspaper items and other sources, such as press releases, Government commissioned enquiries into museums policies, procedures and funding initiatives from many coun-

Museums and the Web 2000

tries (UK, USA, France, Germany and Italy) and specialist interest papers on topics including latest updates on conservation and restoration techniques.

Originally presented in hard copy, this was converted into HTML and was linked from the default page. It may be searched by author's family name or general subject area, for example, art crime, curators, or new museum design. Whilst this delivers greater flexibility and transparency of use for the student, this does create greater maintenance issues.

The Development of a Study Skills' Section

Most academics are concerned about students' generic study skills but given the highly multinational mix and large proportion of study abroad students at RAIUL, it was felt that this was an area requiring special emphasis to implement standard University-wide guidelines. There are links to other sections on the CWIS including "Writing across the Curriculum"(a supplementary study skills program run under the direction of the University Writing Coordinator, to promote good academic writing practice within the RAIUL community.) and a RAIUL Library generated guide to MLA citation system. In addition, there is information on other library and research resources on arts and museology in London that is available to RAIUL students.

This also related to our students' usage of the Internet Resources page; students quickly assumed that because faculty had listed websites on the page, they therefore had faculty approval as sources to be (often quite heavily) used in researching the major paper for the module. It took students sometime to realise that this was not the case. Although the information linked to, might be of a sound nature, it was not always the most authoritative source available, and the Internet was not to replace the traditional skills of library-based research carried out through books, journals and periodicals. Therefore, as part of the study skills' section, we also include a link to the online tutorial, Internet Detective <http://www.sosig.ac.uk/desire/internet-detective.html>, formulated at the University of Leeds, UK. The aim of this tutorial is to give the user the skills required to evaluate the reliability and standard of information contained on Internet sites. Completion of this tutorial is something we recommend to all students during the first two weeks of the semester.

Preliminary Findings

We are now approaching the end of the third iteration of our online module and we return to our initial thoughts at the onset of this piece of action research.

How does an online resource module encourage student-centred learning?

During the first iteration, we began to observe students being more proactive and responsible in their approach to finding materials and information through the online module. They had visited galleries that were included in 'Museum of the Week' and actively sought other websites that they were quick to inform us about and asked to be included on the online module.

Unfortunately during the first iteration this positive approach was not always reflected in quality of work as students had not developed critiquing skills of online sources. The development of the study skills' section we hope has begun to address this issue.

How will students react to an online module presence?

Some of the art history faculty were anxious about student reaction to an online module and level of IT competency. Throughout all the iterations, most of the students showed average and above level of IT competency – often exceeding our own! The majority of the students in all three iterations was very positive about the online module and in the questionnaire asked for it to be continued. One or two had some initial reluctance but when our rationale was explained, they gradually 'accepted' the online module.

How can an online resource module help faculty?

As stated in the introduction, there is much faculty concern about the time taken to develop an online module. During and after each iteration, significant changes were made to the module, reflecting our methodology of action research. For example, in fall 1999 the default page had to be changed to remove the link to the Museum of the Moving Image information page, due to the museum's closure. This took at least a day's work and several more in sub-

sequent broken links. In addition, the online module became almost an extension of one's psyche and would draw one in to tinker relentlessly. For example, mid-way through the semester, we suddenly had to develop a 'previous museums of the week' area. We estimate that the development of an online module took approximately twenty times as long as to prepare for as a traditionally taught module.

However, the online module did make significant reduction in the administration overheads. Perhaps most significantly it constantly challenged the faculty in their approach and educational rationale to the teaching of the module. Students would make numerous suggestions about the online module and this would result in us reflecting in the content and delivery of the module. For example, there were many requests for online placement of lecture notes and past final exams. We decided not to provide these as we feel these could essentially be detrimental to the development of good study skills and academic practice: the essential functions of university education.

Is an online module suitable for a subject such as art history?

Our experience of developing this module for online use, in comparison with that of other American institutions, has pointed out that indeed the online module provision format can be of great benefit to the discipline of art history. Whilst many institutions have sought to incorporate web based technology into teaching practice (Costache, 1998), to our knowledge few institutions have sought to develop such encompassing projects regarding museology.

5. What are the resource implications for a small liberal arts university, such as RAIUL in deploying LTs such as online module?

Over 300 hours have so far been expended on the development of this one project. It has had an significant impact on all of the support services; this will need to be considered if similar and more extensive online modules are to be developed and maintained.

Many of our initial teething problems were connected to the process of publishing to the CWIS

and this is a good example of ensuring that procedures are in situ before launching into such a project. IT and AV Services had little time to organise a standard publishing process Therefore, in the first iteration there were problems and delays in updating the content of the site: changes to the online module could be enacted only by the Web Development Officer in IT and not individual faculty.

It became very clear in the early stages of the project that extensive and continued staff training is required in two specific arenas:
- IT technical training
- Staff development in using C & IT to improve teaching and learning

In line with all other CWIS web publishing, the software used to generate and maintain the module was centred on *Microsoft FrontPage*. It is commonly used throughout RAIUL because it does not assume any prior knowledge of HTML or other programming languages. The user does not to learn HTML to generate web pages. It was hoped that once IT & AV Services had assisted faculty in generating the initial site, it would then be possible after minimal training for individual faculty members to maintain their own course sites.

However, after the initial stages, it became apparent that technical support would be required on a semi-regular basis. Unfortunately FrontPage has a number of idiosyncrasies and often IT and AV Services is required to advise faculty on these. In addition, for such an online visual presence, image generation is fundamental. IT and AV Services helped in the production of all the central images especially on the default page. The images were generated in Adobe PhotoShop, which is a non-trivial package, and this service is always required in the generation of any significant online module of this type.

The Dearing Report (1997) recommended that faculty should develop learning and teaching strategies which focus on the promotion of student learning. As the online presence was fine-tuned, the faculty would call upon the services of the learning technology advisor as a 'sounding board' – discussing the best way forward to enhance the online module. This continued throughout all the iterations.

Proposals For The Way Forward

There has been a certain amount of interest expressed by colleagues at other UK universities who run parallel Museum Studies modules in the possibilities of collaboration. One area might be to explore the possibility for computer conferencing between the students of multiple institutions towards a mutual furthering of understanding museums and associated issues. Exactly how we as faculty might wish to direct this venture has yet to be decided.

An ideal area for collaboration in the way forward and expansion of this project would be for us as an institution to work alongside the educational department of one or more museums. Examples of this might be the COMPASS project under development at the British Museum (Loverance, 1998) or the 24-Hour Museum Curriculum Navigator < http://www.24hourmuseum.org.uk> in which student and faculty evaluation of the ongoing developments might seek to contribute to the educational goals of the final project outcomes in both cases. However, despite past serious attempts to establish such working relationships, no projects have so far been forthcoming.

In terms of additional learning support materials provided for this module, a set of thirteen CD-ROMs covering major world collections was recently purchased, and is available for student use on a short term loan basis. These CD-ROMs are published by the Spanish publishing house linked to *La Vangardia* newspaper in Barcelona, Spain. The written material is in Spanish, but it has been evaluated as being a useful and applicable resource for our student cohort considering that many Americans learn Spanish as a preferential second language, and also the advanced level of Spanish tuition within RAIUL's Modern Languages Program. Online guides to this set, similar to those provided for the other CD-ROMs on the CWIS, will be developed. The wide and varied world art content of this set also reflects the multicultural ethos of RAIULs educational mission, and clearly demonstrates how LTs can serve this aim.

The other major development we wish to see in the area of learning support materials provision is the acquisition of the full CD-ROM archive of *The Art Newspaper*, since publication began in 1983. *The Art Newspaper* is, for our purposes, the single most authoritative source covering the latest developments and news within the broad spread of topics, events politics and economics which impinge upon the art world encompassed by the module. The coverage is international, being published in joint co-operations involving the U.K., Italy and the USA. The single major advantage that the CD-ROM version offers over either the printed or web-based based <http://www.theartnewspaper.co.uk/.> alternatives is that it allows students the ability to sequentially track the development of an issue (for example, a development in art law, such as *droit de suite*, or critical debate surrounding the effects of restoration with regard to the Sistine Chapel). Whilst printed copy versions can be searched by hand, this is a time consuming process, the CD-ROM version eases this process, thereby encouraging initial student involvement to further their research objectives. CD-ROM updates to the archive are produced at five-yearly intervals, therefore requiring only modest and sporadic financial outlay on behalf of the institution to maintain the resource.

We are also proposing to the senior management at RAIUL a number of options for supporting the large-scale use of C & IT in the curriculum. This would include:

- Workshops for faculty which discuss the pedagogical implications of moving to an online course as well as practical IT skills
- Using early adopters as facilitators to other faculty
- Providing 'time out' for faculty to develop online modules, similar to the model adopted at Coventry University (see http://www.edu.coventry.ac.uk /taskforce/TheReview/TFREV99.html).

Conclusion - Changing Times

Over the past eighteen months, we have seen institutional web sites develop at an alarming rate, most with greater imagination of display and content than in our online module. In some instances, this has happened to such an extent that for our purposes some, such as *The Wallace Collection* <http://www.wallace-collection. org.uk> now are valuable resources in their own right as revision or aide-memoire tools for students following visits too. This

has had inevitable consequences in altering the manner in and frequency with which students use the CWIS site, as their access point for museums on the web. These developments we could not have foreseen, nor the extended use of the CWIS site prior to examination periods, as has been noted in ad hoc observations by faculty of students.

References

Costache, 1998. Dr. Irina D. Costache, "The Work of Art (Historians) in the Age of Electronic (Re)Production", CHArt conference, 1998. http://www.loyno.edu/~artis.

Christoph, K., G. Culp, C. Kerns, W. Koffenberger and V. Kumar 1998. "Teaching-Learning-Technology Centres: Emerging Models for Faculty Support" Presentation at Educom '98, "Making the Connections" October 13 –16, 1998, Orlando, Florida.

Dearing 1997. National Committee of Inquiry into Higher Education (1997) Higher Education in the Learning Society (the Dearing Report) HMSO/NCIHE.

Kemmis, S and R. McTaggart 1988. The Action Reseach Reader. Geelong: Deaking University Press.

Littlejohn, A. and S. Cameron 1999. "Supporting Strategic Cultural Change: the Strathclyde Learning Technology initiative as a model." ALT-J Volume 7, Number 3. University of Wales Press.

Loverance, R. (1998). COMPASS: A New Direction for the British Museum. Computers and the History of Art, CHArt 8.1, 5-11.

Cooperative Visits for Museum WWW Sites a Year Later: Evaluating the Effect

Thimoty Barbieri and Paolo Paolini, Politecnico di Milano, Italy

Abstract

Webtalk-I is a powerful tool that allows creating Virtual Reality three-dimensional worlds, in which people can meet, by means of an Internet connection. Each one of the virtual visitors can remotely explore the Virtual world. In addition a virtual visitor can examine and interact with components of the world. Like in a real world situation, a visitor can see where the other visitors are currently located, where they are going, and what they are doing. Visitors exchange opinions or information with other visitors, using the keyboard. Visitors can interact with 3D objects, sharing the experience of the interaction with other visitors. An experimental application of Webtalk-I was presented last year during the closing plenary of MW99. It consisted of a reconstruction of a virtual museum, based on the Milan Science Museum, in which visitors could operate Leonardo's machines. *After extensive testing, the environment, called "Virtual Leonardo" was officially opened to the public on June 7, 1999, in an extended and debugged version. We tried also some experimental virtual guided tours (one during ICHIM 99), with interesting results in educational terms. In this paper we evaluate the results of the first 6 months: how many visitors we had, what they did, the problems they had, the suggestions they gave us. Based on this experience is the design of the new WebTalk-II platform, currently under development.*

Cooperating in Virtual Spaces

The great part of museum web sites offer navigation paths called "virtual tours". In the simplest cases, these tours are in reality a collection of web pages, organized in a logical sequence, which offer a sort of guide to the museum. To exploit more fully the possibilities of multimedia technologies via the internet, another common approach is to provide 3D environments which the cyber-visitor can navigate freely. These environments are very often QuickTime VR shoots which can be viewed with a standard plug-in. While this approach can convey a minimal feeling of 'being there', several questions arise on this approach. First of all, the task of guiding the visitor is left to the content of the web page itself. Moreover, the visitor has no notion of other visitors which may be more experienced and with which he could exchange ideas or comments, quite a common scenario during a visit to a real museum. Secondly, not always mimicking the reality of the museum is the winning choice in presenting the museum contents. One can exploit the freedom from the chains of physical reality, and represent in electronically recreated worlds what would be nice to see in the real museum, but the constraints of physics prevent to do.

Supporting cooperation between users during web browsing is not such a new idea anymore. Several players in the Internet arena have by now realized that surfing web sites is one of the few activities that is still experienced alone. The net offers a number of chat-boxes and virtual communities which are more or less unrelated to an underlying site (Active Worlds, http://www.active worlds. com; Blaxxun Colony City, http://www.colonycity. com/ index.html; Ultima Online, http://www.owo. com). This approach often lacks a real referencing system to already existing web contents with a complex structure. We have thus a good 3D cooperation system, but a weak link to any existing web site.

Recently it has become possible to see efforts to support cooperation between users visiting the same web site, or even the same web page. These approaches usually get to the user via NetMeeting (allowing audio and video links with a pre-arranged rendezvous on a given server), or use special plug-ins to integrate into the web site the typical chat functionalities and cooperation patterns of cyber communities. There is still a lot of 'bidimensional thinking' in these solutions, and as a consequence, cooperation is clumsy and indirect. It is only the learned familiarity of the users with the list-of-users and colors-of-different-meanings metaphors that make the system work (Hypernix Gooey, http://www.gooey.com). Here we have a fairly tight link to web contents, but a poor cooperation system (or at least less imaginative than it should be), cast in a 2D frame.

We are convinced that an interesting solution will combine 3D Virtual Communities techniques with 2D web site structures. Collaboration is supported within the museum environment by any 3D repre-

sentation, augmented with a 3D access structure to the museum's web site contents. This is the underlying philosophy of the WebTalk-I and WebTalk-II projects at Politecnico di Milano.

With WebTalk-I, you can draw the museum environment in 3D, and decide the position of the exhibits inside it. You can specify for every object the actions that may be performed on it (click it, drag it, rotate it, light it, hit it). You can also decide if the effects of these actions are to be seen only by the actor, or you can make them shared, that is the effects are seen by all the people which are navigating the museum space in that same moment. You then define the links that allow to jump from the 3D space to the related 2D web page. For example, clicking on an info billboard next to a huge 3D mechanical clock, pops up the web site page related to the clock. While you walk in the 3D museum, you see all the others in the form of avatars, little human figures. This way it is very easy to see at a glance how many people are viewing the same information (space) you are, and what each user is doing in every single moment. This is because 3D is the metaphor we use everyday to cooperate in real life.

3D spaces allow to use a whole different set of rules for cooperation. An immediate advantage is the possibility to create 'special users' which can function as guides or clerk assistants, and guide other users (in groups or one by one) to the visit of the site. These guides can be driven by humans, can be automated agents with artificial intelligence, or can be robots which follow pre-recorded tours.

Technically speaking, WebTalk-I uses the VRML97 language to represent the 3D shapes, and the Java language for the communication engine with other users. These are two Internet standards, so users should not have problems installing the necessary software to experience the virtual collaborative museum.

Our first goal was to apply these ideas to a real museum, creating a suitable 3D environment. We approached a museum with an existing website, to cooperate and with sufficient exposure. This is how Virtual Leonardo started its days on the web.

Virtual Leonardo: evaluating effects and reactions

You can enter Virtual Leonardo from the main page of the National Science Museum in Milan (http://www.museoscienza.org). The environment represents rather faithfully the inside of the cloister of the monastery which houses the museum. From the cloister you can enter different rooms, and each room contains a 3D version of a machine inspired by Leonardo's drawings. These machines almost never worked in reality. In Virtual Leonardo, they appear in full scale and fully functional. While the real museum offers some wooden working models that can be operated by the museum staff, the virtual museum shows you what is not possibile to recreate in reality, and allows you to touch whatever you want.

Among the available machines there is the famous Aerial Screw, the Pulleys, the Lagoon Dredge, the Parachute, the Pile Driver. Beside each machine you can click on the info billboard to jump to the related web page of the museum.

Figure 1: Four users (three in sight, and one viewing the scene) are looking at the Aerial Screw flying. They have been reading the explanations provided by Leonardo's avatar, and they are ready to click on the billboard to read the related page.

The server went live on June, 7th 1999, and it is still running at present. There is generally free admittance to Virtual Leonardo, and everybody is allowed

Figure 2: Linking 3D space with the related 2D web page, it is possible to be guided by somebody else to discover information you might have overlooked following 2D links or using a keyword search all by yourself.

to connect and visit at any time. However, from time to time an expert from the museum staff might organize a virtual guided tour, using an avatar shaped in the form of Leonardo himself. This way, he can lead the cyber-visitors to a 3D tour with an explanation of the machines. Nobody really needs to be at the museum to do this, not the visitors nor the guide. A virtual tour was successfully demonstrated at MW99 and at ICHIM'99, where the virtual guide led the audience around to the discovery of Virtual Leonardo.

In six months (between Jun, 7th and Dec, 31st 1999), the system itself was hit **1547** times. This figure includes all trials to get connected, even by people who didn't have the proper software installed. Successful connections by people who managed to start the virtual system numbered **501**. This was more or less expected, as loading a page with VRML graphics and a Java program has more requisites than a simple web page, and the user has to be prepared in advance. Even if there is an installation page in which is clearly stated what is needed to run Virtual Leonardo, most people give it a try all the same, even without the proper software installed.

The total contiguous time spent by all users in Virtual Leonardo was **6,975** minutes, which is approximately **116** hours. The visitors have spent an average of **14** minutes per visit, and the maximum connection time with a user reached **304** minutes, that is around **five** hours.

We classify connections under 2 minutes as failed (since on average it takes a couple of minutes to load the system), and connections between 2 and 10 minutes as unsatisfying, because such a short period probably indicates that no cooperation or very little cooperation has occurred between the user and the other participants in the museum. This usually means that the user did not find anybody to interact with, just strolled around a bit and then disconnected. This leads us to a primary rule: cooperation mechanisms work as long as there is somebody else to cooperate with. Trivial as this might sound, great effort has to be spent to keep the cooperative environments populated. The majority of cyber-communities play on the sense of personal ownership. They let you build or rent some virtual space, so you connect often to look at your building or piece of virtual space.

A virtual museum should offer guided tours led by an expert at predefined times, attracting visitors willing to learn something in an innovative and entertaining way. It is this technique, together with continuous updating of contents and simplicity of use, that brings *satisfying connections* (above 10 minutes) into the system.

Virtual Leonardo got **148 (30%)** failed connections, **251 (50%)** unsatisfying connections, and **102 (20%)** satisfying connections. Unsatisfied users kept the connection open for an average of **5.5** minutes, while satisfied users have been online with the system for an average of **53.5** minutes. Such a difference in connection times stresses again the primary rule of cooperation: when there *is* somebody else, the system works and keeps you on for almost one hour.

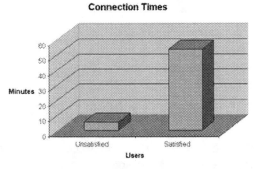

Figure 3: The bar diagram shows average connection times between unsatisfied and satisfied users. The satisfied users stay connected way longer!

Even if this is a bad thing to do (for privacy reasons), we logged all conversation, and we observed that conversation in the museum is always sparse, like "hello, anybody in here", or "where are you?", or "how do I make this thing work?". This changes completely when there is a guide leading a tour and moderating conversations. In this case the topics were often focused on Leonardo, on flying principles, and on the 'Last Supper'.

Another interesting observation stems from the data gathered on the different type of actions. In broad lines, a user can *move* his avatar, *use* an object, or type a line of *chat*. During the observation period, the users generated **105,049** events, of which **5%** were caused by chatting, **26%** by playing and touching the exhibits, and **69%** by moving around the virtual space.

This has both technical and natural reasons. Technically speaking, the system does not make a good optimization of movement events, overloading both the network and the logged data. On the other hand, it is true, also from personal experience and from

Breakout of event types

Figure 4: The diagram breaks out the types of events in Virtual Leonardo. There has been a lot more walking than talking!

direct observation of other people using the system, that in general one is more concerned with moving and exploring than typing messages. Secondly, moving and typing proved awkward, and in the end most of the users just chose to move around and spare the talking. This has only in part to do with the difficulty of coordinating mouse movements and keyboard typing. It has been observed in other Cooperative Spaces with vocal communication systems, that movement in virtual space and using the movement commands reduces intercommunication (Ellis, 1991). Moreover, a problem which has still to be solved in a satisfying manner is coordinating vo-

cal communications within a large group without creating confusion. Probably the one-liner chat metaphor is still the best solution at the moment.

Lessons Learned and Future Work

Observing the users reacting to the system, and collecting their praise and their complaints, has been of great importance to define the growth path of our project. The general idea worked and attracted visitors. The museum staff was thrilled to have the possibility to discuss Leonardo with working models in full scale, and to the broadest audience possible – the world.

The problems, however, are still many:
- Technical issues proved to be an insurmountable barrier for less experienced users.
- It is difficult to add contents to the 3D museum, because it requires a person proficient in VRML programming and not just a modeler. This leads, in the end, to two parts of the web site to mantain, the 2D part and the 3D part, with the 3D part lagging behind.
- In general, one needs more people at the site at the same time. As this is not always possible, it is important to supply automated guides or pre-recorded paths to follow, in order to allow co-operation at least with the robots if not with other people.
- The user interface could be greatly enhanced, and could support a richer set of cooperation possibilities.

It is absolutely necessary to remove technical difficulties. While it is true that the users' interest in cultural content might help them endure several glitches of the system, by eliminating the technical problems the audience can become broader and the cooperation more effective. This is why the new system will drop VRML and go for an all-Java solution which will work outside the browser. The users will install a dedicated program, and the environment will be automatically installed, just at the price of double-clicking the 'Setup' icon. Using Java, we will also be able to read in 3D shapes written in any technique the museum designer might choose, be it VRML, 3D Max, X3D, Lightwave, etc. Whatever new standard will appear in future, it will be just a matter of adding a new part of the program to load it in.

The link to the existing museum web site could be made tighter or looser. There are two possible strategies to follow here. One could re-create a completely different version of the web site in 3D, duplicating the authoring efforts and mantaining two websites instead of one. This could be the way to follow if the 3D portion of the site has different contents which can be shown effectively only in three dimensions. In this case a tight link to existing 2D content is not needed, even if it could be implemented and used, and the final result is not much different from other Virtual Communities on the web, except maybe that the content is cultural and not focused on idle chatting.

Alternatively, one could provide a 3D shell on a web site which already exists and has a carefully designed structure (possibly described with HDM). The 2D web site could also be generated dynamically from an hyperbase of web contents using another technology developed by the HOC Laboratory, the JWEB system. The WebTalk system could then let you choose for the site a different implementation of the same access structure, which uses 3D environments and metaphors. The use of 3D gives the same web site the ability to be navigated cooperatively: you could log in the entrance room, to find a guide in the form of an avatar (linked to a human operator or an automated agent). The guide can lead groups to web pages they might have never discovered without the advise of an expert on the subject. During this navigation, it is very important to provide the user with the most intuitive interface possible. A 2D map might represent the navigation in space to help the user locate other visitors or the guide. Special 3D spots or conveyorbelts might be followed in the space to go to important sections of the museum. Hyperspace jumps and hyperspace bookmarking facilities might be provided. Once you reach a specific area, you could jump to the related portion of the conventional web site. Again, the key here is that the 3D representation could map the existing web site by providing an access structure which is logically the same, but augmented with cooperation possibilities (I follow somebody, somebody follows me…) difficult to represent in 2D.

Cooperation possibilities might take many different forms. We are defining *cooperation elements*: small rules that decide what an user can do with other users and with the system. We are then going to combine the elements in sets, called *cooperation metaphors*. The designer of the 3D web site can decide which cooperation metaphors are to be linked to groups or single users. For example, he might decide that the museum can be visited only by guided groups (*rule: groups are preformed and need a guide*), and that talking to the guide is allowed but not talking between the group participants (*rule: intergroup communication forbidden*). These rules, set in this fashion, might be grouped in a metaphor called *Restricted Guided Tour* and assigned to all users incoming from 1 PM to 6 PM, when a human operator is available for guided tours. Many cooperation rules can be envisioned and we are formalizing them in a chart.

All these ideas will be part of the new platform, WebTalk-II (http://webtalk.elet.polimi.it), of which a running prototype is expected towards the end of the year.

References

Conference Proceedings

Barbieri T., Paolini P, et al. - Cooperative Visits to 3D Virtual Museums, in *Proceedings International Conference for Cultural Heritage & MEDICI day*, http://www.medicif.org, , September 1999

Barbieri T., Paolini P. – WebTalk: a cooperative environment to access the web in *Proceedings EUROGRAPHICS'99*, Milano 1999

Billinghurst Mark, Baldis Sisinio, Miller Edward, Weghorst Suzanne - Shared Space: Collaborative Information Spaces - in *Proceedings of HCI International 1997*, pp. 7-10 http://www.hitl.washington.edu/publications/p-96-5//p-96-5.rtf

Garzotto F., Mainetti L., Paolini P., Navigation in *Hypermedia Applications: Modeling and Semantics, Journal of Organizational Computing*, Vol. 6, N. 3, 1996

M. A. Bochicchio, R. Paiano, P. Paolini - JWeb: an HDM Environment for fast development of web Applications - *Proceedings of Multimedia Computing and Systems 1999 (IEEE ICMCS '99)*, Vol.2 pp.809-813

Paolini P., Barbieri T., et al. – Visiting a museum together, in *Proceedings Museum & Web99*, Pittsburgh, Archives & museum Informatics, 1999

Articles

Dorota Gut, Internet Gazeta Wyborcza, LATAJVCE MACHINY LEONARDA, (The Fantastic Machines of Leonardo), Appeared October 1999 http://www.gazeta.pl/

Matthew Mirapaul, New York Times on the Web: At This Virtual Museum, You can Bring a Date, Appeared June 1999 http://www.nytimes.com

Matthew Mirapaul, Java Industry Connection on Sun's Java Web Site: At This Virtual Museum, You can Bring a Date, Appeared July 1999 http://java.sun.com

Valeria Camagni, PC Professionale June 1999, Con la tecnologia WebTalk navigare nel Web diventa un'attività sociale (With the WebTalk technology, surfing the web becomes a social activity), pg, 246

Books and Literature

Ellis, S.R. – Representation in Pictorial and Virtual Environments, Taylor and Francis, London, 1991

Kalawsky, R.S. – The Science of Virtual Reality and Virtual Environments, Addison-Wesley, Wokingham, 1993

Roehl B. et al. – Late Night VRML 2.0 with Java Ziff-Davis Press, Emeryville, 1997

Zyda M., Singhal S. – Networked Virtual Environments, ACM Press, New York, 1999

Web Sites

Active Worlds Web Site
http://www.activeworlds.com

Blaxxun ColonyCity Web Site
http://www.colonycity.com/index.html

Hypernix Gooey Web Site
http://www.gooey.com

National Museum of Science and Technology "Leonardo da Vinci", Virtual Leonardo Web Site
http://www.museoscienza.org/leonardovirtuale

NetMeeting Product Home Page
http://www.microsoft.com/windows/netmeeting

OZ-Virtual Web Site (as described at)
http://www.digitalspace.com/avatars/oz.html

Ultima Online:
http://www.owo.com

WebTalk Web Site
http://webtalk.elet.polimi.it

Who's Out There? A Pilot User Study of Educational Web Resources by the Science Learning Network

Rob Semper, Noel Wanner Exploratorium, USA and Roland Jackson, Martin Bazley Science Museum, UK

Abstract

The Science Learning Network (SLN) is a world-wide partnership of science museums created to explore the development of World Wide Web resources for school science education. Supported by the Unisys Corporation, it grew out of an initial experimental partnership of six US science museums, funded additionally by the National Science Foundation. The SLN has developed a significant number of online resources based on museum resources primarily intended for teachers and school students (http://www.sln.org). Although there is evidence that these resources are widely used by tens of thousands of users, there is little detailed understanding about who uses the resources and how they are being used. More generally, there is little understanding of the use of educational on-line materials. As the use of online learning resources for both formal and informal science learning continues to grow, it is important that producers of these materials and activities have a developing knowledge of their audiences and modes of use, and of methodologies for evaluating their use and effectiveness.

Goals of the Study

This study was designed to explore the development of an integrated methodology for evaluating the use of on-line resources, and then to pilot-test this methodology to provide information about the use of three specific SLN on-line resources.

The Exploratorium, San Francisco, produced two of the resources examined: Cow's Eye Dissection and Science of Cycling. The Franklin Institute, Philadelphia and the Science Museum, London jointly produced one of the resources examined: Flights of Inspiration

Flights of Inspiration
http://www.nsmi.ac.uk/flights/
http://www.fi.edu/flights/

Science of Cycling
http://www.exploratorium.edu/cycling/

These sites were chosen to contrast a range of likely types of use. Cow's Eye Dissection is a highly structured linear resource that was designed to be used in a step-by-step manner in classrooms. Flights of Inspiration, which (unlike the other two resources) is based on museum collections, is also designed for classroom use but is less linear, more amenable to browsing, and contains material of wider interest. Science of Cycling is presented in a particularly informal way, and was not designed primarily for use in a curriculum context, but rather as informational material for a wide audience of students, educators, and the public.

Cow's Eye Dissection
http://www.exploratorium.edu/
leaning_studio/cow_eye/

The overall goals of the study were to:
- develop an integrated methodology for evaluating web resources for learning
- establish who is using the resources and in what contexts
- find out how the resources are being used and how they might be made more effective.

Overall Methodology

The methodology developed is deliberately diverse, to provide a range of types of information about resource use that complement and illuminate each other. The techniques used were:

- server log analysis, providing detailed quantitative data on file accesses and pathways of use
- an online pop-up questionnaire, providing data on the user profile and modes of use
- follow-up telephone interviews with some questionnaire respondents to expand the data
- direct observation of classroom use and analysis.

Together, the range of techniques, from wholly mechanical and quantitative to individually human and qualitative, provides a rich inter-locking picture of use.

There is little published evaluation of online learning resources, although an extensive analysis of use of the Why Files, using server data and online sur-

vey, has been published (W. P. Eveland and S. Dunwoody, "Users and navigation patterns of a science World Wide Web site for the public" *Public Understanding of Science* **7**, (1998) 285-311). A further relevant paper examining visitors to a museum website was presented at the Museums and the Web Conference in 1999 (J. Chadwick and P. Boverie, "A Survey of Characteristics and Patterns of Behavior in Visitors to a Museum Web Site" *Museums and the Web 1999*, http://www.archimuse.com/mw99/papers/chadwick/chadwick.html).

Log Analysis

Web site logs contain a wealth of information about how the Web site is being used. Each time the Web server responds to a particular request from a browser, for example to view a new page, download some data or input some text, it records to its logs a series of data about the request and the requesting host computer. By analyzing the log files it is possible to learn a great deal about the type of person using the web site and how they make use of it.

For this project, we analyzed the log files for these resources for a five week period of 1999 (November 14th through December 18th). This is over the same time frame as the on-line questionnaire was on-line (see below). The specific log records for the three SLN resources of interest, The Cow's Eye Dissection (Cow's Eye), the Science of Cycling (Cycling) and Flights of Inspiration (Flights) were isolated from the general Web site log files of the Exploratorium, the Franklin Institute and the Science Museum (NMSI), London. Because the Flights Web site was running on both the Franklin Institute's and the Science Museum of London's server, we analyzed four log files in total. These two Web sites were cross-linked at the top page (i.e. users who entered the Franklin Institute Flights top page could like to the UK version and vice versa.) In some cases, where appropriate, the data were merged between the two different log files for Flights.

These logs were analyzed using the software package Summary Pro (version 1.4.1) from Summary.Net http://www.summary.net which provides over 100 reports detailing Web site operation. (See the report list in Figure 4.)

List of Reports
for Cow's Eye

Time	Content	Referrers	Visitors	Browser
Hourly Report	Pages	Domains	Root Domains	Browsers
Daily Report	Downloads	Referrers	Domains	Screen Size
Weekly Report	Graphics	Search Words	Hosts	Color Depth
Monthly Report	Others	Search Phrases	Known Robots	Window Width
Yearly Report	All Requests	Full Referrers	Possible Robots	Window Height
Time of Day	Directories	New Referrers	Modem Speed	Java
Day of the Week	New Requests	Over Time	Platforms	Cookies
Month of the Year	Pages Over Time	Steps	Peak Days	Plugins
Bandwidth	**Visit**	**Problems**	**Visit Details**	**Subsets**
Requests by Bytes	Entry Point	Bad Links	Duration	Ads
Peak Hours	Exit Point	Failed Requests	Pages per Visit	Cntl
Peak Days	Steps	Gaps in Service	Hits per Visit	User1
Transfer Size	Avg. View Time	Least Requested	Bytes per Visit	User2
Transfer Time	Tot View Time	Reloads	Visits per Host	
General	**Paths**	**Details**	**Details**	**Custom**
Summary	Sources	Virtual Servers	Directory Detail	Requests One
Log Detail	Destinations	CGI Arguments	Methods	Requests Two
Manual	Paths	Auth. Users	Result Codes	Requests Three
	Refers To	Cookies	Agents	Referrers One
	Local Referrers	File Types	Bytes by Type	Referrers Two
Other	**Daily**	**Weekly**	**Monthly**	
Hijacking	Pages	Pages	Pages	
Search Engines	Downloads	Downloads	Downloads	
Phrase by Eng.	Graphics	Graphics	Graphics	
Modem Proxy	Others	Others	Others	
		Requests	Requests	
		Refers	Refers	

● **Summary Main Page** Questions or comments: help@summary.net
Copyright 1998,9 by Summary.Net - Updated 10/29/99

Figure 4 Summary.Net reports

This analysis software can show information about the host computer requesting access, the navigation path that the visitor takes through the site and the length of time for the visit. It is also possible to get information about how the visitor was referred to the site, the search phrases that were used to find the site, the speed of the connection, and even the type of browser and operating system which the visitor used.

The results we are reporting on here are based on a preliminary analysis of the use of these SLN resources. Because the connectivity on the Internet is complex and often convoluted, it is often hard to determine with precision any particular result or what any result actually means in detail. At best log analysis should serve as a general guide to what is going on. Nevertheless we believe that these initial results can be highly informative about the current state of the use of educational resources on the Web.

Figure 5 provides a summary of the log analysis data for the three resources. For this analysis, a visit is defined to be a sequence of requests all made from the same IP address with no gaps exceeding 30 minutes. It is important to remember that some visits are actually from Web sites that have cached the site at other locations where additional users will access the material. This means that the visits

number typically underreports the number of people who have accessed the resource. A unique host is a distinct IP address that is requesting access. In some cases a number of users will use the same host at different times and so this number undercounts the number of individuals accessing a particular site. This is why the visits number is higher than the host number. Countries indicates the number of individual countries as shown by the root domain name making a request for the Web page.

A page request is a request for an individual page. A hit is a single request to the Web site for a page, a graphic element or a link to a new page. Loading a single page can generate many hit requests. A page with a lot of graphical elements will generate more hits than a page that is composed of mostly text or a few images. Referring domain and referring pages indicate the most recent URL that the Web browser was pointing to before it came to this resource. The pages per visit and hits per visit are average numbers. The duration of visit indicated the average visit length in minutes. The visit per host indicates how many users on average have accessed the resource from the same host.

	Cow's Eye	Cycling	Flights
Visits	16,806	25,153	7,222
Unique Hosts	7,480	14,502	5,308
Countries	68	74	55
Page Requests	50,470	30,283	14,516
Hits	234,179	192,515	46,943
Referring Domains	342	246	117
Referring Pages	534	404	192
Pages per Visit	3.0	1.2	2.0
Hits per Visit	14.0	7.7	6.5
Duration of Visit	6:21	10:13	7:35
Visits per Host	2.2	1.7	1.4

Note: Preliminary Data.
For Flights the last four categories are based on NMSI data.

Figure 5 Summary table of log analysis

Who are the visitors using these resources?

Analyzing the root domain address data provides an initial view of the user community. The root domain is the part of the address which indicates that the host computer for the connection comes from a com, edu, org, net, mil or gov (in the US mostly) server or a server in a specific country like us, ca, uk, etc. Because there is no direct tagging of individual users on the Internet, one has to make an educated guess about users' identities through analyzing the host IP addresses. This is akin to determining who the public museum visitors are through analyzing their zip code. For the Web, the IP number and the domain name is the key piece of information.

Figure 6 shows the distribution of the top 15 root domains for each resource (out of a total of about 70 different root domains for each resource). Because of the history of Web development and the pattern of domain creation on the Internet there is disproportionate weighting to com, net, us, edu and org (the first five categories in terms of access on the chart.) While there is general similarity in root domain access for the different resources, there are some interesting differences between institutions.

The root domain data serves to give only a crude idea of the background of the users. But the next level of domain information begins to provide enough detail to become interesting. The following

Top Domain	Description	Cow's Eye	Cycling	Flight	Flight NMIS
com	Commercial, mostly U.S.	10,599	7,054	6,870	264
net	Network Providers	9,037	5,407	5,090	242
us	United States	4,683	1,420	1,269	17
edu	U.S. Educational Inst.	2,804	1,635	1,435	20
org	Organizations, mostly U.S.	2,057	1,118	531	212
ca	Canada	1,878	1,063	884	58
uk	United Kingdom	859	1,343	326	959
au	Australia	405	734	229	19
fr	France	309	278		
nl	Netherlands	282	257		29
de	Germany	254	238		
no	Norway	223			
jp	Japan	214	250	172	
ch	Switzerland	160			
ie	Ireland	159			16
se	Sweden		221		
mil	U.S. Military			190	
nz	New Zealand		320	19	
ru	Russian Federation		186		
gov	U.S. Federal Government			93	
sg	Singapore			92	
es	Spain				22
il	Israel			177	8
my	Malaysia			109	
gr	Greece				11
in	India				10
si	Slovinia				8

Figure 6 Root domain distribution

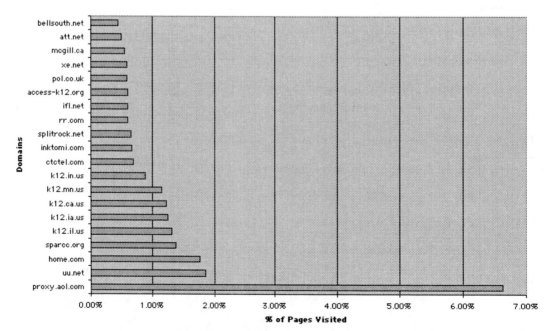

Cow's Eye Visitor Domains
(Top 20 Out of 2179 Total)

Figure 7 Cow's Eye requesting domains

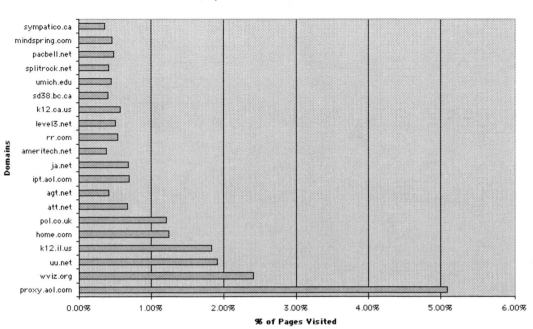

Figure 8 Cycling requesting domains

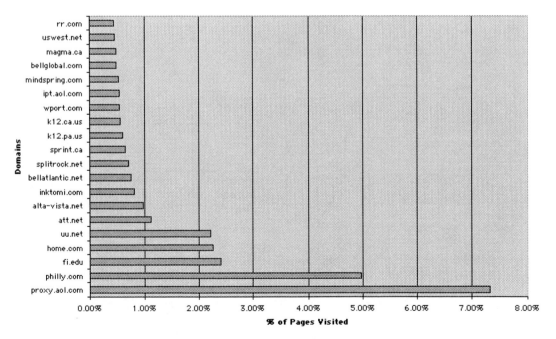

Figure 9 FIghts requesting domains

set of figures show the top 20 requesting domains for each of the three resources.

One interesting question to ask is how much are these resources are being used directly in school classrooms compared to the more informal use by individuals (including students and teachers) from elsewhere. While there is no easy direct way to determine this information, it is possible to make some inferences by looking at the difference in domains. Of the top 20 domains for Cow's Eye, at least 10 can be recognized as serving schools in some way (a K-12 or a statewide school network for example). For Cycling, the number appears to be closer to 5. While some schools may be using commercial networks or getting their access in different ways this difference still makes some sense given the explicitly curricular nature of the Cow's Eye activity compared to the more informal aspect of Cycling.

Another interesting aspect to note is the enhanced European focus of the users of the NMSI version of Flight. This is evident in the number of European ISP's that are in the NMSI top 20 as well as an interesting country skewing in the root domain list.

When are the visits happening?

The logs can also provide information about when the visits are happening. The next chart shows the

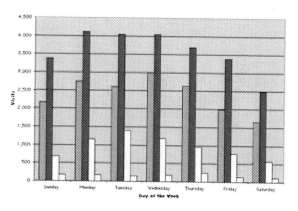

Figure 11 Weekly visit analysis

distribution of visits during the week for each resource.

The distribution appears to be roughly similar for the different resources. The distribution follows the

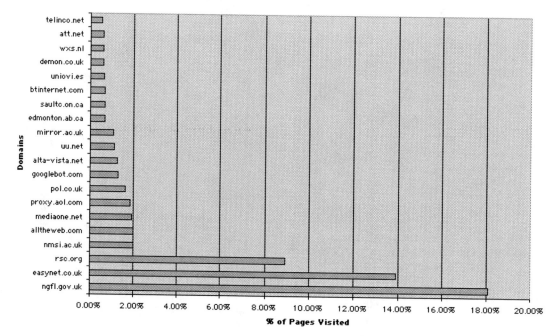

Figure 10 Flights-NMSI requesting domains

general trend of higher access during the week (the assumption is that more people have access to high-speed connectivity at school or at work.) One interesting observation we discovered is that the weekend drop-off of page views is less pronounced for the UK Web site. Upon further investigation, we learned that the National Grid for Learning, the major UK educational access system for on-line education does a major download of Web resources every Sunday which accounted for much of the increased Sunday activity.

How did the users find these resources?

The next set of figures show the referring domain data for each of the resources. These addresses show where the browser was just before coming to the resource.

There are a number of interesting things to note in these charts. The total domains referring to these resources are between 100 and 350 illustrating the widely distributed nature of Web activity. The referrals come from other locations on the resource

hosting Web site (exploratorium.edu, fi.edu etc), SLN's home page (sln.org) and many external Web sites. Some of these external sites are search engines (i.e. search.yahoo.com) others are collectors of educational Web sites (i.e. washington.edu, wested.org, lib.oh.us). It is also interesting to note the amount of traffic that is driven to each resource from the sln.org Web site.

What did the visitors do at the site?

The logs also provide information about the visit itself. Information is available about the path the user followed, the graphics that were downloaded and the exit point from the resource. This data is too extensive to present in this paper, and will require further in-depth data analysis. But there are a few interesting things that can be easily shown. The first is the average duration time of the visit. The next figure shows the duration in time bins measured in seconds.

Notice that the time scale is not linear but rather geometric because of the method of obtaining the data by the log analysis software. The duration for each of the resources averages between 6 and 10

Figure 12 Cow's Eye referring domains

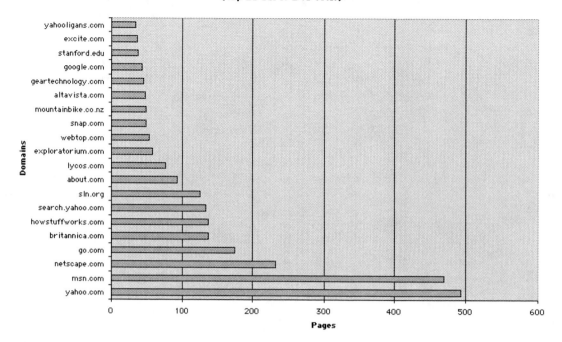

Figure 13 Cycling referring domains

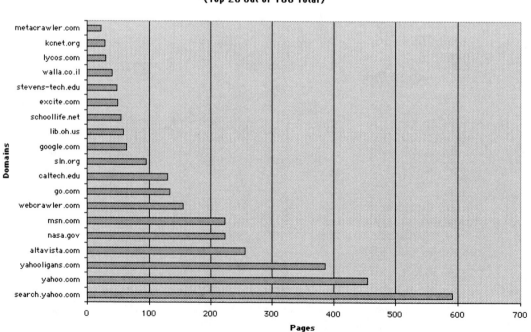

Figure 14 Flights referring domains

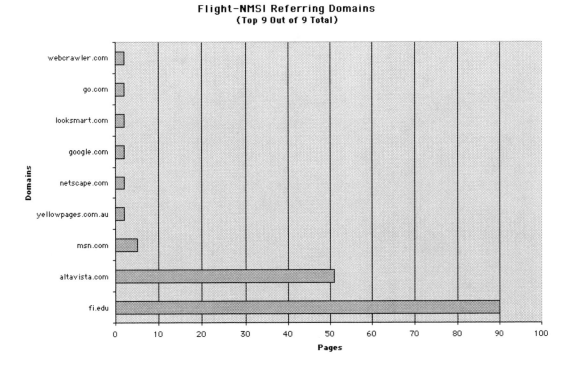

Figure 15 Flights-NMSI referring domains

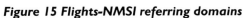

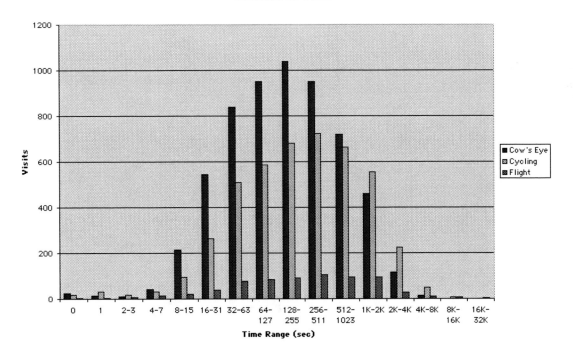

Figure 16 Visit duration distribution

minutes. (The data for the two Flight resources has been added together.)

The analysis of number of pages per visit is shown in the next chart. (The two flight resource hosts' data were summed for this analysis.) Here the x-axis shows how many additional pages are requested after the entry page. While the large number of 0 additional pages clearly shows the browsing feature of the Web, the long tail of the data indicates that some people do in fact view a lot of the material further "down" in the resource.

These charts only show the barest fraction of the log data reports that Summary is capable of producing. Clearly, this data will reward careful further analysis. We will continue to mine this data for information on user behavior with the goal of producing better, more useful educational resources, both for school audiences and for the general public.

Online Survey and Follow-up

For this part of the study an online survey was produced. There were 10 questions, some of which allowed more than option to be selected via a drop down menu while others used radio buttons restricting users to single choices. Free-form text fields were avoided to ensure all data could be summarized numerically. At the end of the questionnaire respondents were asked to supply their email ad-dress if they were willing to be contacted for follow up interviews to provide more qualitative free-form data.

The questionnaire appeared as a separate pop-up browser window, triggered from the homepage only of each resource, so as not to interfere with user experience of the resource. Respondents were requested to continue browsing or using the resource and to return to the questionnaire window at the end of their session. After submitting their responses they were presented with a screen summarizing the responses collected to date. They could therefore see their own response in the context of those of previous respondents.

Data were gathered from each of the three sites during the period 17 Nov - 19 Dec. The data were stored on a server run by the Web company, which coded the questionnaire. The link to the pop-up window questionnaire from each of the sites was removed on 19 December and the data downloaded for analysis. The next figure shows the number of respondents for each resource.

Resource	Cow's Eye	Cycling	Flights
No. of respondents	671	518	284
Total # of visits to site 17 Nov – 19 Dec	16,806	25,153	7,222
Sample size as percentage of total	4%	2%	4%

Figure 18 On-line questionnaire summary data

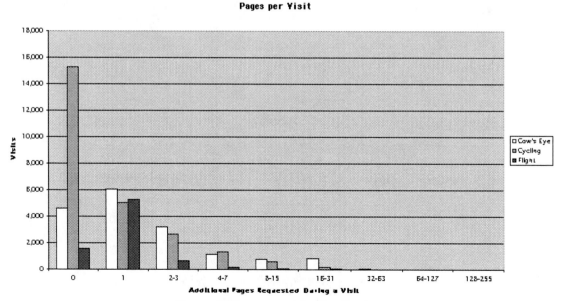

Pages per Visit

Figure 17 Page per visit distribution

Results

The questionnaire was designed to focus on the following aspects of the visitor:

1. Who are you?
2. Why are you using this resource?
3. How are you using this resource?

The results of the survey are presented below under these categories.

Who are you?

The relevant questions here are those relating to age, gender, number of years on Internet and the bandwidth of their Internet connection. These questions helped to set subsequent data in context, as well as sampling and comparing the audiences of the three sites.

Key findings

Across all three sites it was found that 50–64% have used the Internet for more than 2 years and 51% of users were aged 23–49. Though the respective percentages for both ISDN and broadband were small, when added together for each resource, they seem to indicate that a significant percentage of visitors (14-22%) now have access at speeds faster than 56k. This could have impact on design decisions about whether to include streaming media or large files in web resources. Around 40% of users were on 56k Internet connections, but a significant proportion was unsure. Averaged across all three sites, there was a 58/42-male/female split, but there were significant differences between the individual sites.

Cow's Eye attracted the highest proportion of 'newbies', reflecting perhaps the higher proportion of use by younger students. 61% of users were female, 46% of them under 22.

In contrast Cycling's principal users describe themselves as 'interested individuals', 80% of them were male, 84% over 22 years old and significantly more experienced on the Internet than the Cow's Eye users.

Flights users lie between these two extremes in most respects, but had the largest proportion (23%) of over 50s users, perhaps because of the strong historical content.

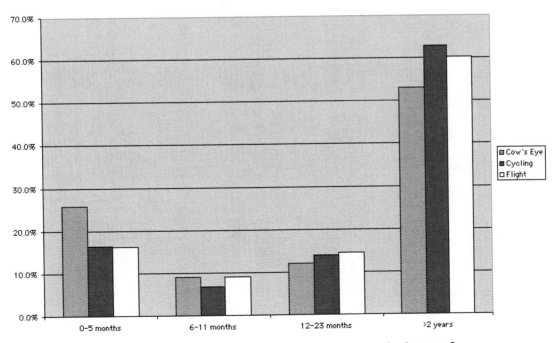

For how long have you had access to the Internet?

Figure 19 For how long have you had access to the Internet?

Are you using this site for the ...

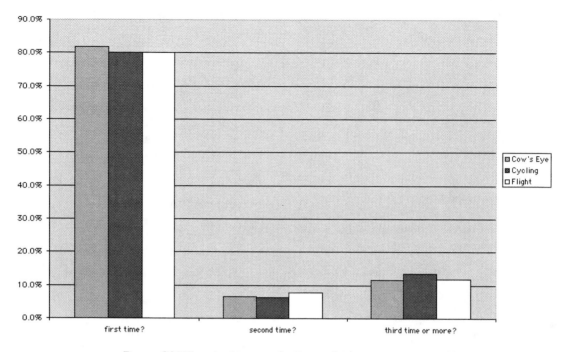

Figure 20 What is the speed of your Internet connection?]

Are you ...

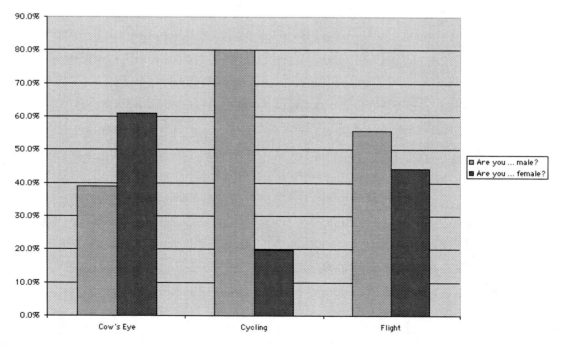

Figure 21 Are you male or female?

What is your approximate age?

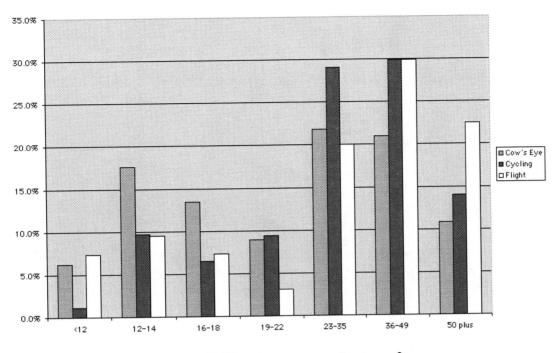

Figure 22 What is your approximate age?

Are you using this site as ...

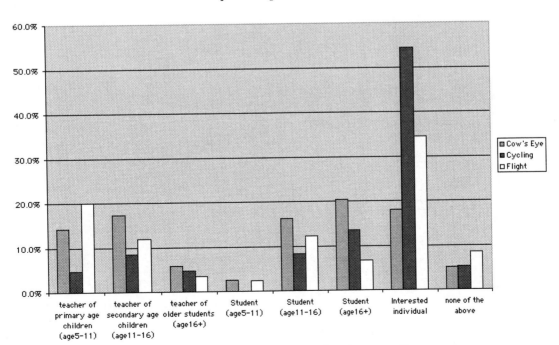

Figure 23 Are you using this site as a ...?

What brought you to the site?

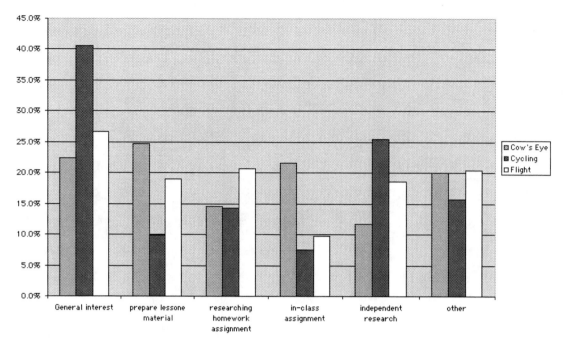

Figure 24 What brought you to this site]

Are you accessing this resource from ...

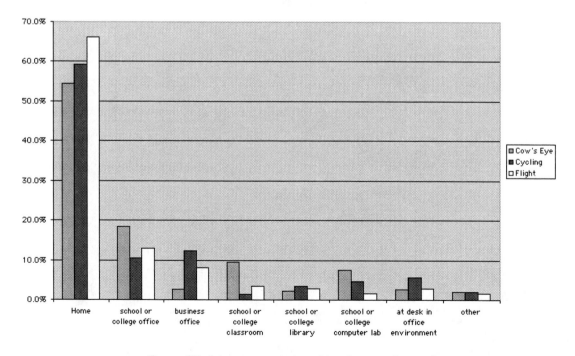

Figure 25 Are you accessing this resource from...?

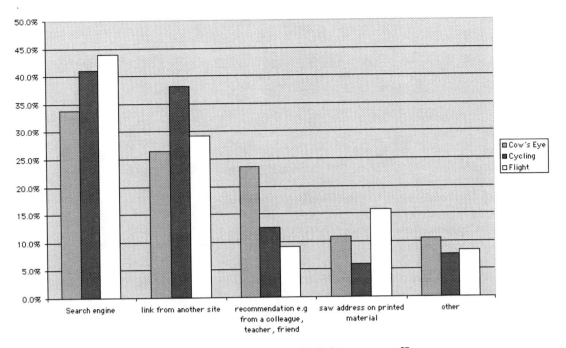

Figure 26 How did you find this resource?]

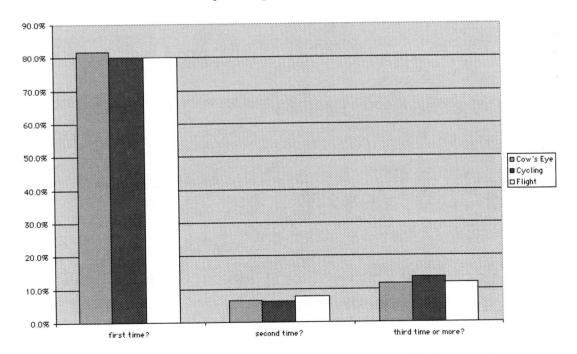

Figure 27 Are you using this site for the first time/second/third or more?

Why are you using this resource?

The main aim here was to gain a sense of how often these resources were used educationally and in what type of setting. The relevant questions were "are you using site as a....(type of user)?, "what brought you to this site?", "from where are you accessing this resource", "how did you find this resource" and "is this the first/second/third time you have used it?"

Key findings

On average about half of access (55-66%) was from home. All sites were being used for the second time or more in 15% or more cases. Of the three, Cow's Eye was being most extensively used in explicitly educational settings (38%), especially with secondary and post-16 classes. Cow's Eye also has the most well defined audience, with the smallest proportions classifying themselves as 'interested individual' or 'none of the above'. By contrast Cycling was being used least often in an explicitly educational setting (20%). This would seem to support the finding in "Who are you?" above, that its principal users describe themselves as 'interested individuals', mostly over 22 years old and experienced on the Internet. Flights was used in educational settings by 21% of users. It was most frequently found using search engines, probably because it is the most recent site and because of popular search terms such as 'flight'.

How are you using this resource?

The emphasis here was on finding out what people had actually done with the resource.

Key findings

As a general summary, around 45% stated that they worked alone and 9% worked with someone else. On average 15% made use of the suggested activities, 10% copied material into another document and nearly a quarter (19-26%) viewed multimedia clips. Cow's Eye was demonstrated to whole class twice as often (11%) as the other two. The site was designed for this purpose and its use appears to reflect that design. Surprisingly Cycling had less use of 'multimedia clips' than in Flights, which has almost none. This may reflect a problem with the phrasing of the questionnaire, or with user understanding of the term "multimedia". Flights was much more frequently printed out than Cow's Eye. In general this proved to be the least satisfactory question (on the face of it, the total of those who worked alone and those who worked with someone else should total 100%!). The follow-up by subsequent phone interview was designed to expand on this area in particular.

This questionnaire technique will be developed further for the evaluation of online resources, and could be redesigned to focus more on the uses to which the resource is put and subjective comments on effectiveness.

Follow up Interviews

Respondents who left their email addresses as part of the survey were contacted and telephone interviews arranged, in which all the online questions were run through again, probing in more detail where appropriate.

These were carried out after the submission of this paper and will be reported at the conference itself.

Classroom Evaluation

Classroom evaluation was carried out in two phases in the UK: Phase 1 September-December 99 in primary (elementary) schools and Phase 2 January – March 2000 in secondary (high) schools.

Classroom evaluation mirrors the type of user evaluation carried out in the initial development of a web resource, providing highly specific feedback on factors such as attractiveness and usability. Any findings that are relevant to the wide picture of use built up through the varied overall approach described in this paper will be presented at the conference itself.

What Does it Mean?

Initial comparisons of the user surveys and log analysis

By comparing of the two data sets, a number of interesting connections appear, leading to some hypotheses, and many further questions for research.

The scope of the project to this point has not involved an in-depth statistical analysis of the data sets, or the correlation between them. Such an analysis will be part of future research based on this pilot. (Further insight could be gained from comparisons between the quantitative data outlined here and the qualitative information gleaned from classroom observation and telephone interviews with smaller subsets of questionnaire respondents. The results of the pilot classroom observation and user interviews will be discussed at the presentation of this paper at MW2000)

Some of the possible hypotheses and questions suggested by a first look at the pilot study data are outlined below:

Information design/navigation has an impact on educational use versus other use

Why are some resources more successful in classroom settings than others? Both the questionnaire and the log analysis seem to suggest that the Cow's Eye resource had a larger proportion of classroom educational use. The large number of clearly educational domains (5 out of the top 20 visitor domains) in the visits to resource seems to fit well with the large number of respondents who identified themselves as explicitly educational users (38%). It is worth noting that there may be more educational domains visiting the sites, since not all schools get internet access through a k12 or .edu domain. Cow's Eye was followed by Flights, with Cycling having the least number of clearly educational domains visiting, and the least number of respondents claiming educational use. Cycling also had the highest share of users identifying themselves as simply "individual".

One possible explanation for this difference could be the design of the resources: Cow's Eye is quite linear, with a set of instructions for step-by-step use, which may make it quite adaptable to use in a traditional classroom or curriculum. Flight has a certain amount of explicitly educational material, designed for classroom use, while Cycling has very little, requiring flexibility and adaptation for use in a standard curriculum. Alternatively, the difference could due to the content of each of the resources: perhaps the Cow's Eye Dissection is a natural part of a life-sciences curriculum, while the Science of Cycling fits less neatly into a physics or other cur-

riculum, requiring more adaptation or flexibility from teachers and students. This question will be explored through further observation of classrooms and discussions with teachers.

Use of resources in educational settings yields longer visits and more focused use

Why do some resources receive longer visits than others do? The distribution of the length of use curve is roughly the same for all three resources, though the length of use. The length of visit for Cow's Eye shows a preponderance of users who stayed for between 1-8 minutes, a much longer duration than the other two resources. Since both the questionnaire and the Summary data on visitors' domains suggest that Cow's Eye is being used in classrooms to a larger extent than the other two resources, it is possible that the length of use is a result of use as a classroom resource, for research and assignments, instead of a "browsing" site for casual users. Another possibility could be that the linear design of Cow's Eye invites and rewards sustained visits, as opposed to the more modular approach of the other resources.

The role search engines play in brokering Web site visits

How do people find a given web resource? Both the questionnaire and the log analysis seem to suggest that search engines or portal sites play a crucial role in bringing visitors to a given resource. Since roughly %40 of questionnaire respondents indicated that a search engine had brought them to the site, and given the repeated appearance of search engine/portals like msn.com, yahoo.com, and netscape.com in the top referring domains for each resource, the role of search engines seems established. This seems to suggest that a strong understanding of how search engines create their indexes could help in the creation of successful resources, resources that can be found amidst the clamor of competing information on the Web.

These questions are clearly only starting points, and there are many others to be generated from the examination of the various data sets gathered during this project. Each of these questions could support a separate research effort. One of the goals of this pilot was to evaluate the usefulness and feasibility of more research of this kind; it seems clear that such research will be worthwhile.

Conclusions: Towards a template for evaluation of educational websites

When designing this pilot, we chose to gather and examine many different types of data over a relatively brief period. The rationale was that by doing this, the strengths and weaknesses of each type of data could complement each other, producing insights into user behavior, preferences and patterns of use. Ideally, this multi-faceted data should help to identify "who's out there" and what use they are making of the educational resources like those produced by SLN museums. During the course of the study, each data type has revealed strengths and weaknesses. Some of these weaknesses should lead to a revision of the process for future studies. On the whole, what we have seen in this pilot seems to strengthen the argument for this model of a multi-faceted user research study.

Log analysis

Log analysis is a method that yields a great deal of quantitative data on file accesses to the resource. No "cookies" or personal information are gathered. This method has the advantage of neither invading the privacy of users nor disrupting the user's experience by requiring the user to choose to participate in a study. Data can be gathered on every user who visits a site, giving a broad and in some ways complete picture of use. However, the anonymity of the data makes interpretation difficult. If a given user stays in a resource for only 30 seconds, we will never know why she left: had she found what she wanted? Had she been irritated by confusing navigation? Was she bored? Without recourse to more in-depth and qualitative data, we will never know. Thus the weakness of log analysis is largely a lack of depth.

The choice of analysis software has an impact on this type of data: different programs use different methods to generate reports on log data, which can confuse results when compared with reports from other software.

Online questionnaire

The online questionnaire generates quantitative data on specific user's identity, purpose and modes of use. This form of quantitative data adds depth to log analysis, by asking some of the questions missing from log data: who are you? Why are you here? What are you doing? The strength of this method was that it gathers a greater depth of information than log analysis, while still gathering a large enough sample to be significant, without a huge outlay of time by researchers.

The weaknesses of this method are again lack of depth, and they are the result of the technological solution we chose to administer the questionnaire. In order to create a questionnaire which could generate numerical results dynamically from a database program, we had to choose questions which could be answered by choosing from a pull-down list of possible options, or by checking a series of "radio-buttons" for each response that was applicable. Thus we limited the range of possible responses a participant could choose, and we did not allow for any elaboration. Allowing participants to type their responses into a text field would have allowed for a full range of responses, though it would have required an elaborate effort to read, sort and code the responses into numerical data.

The "multiple-choice" format was also chosen in an effort to limit the time the questionnaire would take, thereby hopefully increasing ease of participation. For any voluntary survey, participation levels are a concern, especially on the web, when less demanding sites are only a click away. In order to encourage participation, the questionnaire did not ask for specific personal information, protecting the privacy of the users. It was also designed so the respondent could see his/her own responses in the context of all responses to date, thereby enabling the respondent to be a more active participant and providing a small "carrot" for participating.

Thus the choice of possible responses offered to the users becomes crucial to the success of any such questionnaire. By failing to offer a relevant set of choices, or by choosing responses that are too general, the effectiveness of the question is severely limited. Several of the questions from the initial questionnaire will be revised for future research efforts. (By administering a questionnaire on the web, such iterative trials and revisions are easily carried out.)

The weaknesses or limits of the questionnaire may be addressed through telephone follow-up and classroom observation.

Follow up interviews

These interviews are currently being carried out. The decision to undertake these interviews was largely based on the results of the log analysis and the questionnaire: given the limits of the two quantitative data sets, we sought the ability to probe user experience in a more open-ended and responsive way. So when a user says, "Oh, your site bored me," or "It was useless in my classroom," we can ask "why?" Instead of being limited to the category of "other", responses that don't fit our pre-conceived categories can be looked at in detail. By limiting our interviews to questionnaire respondents who volunteered for further conversation, we may skew our results somewhat, but we should gain insight into the blank spaces left by other data types.

Classroom observation

This is essentially an 'ethnographic'-type of study. For each classroom, the observer needs to be aware of the lesson content a teacher is trying to convey, and how it fits into the overall scheme of work in that classroom and the school and school system as a whole. Educational systems and curricula vary widely from country to country, and from state to state within the United States, and this can have a strong effect on how given resource is approached, and even on how computers and networks are viewed and implemented within the classroom. (A teacher whose class can use computers only in a "computer lab", far away from other materials and tools will find a web resource that contains recipes for student experiments far less useful than a teacher who has computers in the classroom. A sobering possible scenario for the apparent educational "success" of the Cow's Eye Dissection is that it lends itself easily to a computer-lab environment.)

As we move forward with this pilot study, we will develop a protocol for in-classroom evaluation, with brief follow up discussion(s) with the teacher. This will enable us to gather in-depth qualitative data (stories) reflecting how a given web resource is successfully or unsuccessfully used in a classroom setting.

The Invisible Web Visitor: Moving towards understanding the audience

By combining log analysis with questionnaires and log analysis and user observation/interviews, insights may be gained into the stories behind the numbers, while the numbers help to place the stories into the context of the entire use pattern for that resource. From our experience with this pilot study, this form of multi-modal research into web resource use is an extremely rich source of information, one we have only begun to explore. The information we gathered begins to reveal a picture of a previously invisible audience, and may yield valuable guidance for on-going efforts to create web resources, which serve the educational and public audiences of museums.

Acknowledgements

The authors would like to thank Unisys Corporation and especially David Curry, VP of Corporate Affairs for the strong support they have shown for this project and their major continual financial and intellectual support for the entire Science Learning Network over the years. We would also like to thank the many museum members of the Science Learning Network for their insight and encouragement and the Web design and operation staff of the Exploratorium, Franklin Institute and the Science Museum of London for their work in the development of the resources we have analyzed for this project.

The log analysis section of this project could not have happened without the great support of the Web administrators at each of our institutions. We want to acknowledge Katie Streten, Web Site Manager at the Science Museum, London and Karen Elinich, Director of Educational Technology Programs at the Franklin Institute for generously and quickly providing their data logs for analysis. At the Exploratorium, Ron Hipschman and Larry Shaw helped with data analysis, Jim Spadaccini with the questionnaire development and our special thanks to Bill Carson who managed to wrangle the data into usable form and keep summary.net running.

About the Authors

About the Authors

Francesca Alonzo

Francesca Alonzo works as multimedia consultant for HOC (Hypermedia Open Center) at Electronic Engineering and Computer Science Department - Polytechnic of Milan. She graduated in Philosophy, mass communication branch, at the "Federico II" University in Naples, she's on the register of the free-lance journalists. After a long editorial activity she attended a master to become "multimedia Editor" in Milan, which allowed her to begin the collaboration with the HOC Lab. She collaborates to the design of cultural hypermedia applications (interactive movies, interactive fables and information kiosks for museums), she manages and coordinates the activities of some projects concerning Internet new technologies (WebTalk-WWW cooperative visits). She coaches, as a tutor, the students preparing the Computer Graphics exam (prof. Paolo Paolini).

Sarah Ashton

Sarah Ashton joined the Museum in February 1998. Prior to this she was a Research Associate in the Department of Information Studies, University of Sheffield. Sarah was Project Manager for the maritime information gateway and is responsible for its ongoing maintenance and development. She has an MA in Librarianship from Sheffield University.

Martin Bazley

Martin Bazley is Internet Projects Manager in the Education and Programmes Unit at the Science Museum, London. He is involved in the development, implementation and evaluation of Internet-based educational projects, including the STEM and COMO projects.

Thimoty Barbieri

Timothy Barbieri has a degree in Computer Science Engineering from University of Milano. He was on the chief developers of HOC's WebTalk system, and is taking part as designer and networking programmer in HOC's new Java3D WebTalk project. In the meantime, he runs his own company, ITECH Engineering, which is mainly active in consulting for SOHO heterogeneous networks, web solutions, technical writing, teaching and translations. Since 1992 he has been consultant for an important Belgium-based computer graphics company, Barco Graphics, specializing in graphical digital pre-press production systems. He is also very active in simultaneous interpreting.

David Bearman

David Bearman, President of Archives & Museum Informatics in Pittsburgh, consults for cultural institutions on information strategy. Since leaving the Smithsonian Institution, where he was Deputy Director of the Office of Information Resources Management, he has assisted archive and museum consortias to rethink their approaches to management and delivery of cultural resources. Bearman has been responsible for guiding the development of a national information system for archives in the U.S., national policies towards electronic records management in several countries, national and international museum collaborations and network initiatives, and the definition of a variety of archival and museum related information standards. Currently Bearman is Director for Strategy and Research for the Art Museum Image Consortium and co-organizer of Museums and the Web, ichim, and other international cultural heritage conferences.

Nuala Bennett

Nuala A. Bennett is the Digital Cultural Heritage Community Project Coordinator. She holds has a B.A. in Computer Science, Linguistics and German from the University of Dublin, Trinity College (Ireland), and a M.S. in Library and Information Science from the University of Illinois. Her previous experience includes Research Information Specialist with the NCSA (National Center for Supercomputing Applications) for the "Interspace" project, Research Programmer and Project Coordinator for medical informatics projects with the CANIS (Community Architectures for Network Information Systems) Laboratory at the University of Illinois Graduate School of Library and Information Science.

Torsten Bissel

Torsten Bissel studied physics at the University of Bonn. Since 1995 he is a member of the 'Value-added Solutions' (VaS) research group at GMD. His main focuses are network security and copyright protection, innovative web applications, and intelligent agent technology.

Manfred Bogen

Manfred Bogen has been active in the area of group communication, X.400 development, and X.400 standardization since 1983. In 1987 he became head of a research group being responsible for the provision of innovative multimedia services in international Internet environments. He worked in several

programme committees of international networking conferences and he was the programme committee chairman of the TERENA Networking Conference 1998 (TNC'98). He was convenor of the TERENA working group on quality management for networking (WG-QMN) and a member of the TERENA Technical Committee until 1999. As a computer scientist his interests are the identification and implementation of innovative multimedia solutions and distributed media applications. Manfred Bogen has a MSc in Computer Science of the University of Bonn, Germany, and among other publications he is co-author of two books about X.400 and distributed group communication.

Yvonne Cleary

After graduating from Dublin City University with a BA in Applied Languages (Translation with Interpreting) in 1996, I worked at Siemens, Munich. I completed the MA in Technical Communications at the University of Limerick this year, and am currently working as Junior Lecturer in Techncial Communciation. The MA thesis is the basis for this paper. This thesis recently won Best Thesis Award at Localization Checkpoint, a conference organized by the Localization Research Center of the University of Limerick. The award, sponsored by Symantec and judged by industry professionals, was presented by Irish Minister for Trade, Commerce and Technology, Mr. Noel Treacy.

Maria Daniels

Maria Daniels is Visual Collections Curator for Perseus Project an evolving digital library of humanities resources based at Tufts University. Among its resources, Perseus includes the works of numerous Greek, Latin, and English Renaissance authors, an art catalog of 5,000 ancient objects from dozens of museums worldwide, and 50,000 photographs. The Web site receives about 250,000 hits a day from visitors from Andorra to Zimbabwe. Maria has created on-line exhibits, including QuickTime and QTVR movies, for the Perseus Project Web site. She oversaw the creation of special Web exhibits on the ancient Olympic games and on Hercules, which are noteworthy for having integrated museum objects from a range of collections with primary and secondary source texts on aspects of ancient Greek athletics and mythology. Most recently, Maria has collaborated with the Museum of Fine Arts, Boston, on the digitization of their extensive collection of Roman art. In addition, she is a freelance and archaeological photographer who travels frequently to the Mediterranean for her work.

Evan Dickerson

Since joining the faculty at Richmond in 1995, Evan has sought to facilitate the extension of the IT and Teaching Initiative at the University, with particular emphasis upon online course provision using the IntraNet and the incorporation of computer conferencing into the Fine Arts curriculum (a paper based upon this ongoing work was presented at ALT-C, Bristol, September 1999). Other active research includes the oeuvre of Carlo Crivelli, the arts in Nazi Germany (paper presented at CHArt conference, 1997) and work on the uses of technology for the teaching and research of art history (at the Institute of Education, University of London, 1997-1999).

Michael Douma

Michael Douma is chief web designer for his firm, Michael Douma Productions, a firm that focuses on making web sites easy to use. His work recieves continued recognition as daily/weekly picks or as featured articles from Yahoo, USA Today, UKPlus, PBS, Associated Press, MSNBC, The Boston Globe, Newsweek, and CNN, among others.

Guiliano Gaia

Giuliano Gaia started working on the Net at the University of Milan, with a thesis about the conferencing system 'The WELL'. He is Internet consultant for firms and non-profit organizations (such as World Wide Fund for Nature) and continues his collaboration with the University. Now he is in charge of the Internet services of National Museum of Science and Technology 'Leonardo da Vinci' in Milan.

Franca Garzotto

Franca Garzotto is Associate Professor of Fundamentals of Computing at the Department of Electronics and Information, Politecnico di Milano. She has a Degree in Mathematics from the University of Padova (Italy) and a Ph.D. in Computer Science from Politecnico di Milano. Her research interests have focused on document modeling, hypermedia

design, usability hypermedia. She has been involved in various ESPRIT research projects in the above fields. She was tutorial chair and/or member of the technical program committee of several editions of the many international conferences: ACM Hypertext and Hypermedia, ACM Multimedia, ICHIM, WebNet. She served as Program Chair of the International Workshop on "Hypermedia Design", held in Montpellier - France in June 1995. She served as Co-Chair of the First International Workshop on "Evaluation and Quality Criteria for Multimedia Applications", held in S. Francisco - CA, November 1995. She was SIC-WEB (Acm Special Interest Group on Hypermedia & Web) vice chair from 1997 to 1999.

David Greenfield

David Greenfield has been kicking around the world of New Media for 10 years and has been involved in the development of CD-Rom's, Computer Based Training, interactive museum kiosks, animation and web sites. Currently he is developing a computer resource center to provide Skirball Center visitors with high-speed internet access and CD-ROMS. Additionally, he is leading the web-development group and is developing site-specific interactive content for the Center as both virtual exhibitions and as companion pieces to museum exhibits.

Amanda Grunden

Amanda Grunden is a Research Information Specialist with the Digital Imaging and Media Technology Initiative, being responsible for the integration of technology into the Digital Cultural Heritage Community project. Amanda, who holds a Ph.D. in Anthropology from the University of Illinois, has significant experience with the Web Technology Group of the Academic Outreach Program at the University of Illinois. She was also instrumental as a project leader for the University of Illinois Spurlock Museum's work on the "Museums in the Classroom" project, and she operates her own educational technologies consulting business, Acadimage.

Volker Hadamschek

Volker Hadamschek studies physics and computer science at the University of Bonn. Since 1999, he is a member of the 'Value-added Solutions' (VaS) research groups at GMD. His main research interests are agent technology, information retrieval, and watermarking solutions.

Michael Henchman

Michael Henchman is a chemistry professor at Brandeis University, who is actively invovled in teaching Science and Art issues to undergraduates and the general public. Current research interests include: Application of science in the examination of works of art: authentication, image evaluation; Teaching chemistry and art to studio artists and art historians: the development of web sites to present complex images and promote interactive learning. The development of a modern undergraduate curriculum in chemistry Gas kinetics, dynamics of molecular collisions, kinetics under non-Maxwellian conditions, isotope effects; Gas phase ion chemistry — thermodynamics and kinetics: electrons, ions, solvated ions, clusters.

Nora Hockin

Nora Hockin is the Director of Digital Content with the Information Highways Application Branch of Industry Canada, a Canadian federal department. She holds a Diploma in Germanistik from the University of Kiel, a B.A. in Modern Languages and Literature from the University of Toronto, and a M.A. in Public Administration from Carleton University. Nora is an executive with 25 years of policy and program experience in the Canadian federal service (Transport Canada, Department of Communications, Ministry of State for Science and Technology, and Industry Canada).

Kristine Hoff

Kristine Hoff has obtained a BA in Art History from the Department of Art History, Aarhus University, Aarhus, Denmark, as well as a MSc Information Science, Department of Information Science, City University, London, UK. Her dissertation investigated the managerial issues of developing and maintaining a web site in a small art museum. She is currently working on her MA thesis at Aarhus University. The subject is the quality of visitors' experiences in virtual art museums. During her studies, Kristine has worked as a student assistant at the Museum of Photographic Art in Odense, Aarhus Art Museum, and Vejen Art Museum.

Glen Hoptman

Glen Hoptman, Publisher of the Lightbeam Group/ Studio, started his involvement in the use of electronic media and education as a participant in the

Workshop in Designing Television for Children in 1973, at Harvard's Graduate School of Education. Since then, in addition to numerous teaching and senior organizational-management experiences, he has created a laboratory for interactive educational technologies at the Smithsonian Institution and published many international award winning interactive educational applications, in addition to numerous other credits and accomplishments. He has written extensively on new philosophies of knowledge and education, which are emerging as a result of the proliferation of "new media technologies." Among his education and museum media project credits are The Virtual BioPark and Amazonia/Smithsonian Institution and Computer Curriculum Corporation (Project Originator and Consulting Executive Designer), The Historical Almanack/Colonial Williamsburg Foundation (Executive Producer), and Moneyopolis/Ernst & Young (Executive Producer). He has been selected as one of the top multimedia developers in the country and is currently working on several Web-based content initiatives and serves as a consultant to the Congressional Web-based Education Commission, and as Chairperson of the New York Times Learning Networks Advisory Board. Glen will direct a re-staging of The Lord of the Flies, for a November 2000 production in Washington, DC.

Roland Jackson

Roland Jackson is Head of Education and Programmes at the Science Museum, London. His responsibilities include all services for educational groups, public programmes and the interactive or 'hands-on' galleries, and he is actively involved in developing the educational use of the Internet and related technologies. Further details are available at http://atschool.eduweb.co.uk/jackson/roland.htm.

Jonathan Latimer

Jon is experienced in managing all phases of trade, reference, and educational publishing, marketing and multimedia production. He has a track record of achievement in building strong organizations and producing high-quality profitable projects. His works include writing and editing the Encyclopedia of the Environment for Marshall Cavendish, Editorial Director for the Macmillan Dictionary for Children, Editor-in-Chief for Peterson's, Publisher for Trade and Reference at Ligature, among numerous other

high level publishing responsibilities. Jon was involved in the basic design of the Virtual BioPark and Amazonia products for Computer Curriculum Corporation among other interactive design initiatives.

Paul Marty

Paul F. Marty is a specialist in the application of advanced information technology to the study of history and, in particular, museum environments. He is currently the Director of Information Technology at the University of Illinois' Spurlock Museum (www.spurlock.uiuc.edu) and is responsible for the design, development, and implementation of advanced information systems at this museum. These systems manage the entire information flow of this growing university museum, maintain digital images and data on the 40,000 cultural and ethnographic artifacts in the museum's collections, and control such internal operating procedures as registration, conservation, education, and collections management. He holds a BS in Computer Science Engineering, a BA in History, and an MA in Ancient History, all from the University of Illinois. He has studied Classics and Ancient History at King's College, Cambridge University, and is currently pursuing a Ph.D. in Information Science through the Graduate School of Library and Information Science at the University of Illinois. His dissertation research is centered on an ongoing ethnographic study of the museum professionals at the Spurlock, whose roles and responsibilities in the preservation, dissemination, and interpretation of knowledge have been shaped and influenced by the integration of information technology into their unique environment. His academic projects encompass such topics as museum informatics, computer-supported cooperative work, and computer-mediated communication.

Patricia Miller

Patricia L. Miller is the Executive Director of the Illinois Heritage Association, a statewide nonprofit museum service organization headquartered in Champaign, Ill., from 1982 to the present. She completed the Graduate Art Museology Program, University of Illinois at Urbana-Champaign, in 1972-73. She holds a M.A., History of Art, University of Illinois at Urbana-Champaign, 1972, and a B.A., History of Art, University of Illinois at Urbana-Champaign, 1957. She is a visiting instructor in the

Historical Administration Program, History Department, Eastern Illinois University, Charleston, Ill. where she has taught courses in historic preservation and museum administration since 1985. She serves as a consultant to museums, historical agencies, and preservation organizations, and has completed over 20 consultations for the Museum Assessment Program, coordinated by the American Association of Museums. She is a senior examiner for the AAM's accreditation program. Miller is co-author of two local history books, and has published numerous articles on museum administration and collections management. Miller is a frequent speaker at professional conferences. In 1999 she was one of five recipients of an Award for Superior Voluntary Service as an AAM Peer Reviewer. She was a council member of the American Association for State and Local History, 1990-94.

Joan Nordbotten

Joan C. Nordbotten, joan, is an associate professor in Information Science at the University of Bergen, and author of a textbook on the analysis and design of information systems, over 25 international conference and journal articles on data management and interface evaluation, as well as numerous technical reports. Current interests include: multi-media, multi-database management for museum and library applications, and system and user interface evaluation.

Paolo Paolioni

Paolo Paolini is the manager of HOC laboratory. He is full professor at Politecnico di Milano (Computer Graphic), Lecturer at the Faculty of Engineering and Industrial Design at Politecnico di Milano and Lecturer at the School of Communication Sciences at the University of Italian Switzerland (USI)-Lugano. He has more than 70 published papers on the following subjects: relational Data Bases, Data Modeling, Abstract Data Types and Data Bases, Views for Data Bases, Automatic generation of documents, Hypermedia and WWW modeling and design, Multimedia implementation, Hypermedia evaluation, Automatic generation of Hypermedia (WWW), collaborative access to WWW, cultural applications of new technologies, use of advanced technologies for education and training. He has been chairman of several conferences, including the ACM conference on Hypertext (1992-Milan). He is currently

Associated editor of TOIS (transactions on Information Systems), an ACM journal. He has been involved in 10 different European funded projects, and for several of them he has been scientific coordinator. (At the University of Italian Switzerland (Communication Science) he is developing a research activity on the communication based upon advanced technology and also on Digital Library. At the University of Lecce he has developed the Telemedia Lab, active in advanced multimedia technologies and application. The Telemedia Lab currently employs nearly 15 people, and Paolini has kept strong scientific ties with it. He has been professional active in the areas of Software Engineering, Information Systems analysis and design, Office Automation, Multimedia design and development, WWW design and development, tools for WWW and electronic commerce. He has also managed small companies in the IT area (up to 50 people), and coordinated several multidisciplinary working teams.)

Susi Peacock

Susi Peacock has recently moved from Richmond, The American International University in London to Queen Margaret University College in Edinburgh (http://www.qmuc.ac.uk) to develop virtual learning environments working with faculty drawn from health care (including physiotherapy, nursing, radiography and podiatry), social science, drama and communications. This will be continuing her work at RAIUL which explored and developed the innovative use of C & IT in the curriculum where she worked with faculty in social science, languages, business and the humanities. She has presented research at conferences including ALT-C, Digital Resources in Humanities, Computers in Art and Design Education (CADE) and Writing and Computers. Her master's research, based at the BT Research Laboratories, investigated the impact of IT on work with case studies in distance working. She is currently researching into the use of online asynchronous and synchronous discussion groups for building academic online communities and into the holistic opportunities afforded by new technologies to enable universities to become truly digital.

Rebecca Reynolds Moore

Ms. Moore's credentials include a B.A. in art history from Smith College and an M.B.A. from Boston University's Graduate School of Management. Ms.

Moore started her career at the Smithsonian Institution's National Museum of American Art focusing on marketing, public programs and development, after having interned and volunteered at the Library of Congress, the Phillips Collection, and the National Museum for Women in the Arts in Washington, D.C. Ms. Moore launched MuseumShop.com, Inc. in 1997 to help bring museum stores to the Internet. Ms. Moore is responsible for the overall day-to-day operations, as well as the Company's growth to include museums from around the world. Ms. Moore also founded Venture Forth in 1995, a consulting firm offering strategic marketing, new product development and market research services to companies on the Internet, and in the publishing, entertainment and high technology industries. Prior to that, Ms. Moore worked for two Boston-based consulting firms focusing on business development, marketing, and regulatory programs for a wide range of organizations and industries. Ms. Moore is a member of the American Association of Museums and the American Marketing Association. MuseumShop.com is an exhibitor affiliate of the Museum Store Association, and a member of the Museum Computer Network, the Massachusetts Software Council, the Massachusetts Interactive Multimedia Council, and Business for Social Responsibility.

Kelly Richmond
Kelly Richmond, Communications Director for the Art Museum Image Consortium, is completing her Master of Arts Management at Carnegie Mellon University in May 2000. Previously she worked at America Online from 1992-1998 in increasingly responsible position in Marketing to AOL Partners and National Accounts. Kelly has a B.A. in History and Art History from the College of Wooster (Ohio) and a Certificate in Business Administration from Georgetown University (DC).

Claus Riemann
Claus Riemann is a mathematical-technical assistant researching in the area of real-time tracking systems in blue room studios before he moved to the VaS research group where he worked on network security, innovative Web applications, and copyright protection. Actually he has joined GMD's central administration department to initiate a workflow system of electronic circulation folders.

Sophia Robertson
Sophia Robertson has worked at the National Maritime Museum for three years, having begun her Museum career at the Victoria & Albert Museum. She was Content Project Manager of the Search Station Project. She has an MA in Museum and Gallery Management from City University.

Beth Sandore
Beth Sandore is Head, Digital Imaging and Multimedia Technology Initiative program and Associate Professor at the University of Illinois at Urbana-Champaign Library. Her professional experience and research focus on technology development and evaluation in libraries, including experimental work with image and multimedia databases. Her recent publications include a user evaluation study of the Museum Educational Site Licensing image database, a book on technology and management in libraries co-authored with F. W. Lancaster, and a Fall, 1999 issue of Library Trends devoted to digital image access and retrieval. Her research has been supported by the Institute of Museum and Library Services, the J. Paul Getty Trust, the National Science Foundation, and the Intel Corporation. She has served in an advisory capacity for a number of groups on imaging and technology evaluation projects, including the U.S. Department of Education, the Getty Information Institute, the Andrew Mellon Foundation, and the Oregon Historical Society.

Scott Sayre
Scott Sayre is the Director of Museum Media and Technology at The Minneapolis Institute of Arts. In 1997 Scott led the formation of a collaborative online partnership with the Walker Art Center resulting in the development of ArtsConnectEd, a comprehensive resource for teacher and students. Scott's other projects include the development of the MIA's web-site in 1993 and the formation of the Institute's in-house Interactive Media Group in early 1991, which has produced and installed nine interactive multimedia programs throughout the museum's galleries. Prior to Scott's work at the Institute, Scott held the position of Applications Researcher as the University of Minnesota's Telecommunications Development Center. Scott has a Doctorate in Education from the University of Minnesota and in 1996 received the Larry Wilson Award for Outstanding Achievement in a Non-School Environment.

Rob Semper

Rob, a physicist and science educator, is Executive Associate Director of the Exploratorium and head of the Exploratorium's Center for Media and Communication. In addition to supporting the graphics, media, editorial and information resources needs of the Exploratorium, the Center is the home of an extensive commercial publishing program, a variety of radio and television broadcast projects, the Interactive Media Laboratory researching the use of new tools for learning and the Exploratorium's Website which develops interactive media for the museum setting and external venues. Rob has been project director for a number of NSF and NASA sponsored Internet testbed projects designed to explore the use of on-line museum responses to support school science instruction and he is executive producer of Live @ the Exploratorium, a program of live audio and video Webcasts bringing access to authentic scientific discovery to children and adults at home and school. He is also executive producer of "The Exploratorium_s X-Lab", an integrated children_s television, publication and Website project focused on developing problem solving skills. In 1988, during a leave, he was director of a creative collaboration between Apple Computer and Lucasfilm Ltd. which developed interactive multimedia education projects combining computer graphics and film and video technology. He was the recipient of the 1994 NSTA's Informal Educator of the Year award.

Jim Spadaccini

Jim Spadaccini is the founder and president of Ideum, a design and consulting firm specializing in creating educational experiences online. Before forming Ideum, Jim was the Director of Interactive Media at the Exploratorium in San Francisco. There he led the Exploratorium's Web site to three consecutive Webby Awards (Best Science Site 1997- 1999) and a Smithsonian Computerworld Award (1999). Jim is also an instructor at San Francisco State's Multimedia Studies Program, where for the last five years, he's taught "Understanding the Internet: An Insider's Guide."

Kevin Sumption

Kevin Sumption has worked for over eight years as both a science and social history curator. He is currently the national project manager of Australian Museums On-Line and Curator of Information Technology at the Powerhouse Museum. He is also a lecturer in Design History and Theory and Research Methodology at the University of Technology, Sydney. For many years Kevin developed and managed the Powerhouse Museum's computer-based education programs and has also published a number of texts on computer aided design, computer animation and desk top publishing. He has just finished working on the exhibition "Universal Machine", which examines the origins, meaning and impact of contemporary information technology. He has also just completed his Masters of Arts at the University of Sydney, where he has been examining the legacy of traditional museum based education on the design and delivery of on-line museum teaching and learning programs.

Chris Tellis

Chris Tellis founded Antenna Audio in 1986 and is responsible for developing the hardware and techniques, which have established Antenna Audio as the leader in the field of museum audio tours. Mr. Tellis oversees the international operations of the company and is tasked with charting Antenna's expansion into digital distribution channels. He also spends a significant amount of his time handing out tours to museum visitors. Mr. Tellis has lectured extensively on audio interpretation and technology to, among others, the American Association of Museums, The National Park Cooperating Association's Conference, the National Association of interpretation and the International Conference of Cultural Heritage Informatics. He is a former director of Art Zone, a Sausalito based non-profit organization which works to preserve low income housing for artists and maritime workers. Mr. Tellis is a graduate in Administrative Science from Yale University.

Jennifer Trant

Jennifer Trant is the Executive Director of the Art Museum Image Consortium (AMICO), and is a Partner in Archives & Museum Informatics. She is co-chair of Museums and the Web and ichim, and is on the program committee of the Digital Libraries conference, and the Board of the Media and Technology Committee of the American Association of Museums. Prior to joining Archives & Museum Informatics in 1997, Jennifer Trant was responsible for Collections and Standards Development at the Arts and Humanities Data Service, King's College,

London, England. As Director of Arts Information Management, she consulted regarding the application of technology to the mission of art galleries and museums. Clients included the Getty Information Institute (then the Getty Art History Information Program) for whom she managed the Imaging Initiative and directed the activities of the Museum Educational Site Licensing Project (MESL). She also prepared the report of the Art Information Task Force (AITF), entitled Categories for the Description of Works of Art for the College Art Association and AHIP. A specialist in arts information management, Trant has worked with automated documentation systems in major Canadian museums, She has been actively involved in the definition of museum data standards, participating in numerous committees and regularly publishing articles and presenting papers about issues of access and intellectual integration.

Michael Twidale

Michael Twidale is an Associate Professor at Graduate School of Library and Information Science, University of Illinois at Urbana-Champaign. Before that he was a faculty member of the Computing Department at Lancaster University, UK. His research interests include computer supported cooperative work, computer supported collaborative learning, user interface design and evaluation, museum informatics, and the application of ethnographic methods to computer systems design and evaluation. All these involve the use of interdisciplinary techniques in order to better understand the needs of end users and their difficulties with existing computer applications as part of the process of designing more effective systems. Current projects include an investigation into data quality in museum databases and collaborative techniques for improving that quality, and the potential of advanced technologies for providing more individualized tours of museums, drawing on the practice of docents.

Sara Valenti

Sara Valenti has a master degree in Computer Science Engineering from University of Milano, where she is currently research assistant. Her research interests include hypermedia requirements analysis, web modeling, dynamic web architectures.

Noel Wanner

Noel Wanner is Director of Interactive Learning Technology at the Exploratorium, a museum of Science, Art, and Human Perception in San Francisco. He has worked for many years on the applications of innovative technologies in learning environments from the museum floor to the web to the classroom. He also has established the Exploratorium's webcasting intitiative, Live@The Exploratorium.

Marsha Weiner

Marsha has 20 years experience in product development in television, radio, publishing, toys and games and new technology. Current clients include National Public Radio, Gannett USA Today, Smithsonian Institution, Reading Revolution, SmarterKids.com, and Public Broadcasting. Prior to working in product development, Marsha was a professional modern dance, kindergarten teacher and instructor at New York University.

Archives & Museum Informatics

*publishes current reports from experts wordwide on
issues critical to cultural heritage in the information age*

Museums and the Web 2000:
Selected papers from an international conference
Edited by David Bearman and
Jennifer Trant
ISBN: 1-885626-20-7
Approx. 200 pages and CD-ROM
(requires Web browser)
$50.00

This print volume includes the best of the
papers presented at **Museums and the Web
2000** on April 16-19th, 2000. The CD-ROM
includes all papers submitted, abstracts of all
presentations and biographical information for
all presenters.topics covered include Virtual

Museums and the Web 99:
Selected papers from an international conference

Edited by David Bearman and Jennifer Trant

ISBN 1-885626-17-7 (available March 1999)
245 pages, and CD-ROM (requires web browser)
$50.00

This volume includes the best of the papers
presented at **Museums and the Web 1999**.
An accompanying CD-ROM contains all
papers, outlines of demonstrations, as well as
biographical and contact details for speakers.
The print volume serves as a record of the
formal papers which offer a long-lived contribu-
tion to the field. The CD-ROM includes many
additional papers and links to the sites featured,
reflecting the interactive experience of the
presentations and highlighting the technical
features described.

Museums and the Web 1998: Proceedings (CD-ROM)
Edited by David Bearman and Jennifer Trant
CD-ROM (requires web browser, Netscape 3.0 or equiva-
lent) 1997. $25.00

Over 60 papers by museum professionals in 16
countries were presented at **Museums and the
Web 1998**, April 21-25, 1998, in Toronto,
Ontario, Canada. This CD-ROM includes the
texts of conference papers and links to the sites
featured, capturing the interactive experience of
the presentations, and offering a comprehensive
overview of the the major challenges facing
museums and society as the Web evolves.
Includes the results of the "Best of the Web" and
**beyond interface: net art and art
on the net**" curated by Steve Dietz.

Museums and the Web, 1997: Selected Papers
Edited by David Bearman and Jennifer Trant
ISBN 1-885626-13-4 (1997), 373 pp., $30.00

The **First International Conference on Muse-
ums and the Web**, (Los Angeles, March 1997),
featured a wide range of reports on how muse-
ums were using and being changed by the World
Wide Web. The thirty-two papers in this volume
address challenges facing both the cultural
heritage community and the technology as the
missions of museums intersect with the opportu-
nities of the Internet. They examine the political
and economic aspects of culture on the Web, the
future of museums and of collections, the
challenges of managing and integrating Web
technology, and issues in creating and using Web
resources.

Proceedings from past ICHIM Meetings

Cultural Heritage Informatics 1999:
Selected papers from ichim99, the International Cultural Heritage Informatics Meeting

Edited by David Bearman and Jennifer Trant
ISBN 1-885626-18-5 (1999) 255 pp., $50.00

Papers from the Fifth International Cultural Heritage Informatics Meeting, **ichim99** in Washington DC, have been edited for this print publication. Sections reflect the major themes of the conference: interactivity, converging technologies, user involvement, and new models for museum multimedia.

Museum Interactive Multimedia: Cultural Heritage Systems Design and Interfaces

Edited by David Bearman and Jennifer Trant
ISBN 1-885626-14-2 (1997), 233 pp., $30.00

A decade of progress in interactive multimedia in museums forms the basis for papers on systems design and user interface from the Fourth International Conference on Hypermedia and Interactivity in Museums (le Louvre, Paris 1997). These papers focus on design systems development and evaluation methodologies), interfaces (visitor aware systems and interactives providing geographical and chronological views of data), and case studies of museum ew multimedia ranging from collection catalogs to 3D environments.

Multimedia Computing and Museums

Edited by David Bearman
ISBN 1-885626-11-8 (1995) 388 pp., $20.00

Volume 1 of selected essays from the Third International Conference on Hypermedia & Interactivity in Museums (ICHIM 95 / MCN 95) on the technological, cultural and intellectual issues raised by the use of multimedia technologies to represent cultural heritage. Papers profile the iimpact of technologies on museum applications and audiences, and on the relationship of museums to society.

Hands on: Hypermedia and Interactivity in Museums

Edited by David Bearman
ISBN 1-885626-12-6 (1995) 293 pp., $20.00

Volume 2 of selected papers from the Third International Conference on Hypermedia & Interactivity in Museums (ICHIM 95 / MCN 95) reflecting the evolution of delivery mechanisms for interactive multimedia, the new social and institutional arrangements they engender, and the continuing importance of intellectual property issues. Groups of essays address fixed-format publishing, in-house interactives, networked access, museum consortia, museum teamwork, commercial partnerships and intellectual property.

Museums and Interactive Multimedia

Edited by Diane Lees
ISBN 1-8856263-89-X (1993) 436 pp., $20.00

The proceedings of the Second International Conference on Hypermedia & Interactivity in Museums (ICHIM 93) include over sixty presentations by authors from over twenty nations on the issues of design and implementation of museum interactives.

Hypermedia and Interactivity in Museums −Out of Print−

Edited by David Bearman
ISBN 1-885626-03-7 (1991) 340 pp.,

Order Details

Email info@archimuse.com for details or contact us at:

Archives & Museum Informatics
2008 Murray Ave, Suite D
Pittsburgh, PA 15217 USA
Phone: +1 412 422 8530
Fax: +1 412 422 8594
Email: info@archimuse.com
www.archimuse.com

Online Order Form at
http://www.archimuse.com/pub.order.html

Titles on Archives and Electronic Records

Electronic Records Research 1997: Resource Materials (CD-ROM)

Edited by David Bearman, Kimberly Barata, and Jennifer Trant

CD-ROM (requires web browser, Netscape 3.0 or equivalent) 1997. $25.00

This CD contains copies of over 100 papers and executable links to hundreds of sources on the definition, policy, capture, storage, and migration of electronic records together with an annotated bibliography and the archival Web sites of the major research projects at the University of British Columbia and University of Pittsburgh. In addition this essential reference contains biographical and contact information for researchers in these fields worldwide.

Electronic Evidence: Strategies for Managing Records in Contemporary Organizations

By David Bearman
ISBN 1-885626-08-8 (1994) 314 pp., $30.00

A collection of previously published papers, accompanied by a new essay exploring the evolution of concepts of electronic records management. The papers reprinted here were originally published between 1989 and 1993, in journals in the United States, Canada, Portugal and Australia, as well as in a United Nations Report. Includes a detailed index by Victoria Irons Walch.

Electronic Records Management Program Strategies

Edited by Margaret Hedstrom
ISBN 1-885626-07-X (1993) 156 pp., $20.00

Papers prepared for a joint meeting of SAA-CART and NAGARA-CIT in the spring of 1993. Includes the results of brainstorming sessions, an essay on program structure options by David Bearman and Margaret Hedstrom, and an annotated bibliography by Richard J. Cox.

Forthcoming Titles

Archives & Museum Informatics Reader

Edited by David Bearman, Jennifer Trant, and Costis Dallas
ISBN: 1-885626-21-5
Approx. 250 pages (Available summer 2000)
$40.00

A collection of outstanding papers from both the ICHIM and Museums and the Web conferences provides an excellent background into museum web development and hypermedia. The *Reader* provides a historical perspective of the development of hypermedia in museums, surveying the past 10 years, and exploring subjects ranging from web site design, to virtual museum tours, and intellectual property rights issues.

Managing Web Sites

By Stephen Smith
ISBN: 1-885626-22-3
Approx. 120 pages (Available summer 2000)
$35.00

Is your website taking over? Get practical advice on how to regain control and plan future developments in this workbook prepared by an experienced web site administrator.

Bulk Orders, Standing Orders, and Classroom Discounts Available
Shipping and Handling

Prepaid orders from the United States are shipped free of charge. A $5 US shipping and handling fee applies to invoiced US orders. International orders please add $10 US *per item* for shipping and handling.

Payment

All prices are in US Dollars. Payment can be made by cheque, money order, bank draft, bank transfer, or credit card (VISA, Mastercard, or American Express). Cheques must be payable to Archives & Museum Informatics, in US funds, drawn on a US Bank. Money Order or Bank Draft should be payable to Archives & Museum Informatics. Call or email for Bank Transfer details.

About the CD-ROM

This book is accompanied by a CD-ROM containing versions of all these papers and many others, presented in HyperText Mark-Up Language (HTML), the technical language of the Web. It also includes abstracts of all the papers, demonstrations and workshops presented at the conference, and the biographies of all speakers and presenters. These electronic versions include color illustrations and links to the sites discussed and referenced.

You don't have to be connected to the Internet to read the papers on the CD-ROM or to navigate the full background information about the conference. You will need your own connection to the Internet to go to the linked museum sites and to follow the external links in the papers.

To use the CD-ROM, you will need a Web browser (Netscape 4.0 or Internet Explorer 4.0 or higher are recommended). Put the CD in your computer, launch your browser, and, using the File / Open menu choices, navigate to the index.html file in the main directory of the CD-ROM. Open this file in your browser — all other files are linked from there.

- **Speakers** provides a list of all the speakers at the conference and links to their abstracts, biographies and papers (where available).

- **Sessions** provides an overview of the Museums and the Web 2000 conference program and links to abstracts and paper biographies

- **Best of the Web** will take you to the results of the Best of the Web 2000 conference, but you have to be connected to the Internet to do this.

If you have any questions or problems using the CD-ROM please email info@archimuse.com, and we'll do our best to help you.